Bond Girls

Bond Girls

Body, Fashion and Gender

Monica Germanà

BLOOMSBURY VISUAL ARTS
LONDON • NEW YORK • OXFORD • NEW DELHI • SYDNEY

BLOOMSBURY VISUAL ARTS
Bloomsbury Publishing Plc
50 Bedford Square, London, WC1B 3DP, UK
1385 Broadway, New York, NY 10018, USA

BLOOMSBURY, BLOOMSBURY VISUAL ARTS and the Diana logo are trademarks of
Bloomsbury Publishing Plc

First published in Great Britain 2020

Cover design: Design Holborn
Cover image © Hans Neleman/Getty Images

A catalogue record for this book is available from the British Library.

A catalog record for this book is available from the Library of Congress.

ISBN: HB: 978-0-85785-643-2
 PB: 978-0-85785-532-9
 ePDF: 978-1-35012-471-4
 eBook: 978-1-35012-470-7

Typeset by RefineCatch Limited, Bungay, Suffolk
Printed and bound in Great Britain

To find out more about our authors and books visit www.bloomsbury.com
and sign up for our newsletters.

For my little sister, Danila, who used to borrow my ballerina shoes, and Byron, who wears his bow tie with canine panache.

Contents

List of Figures

Acknowledgements

The long gestation of this project means the list of people to thank is also extensive, and I hope to be forgiven for any unintentional omissions.

I would like to thank my editor at Bloomsbury, Frances Arnold, and her assistants, Ariadne Godwin, Pari Thomson, and Yvonne Thouroude, for their faith in my research and patience with my progress, which, at times, was hindered by life's own complications. Special thanks also go to Svetlana Muraskina, the University of Westminster IT technician who helped me retrieve the missing manuscript file following the theft of my laptop.

I am also grateful to Indiana University, who selected me for an Everett Helm Fellowship, which allowed me to visit the Lilly Library in Bloomington where I had the pleasure of reading Ian Fleming's manuscripts. Special thanks to the Associate Director and Curator of Modern Books and Manuscripts, Erika Dowell, for granting me permission to reproduce and publish a page from Ian Fleming's MS 'The Moonraker'.

Among my academic colleagues, I am particularly grateful to Professors Alex Warwick and Catherine Spooner, whose excellent insights into the fascinating complexities of fashion have been very influential to the development of my views on the function of dress in literary and visual representations. I would also like to thank Dr Michael Nath, for the stimulating chats about Fleming's *Moonraker*, Dr Anne Witchard for helping me with the ad-hoc fashion queries and initial stages of the project, and Dr Matt Morrison for his useful comments on the project's scope. Special thanks go to Dr Simon Avery for his invaluable feedback on this project.

I was fortunate to discuss some of my ideas with Bond expert and documentary film-director John Cork, who helped to contextualize the Bond EON franchise within the wider film business. I am also grateful to Michael Infante, Alice Dyson-Jones and Kym Davies at One Media for showing me around Pinewood Studios, and pointing me in the direction of the display of Eva Green's Roberto Cavalli dress.

Special thanks, too, to colleagues who have invited me to share my ideas outside my own institution: Dr Ingibjörg Ágústsdóttir at the University of Iceland, Dr Christine Berberich at the University of Portsmouth, Professor Agnieszka Soltysik Monnet at the University of Lausanne, and Dr Ian Kinane at the University of Roehampton.

On a personal level, my utmost gratitude goes to Liam Murray, who cooks scrambled eggs better than James Bond, and whose support I value more than he will ever know.

Last but not least, *grazie*, Elliott Patrick Germanà Murray, for giving my life 'licence to thrill', and especially for not delivering on the threat to delete all of my computer files.

James Bond Timeline

1908	Birth of Ian Lancaster Fleming
1953	Ian Fleming, *Casino Royale*
1954	Ian Fleming, *Live and Let Die*
1955	Ian Fleming, *Moonraker*
1956	Ian Fleming, *Diamonds Are Forever*
1957	Ian Fleming, *From Russia with Love*
1958	Ian Fleming, *Dr No*
1958–1984	James Bond comic strips published in *The Daily Mirror*
1959	Ian Fleming, *Goldfinger*
1960	Ian Fleming, *For Your Eyes Only*
1961	Albert R. (Cubby) Broccoli and Harry Saltzman found EON Productions
1961	Ian Fleming, *Thunderball*
1962	Ian Fleming, *The Spy Who Loved Me*
1962	Terence Young (Dir.) *Dr No*
1962	*Dr No*: First James Bond Comic Book (Classics Illustrated)
1963	Ian Fleming, *On Her Majesty's Secret Service*
	Terence Young (Dir.) *From Russia with Love*
1964	Ian Fleming, *You Only Live Twice*
	Death of Ian Fleming
	Goldfinger (Dir. Guy Hamilton)
1965	Ian Fleming, *The Man with the Golden Gun* (published posthumously)
	Thunderball (Dir. Terence Young)
1966	Ian Fleming, *Octopussy* and *The Living Daylights* (published posthumously)
1967	*You Only Live Twice* (Dir. Lewis Gilbert)
	Casino Royale (Dir. John Huston et al.)
1968	Kingsley Amis (as Robert Markham), *Colonel Sun*
1969	*On Her Majesty's Secret Service* (Dir. Peter Hunt)
1971	*Diamonds Are Forever* (Dir. Guy Hamilton)
1973	*Live and Let Die* (Dir. Guy Hamilton)

	The World Is Not Enough (Dir. Michael Apted)
	Raymond Benson, *The World Is Not Enough* (novelization)
2000	Raymond Benson, *Doubleshot*
2001	Raymond Benson, *Never Dream of Dying*
2002	Raymond Benson, *The Man with the Red Tattoo*
	Die Another Day (Dir. Lee Tamahori)
	Raymond Benson, *Die Another Day* (novelization)
2006	*Casino Royale* (Dir. Martin Campbell)
	Casino Royale (Sony Online) (mobile videogame)
2008	*Quantum of Solace* (Dir. Marc Forster)
2008	Sebastian Faulks, *Devil May Care*
2011	Jeffrey Deaver, *Carte Blanche*
2012	*Skyfall* (Dir. Sam Mendes)
2013	William Boy, *Solo*
2014–p.d.	Dynamite Entertainment James Bond comic books series
2015	Anthony Horowitz, *Trigger Mortis*
2015	*Spectre* (Dir. Sam Mendes)
2018	Anthony Horowitz, *Forever and a Day*

Glamorous Eye-Candy? Bond Girls Revisited

Sexy, attractive, stylish. In the popular imagination, Bond Girls conjure up an image of devil-may-care sexuality, sensual beauty, and sophisticated glamour. But the dubious gender politics of the James Bond films (and novels) have been sparking off heated debates since a bikini-clad Ursula Andress rose out of the Caribbean Sea in the cinematic adaptation of Ian Fleming's *Dr No* (Young 1962), the first Bond film. At the end of the 1970s, director Terence Young, significantly, felt the need to set the record straight:

> They must have innocence, but be able to kill a man without showing any guilt. They are women of the nuclear age, freer and able to make love when they want to, without worrying about it afterwards.
>
> <div align="right">'What has happened to Bond Girls?' 1978: 10</div>

But not everybody would agree that Bond Girls, as Young suggested, are more than the glamorized objects of Bond's misogynistic sadism. Reviewing Young's third Bond film, *Goldfinger* (1964), for instance, film critic Nina Hibbin condemned 'the constantly lurking viciousness, and the glamorisation of violence … the carefully timed peaks of titillation and the skilfully contrived sensationalism' (qtd. in Chapman 2000: 87). Pointing to the alleged vulnerability of Bond's women, in the academic field, literary critic Umberto Eco has suggested that the literary Bond Girl 'has been made frigid and unhappy by severe trials suffered in adolescence' ([1979] 2007: 154), while film scholars Tony Bennett and Janet Woollacott have drawn attention to female oppression produced by 'her skewed positioning in relation to traditional, patriarchal orderings of sexual difference' (1987: 116); it is Bond's job to put 'her back into place beneath him' (1987: 116).

Alongside accusations of misogyny, many of the negative responses concentrated, as they still do, on Bond's presumed glamorization of violence. Even Ian Fleming, the literary father of James Bond, acknowledged concerns about the treatment of violence in his novels, though he felt that the darker and seedier sides of his work simply reflected human nature: 'my books have no

social significance, except a deleterious one,' he told *The New Yorker*, 'they're considered to have too much violence and too much sex. But all history has that' (qtd. in Hellman 1962: 33). But in spite of Fleming's justifications and increasing fame, audiences and critics have continued to be divided, particularly after Albert R. 'Cubby' Broccoli and Harry Saltzman set up EON, the longest-living film franchise in the world, and produced the first Bond film, *Dr No*, in 1962.

Bond Girls: Body, Fashion and Gender offers a new way of looking at Bond Girls, and brings to the foreground their feminist challenge to the patriarchal foundations of the Bond narratives. Read 'against their grain', the Bond novels and films reveal, rather than a straightforward celebration of masculine heroism, profound anxieties about female authority. Behind the glamour of Bond Girls is a defiant denunciation of the male hero's inadequacy; behind Bond's impeccably styled masculinity are the preoccupations of a late-1950s manhood in the face of a rising female emancipation. Drawing attention to the importance of the 'look' to the world of Bond, this original re-reading of Bond Girls exposes, for the first time, the subversive codes of fashion and body to articulate the gender preoccupations at the heart of these cultural products.

The book's focus on 'looks' points to the common ground between film and fashion. Discussing general preconceptions about film adaptations, Robert Stam argues that, more than the written text, 'film offends through its inescapable materiality, its incarnated, fleshly, enacted characters, its real locales and palpable props, its carnality and visceral shocks to the nervous system' (2005: 6). It is precisely the interplay between the materiality of the film objects and acting bodies and the immateriality of the ideas and story it conveys that make film into 'a composite language [which,] by virtue of its diverse matters of expression ... "inherits" all the art forms associated with these matters of expression' (2005: 6). Among the multiple art forms referenced in film is fashion, the manifestations of which can also be read as 'language'; after all, it is possible to make a 'fashion statement', or even operate a 'dress code', and structuralist critics such as Roland Barthes have extensively investigated the structures behind fashion's codes ([1967] 2010).

Still, as the following chapters demonstrate, as a system, fashion is never linear, and the complex meanings produced by clothes are ambiguous more often than not. It may be more useful to think of fashion, following sociologist Fred Davis's suggestion, as a 'quasi-code, which, although it must necessarily draw on the conventional visual and tactile symbols of a culture, does so allusively, ambiguously, and inchoately' (1992: 5). The multiple codes of film and fashion point to the clothed body as a readable text, the decoding of which can lead to surprising revelations. A reading of body and dress, in this particular

context, opens up new ways of thinking about the politics of gender throughout the Bond film franchise and literary novels.

As part of the collaborative project that film is, the work of Bond costume designers such as Tessa Prendergast, Emma Porteus and Lindy Hemming has crucially contributed to create looks which – while paying homage to current trends – also incorporate an element of experimentation. Their sartorial directions represent the female body in ways that tease out the opposites of passive feminine display and active male gaze, as captured in Beatrice Dawson's designs for the queer character of Pussy Galore (Honor Blackman) in the film *Goldfinger*, and Hemming's playful homage to Andress's bikini scene in *Casino Royale* (2006), where it is the swimming trunks of James Bond (Daniel Craig), that grab the spectator's attention.

Bond films do not just reference fashion; they make fashion. The characters, and the actors who gave them life, have had a continuous impact on the world of fashion and consumer culture. As early as 1964, Shirley Eaton, who played Jill Masterson in *Goldfinger*, appeared on the cover of *Life*. Since then, Bond Girl actors have frequently appeared in highly publicized red-carpet events, dedicated fashion spreads, and popular magazine features. Countless websites list the moments that have become fashion classics in the Bond films. Katharine Hamnett and Diane von Fürstenberg's collections dedicated to the women of James Bond, discussed in the conclusion of this book, have signalled the Bond films' impact on *haute couture*. Linking fashion to Bond's literary and cinematic debuts, the exclusive James Bond Beach and Fleming's Goldeneye villa-turned-resort in Jamaica have been used for themed fashion-shoots featuring, in a 1999 *Vogue* issue, 'our Bond Girl . . . running in dangerously sexy swimwear and ready-for-action separates' inspired by iconic film scenes, including, perhaps inevitably, an Ursula Andress bikini moment ('License to Thrill', 1999).

But concerns about the sexualization of women in the Bond narratives have persisted. In the twenty-first century, sociologist Linda Lindsey's retrospective analysis still shares similar concerns to those of earlier feminist reviewers:

> In four decades of James Bond films . . . women are depicted *enjoying rape*. Bond is the suave, charismatic good guy – the supposed fantasy of every woman and enviable role model of every man. James Bond gets to play out men's fantasies – he drives fast cars, fights ruthless villains, wears a nice suit, and has sex with any 'girl' he desires, all who eventually *say yes to him*. Bond films are a composite of sex, spectacle, and menace . . . Once raped women are then ignored by the male star, sometimes murdered by him, and often murdered by someone else.
>
> [1990] 2005: 352; my emphases

The notion that 'James Bond gets to play out men's fantasies' echoes the oft-quoted line from Raymond Mortimer's review of Fleming's *On Her Majesty's Secret Service* (1963): 'James Bond is what every man would like to be, and what every woman would like between her sheets' (Mortimer 1963: 28); generalizing desire, both exclude the possibility of queer sexuality. It is true that sexual violence is, at the very least, implied in some of the Bond films; in *Licence to Kill* (Glen 1989), for instance, Felix Leiter's new bride is presumably violated before being killed by the villain's henchmen. Nevertheless, female rape and sexual enjoyment, with the exception of sexual fantasy, are, arguably, mutually exclusive concepts; unlike rape, enjoyment presumes consent, as indeed implied – '[they] say yes to him' – in Lindsey's ambiguous summary of Bond Girls' sexual treatment. Indeed, while novelist Jeanette Winterson also playfully suggests that Bond Girls are for 'lovemaking', they are not merely there for Bond's gratification. Female pleasure, in fact, occupies a significant position in the Bond films: 'women want Bond because he satisfies them sexually', she notes, 'and any woman in touch with her body will want a lover who does that' (2002).

More women-centred evaluations of Bond Girls' roles come from those directly involved in the making of the films. Pussy Galore actor Honor Blackman's reflection on her performance in *Goldfinger* as 'romping about on international locations with the sexiest man ever seen on screen', contradicts, or even subverts, notions of female objectification attached to the raunchiest and most memorable Bond Girl's name ('What has happened to Bond Girls?' 1978: 10). Producer Barbara Broccoli, who co-manages EON with her stepbrother Michael G. Wilson, has also put forward a more positive re-assessment of Bond Girls, old and new:

> The women were unique for their time. Pussy Galore, for instance, was a female pilot. A lot of them were sexual predators who gave as good as they got. They had professional careers and did extraordinary things. I think the early women were very progressive.
>
> qtd. in Hastings 2008

Against conventional responses solely focusing on Bond Girls' physical display, Broccoli puts an accent on the active roles Bond Girls have played throughout the film franchise. Similarly, discussing her role as Madeleine Swann in *Spectre* (Mendes 2015), Léa Seydoux speaks of her character as 'different . . . tougher, and more sensitive . . . a modern woman', because 'she takes her destiny in her own hands. She's not passive' (qtd. in Waters 2015).

Bond Girls' tough, modern and active characterization is in fact nothing new. Another strand of feminist readers has argued for an alternative reading of these

characters, re-assessing them in the light of their actions. Christine Bold, for instance, draws attention to the fact that 'Bond frequently depends on women to guide him through the enemy territory of his exotic locations', and that Bond Girls, in turn, do not always require rescuing: 'as often as Bond snatches women from the jaws of death, they repay the compliment' (2003: 171–2). As villains, Bond Girls can also give the hero a hard time: 'there are always multiple attractive female characters that tempt . . . and hinder Bond over the course of his mission', Lori Parks reminds us (2015: 256).

Regardless of their allegiance, Bond Girls/Bond Girl Villains are never inconsequential to the development of the plot. Fleming himself, discussing the origin of his character's name, inspired by the American ornithologist James Bond, explained, 'I wanted Bond to be an extremely dull, uninteresting man to whom things happened; I wanted him to be the blunt instrument' (qtd. in Hellman 1962: 32). Bond exists, from the start, in an ambiguously passive, rather than active position. Bond Girls *are* some of the 'things that happen' to him.

Feminine exhibitionism and masculine voyeurism: negotiating the male gaze

In her influential study of the male gaze, 'Visual Pleasure in Narrative Cinema' (1975), film scholar Laura Mulvey claimed that passive exhibitionism is, traditionally, attached to the visual representation and appeal of female bodies: 'in their traditional exhibitionist role [*sic*] women are simultaneously looked at and displayed, with their appearance coded for strong visual and erotic impact so that they can be said to connote *to-be-looked-at-ness*' (1975: 11). Mulvey's study exposed the mechanisms of patriarchal oppression through distinctive cinematic techniques applied to the representation of female bodies on screen. Speaking from a similar angle to Mulvey's – albeit focusing only on some moments in Western visual art – art critic John Berger had also suggested that 'men act and women appear', and that while 'men look at women . . . she [woman] turns herself into an object – and most particularly an object of vision' (Berger [1972] 1990: 41). In retrospect, the value of these positions is in the gendered framework they offered to discuss power relations in the omnipresent visual representations of women.

Later responses to these initial ways of thinking have, however, exposed the gaps and problems with the binary structure within which these theories of

the male gaze still operate. Defining women as the passive object of the male gaze, these models also imply that the *female* gaze can only be inward-looking and self-scrutinizing. Revisiting her own argument, Mulvey has attempted to rethink the ambiguous position of the female spectator:

> It is always possible that the female spectator may find herself so out of key with the pleasure on offer, with its 'masculinisation', that the spell of fascination is broken. On the other hand, she may not. She may find herself secretly, unconsciously almost, enjoying the freedom of action and control over the diegetic world that identification with a hero provides.
>
> 1981: 12

But while the possibility of female identification with the active male hero may be a significant development, the fundamental masculine/feminine binary split remains apparently unsolved.

Although Mulvey's initial theory revolves around the classic cinematography of Alfred Hitchcock and Joseph von Sternberg, her argument could be applied to the Bond films. Discussing *Skyfall* (Mendes 2012), for instance, reviewer Katy Brand's response points to the partial overlap of her gaze with Bond's: 'I liked looking at the girls too – I liked looking at their glamorous outfits and their glossy hair and I enjoyed their somewhat reckless attitudes to responsible sex, a triptych of admiration I imagine I shared with Bond himself' (Brand 2012). The focus of shared pleasure (Bond Girls) here seems to suggest, as Mulvey argues, the female spectator's adoption of the male gaze. Nevertheless, there are also some notable deviations. Assessing the hero's evolution since its twentieth-century debut, the reviewer also notes that although 'these days Bond is still very much the action hero . . . his girl at least gets to do something exciting along with him, and the glamorous dress is ripped and bloody within minutes' (Brand 2012). While the collusion with the male gaze prompts the female spectator to share the conventional appreciation of Bond Girls' display, it also simultaneously blurs the active hero/passive heroine opposition.

That the consequence of the Bond Girl's *active performance* is inscribed in her costume proposes another important departure from Mulvey's analysis, suggesting that a more dynamic visual mechanics is in place. Indeed, the notion that 'the glamorous dress is ripped and bloody within minutes' is not merely suggestive of the Bond Girls' endurance of sadistic violence so frequently discussed in relation to Bond narratives, but of the active/passive inversion operated by Bond Girls, and their clothes. Drawing attention to Mulvey's reliance on 'an active/looking, passive/looked-at split corresponding to a male/female

gender division', film scholar Pam Cook rightly notes that 'Mulvey's description ignores both the active dimension of exhibitionism . . . and the passive dimension of voyeurism' (1996: 48). In critiquing previous understandings of the gaze in film, Cook's argument significantly references fashion and costume as central components in film analysis:

> The definition of display as passive sets up a number of blocks. It confirms its derogatory association with femininity. . . . It reinforces the idea that costume simply reflects, or facilitates the objectification of women. . . . It minimises the extent to which display (and, by implication, femininity) is a troublesome phenomenon which intrudes on, rather than serves the interests of, the narrative.
>
> 1996: 48

Throughout the following chapters, a sartorial analysis of Bond Girls exposes their performance of femininity as an active challenge to sexist and racist ideologies, rather than as passive victims of patriarchal and imperial masters. Inscribed in their clothes are multiple patterns of disruption to the political foundations of Bond's world.

The analysis starts with a deconstruction of Bond's masculinity, through a close reading of his physical attributes and stylized look. As his impeccable elegance is placed within a quintessentially English tradition centred on the dandy, Chapter 1 draws attention to Bond's sartorial juxtaposition to the villains' more eccentric styles and grotesque bodies. This apparently binary opposition, nevertheless, points to the permeable boundaries between Bond and the villain. Turning to the historical context of Bond's literary origin, the chapter concludes with a re-assessment of Bond within the post-war discourse of veteran bodies and scarred masculinity; the gentleman's suit, then, becomes the exterior armour that conceals the damaged body within.

The investigation of 'foreignness' continues in Chapter 2, which explores Bond Girls' racial, ethnic, and national identities. Through an analysis of fashion's engagement with 'exoticism', the chapter explores the complex construction of Bond Girls' ethnicities and their positioning alongside/against Bond's white Englishness. Rather than stereotyped objects of the colonial gaze, ethnic minority Bond Girls can, in fact, function as agents of colonial and 'foreign' resistance.

Challenging the binary terms of sexual difference, Chapter 3 focuses on 'cross dressing', broadly intended as women's appropriation of traditionally masculine clothes; as they signal, historically, the rise of female emancipation, the function of such sartorial imports, from active wear to power dressing, undermines the active/passive, male/female oppositions, and showcases Bond Girls' control of

their own missions. Moreover, teasing out latent homoerotic tensions, cross-dressed Bond Girls also point to the queer subtexts of Bond narratives.

Power – and its complex relationship with female sexuality – is the object of Chapter 4's investigation of the function played, in particular, by fetish wear. A discussion of controversial fashion items such as fur and corsetry articulates the complex nuances of female desire at play in the Bond narratives. Finally, the analysis of phallic associations in Bond Girls' apparel, as conveyed by weaponry and footwear, proposes a definition of 'tough' femininity that moves away from conventional readings of biological sex/gender.

Drawing this sartorial exploration of Bond Girls to an end, the conclusion considers the wider legacy of the Bond cultural phenomenon, and the different kinds of consumption it encourages. The perpetuation of the Bond look paradoxically subverts the stability of the 'tough' masculine model associated with Bond, as it points to its regressive unchangeability. Set against the unalterable Bond, are Bond Girls' dynamically diverse femininities, whose impact on fashion, and female consumption, speak of a desire to break rules and move fast.

Fashion and feminism

Fashion, and its relationship with femininity, has traditionally been regarded with at least some level of suspicion by feminist and gender scholars. At the beginning of the new millennium, Pamela Church-Gibson lamented that 'fashion and feminism are still uneasily circling each other, not yet properly reconciled' (2000: 349). In particular, fashion's supposed frivolity and alleged objectification of female consumers has led to a problematic identification of women with fashion. As Jane Gaines recorded in the 1990s, 'in popular discourse, there is often no distinction made between a woman and her attire. She *is* what she wears' (1990: 1). Worryingly, the apparent continuity between women and fashion risks fixing women's identities into rigid gender categories coded through clothing.

The 'rule' of fashion, it follows, may be the enemy of female emancipation. It is perhaps unsurprising that, in the conservative gender climate of post-war Europe, feminist thinker Simone de Beauvoir blamed fashion for hindering middle-class women's emancipation:

The goal of the fashion to which she [woman] is in thrall is not to reveal her as an autonomous individual but on the contrary to cut her from her transcendence

so as to offer her as a prey to male desires: fashion does not serve to fulfil her projects but on the contrary to thwart them.

[1949] 2009: 586

For Beauvoir, female exhibitionism as enabled by fashion was nothing but detrimental to the feminist goals of autonomy and self-fulfilment. The accent on women's sartorial exhibitionism had emerged most evidently since the late nineteenth-century's 'Great Masculine Renunciation', which signalled, according to psychoanalyst John Flügel, the middle-class man's puritanical repudiation of the frivolities of fashion ([1930] 1950: 111), while it simultaneously implied that, 'devotion to fashion ... was adduced as a natural weakness of women' (Hollander [1978] 1993: 360). Thus, whereas 'elegant men's clothing during this time was ... more subdued and abstract in the way it looked', fashion historian Anne Hollander observes, 'women's clothing was extremely expressive ... and very deliberately decorative and noticeable' ([1978] 1993: 360). This, fashion scholar Helene Roberts argues, reiterated the established active/passive paradigms emphatically inscribed in the nineteenth-century polarized codes of gendered clothing:

> More than identifying each sex, clothing defined the role of each sex. Men were serious (they wore dark colors and little ornamentation), women were frivolous (they wore light pastel colors, ribbons, lace, and bows); men were active (their clothes allowed them movement), women inactive (their clothes inhibited movement); men were strong (their clothes emphasized broad chests and shoulders), women delicate (their clothing accentuated tiny waists, sloping shoulders, and a softly rounded silhouette); men were aggressive (their clothing had sharp definite lines and a clearly defined silhouette), women were submissive (their silhouette was indefinite, their clothing constricting).
>
> Roberts 1977: 555

While other fashion historians have offered more nuanced views of the nineteenth-century corseted figure, as explored in Chapter 4, fashion's alleged perpetuation of biological essentialism based on the binary 'facts' of sexual difference, exposes gender's constructedness, rather than its biological foundations.

Discussing fashion as cultural 'technique' for the negotiation of the body in a social environment, fashion theorist Jennifer Craik notes the persistence of this binary approach: 'whereas techniques of femininity are acquired and displayed through clothes, looks and gestures, codes of masculinity are inscribed through codes of action, especially through the codes of sport and competition' (Craik [1993] 1994: 13). Significantly, the introduction of sports to female participants, as

explored more in detail in Chapter 3, was immensely influential to the Dress Reform Movement, and eventually led to the female appropriation of trousers, in itself a sign of the progressive erasure of the active/passive dualism of normative gender roles. Moreover, as an analysis of women's role as *active* consumers of fashion demonstrates, the relationship between clothes and gender produces alternative readings of controversial items such as the corset and the stiletto heel. Consequently, by placing a stronger emphasis on female active desire, sartorial discourse can in fact shift the paradigms of the male gaze around, as fashion practice suggests that 'women primarily dress to please other women' and that 'there is no clear evidence as to whose "eyes" women view other women through' (Craik [1993] 1994: 56).

The variety of contexts which involve women in fashion consumption is indeed suggestive of their active engagement with a construction of femininity and female desire in relation to itself, rather than framed by male desire:

> Women ... dress for 'each other': this colloquial observation contains, compressed within it, a number of important truths which include an awareness of the rituals of shopping, dressing up, adolescent identity parades, masquerade and the concept of same-sex looking.
>
> Church-Gibson 2000: 350

The concept of masquerade is indeed central to an understanding of both Bond's stylized masculinity and the shifting paradigms of Bond Girls' femininities, visible in their performances of ethnic identities, male 'cross-dressing', and fetishized *femmes fatales*.

Psychoanalyst Joan Riviere's article 'Womanliness as a Masquerade' (1929), famously defined femininity as 'a mask, both to hide the possession of masculinity and to avert the reprisals expected if she was found to possess it' ([1929] 1966: 213). Referencing Riviere's influential argument, Mary Ann Doane proposes that 'by destabilizing the image, the masquerade confounds this masculine structure of the look' (1982: 82). Reconfiguring the male gaze, the awareness that femininity *is* performance encourages the female spectator to apply their own control on the 'over-presence of the [feminine] image' (1982: 78). Indeed, wearing femininity as a 'mask', the female spectator may occupy an active and self-aware position more effectively than in Mulvey's process of 'trans-identification', which, 'does not sit easily and shifts restlessly in its borrowed transvestite clothes' (Mulvey 1981: 13). As Mulvey's metaphor does not imply the radical blur embedded in more recent understandings of trans sex/gender identity, it does not, completely, depart from 'a framework of binary oppositions (masculinity/femininity: activity/passivity) that necessarily masculinise active female desire' (Stacey 1994: 27).

Shifting the focus to narratives that frame masculinity as spectacle may produce a different understanding of the mechanics of the gaze. This is precisely what exposes the contradictory construct that is Bond's masculinity; though required by his job as a secret agent to be invisible, his distinctive sartorial look means that he is in fact persistently scrutinized, spied upon, and even, of course, admired. Although Bond's visibility is a problem from its literary start, the recent films have drawn emphatic attention to Bond's body. Discussing his debut role in *Casino Royale* (Campbell 2006), actor Daniel Craig, the latest Bond, identifies a shift in the object of the gaze:

> Beautiful women are always part of the story. In the past maybe they were more objectified. They were just eye candy. Now they're integral and powerful in their own right. They're beautiful, but now things are almost reversed. In this movie I don't think we objectify women. I'm the one taking my clothes off most of the time.
>
> Craig 2008: 58

Although Craig's perception that 'things are almost reversed' may simplify the complex gender dynamics still in place in contemporary Bond productions, this is a view that Eva Green, who plays Bond Girl Vesper Lynd in *Casino Royale*, would also agree with: 'he is the Bond girl, not me. He's the one who comes out of the sea with his top off', she said of bodily display in *Casino Royale* (Jeffreys 2007). As film scholar Lisa Funnell reminds us, the emphasis placed on Craig's physique twists the male-gaze aesthetics of previous films by drawing on a self-conscious reference to Andress's bikini scene in *Dr No*:

> This scene presents the exposed muscular body of Bond as spectacular, passive, and feminized, positioning Craig in the role of Bond Girl as the visual spectacle of the Bond film ... The Bond-Bond Girl hybrid is simultaneously active and passive, masculine and feminine ... and Bond and Bond Girl.
>
> 2011: 467

The temporary collapse of the feminine/masculine roles within the scene, and its problematic 'feminization' of Bond, draw attention to the slipperiness of fixed gender roles and the mechanics of visual consumption.

Consuming Bond

In *Casino Royale*, as discussed in more detail in Chapter 4, Bond and Vesper buy each other's clothes, in a reciprocal act of sartorial control. Bond's attempt to

'fashion' Vesper in a frock designed to distract his opponent at the card table reveals his presumptive understanding of the male gaze. It is, however, Vesper's own knowledge of clothes – and the mechanics of the male gaze – that trumps his effort, signalling a field in which women have, with little doubt, the upper hand: fashion.

Referring to the early cinematic Bond Girls, film scholar James Chapman has observed that 'women are commodities, to be consumed by Bond and then discarded' (2000: 95). But a close reading of fashion – and the structures of its consumption – encourages a more nuanced – and subversive – view of the Bond Girl continuum. There are, indeed, parallels, between the slippery paradigms of the gaze, and those of consumption. As Stacey reminds us, 'in the same way that women are both subjects and objects of relations of looking, they can also be seen as both products and consumers of commodity exchange' (1994: 8); fashion, in particular, functions as a unique system in which women are both active subjects – consumers – and passive objects – images. The close relationship established between women's clothes and female pleasure underscores this ambivalence: 'while fashion, and in particular *haute couture*, may inspire desire in men, and may make women the object of masculine desire', fashion critic Alison Bancroft notes, 'women are by no means passive within this process, nor are they entirely absent from it' (2012: 18). Women's consumption of fashion reiterates the active pursuit of feminine pleasure, and, implicitly, a desire for self-determination.

That this might be the case is also demonstrated by the ways in which the early Hollywood cinema industry influenced, through its conscious encouragement of fashion consumption, the transformation of certain social conventions and gender norms. Since its 1930s Hollywood heydays, the film business has engaged in a mutually beneficial collaboration with other consumer-led industries through 'the showcasing of fashions, furnishings, accessories, cosmetics, and . . . the establishment of "tie-ups" with brand name manufacturers, corporations, and industries' (Eckert 1990: 106). Fashion marketing strategies would therefore 'encourag[e] the emulation of Hollywood's "theatrical" identities in the name of self-improvement' (Berry 2000: 184), and female consumers would play a central role in this process. What this dual consumption produced, then, was a move away from the prescriptively static models of femininity based on 'natural'/biological readings of the female body to consumer-inspired performances of a dynamic femininity, dictated by the change-led industry that fashion quintessentially embodies (see Berry 2000: 185).

In this sense, the gender politics of 'Bond consumption' may conceal a surprisingly subversive subtext. Whereas Hollywood became a useful market-

booster following the 1929 Wall Street Crash and America's Great Depression, EON found itself in a more favourable position in the climate of economic revival of Britain's Swinging Sixties; attention to consumption – including both product placement and fashion tie-ups – was central to the Bond films from the start. But more specifically, as Anna Vreeland, then editor-in-chief of US *Vogue*, put it, Bond embodied the 1960s 'youthquake', a term she coined to describe the decade's celebration of youth culture:

> There is a marvellous moment that starts at thirteen and wastes no time. No longer waits to grow up, but makes its own way, its own look by the end of the week. Gone is the once-upon-a-daydream world. The dreams, still there, break into action: writing, singing, acting, designing. Youth, warm and gay as a kitten yet self-sufficient as James Bond, is surprising countries east and west with a sense of assurance serene beyond all years.
>
> 'Youthquake' 1965: 112

Although the article concentrated on the lives of vibrant young women, Bond's style nevertheless captured the dynamic, carefree, devil-may-care attitude that the *Vogue* editorial attributed to the 1960s youth. Significantly, and in line with the decade's flirtation with unisex styles, Bond could be read, in Vreeland's acute fashion vision, as a cross-gender style icon, whereby his hedonistic lifestyle, irreverent disregard for rules, and relaxed sexual mores spoke to the girls and young women that the publication increasingly addressed. Indeed, Bond's embodiment of a cross-gender lifestyle model, as explored in the final chapter, is also visible in the 'Bondanza' or 'Bondmania' phenomena, which have promoted the consumption of goods – largely related to fashion – since the beginning of the film franchise (see Moniot 1976).

While perpetuating the myth of Bond's untarnished masculinity, the male consumption of Bond taps the largely feminine/gay domain of fashion. As Winterson notes:

> He's got more outfits than Barbie. The hand-made clothes, beautifully tailored, are not exactly a he-man pursuit. Only a dandy gets fitted up . . . Men who enjoy a bit of made-to-measure are indulging their senses just as women do. Gay men have known this for years – look at Oscar Wilde and Dirk Bogarde. There's nothing wrong with liking clothes, but it's a girl thing.
>
> Winterson 2002

As provocatively put by Winterson, Bond's self-consciously stylized image implicitly undermines the rigidly heteronormative values of his character, and straight male spectators. Simultaneously, however, in sharing fascination with

Bond's sartorial appeal, the Bond cult reinforces, paradoxically, the character's highly stylized performance of a static masculinity against the dynamic, changeable look of Bond Girls.

It's all about the Girl

As Funnell rightly observes, the Bond Girl 'archetype is not rigidly formulaic', although, as a category, 'the term has been over/misused in social, critical, and academic discourse to refer to nearly every woman who appears on screen regardless of her role, allegiance, or competency' (2018: 12). Her definition, which stems from Bond's use of the word 'girl' to address his love interests in Fleming's novels, incorporates both the Bond Girl's centrality to the plot and her emotional involvement with Bond:

> The term Bond Girl refers to a particular female character of the Bond film. She is a non-recurring character and lead female protagonist, central to the plot of the film and instrumental to the mission of James Bond. However, the defining feature of the Bond Girl is the strong, intimate and intense relationship she builds with Bond.
>
> 2008: 63

This definition also points to the problematic positioning of some of the female characters in the Bond narratives, particularly when emotional intensity and intimacy do not always coincide. For instance, the cinematic Moneypenny's intense desire for Bond is, at times, undeniable, but never actualized. The reverse is true of characters such as Gala Brand, who, in Fleming's *Moonraker*, is engaged to marry another man, though she shares a 'soft-hard quick kiss' with Bond, who falls for her ([1955]: 152). Although physical demonstrations of affection are not the only measure of emotional commitment, the scarcity of Bond's emotional verbal communication leaves little else to evaluate the strength of his involvement with a woman. Intensity of feeling for a woman and intimacy are skewed in *Skyfall*, where Bond Girl Séverine is problematically killed off before Bond can establish a meaningful connection with her, while Bond's emotional involvement is entirely taken up by his relationship with M, played, one last time, by Judi Dench. Elsewhere, Bond's 'intense' sexual liaisons principally speak of lust rather than love; such is the case, for instance, in his encounters with Bond Girl Villains Fiona Volpe in *Thunderball* (Young 1965), or Helga Brandt in *You Only Live Twice* (Gilbert 1967).

But the term 'Girl' also signals the apparent infantilization of women, whose 'girlhood' is not placed on the same hierarchical level as Bond's 'manhood'. In more recent times, this has led some actors, including Monica Bellucci, who played the minor character of Lucia Sciarra in *Spectre* (Mendes 2015), to volunteer herself out of the Bond Girl 'club': 'I can't say I'm a Bond girl because I'm too mature to be a Bond girl. I say Bond lady; Bond woman' she told *The Guardian* in interview (qtd. in Smith 2015). Bellucci's comment has more to do with age – at fifty-one, she has become the oldest female actor to play one of Bond's love interests to date – than feminist resistance to the 'Girl' category. Other actors have, in fact, re-appropriated the term, reading it, as this book does, against its patriarchal grain. Interviewed by Maryam D'Abo for her documentary *Bond Girls Are Forever* ([2002] 2006), Rosamund Pike, who plays Bond Girl Villain Miranda Frost in *Die Another Day* (Tamahori 2002), claimed that 'Bond Girl' is 'more fun' and preferable to 'Bond Woman' (*Bond Girls Are Forever* [2002] 2006).

Likewise, Naomie Harris, who has played Eve Moneypenny since *Skyfall*, while aware of the problematic clichés attached to the Bond Girl tag, has shown no sign of critical resistance to the term *per se*: 'I don't find it offensive . . . That's just the title that's assigned to women who are in Bond movies – although today we've moved on so far in terms of the nature of these roles that they're not really stereotypes anymore, they can be anything' (qtd. in Rothman 2012b). 'Bond Girl', in Harris's view, has become a brand, cementing the continuity of the character in her various incarnations, but also at risk of perpetuating some of the problematic gender issues that the Bond narratives bring to the forefront: 'while it is difficult to avoid using the term "Bond Girl" given its cultural pervasiveness', Funnell concludes, 'it is important to be mindful of the messages being relayed through it about gender, sexuality, and power' (2018: 12).

In spite of its problematic ramifications, the 'Bond Girl' tag ought not to be synonymous with the negative associations that patriarchy attaches to language. Marking the fiftieth anniversary of the release of *Dr No*, 2012 was Bond's *annus mirabilis*, celebrated with the release of *Skyfall* and multiple parallel events. It was also the year of the London Olympics and Queen Elizabeth's Diamond Jubilee; Danny Boyle's Opening Ceremony celebrated the three milestones in a playful Bond parody where Bond (Craig) was accompanied by Her Majesty the Bond Girl/M, to arrive at Stratford Olympic Stadium in a staged parachute jump. A tribute to Bond's pervasive significance in British popular culture, the queen's cameo appearance as Bond Girl also distinctly imprinted a seal of recognition of Bond Girls' authority. Aware of past and current debates, this book has made a conscious decision to keep the 'Bond Girl' terminology as an inclusive category

for the female characters in the Bond narratives. This does not take away from a differentiation of the roles played by the female actors in the Bond narratives, as it will be consistently accounted for in the context of each chapter.

But there is also something ideologically specific to the use of 'Bond Girls' to refer to characters as diverse as Pussy Galore, Moneypenny, and even M, and it comes from the primary angle of this analysis: fashion. Throughout the twentieth century, and particularly in the 1920s and then, again, in the 1960s, fashion has displayed an increasing fascination with youth. While youth obsession has exposed the pressures on women to appear eternally – and preternaturally – young, there is another way of looking at the 'Girl' cult that 'Coco' Chanel, in particular, embodied. As Hollander reminds us:

> Chanel ... showed how to be a young, slim, and independent Girl until she died at the age of eighty-eight, still addressed as 'Mademoiselle'. She was the lover of many but nobody's wife, mother or daughter, rich by her own professional efforts, a good friend and social equal of the great and near-great. It was all unheard of before, except for notorious stage performers beyond the social pale.
>
> 1994: 135

Pioneering a notion of 'Girl Power', as the founder of one the oldest and most successful fashion houses in the world, the concept of youth evoked by Chanel's persona and *couture* is less about actual age than a self-conscious model of modern femininity.

It is not a coincidence that the world of Bond Girls has intersected with the Chanel brand in multiple ways. Carole Bouquet, who had become famous for her portrayal of the resilient Melina Havelock in *For Your Eyes Only* (Glen 1981), was chosen to endorse Chanel No. 5 in the 1986 advert, where a woman, power-dressed in a red suit, drives her car through a desert landscape to meet her lover. A couple of decades later, in the 2011 advert for Chanel's Coco Mademoiselle, Keira Knightley plays a model who arrives at a photoshoot after a reckless motorbike ride through Paris, where billboards already frame her as the object of the gaze. On set, she willingly performs provocative poses for the male photographer, knowingly manipulating his desire; at the end, she swiftly jumps off a balcony and on to her motorbike, thwarting the prospect of the expected sexual encounter. It is not surprising that Knightley's performance of a leather-clad young woman led journalists to make comparisons with previous Bond Girl actors and even speculate she may be the next Bond Girl in line (Gray 2014). Simultaneously active and passive, assertive and submissive, she embodies the intricacies of Bond Girls' complex femininity, self-consciously 'presenting men

with an image that they desire' (Bruzzi 1997: xix), and yet, ultimately breaking out of the frame imposed on her. It is also no coincidence that such a role is attached to Coco Madamoiselle, the scent title evocative of the rebellious 'Girl' behind the Chanel brand.

The revised lyrics of Joss Stone's cover of James Brown's 'It's a Man's Man's Man's World' (Brown and Newsome 1966) played in the advert, gesture to the complex gender politics of Bond's world as this book interprets it. Although the centre of his world may be a man, its meaning is perpetually pulled apart by the centrifugal force of its female characters:

> A woman makes a better man
> This is a man's, a man's world
> But *it would mean nothing*
> Not one little thing
> Without a woman or a *girl*.
>
> Stone et al. 2004; my emphases

'Bond. James Bond':
Masculinity and Its Discontents

'There is one thing about which James Bond can rest easy: his manhood', writes *Guardian* journalist Catherine Shoard in response to the possibility of a female Bond in future films. The eventuality seems unlikely; Barbara Broccoli's statement that 'Bond is a male character . . . was written as a male . . . and will probably stay as male', leaves little room for change other than her hopeful promise to 'create more female characters and make the story fit those female characters' (Shoard 2018). Unlike other fictional characters, such as Dr Who (recently played on TV by Jodie Whittaker), whose gender and sexuality may more easily shift, James Bond's particular kind of masculinity would appear to resist change, even in a post #MeToo context.

It may seem strange to start a critical exploration of Bond Girls with an analysis of James Bond's masculinity. This chapter's investigation of the 'Bond look', however, is the starting point of a re-assessment of the gender politics of his world, and a tool to unveil the problematic foundations of the kind of masculinity he represents. As a modern-day dandy, Bond embodies a sartorial impeccability both rooted in English historical tradition and simultaneously located in a specific mid-century context.

The very notion of Bond's distinctiveness, however, poses questions about masculine exhibitionism and the impact of spectacular masculinity on the politics of gender. No longer the active controller of the gaze, Bond in fact occupies the traditionally feminine position of the object of voyeuristic interests. This inversion challenges the accepted hierarchy of conventional gender roles and, in particular, the active Bond/passive Bond Girl opposition.

Similarly, costume analysis exposes the problems with Bond's troubled relationship with identity. Though Bond's Englishness is apparently juxtaposed with the villain's problematic 'foreignness', the emphasis placed on disguise and masquerade, in both novels and films, makes nationality and race into slippery categories of identity. This signals, therefore, the porous boundaries that separate Bond from the 'foreign' villains.

But it is when this chapter turns to Bond's unclothed body that a new way of looking at Bond – and Bond Girls – emerges; when the armour of his flawless suit is cast off, what is left is the scarred body of a wounded man. The cultural history of prosthetics and veteran rehabilitation throws a different light on Bond, firmly locating his cultural roots in the trauma of post-war masculinity.

Fashioning James Bond: Sean Connery, Anthony Sinclair, and Ian Fleming

The first glimpse film audiences worldwide caught of James Bond was a series of shots displaying Sean Connery's back and dealing arms at a card table, while sitting across from the first cinematic Bond Girl, Sylvia Trench (Eunice Gayson), in *Dr No*. 'Bond. James Bond', the voice says, as a close-up shot frames a cigarette-lighting Connery wearing a midnight blue evening jacket, accessorized with a bow tie and turn-back cuffs. The scene setting at the Le Cercle Casino in London references Bond's literary genesis, nine years earlier, in Ian Fleming's *Casino Royale* (1953). The novel's opening line – 'The scent and smoke and sweat of a casino are nauseating at three in the morning' ([1953] 2006: 1) – placed Bond firmly within the seedy glamour of the gambling world.

Capturing the suave glamour of which Bond later became an iconic symbol, Bond's first sartorial appearance signals multiple references to a distinctive tradition in masculine dress. The detail of the turn-back cuffs was significantly followed up in several of the James Bond movies, re-emerging in the tuxedos worn by Connery in *From Russia with Love* (Young 1963), and Roger Moore in *The Man with the Golden Gun* (Hamilton 1974), and the latter's Chesterfield coat in *Live and Let Die* (Hamilton 1973). Most recently, the turn-back cuff has been seen on Daniel Craig's Tom Ford suit in *Quantum of Solace* (Forster 2008). That the cuff soon became associated with Bond is also evident from its appearance in the spoof version of *Casino Royale* (Guest et al. 1967), starring David Niven and Ursula Andress, whose name had, by then, become associated with Bond (see Spaiser 2016a). The detail also appears in Fleming's *Moonraker*, though placed at the end of villain Hugo Drax's jacket sleeves, rather than Bond's:

> Bond concluded his inspection with Drax's clothes which were expensive and in excellent taste – a dark blue pinstripe in lightweight flannel, double-breasted with turnback cuffs, a heavy white silk shirt with a stiff collar, an unobtrusive tie

with a small grey and white check, modest cuff-links, which looked like Cartier, and a plain gold Patek Philippe watch with a black leather strap.

[1955] 2004: 39–40

We will return later to the significance of this stylistic overlap between the villain and Bond, as well as on the function of Bond's scrutinizing gaze. In the meantime, it is interesting to note that Fleming himself used to wear the style of turn-back cuffs which became associated with Bond. On the set of his last interview, published posthumously in *Playboy* in December 1964, Fleming was described as 'a tall man, lean, tending to be florid, wearing a navy-blue suit of typical British cut marked by one eccentricity: cuffs on the sleeves' (Fleming 1964: 97; see also Tanner 2003).

Though far from extravagant, Fleming had indeed distinctive sartorial preferences. After the war, biographer John Pearson notes:

[Fleming] had finally assumed the dress which was to be his working uniform for the rest of his life – the polka-dot blue bow tie, the black moccasin shoes . . . , the blue shorts with the sleeves cut short just above the elbow, the dark-blue suit he would send back to the tailor so often that the man would talk about 'fixing some new cloth to Mr Fleming's original buttons'.

[1966] 2013: 208

Novelist Kingsley Amis, who was one of the earliest appreciators of Fleming's work, when discussing the assumed costliness of Bond Girls' outfits, claims that 'the snobbish approach to women's clothes is along the lines of *fashion*, and Mr Fleming couldn't show less interest in that. Bond-girl's clothes are carefully designed to be outside of fashion, to be timeless' (Amis 1965: 45). The year of *Dr No*'s cinematic release, however, a *Vogue* article on the Flemings revealed that '[Fleming] dresses well but simply', with a penchant for a 'black-and-white spotted bow tie', and that while 'not fancy dressed, . . . [he] is interested in his clothes and even more interested, perhaps, in the clothes of his friends, especially when touched by any dash of eccentricity' (Harling 1963: 222). Biographer Andrew Lycett also confirms Fleming's preoccupation with his sartorial look after the war:

Over these years Mr Fleming's own style had evolved. In London he wore blue two-piece suits, a cotton shirt and, always, a bow tie. For relaxation he favoured lightweight suits, perhaps in hound's-tooth check. His distinctive golfing garb was epitomised by the jacket auctioned at Bonhams in 2010 and described as 'tailored in tweed with a loud black, white and turquoise check, and bearing the

label of Benson, Perry & Whitley Ltd'. When dressing down, or in his beloved Jamaica, he donned short-sleeved Sea Island cotton shirts, shorts and even sandals. Although he liked good things, he was not flashy or indeed profligate. Thus he opted for tailor Benson, Perry & Whitley on London's Cork Street, around the corner from, but not actually on, Savile Row.

<div align="right">Lycett 2012</div>

Rather than showing no interest in fashion, as Amis had assumed, Fleming seemed to have very specific – if not extravagant – taste for clothes, and, most importantly, sartorial detail. As Lycett notes, Fleming's 'suits ... came with distinctive features such as turn-back cuffs' (Lycett 2012). The turn-back cuff was one of the distinguishing features of a certain post-war Edwardian revival, an eminently English bespoke style developed by Savile Row tailors to cater for the sartorial needs of 'ex-guardsmen and aristocratic loafers ... whose bespoke wasp-waisted outlines set themselves against the baggy, democratic hang of the Utility and demob suits that served the majority of the population' (Breward 2016: 136–7).

One of these tailors was to play an important role in fashioning James Bond: Anthony Sinclair. As David Mason – who revived the Anthony Sinclair brand in 2012 – reminds us, 'Sinclair had the distinction of making handmade day clothes worn by gentlemen officers of the British Army when they were not in uniform, amongst whom was Irish Guards officer and former tank commander, Terence Young' (qtd. in Stempien 2015). It was indeed Young who took Connery under his sartorial wing and, while 'teaching him how to walk and how to talk, how to eat and what to drink', also took him to Sinclair (Fig. 1), who became the first designer to dress James Bond 'in the classic, understated style that had become known as the Conduit Cut' (Stempien 2015; see also Cook and Hines 2005: 152). Anecdotally, Connery, who was unaccustomed to wearing gentlemen's suits on a regular basis and 'preferred to go around in jeans and bomber jackets' (Cosgrave 2012: 11), was advised to 'wear the suits around the clock – even sleeping in them – so that he was completely at ease in the clothing when filming began' (Stempien 2015). The trick apparently worked, as Connery admitted 'the suits [felt] just as comfortable after a full night's rest' (Cosgrave 2012: 11). In more than one way, Connery was literally 'fashioned' into Bond through the sartorial and stylistic collaborations of the literary character's creator, Fleming, the director of the first Bond cinematic adaptation, Young, and the sartorial enterprise of Sinclair.

These background stories about the origins of the Bond look should begin to throw some light on the influence that clothing has exercised on the creation and endurance of Bond as the hub of complex identification fantasies. Even as he

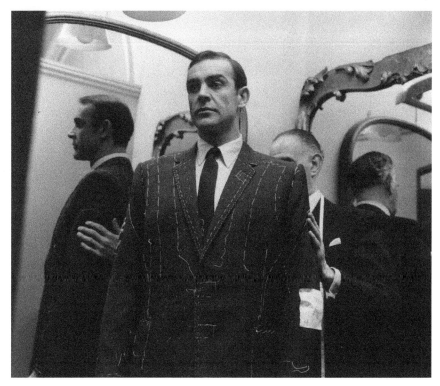

Figure 1 Sean Connery and Anthony Sinclair, fitting session (Courtesy of REX)

dismissed Fleming's own interest in fashion, Amis pays some attention to the literary Bond's sartorial look, drawing comparisons with contemporary TV heroes such as John Steed of *The Avengers* (1961–69), and Inspector Barlow of *Z Cars* (1962–78):

> Clothes probably don't make the man, but they can tell us a lot about him.... Sartorially, he [Bond] is pitched midway between the dandyism of Steed and the reach-me-down anonymity of Barlow. Sea Island cotton shirt, tropical worsted trousers, black leather sandals for relaxing, dark blue alpaca suit with thin black knitted tie for ordinary purposes, Hong Kong's pyjamas – clothes we should like to wear (unlike Barlow's) and would dare to (unlike Steed's).
>
> Bond as dresser, then, takes us in the direction of wish-fulfilment without losing contact with what we commonly regard as real and likely.
>
> 1965: 6

The comparisons seem adequate especially when looking at Steed's use of the new dandy's accessories – bowler hat and umbrella – as weapons. Such conversion of fashion items into combat tools bears significance when considering, as seen

later in this chapter, the symbolic significance of Bond's suit as modern-day armour.

What is also interesting here is the 'fantasy' construct that Bond channels, and the particular kind of ambiguous heroism he embodies. In his frequently quoted essay, 'How to write a thriller' (1962), Fleming drew attention to the escapist scope of his works:

> I am not an angry young, or even middle-aged, man. My books are not 'engaged.' I have no message for suffering humanity and, though I was bullied at school and lost my virginity like so many of us used to do in the old days, I have never been tempted to foist these and other harrowing personal experiences on the public. My *opuscula* do not aim at changing people or making them go out and do something. They are written for warm-blooded heterosexuals in railway trains, aeroplanes and beds.
>
> 1962: 14

The defensive tone about the lack of political value in his fictional work here clashes with a reference to an implied readership of 'warm-hearted heterosexuals', which, in fact, speaks volumes about the gender politics at play in the novels. The apparent contradiction also emerges in his self-conscious distance from the Angry Young Men, of which Kingsley Amis was also an eminent representative. Indeed, as Lynne Segal suggests of the protagonist of Amis's *Lucky Jim* (1954), there is some similarity in the portrayal of masculinity offered by the two authors:

> The new hero is male, the 'intellectual tough' or 'tough intellectual'. He is rude, crude and clumsy, boasts his political apathy, his suspicion of all causes, and is out to do nobody any good but himself. His heroism consists in the fact that he is honestly self-serving, fiercely critical of all he sees as phoney, pretentious or conformist – a passion which expresses itself most readily in a rejection of what he sees as womanly, or domestic. He exudes a bullying contempt for women.
>
> 1997: 1

Though certainly not 'domestic', Bond arguably has a more nuanced relationship with women. Moreover, though he might not share Jim's 'tough' intellectualism, he certainly displays a fair amount of cruelty and disregard for social conventions. Bond's complex masculinity is an ambiguous combination of respect for certain ideals – namely, Queen and Country – with disregard for social norm.

While Bond shares aspects of his quest against an arch-villain with the chivalric hero of older tales, he is also, as Amis suggests, the descendant of other charismatic figures closer to home, such as the detective characters of

Sherlock Holmes, Hercule Poirot, and Nero Wolfe. Although, as an action hero, Bond frequently displays physical prowess, he nevertheless also shares with these predecessors acute powers of cerebral deduction and, on a personal level, a manifest fastidiousness about his sartorial appearance. As with these apparently normal, and yet extraordinarily gifted characters, Bond impersonates the model for the identification fantasies of readers and cinematic audiences alike. What enables the identification fantasy is Bond's sartorial style, simultaneously unachievable because of its impeccability under all conditions, and yet ordinary enough to be replicated: 'Any fantasy in which the subject is saying, in effect, *I am not as other men are*, is obviously very powerful', Amis notes, '[i]ts power will be increased in proportion as exterior forces say in effect, *You are as other men are*' (1965: 5). The secret-agent fantasy lends itself particularly well to identification: though apparently ordinary, their performance is extraordinary.

The hero's clothes may function to bridge the gap between the ordinary individual and the heroic body of their fantasy; as Alex Warwick and Dani Cavallaro remind us, 'items of clothing are objects of desire that hold the promise of completion, the last piece necessary to close the gap' (1998: 35). Clothes, therefore, may help with the negotiation of desire which, according to psychoanalyst Jacques Lacan, enables the development of identity. Such desire originates in a sense of lack experienced by both men and women, and which Lacan relates to the phallus as a symbol of (masculine) authority (Lacan [1958] 2001). While, in Lacan's system, 'lack' is universally central to all subjective development, when looking at post-war masculinity, the roots of the literary Bond, the concept of a void is crucial to understanding the gender dynamics at play in the 1950s. As Segal explains, 'the post-war contrast between wartime memories and civilian life, and the maintenance of military conscription marking men's entrance into adulthood, were both significant aspects of the tension over "manhood" in the 1950s' (1997: 18). Such tension, Segal argues, led to the misogyny and homophobia that underpin, for instance, the writings of the Angry Young Men (including, indeed, Amis):

> There were at least two opposed faces of masculinity in the fifties. There was the new family man, content with house and garden. And there was the old wartime hero, who put 'freedom' before family and loved ones ... Whatever the real or imagined burdens on men created by the Janus-face of masculinity, new levels of antagonism in the old sex war' are evident in the ubiquitous misogynistic humour of the fifties.
>
> 1997: 20–1

It makes sense, then, to locate Bond's masculinity in the intricate tissue of a post-war emasculated – and yet heroic – kind of manhood. Indeed, Bond's clothes simultaneously idealize the form of the war veteran, and conceal his scarred body.

It is no surprise, then, that the Conduit suit would serve to fashion the quintessentially English masculine figure that Connery's Bond cut. Sinclair's experience – and the bodies he dressed – had a strong military connection. More than that, it catered for those upper-class gentlemen officers whose desire was to distinguish themselves from the crowds of lower rank civilians dressed in demob suits (Stempen 2015). The main outfitter was Montague Burton, and his designs, while inexpensive because machine-produced, did not compare with the quality and cut of Savile Row bespoke tailoring.

Fashion designer Hardy Amies would argue that sartorial errors in Burton's boxy designs, such as double-breast lapels on single-breast jackets, betrayed the brand's ignorance of – or at least disregard for – the tradition of English bespoke tailoring. Amies's historical commentary on the genesis of the gentleman's suit centres, as the title of his book – *The Englishman's Suit* (1994) – suggests, on a strongly patriotic celebration of Englishness. Amies's account does not, however, consider that similar sartorial trajectories in menswear occurred simultaneously in other part of Europe, such as Scandinavia and the Netherlands; as fashion historian Christopher Breward has noted, Amies's English-centred view is tinted with conservative nostalgia, and 'betrays the prejudices and frustrations of a class who felt they had experienced the decline and break-up of the British Empire' (Breward 2016: 77). It is precisely on these terms that it encapsulates the post-war cultural *zeitgeist* from which Bond emerges.

In identifying the suit as an original garment unmistakably derived from English aristocratic dress, Amies outlines its evolution in terms of a linear genealogy, which starts with Charles II and ends in Savile Row. The simplicity of the 'king's new clothes', a knee-length coat, vest (waistcoat), and breeches, as described by Samuel Pepys on 15 October 1666 – 'a long cassock close to the body, of black cloth, and pinked with white silk under it, and a coat over it' (Pepys 2003: 682) – reflected the sobriety of a restored English court. Significantly, the introduction of the king's new English dress displayed, in fact, sartorial influences ranging from the Indian *pajama* jacket worn over trousers, to the Ottoman waistcoat (Breward 2016: 86–7, 39–40; see also Jirousek 2004: 241). But the style, according to Amies, was quickly popular among the largely country-based English gentry, who would find it more comfortable and suitable to riding than the fussier and more sophisticated courtly styles of the past and still in vogue at

Versailles. The king's new clothes were also, significantly, part of an important political manoeuvre: 'from the late seventeenth century, British aristocrats preempted the middle-class and puritanical challenge that their rule was tainted by luxury by promoting a more moderate appearance than their French and other Catholic counterparts' (McNeil and Karaminas 2009: 6; see also Kuchta 2009).[1] English upper-class identity became, according to Amies, associated with a sobriety that set it apart from the excesses of its French counterpart.

Though fraught with historical class tensions and foreign influences outside of England, according to Amies, the suit has retained, in its modern form, the quintessential English characteristics of sobriety and understated elegance that underpin its genealogy. With its manifest connections to a historical past of unchangeable aristocratic values, to Amies, the gentleman's suit reflects the fantasy of class distinction, the stronghold of tradition, and the emblem of conservative national values:

> We, the British, are lucky to have had kings and princes who were interested in dress, not for reasons of personal vanity or means of seduction but because they were sensitive to the importance of dress in maintaining law and order, order to them being a fundamental respect for the Crown as an institution from which distinctions and privileges of class depended.
>
> [1994] 2009: 43

With an upper-class background, and as a secret agent fighting for 'Queen and Country', Bond could not embody the principles of Amies's Englishness more convincingly than Connery did in his appropriation of the English tradition with which he became associated. Nevertheless, as seen in the following sections, Bond's neat identification with upper-class Englishness is far from unproblematic.

Englishness, dandyism, and voyeurism

Bond's self-consciousness about his Englishness emerges by way of contrast with foreign variations of style. A specific sense of (national) identity, for instance, is apparent in the sartorial changes required by his American mission in Fleming's *Live and Let Die* (1954):

> The afternoon before he had had to submit to a certain degree of Americanization at the hands of the FBI. A tailor had come and measured him for two single-breasted suits in dark blue light-weight worsted (Bond had firmly refused anything more dashing) and a haberdasher had brought chilly white nylon shirts

with long points to the collars. He had had to accept half a dozen unusually patterned foulard ties, dark socks with fancy clocks, two or three 'display kerchiefs' for his breast pockets, nylon vests and pants (called T-shirts and shorts), a comfortable light-weight camel-hair overcoat with over-buttressed shoulders, a plain grey snapbrim Fedora with a thin black ribbon and two pairs of hand-stitched and very comfortable black Moccasin 'casuals'.

[1954] 2004: 22

The 'flashiness' of American dress clashes with Bond's customary English sober understatedness. The initial description of his lounge suit in Fleming's *Moonraker* (1955), for instance, is a simple ensemble of 'heavy white silk shirt, dark blue trousers of Navy serge, dark blue socks ... well-polished black moccasin shoes ... [and] black knitted silk tie' ([1955] 2004: 27). There are but few variations to the literary Bond's usual wardrobe. The sleeveless shirt he wears in *Dr No*, is one of the most notable; the material of his suits, serge, is subsequently replaced by lightweight tropical worsted cotton, a higher quality, more resilient fabric frequently used in military uniforms, and therefore appropriate for Bond's action-packed routine. That Bond's attire becomes a formula throughout the series, is particularly evident on two occasions, both of which display Bond's consistent sartorial style. In Fleming's *Diamonds Are Forever* (1956), a list of 'Bond essentials' is further proof of the formulaic character of his wardrobe:

Evening clothes; his lightweight black and white dog-tooth suit for the country and for golf; Saxone golf shoes; a companion to the dark blue, tropical worsted suit he was wearing, and some white silk and dark blue Sea Island cotton shirts with collars attached and short sleeves. Socks and ties, some nylon underclothes, and two pairs of the long silk pyjama coats he wore in place of two-piece pyjamas.

[1956] 2004: 42

The accent on luxury brands is a symptom of the post-war culture of affluence Bond epitomizes (Berberich 2012: 14), and that underscores his distinctive style. Later, in the novel *The Man with the Golden Gun* (1965), Bond returns to London having been previously dismissed as dead in *You Only Live Twice* (1964). Amnesiac and brainwashed by the Russians, Bond purchases an exact replica of his usual attire in order to prove the authenticity of his identity to the Secret Service, while he continues to work as a double-agent. But the Chief Security Officer expresses his concerns about this suspiciously 'brand-new' Bond: 'Wearing his usual rig – dark-blue single-breasted suit, white shirt, thin black knitted silk tie, black casuals – but they all look brand new. Raincoat bought yesterday from Burberry's' (Fleming [1965] 2012: 12). It is Bond's sartorial self-

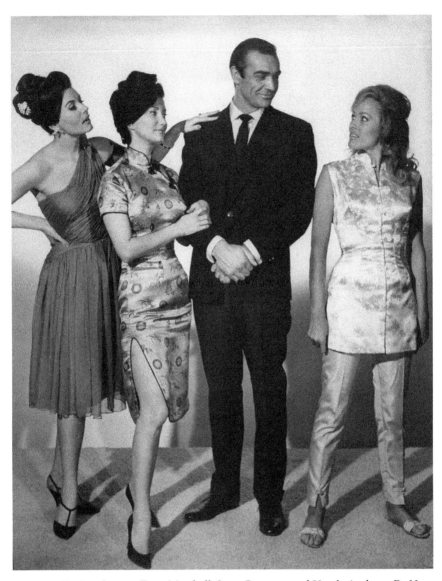

Figure 2 Eunice Gayson, Zena Marshall, Sean Connery, and Ursula Andress, *Dr No* film-set (Courtesy of Danjaq/Eon/Ua/Kobal/REX/Shutterstock)

consciousness that allows the double agent Bond – who is not 'himself' – to act out the loyal British agent he was before his amnesia, through an accurate reconstruction of his clothed self.

There is something quintessentially English behind Bond's 1950s style. Behind the sobriety of his attire is, once again, the type of masculine elegance promoted by Sinclair, 'who was not to succumb to the vagaries of fashion, preferring to turn

out a "well-dressed man" in timeless, elegant style', notes Mason, 'rather than someone who stood out in the crowd' (qtd. in Stempien 2015). 'Relentlessly modern, in the best classic sense' (Hollander 1994: 3), as men's suits are, the 'timeless' temporality of the Conduit Cut suit was simultaneously grounded in a specific historical time, while it also looked back to a two-century tradition; both established and current, it projected an image of unchangeable masculinity. Indeed, there is little doubt that 1950s men's fashion revealed conservative traits as it looked back to a distinctive English tradition:

> While the style's accessories – bowler hat, highly polished shoes and tightly rolled umbrella – provided a hint of the regimental glamour of the parade ground, velvet collars, embroidered waistcoats, ticket-pockets, covered buttons and turned-back cuffs recalled the recherché bonhomie of racetrack and music hall. As a look, it proclaimed its knowing elitism in the traditional language of Brummellian dandyism.
>
> Breward 2016: 137

Emphasis on detail references another important chapter in English men's fashion: dandyism. Anecdotally, the iconic dandy Beau Brummell can be attributed with 'a very important and modern principle of vestimentary behaviour, the principle of "conspicuous inconspicuousness"' (Vainshtein 2009: 94). Being well-dressed without ostentation required, besides access to adequate funds, taste and knowledge. In turn, knowledge of the particularities of dress promoted a habit of mutual surveillance, giving fashionable men licence to perform acts of reciprocal voyeurism ranging from stealing glances to overt staring sessions in all sorts of social contexts: 'it is no accident that monocles, lorgnettes, and quizzing glasses were often featured as among the most salient attributes of dandyism' (Vainshtain 2009: 85).

Since his literary birth on 15 January 1952 (Pearson [1966] 2013: 266), Bond emerges as a character professionally – and, perhaps, naturally – inclined to gaze upon the world around him, absorbing details with a notable fastidiousness. As a secret agent, Bond is indeed primarily required to discover details of intelligence that may prove useful to the Secret Service. This particular aspect of the secret agent's profile is clearly spelled out in Sebastian Faulks's Bond sequel novel *Devil May Care* (2008): 'a man ... who has been trained by the most rigorous and secret organization in his country and whose instincts have been honed by years of self-discipline will see things other travellers barely register' (2008: 20). Indeed, Bond is often captured in the act of spying on people, surveying places, scrutinizing (and deciphering) intelligence documents. His technological tools,

such as microfilm readers, binoculars, and concealed cameras, are all reminiscent of the types of accessories available to dandies in the early nineteenth century. In *A View to a Kill* (Glen 1985), for instance, Bond (Roger Moore) has a camera concealed in a signet ring, which allows him to take 'shots' at the unwitting targets of his gaze.

In more recent times, Bond (Daniel Craig) uses imaging technology on his Sony Ericsson mobile phone to identify potential suspects in *Quantum of Solace*. Bond's voyeurism is here also endorsed by the scene setting; the background is an exclusive performance of Giacomo Puccini's *Tosca* (1900), which revolves around jealousy, and the gaze in a game of seduction, at Bregenz Festival. The stage design features a gigantic eye which 'reverses opera's scopic dynamic by gazing at the audience more than the audience gazes at the stage' (Citron 2011: 316). This is also reinforced by the visual reference to the motif of the 'lover's eye' featured in Georgian brooches and lockets, which, as Hanneke Grootenboer claims, emphasizes the ambivalent function of the gaze:

> Eye miniature portraits ... imply a reversal of the object and subject of seeing and should be considered as (prephotographic) instances of being seen' rather than of seeing. As such, they stand at the foundation of an alternative, reciprocal model of vision, exemplified by the camera.
>
> 2006: 496

In a similar function to that performed by the large-scale eye on the opera stage, the lover's eye miniature, 'as a depiction of a point of view, initiates a transformation of the spectator into a spectacle through its fixating stare' (2006: 496).

These references signal the reversibility of the gaze; a voyeur can turn into the object of the gaze, unwittingly or otherwise, if the initial object of their gaze redirects it back at them. Bond is indeed watched by those who work against him – as well as the film audience – a theme repeatedly referenced in 'the silhouetted figure of Bond seen through a gun-barrel' (Chapman 2000: 63). In *Licence to Kill* (Glen 1989), the emphasis on the gaze is made even more transparent as the customary gun barrel is replaced by a camera, with Bond (Timothy Dalton) positioned in the centre of the lens. In the film, while Q is going through the gadget inventory, Bond Girl and sidekick Pam Bouvier (Carey Lowell) attempts to take a picture of the two men with a Polaroid camera which, in fact, emits a deadly X-ray. These are not strategies exclusively bound to the visual imagery of films. In the novel *From Russia with Love* (1957), in the chapter where Bond's eyes are actively gazing upon the body of Tania Romanova, a hidden camera records their love-making in order to stage a blackmail plot later:

And the view-finders gazed coldly down on the passionate arabesques the two bodies formed and broke and formed again, and the clockwork mechanism of the cine-cameras whirred softly on and on as the breath rasped out of the open mouths of the two men and the sweat of excitement trickled down their bulging faces into their cheap collars.

<div align="right">Fleming [1957] 2004: 186</div>

Significantly, while Bond is here located in the vulnerable position of the unconscious object of the gaze, the hero/villain juxtaposition is expressed in an aesthetic framework; whereas Bond's love-making is described in terms of 'passionate arabesques', the spies are negatively qualified, in fashion terms, by their 'cheap collars'.

Indeed, Bond becomes the target of a kind of 'foreign' voyeurism that subverts the conventional colonial gaze, whereby the white colonizer looks upon, frames, and captures the native, the Other, the 'savage'. In Fleming's *Dr No*, Bond is 'exposed' by a female photographer who attempts to take his photograph at the airport: 'They were moving towards the exit when there came the sharp crack and flash of a Press camera. A pretty Chinese girl in Jamaican dress was lowering her Speed Graphic ... Bond was offhand. This was a bad start' ([1957] 2004: 34). The same evening, at The Blue Hills Hotel, the girl, later named Annabel Chung, makes another attempt:

A glint of light caught the corner of Bond's eye. He turned quickly. The Chinese girl from the airport was standing in the nearby shadows. Now she was dressed in a tight-fitting sheath of black satin slashed up one side almost to her hip. She had a Leica with a flash attachment in one hand. The other was in a leather case at her side. The hand came out holding a flash bulb. The girl slipped the base into her mouth to wet it and improve the contact and made to screw it into the reflector.

<div align="right">[1957] 2004: 41</div>

Annabel's action – though not successful – nevertheless undermines Bond's cover, as she replaces – temporarily, at least – his role as that of the active Western voyeur. Her physical and sartorial attractiveness, which would conventionally situate her in the normative female position of the passive recipient of the gaze, clashes with the equipment she carries, and her ability to use it, to re-direct the gaze back at Bond. This inversion is further complicated by the fact that the girl is portrayed to be very attractive. In the film adaptation former Miss Jamaica Marguerite LeWars plays the part, though clad in a Chinese *cheongsam*, rather than 'Jamaican dress'; the racial connotation of her beauty adds a layer of colonial bias to Bond's scrutinizing gaze.

The reversal of the gaze has clear implications on gender dynamics, consequently challenging conventional active/masculine and passive/feminine binary oppositions. The episode with Annabel prefigures Bond's captivity in Dr No's lair, and it is significant that his physical entrapment is foreshadowed by an attempt to capture his image on camera, as the episode foregrounds a critique of the male gaze. As seen in the introduction, critics have challenged Mulvey's binary approach and undermined the active/passive, voyeurism/exhibitionism oppositions that form the basis of her argument. One suspects, in fact, that Bond's distinctive appearance and formulaic wardrobe make him more, rather than less, identifiable to his enemies. His failure to blend in goes against the dandy's principle of 'conspicuous inconspicuousness', or, at the very least, suggests that he does not succeed in getting the right balance. This, then, further undermines his active role as the controller of the gaze, drawing attention to a form of exhibitionism which, instead, makes him the object of the gaze. In 'genres' conventionally associated with largely male audiences, such as Westerns, Steve Neal argues that 'male figures on the screen are subject to voyeuristic looking, both on the part of the spectator and on the part of other male characters' (1983: 12). When considering the particular kind of action Bond engages in, and his need to maintain his identity under cover, such display means that the audience collude with the villains in 'exposing' and gazing upon Bond. The Bond films, therefore, accommodate a paradoxical narrative in which the apparent controller of the gaze – the male spy – is in fact the passive recipient of the gaze both at a diegetic – within the world of the film – and extradiegetic – outside the world of the film – levels.

There is no doubt that Bond can indeed be the recipient of its audience's erotic gaze. For instance, after rescuing Tracy from her attempt to drown herself in *On Her Majesty's Secret Service* (Hunt 1969), Bond (George Lazenby)'s wet white shirt creates the revealing look of a 'wet-t-shirt competition'; in exposing the toned torso of the Australian model, it also makes a cross-reference to a similar look cast on Honey Ryder (Ursula Andress), as she wades through shallow waters with Bond to escape Dr No's troops. Another cross-reference to Ursula Andress – and her famous screen appearance in the iconic white bikini – features in *Casino Royale* (Campbell 2006), when Bond's muscular body, played by a thirty-four-year-old Craig, emerges from the sea clad in a diminutive pair of La Perla swimming trunks. With a much stronger accent placed on Bond's physicality, Craig's Bond is, more than any of his predecessors, the unquestioned object of the gaze: 'although the actor's impressively muscular corporeality visually emphasizes his masculinity, there is an excessiveness here coupled with

the fetishization of Craig through the use of these shots ... which positions him as object of the gaze' (Cox 2013: 3).

The objectification of Bond's muscular toughness is not a new phenomenon, forgotten as it might have been during the Roger Moore years; as Toby Miller reminds us: 'from the start, Connery was the object of the gaze, posing in 1966 besuited for *GQ* and bare-cleavaged for *Life*' (2003: 238). More recently, the visual pleasure elicited by the insistent emphasis on Craig's strong physique, though apparently showcasing a return to Bond's tough masculinity, also paradoxically blurs categorical gender boundaries. Indeed, as the following chapters demonstrate, the relationship between Bond and the female characters that interact with him, constantly challenge the active/passive, voyeur/object of the gaze distinctions, pointing to the shifting gender dynamics within the Bond cultural corpus.

Replicas and masquerades

At the beginning of the film *From Russia with Love*, Bond appears engaged in action in a garden. Only when he is eventually caught up and strangled by his opponent, do we realize that the victim of the assault is only a stand-in replica dressed up as Bond and wearing a mask that reproduces Bond/Connery's features. Russian theorist Mikhail Bakhtin insightfully argued that the mask – central feature of carnival celebrations – exposes the transient condition of 'natural' identity:

> The mask is related to transition, metamorphoses, the violation of natural boundaries, to mockery and familiar nicknames. It contains the playful element of life; it is based on a peculiar interrelation of reality and image, characteristic of the most ancient rituals and spectacles.
>
> [1965] 1984: 40

While the scene in *From Russia with Love* exposes the slipperiness of the links between clothing and identity through the simulated murder of Bond's replica, it also places emphasis on the permeable function produced by the mask, and by extension, clothing; as Marketa Uhlirova has noted:

> Masks render their wearers mysterious and their identities fluid, making them unpredictable, impossible to capture. And these highly expressive extra layers are never merely devices of concealment – they visualise anonymity, giving it a distinct and forceful image.
>
> 2008: 12

In a dark twist, the audience is made aware that while the 'real' Bond is safe somewhere else in the world, the actor who (unwittingly) stands in for him in the SPECTRE mock assault is *really* killed. Elsewhere, multiple synthetic Bonds, in the form of life-size photographic silhouettes of Roger Moore in Bond costume, appear in the strange circus set-up used by Scaramanga and managed by his henchman, the dwarf Nick Nack, in the film *The Man with the Golden Gun*. The proliferation of Bond images succeeds, temporarily at least, in destabilizing Bond's control of his own and his opponent's positions and movements, a fact accentuated by the mirror surfaces that multiply the images *ad infinitum*.

The original/reproduction opposition, is, of course, a recurrent theme in fashion, and one rich in complexity. On one hand, fashion revolves around the illusion of novelty, which creates the consumer's appetite for different styles. On the other, it relies on the repetition of cycles and self-referential returns to the past for its own sustenance. Moreover, lower-end fashion rests on mass-reproduction of original designs. Originality and reproduction, difference and sameness, then, exist symbiotically in fashion:

> On the one hand, although the domain of clothes is one of serial commodification, the idea of difference allows the fashion trade to personalize its objects as unprecedented creations. On the other, in so far as any new object is only a reinterpretation of previous objects, a slightly altered replica of anterior models, the concept of difference serves to underscore the untenable character of the ideal of originality.
>
> Warwick and Cavallaro 1998: 149

The question of originality in fashion has parallels with Bond's problematic 'uniqueness'. This is made evident through a number of references to masquerades and impersonations that occur throughout the novels and the films. The fact that Bond can be 'replicated' poses doubts about the authenticity of his character, and, by extension, the stability and coherence of identity, a notion which undermines the clear identification of 'goodies' and 'baddies'.

The nature of his profession requires Bond to take an active participation in camouflaging and masquerading. In *Diamonds Are Forever*, for instance, he wears make-up to disguise his features: 'a touch of white at the temples. The scar gone. A hint of studiousness at the corners of the eyes and mouth. The faintest shadows under the cheekbones. Nothing you could put your finger on, but it all added up to someone who certainly wasn't James Bond' (Fleming [1956] 2004: 26). In Fleming's *You Only Live Twice* (1964), and its cinematic adaptation

(Gilbert 1967), Bond literally turns Japanese. Whereas in the novel Bond goes to the community as a *gaijin* (foreign) anthropologist, in the film, he is disguised as a Japanese fisherman. In both versions, however, in order to disguise his identity, Bond is trained by Tiger Tanaka, head of Japan's Secret Intelligence Service, to look and act like a Japanese:

> It was indeed a new man who followed Tiger through the thronged halls of Tokyo main station. Bond's face and hands were of a light brown tint, his black hair, brightly oiled, was cut and neatly combed in a short fringe that reached halfway down his forehead, and the outer corners of his eyebrows had been carefully shaved so that they now slanted upwards. He was dressed, like so many of the other travellers, in a white cotton shirt buttoned at the wrists and a cheap, knitted silk, black tie exactly centred with a rolled gold pin. His ready-made black trousers, held up by a cheap black plastic belt, were rather loose in the fork, because Japanese behinds are inclined to hang low, but the black plastic sandals and dark blue nylon socks were exactly the right size.
>
> Fleming [1964] 2009: 107

The passage underscores the problematic Orientalist discourse frequently identified in Fleming's work. These cultural and racial stereotypes, typically attached to villains and Bond Girls, are now worn by Bond himself. In both novel and film, Bond's Japanese metamorphosis is even more exaggerated by his ninja training camp, from where he comes out equipped with a traditional ninja suit. But it is in the novel that the insistence on the clothes' cheap and mass-produced origin serves to emphasize the sartorial distance between Bond's authentic Savile Row Western style, and its cheap imitations in Japan.

The quick adoption of the Western suit in late-nineteenth-century Japan 'produced many dissonances and mistranslations', while, 'at the same time, Western prejudices reduced these rapid adoptions and amendments to stereotypes about the "inferiority" of Japanese attempts at mimicry' (Breward 2016: 104). Nevertheless, Japan maintained a steady, if ambivalent interest in Western fashion throughout the twentieth century, particularly with regard to the 'rapid incorporation of foreign forms into the grammar of Japanese dress' (Breward 2016: 107). Although, while, according to Amies, the Japanese word for suit – *sebiro* – displays its direct indebtedness to Savile Row (Amies [1994] 2009: 90) – by the 1970s, Japanese designers would have started to rework the Japanese *iki* – 'elegance' – into their Western fashion designs (Breward 2016: 105).

The double-bluff – British Bond wearing a Japanese imitation of English clothes to pass as Japanese – is a good example of simulation facilitated through

dress, pointing to the 'procession of simulacra' that fashion entails (see Baudrillard [1981] 1994: 1). In turn, it also serves the purpose of accentuating the performative slipperiness of clothes, blurring the boundaries between heroes and villains, West and East, original and copy. The Eastern replication of Western models recurs in *Die Another Day*, where Korean villain Colonel Tan-Sun Moon (Will Yun Lee), previously thought dead, takes on the identity of British billionaire Gustav Graves (Toby Stephens) through gene replacement therapy, which enables him to change his racial appearance.

While the film does not directly reference the ethical questions about human genetic manipulation, Graves' genetic 'mask' is, nevertheless, a twenty-first century anxious response to human genetic manipulation, posing a veiled question about the authenticity of human identity. Grave's gene therapy is, in other words, another kind of masquerade, pointing to the paradoxical qualities of the mask; as Warwick and Cavallaro suggest, 'the mask . . . both protects and exposes its wearer, conceals and reveals its attributes, metamorphoses and crystallizes identity, separates and mediates the self and the other' (1998: 132). Significantly, when confronting Bond about his real identity, Graves brings an uncomfortable truth home:

> We only met briefly, you and I. But you left a lasting impression. When your intervention forced me to present the world with a new face, I chose to model the disgusting Gustav Graves on you. Oh, just in the details. That unjustifiable swagger. Your crass quips – a defence mechanism concealing such inadequacy.
>
> *Die Another Day* 2002

In revealing that Graves' is, effectively, a parody of 007, Bond himself is exposed as a travesty of masculinity, an empty – albeit impeccably dressed – shell of a man.

Masks and masquerades are central to an understanding of the slipperiness of identity. This is also made clear, more broadly, by the various cultural references to carnival events throughout the Bond film series. In *Thunderball* (Young 1965), for instance, Bond's escape is facilitated, temporarily at least, by the Junckanoo celebrations in Nassau, Bahamas, which allow Bond to disappear among the party crowds. A scene from the Carnival in Rio de Janeiro features in *Moonraker* (Gilbert 1979), where Hugo Drax's henchman, Jaws, played by seven-foot-tall Richard Kiel, appears dressed up as an oversized clown and almost gives Manuela (Emily Bolton) the kiss of death amid the city's euphoric celebrations. Most recently, the opening scene in *Spectre* (Mendes 2015) is set against a fancy-dress parade along the streets of Mexico City on the Day of the Dead (*Día de Muertos*).[2] The opening sequence, with over a thousand extras in

costume, large-scale skeleton puppets, and the beat of Mexican drums, indeed offers a good rendition of the all-encompassing quality of the carnivalesque space as defined by Bakhtin:

> Carnival is not a spectacle seen by the people; they live in it, and everyone participates because its very idea embraces all the people. While carnival lasts, there is no other life outside it. During carnival time life is subject only to its laws, that is, the laws of its own freedom.
>
> [1965] 1984: 7

To open the film in this way is to say to an audience, effectively, that anything can happen, because the logic of carnival turns everything upside down, collapsing the boundaries between real and unreal, true and fake; 'The dead are alive', reads the caption before the first scene opens with a close-up shot of a large *papier-mâché* skull, while the omnipresence of masked faces and bodies in disguise accentuates the sense of uncertainty about characters' identities. Amid the faceless crowd of *calaveras* (skulls) and *calacas* (skeletons), move Marco Sciarra (Alessandro Cremona), dressed in a white suit and skull mask, and Bond (Daniel Craig), wearing a skull mask and skeleton suit, accompanied by a lady in a corseted purple dress and skull mask. In line with Bond's womanizing habits and the free spirit of carnival, the following scene shows Bond kissing the woman in her hotel room. Then, having discarded the temporary skeleton costume, Bond appears in his Tom Ford grey suit. The sartorial transition could not make the message any clearer; the party is over, and it is now business as usual, which means that Bond is getting ready to kill Sciarra. But while there seems to be no practical reason why Bond would waste the time to change his clothes, it is precisely the change of clothes that identify him as Agent 007, now professionally dressed for the job he is paid to do. Moreover, the change into professional dress means that Bond is now in control, having left the transgressive licentiousness of the carnival space behind him; 'the suspension of all hierarchical precedence during carnival time was of particular significance' (Bakhtin [1965] 1984: 10), Bakhtin reminds us, and by losing the costume, Bond effectively reinstates the authority of the norm that he embodies.

Foreign deviations

Although Bond's firm identification with both Englishness and the Establishment is far from uncomplicated, Bond's white Britishness stands out in direct

opposition to the villain's unclear, or mixed, nationality, and frequently racialized appearance. As for social standing, foreign villains' ostentatious display of wealth and power is typically juxtaposed with Bond's British understated performance of class. In the novel *Live and Let Die*, for instance, Bond notes Mr Big's 'hint of vanity in the diamonds that blazed on his shirt-front and at his cuffs' (Fleming [1954] 2004: 60). As for SMERSH, Red Grant's disguise as Captain Norman Nash troubles Bond in *From Russia with Love* because he 'mistrusted anyone who tied his tie with a Windsor knot. It showed too much vanity. It was often the mark of a cad' ([1957] 2004: 223–4).

In *Diamonds Are Forever*, similarly, the American gangster scene is presented as a darkly glamorous affair through the exceptional sartorial display of the Spangled Mob and their associates. Jack Spang wears 'a roomy, black, single-breasted suit, a white shirt and an almost bootlace-thin black tie, held in place by a gold tie-clip representing a spear' ([1956] 2004: 30). His brother, Seraffimo, when out west in Spectreville, the ghost-town he owns, dresses 'in full Western costume down to the long, silver spurs on his polished black boots. The costume, and the broad, leather chaps that covered his legs, were in black, picked out and embellished with silver' ([1956] 2004: 162). Although apparently placed at the opposite end of the fashion spectrum, attention to detail, points, as noted by Lorraine Gamman, to the common ground between the gangster and the dandy:

> The gangster is a 'dandy' par excellence, like the 19th century Dandy who dressed as if going to a funeral... Today's movie gangsters exhibit similar taste. On screen they are protagonists who carry the action forward, but are also dressed to kill; glamorous figures, in the original definition of the word.
>
> Gamman 2008: 220

Such a display of masculinity leads to a problematic reading of their authority. In drawing attention to himself, the gangster performs an ambiguous kind of masculinity, which threatens to be active, particularly in the perpetration of crime and violence, and yet, in its self-conscious display of narcissism, is also the passive recipient of the gaze: 'gangsters are definitely dandyish', Gamman continues, 'but their suits often operate to contain the gangster's inevitable fragmented identity, that may eventually spill over the screen' (2008: 220). The Spang brothers' sartorial appearance positions them on the margins of society, as well as taste. The 'excessive' details of their vestimentary attributes mark them out as operating outside the norm, as is the case with horse-owner Pissarro:

Pissarro looked like a gangster in a horror comic. He had a round bladder-like head in the middle of which the features were crowded together – two pin-point eyes, two black nostrils, a pursed wet pink mouth above the hint of a chin, and a fat body in a brown suit and a white shirt with a long-pointed collar and a figured chocolate bow tie.

[1956] 2004: 96

Pissarro's bad taste amplifies the gaudy features of gangster style, which is also reflected in his exaggerated physical attributes. The combination of sartorial and physical excess, however, creates the effect of parody, therefore diffusing the force of his menace.

In *Skyfall*, Raoul Silva's sartorial look accentuates the implicit campness of gangster style. The bespoke suit jacket designed by Thom Sweeney aligns him, stylistically, with Gareth Mallory/M (Ralph Fiennes), who also wears bespoke English tailoring; while this symbolizes Silva's earlier incarnation as an MI6 agent, other details, including the light colour of the jacket, suggest a deviation from traditional English style (Spaiser 2014), as does the patterned Prada shirt. As it breaks the coherence of the gentleman's three-piece suit, the flamboyance of Silva's shirt signals his outcast status: 'Additional, excessive focus on male grooming and presentation', Gamman reminds us, 'serves to emphasize, often by a subtle touch to the tailoring of an otherwise immaculate suit, the *lack* of social status of the man in question' (2008: 220). Indeed, as costume designer Jany Temime confirms, the shirt is to convey Silva's position as a villain whose social status casts him out as the anti-gentleman, 'slightly nouveau riche, ... [dressed] to impress Bond' (qtd. in Phili 2012). Additionally, Silva's camp style reflects a manifestly deviant sexuality – in line, as seen later, with most of Bond's villains – which he expresses in his highly sexualized interaction with Bond. That Silva is, on every level, operating outside the norm is further conveyed by the important details of the upturned waistcoat collar and lapels:

Turning up the collar is a way of dissociating from normality – a signing of an assertive yet inward turn. At the same time it is an armouring of the vulnerable nape, emphasising the width of the shoulders and the sheathing of the silhouette into a more streamlined form.

Pajaczkowska and Curties 2008: 62

The clashing elements of his part conventional/part camp style, then, are a reflection of his complex positioning against Bond's Establishment affiliation and perceived straightness.

In fact, on a number of less formal occasions, Bond's dress errs on the side of camp. Film viewers will remember, for instance, the baby-blue towelling suit worn by Sean Connery in *Goldfinger*, and Roger Moore's yellow ski suit in *The Spy Who Loved Me* (Gilbett 1977). Both garments produce an unconventionally playful version of Bond, while, at the same time, undermining the principle of understated elegance that connotes his style. Moreover, accentuating his visibility, such garments question the notion of Bond's invulnerable masculinity because they signal a subversion of the male gaze of which he becomes an object. This is made blatantly obvious in *The Spy Who Loved Me*, as the bright colour of his suit makes him a much easier target to the Russian agents who chase him down the ski slope. Alongside other problematic displays of masculinity, such deviations from Bond's straight wardrobe reinforce the shifting quality of his performance of heteronormativity.

As well as their sexual ambivalence, race and ethnicity are clear indicators of the villains' deviancy. Literary Bond villains, as Eco notes, do not belong to a single ethnic group: 'the Villain is born in an ethnic area that stretches from Central Europe to the Slav countries and the Mediterranean basin: usually he is of mixed blood and his origins are complex and obscure' ([1979] 2007: 151). In *Casino Royale*, for instance, Le Chiffre is a man of very pale complexion, red-brown hair, and small ears 'with large lobes, indicating some Jewish blood'; the veiled anti-Semitic reference is also reinforced by the villain's mixed racial background, 'probably a mixture of Mediterranean with Prussian or Polish strains' (Fleming [1953] 2006: 16–17). Subsequent villains share similarly unclear ethnicities. Goldfinger, like Le Chiffre, is rumoured to have Jewish blood, and, though 'today he might be an Englishman', he comes from the Baltic region. Likewise, Mr Big (*Live and Let Die*) is 'not pure negro', but, 'born in Haiti', has a 'good dose of French blood' ([1954] 2004: 17); Hugo Drax (*Moonraker*) is originally German, but English by adoption; Blofeld (*Thunderball* (1961), *On Her Majesty's Secret Service* (1963), *You Only Live Twice* (1964)), Red Grant (*From Russia with Love*) and Dr No come from mixed-nationality families, Polish and Greek, German and Irish, and Chinese and German respectively. In line with their foreign origins, their dress points to the villains' quintessential 'strangeness'.

Goldfinger is a modern-day Midas. Like a charmless reincarnation of Scott Fitzgerald's Gatsby, in the film, Gert Fröbe drives a 1937 yellow Rolls Royce Phantom III (in place of the novel's Silver Ghost), a model reminiscent of the yellow Phantom I driven by Robert Redford in *The Great Gatsby* (Clayton 1974). With Gatsby, Goldfinger shares an interest in wealth and ostentation. Unlike Gatsby, however, Goldfinger does not have a romantic ulterior motive, and his

ravenous gold accruement is dictated by addiction to the precious metal. All things linked with Goldfinger are yellow or gold in colour, down to the ginger cat Bond uses as an accomplice when snooping around Goldfinger's house: 'Auric Goldifinger', Elisabeth Ladenson rightly puts it, 'is a walking tautology' (2003: 186). His obsession with gold turns him into a sun-worshipper, first seen in Miami, 'wearing nothing but a yellow satin bikini slip, dark glasses and a pair of wide tin wings under his chin'. Whereas Bond admits that 'with his clothes on – a comfortably fitting dark blue suit, a white shirt open at the neck – Goldfinger cut an almost passable figure', on an English golf-course, he becomes the target of Bond's colonial snobbery:

> Goldfinger had made an attempt to look smart at golf and that is the only way of dressing that is incongruous on a links. Everything matched in a blaze of rust-coloured tweed from the buttoned 'golfer's cap' centred on the huge, flaming red hair, to the brilliantly polished almost orange shoes. The plus-four suit was too well cut and the plus-fours themselves had been pressed down the sides. The stockings were of a matching heather mixture and had green garter tabs. It was as if Goldfinger had gone to his tailor and said, 'Dress me for golf – you know, like they wear in Scotland'.
>
> Fleming [1959] 2004: 26, 29, 88

Everything here speaks of the excess that Goldfinger embodies. His clothes are too well cut and his shoes too shiny. Lacking the nonchalance of the dandified English gentleman, as a foreign *nouveau riche* Goldfinger lacks taste, relegating any stylistic decision to his tailor. Such *faux pas* mark him out as a foreigner, betrayed by his self-conscious English masquerade. Even more laughable, in Bond's eyes, than Goldfinger's clothes, is the sartorial performance of his henchman, Oddjob:

> He was a chunky flat-faced Japanese, or more probably Korean, with a wild, almost mad glare in dramatically slanting eyes that belonged in a Japanese film rather than in a Rolls Royce on a sunny afternoon in Kent. He had the snout-like upper lip that sometimes goes with a cleft palate ... In his tight, almost bursting black suit and farcical bowler hat he looked rather like a Japanese wrestler on his day off. But he was not a figure to make one smile. If one had been inclined to smile, a touch of the *sinister*, the *unexplained*, in the tight shining patent-leather black shoes that were almost dancing pumps, and in the heavy black leather driving gloves, would have changed one's mind.
>
> Fleming [1959] 2004: 111; my emphases

Seen through Bond's gaze, Oddjob's ill-fitting suit exposes the British agent's colonial stance. Notably, a cross-reference to Oddjob appears in Anthony

Horowitz's Bond sequel novel *Trigger Mortis* (2015), set to follow Fleming's *Goldfinger*; here the sartorial presentation of the novel's Korean villain, Sin Jai-Seong, blurs the East/West boundaries of fashionableness:

> The last Korean Bond had encountered had been squat and ugly . . . but this one was at least passably good-looking with the confident, easygoing aura that often comes with considerable wealth. He was immaculately dressed in a grey silk suit that had been made to measure, a white shirt open at the neck and well-polished Italian black leather shoes.
>
> 2015: 82

The comparison with Horowitz's nuanced revision highlights Bond's Orientalist prejudice in Fleming's novel, where Bond's bias shows his blindness to the cultural differences between Japanese and Koreans; significantly, Goldfinger himself appears to be more aware of the political implications of such cultural differences, when he explains Bond the reason for his lateness: 'My chap had had a row in a pub with some American Air Force men who had called him a bloody Jap. I explained to the police that Koreans don't like being called Japs. They let him off with a caution' (Fleming [1959] 2004: 121). In a more demeaning way than with Goldfinger – who exercises a sort of 'animal magnetism' (Fleming [1959] 2004: 88) on Bond – Oddjob's foreignness is conveyed in animalistic terms through his 'wild, almost mad glare' and his 'snout-like upper lip'. As Oddjob's mimicry of Englishness fails to convince, it also represents a challenge to Englishness itself; after all, his lethal bowler hat could not be a more effective demonstration of the perils of cultural contamination and hybridity that he embodies.

Orientalist ideology emerges also in *Dr No*, in a fairly explicit form of Sinophobia pervasively at work in both novel and film. The film-set design, for example, emphasizes Miss Taro's Chinese identity through the Oriental décor of her bedroom (Simmonds 2015: 9). In the novel, the pervasive presence of Asian culture reaches its apex within Dr No's 'exquisite prison', where Honeychile and Bond are subject to a form of reverse colonization, through the enforced replacement of their Western attire with Eastern apparel. Whereas Bond's cool reaction displays apparent disregard for Dr No's controlling strategy – 'He took out a linen one [kimono] at random', Honeychile resists wearing the foreign garment, on the grounds that 'the Chinese dress felt strange' (Fleming [1958] 2004: 143, 141,142).

As the novel is set in the 1950s, it can be assumed that Honeychile's 'Chinese dress' is a garment based on the fitted *cheongsam* dress (Fig. 2), which became

fashionable in mid-century China and effectively replaced previous women's styles such as the *ao* (see Garrett 2007). As for Dr No's himself, it would seem incongruous that he would wear a *kimono*, a traditional Japanese garment. In early twentieth-century China, Western dress would have been part of the fashion scene in republican China alongside the official Chinese (Manchu-style) dress for men, a 'side-fastening Chinese gown with a hip-length jacket on top' known as *changshan magua* (Garrett 2007: 131), replaced, mid-century, by the 'Mao suit'.

Considering Dr No's migrating movements, it could be likely that he maintained a more traditional dress than what was conventional in mid-century China, but the mention of a kimono suggests, at best, a generalized attitude towards Eastern dress and an Orientalist stance against the villain. Indeed, Dr No's Chinese foreignness is accentuated by his physical, feline-like, demeanour, as Bond notes that he 'seemed to glide rather than take steps. His knees did not dent the matt, gunmetal sheen of his kimono and no shoes showed below the sweeping hem'. Similarly, his physical description magnifies the character's sinister aura dictated by over-emphasized racial difference: 'the skin was of a deep almost translucent yellow … his prominent cheekbones looked as smooth as fine ivory…. [his] slanting jet black eyes … looked like the mouths of two revolvers, direct and unblinking and totally devoid of expression' ([1958] 2004: 155, 156).

In the film, Dr No's costume is neither a Chinese *changshan magua* nor a Japanese kimono, but a Nehru jacket, the stand-up collar of which is, however, reminiscent of the Chinese mandarin collar. In its inaccurate use, the garment represents yet another manifestation of the Orientalist construction of the villain's foreignness, whereby his Chinese identity is replaced with an Asian, and more specifically, Indian-origin cultural product. Significantly, as Breward notes, the history of the Nehru jacket is bound to the history of Indian emancipation from British Empire, taking its name from Pandit Jawaharlal Nehru, the first prime minister of India after independence. Both in terms of material and style, 'the "closed neck coat" rejected the English sartorial codes in place during Nehru's time as a student and trainee barrister in Cambridge and London in the early 1900s' (Breward 2016: 96).[3] In the Indian scenes of *Octopussy* (Glen 1983), the Nehru jacket is perhaps more appropriately worn by villain Kamal Khan (Louis Jourdan) and his henchman Gobinda (Kabir Bedi), even though Khan is an Afghan prince. More recently, in *Spectre*, Ernst Stavro Blofeld (Christoph Waltz) has worn a bespoke navy silk velvet Nehru jacket from London tailor Timothy Everest in his desert lair (Spaiser 2016b).

Blofeld's Nehru jacket creates an interesting link with previous villains such as Dr No – and indeed also Dr Evil in the Austin Powers parodies – though it

constitutes a change from the villain's previous film incarnations, where his foreignness – as is the case with Hugo Drax (Michael Lonsdale) in the film *Moonraker* – is conveyed by the use of another non-Western garment: the 'Mao suit'. The garment takes its name from the high-collar tunic jacket and baggy trousers worn by the Great Leader Mao Zedung, when he declared the establishment of the People's Republic of China on 1 October 1949. The suit's 'sober colors and a neat cut, encapsulated the proletarian style' (Wu 2009: 3), in a sartorial reaction to the traditional Manchu style of dress and its imperial/feudalist associations, which were significantly gendered: 'The fitted jacket, which demanded an erect posture, was in deliberate contrast to the flowing, loose, and slightly effeminate gowns of earlier times' (Garrett 2007: 134).[4] As the majority of people in post-war China wore less expensive variations of the utilitarian style, the effect was one of cultural uniformity, although the Mao suit bore an ambiguous relationship to the elimination of traditional Chinese customs brought in by the Cultural Revolution of 1966. In *You Only Live Twice*, Blofeld's appropriation of the 'Mao suit' conveys, through its reference to Chinese communism, the most significant threat to Western capitalism even though SPECTRE is not a political organization (see Spaiser 2011). The style later returns to express concerns about another manifestation of cultural control: the mediatic manipulation of information by Elliot Carver in *Tomorrow Never Dies* (Spottiswoode 1997). A reincarnation of Dr No's hybrid ethnic mix, Carver, originally German, is raised by an adoptive family in Hong Kong. His black Mao suit by Kenzo, matched with a silk crewneck by Prada, and rimless glasses by Danish Air Titanium (Simmonds 2015: 246), convey the erasure of East/West cultural borders. It is the dangerous porosity of cultural influences that make him, and other villains, a distinctive challenge to Bond's Englishness.

Although Bond's heroic status rests on a specific kind of upper-class Englishness, his experience of national and class identity is far from unproblematic. The obituary M pens after Bond's presumed death in *You Only Live Twice*, states that 'James Bond was born of a Scottish father, Andrew Bond of Glencoe, and a Swiss mother, Monique Delacroix, from the Canton de Vaud' (Fleming [1964] 2009: 251). Having become an orphan at eleven years of age due to his parents' premature death in a climbing accident, Bond is raised by an aunt, Miss Charmian Bond, in Kent. Rather than 'pure' English lineage, 'James Bond's mixed Scottish and Swiss heritage and his upbringing abroad mark him as as [sic] much of a hybrid figure as any of the villains he encounters on his assignments' (Halloran 2005: 164). Additionally, while Bond's Scottishness is rarely mentioned throughout the books, it appears twice in *The Man with the*

Golden Gun, the last of Fleming's Bond novels. At the end of the novel, Bond declines his knighthood nomination, on the grounds that he is 'a Scottish peasant' (Fleming [1965] 2012: 211); such a statement, in line with Bond's self-conscious uneasiness about his Englishness, unveils the ambivalent status of a colonized subject, which Bond, as a Scot, embodies: 'his dual Scottish and Swiss heritage situates him, at least partially, as a colonial subject' (Halloran 2005: 164). Such ambivalence is apparent in *The Man with the Golden Gun*, as Bond refers, again, to his Scottishness, when discussing his ambiguous feelings about the old-fashioned tradition and rituals of knighthood – 'go to Buckingham Palace and see the Queen and the Duke of Edinburgh and kneel and have your shoulder touched with a sword' – with Mary Goodnight: 'I'd like all those things. The romantic streak of the S.I.S. – and of the Scot, for that matter' (Fleming [1965] 2012: 212), he says. As William Boyd notes, the passage holds problematic implications for Bond's perceived national identity:

> It's surely significant that three times in less than one page James Bond pointedly refers to himself as Scottish. The Flemings were a Scottish family – even though you'd never guess it from hearing Ian Fleming speak ... I wonder if, as he wrote his final Bond, and cognisant of the impending death awaiting, and that very few 'tomorrows' were left to him – Fleming was thinking of his own origins and therefore decided to reinforce the point about Bond's Scottishness.
>
> Fleming [1965] 2012: xv–xvi

The casting of Connery for the first Bond movie 'carried connotations of the history of Scottish antagonism to English imperialism' (Cook and Hines 2005: 151), therefore reiterating such ambiguities. In film, however, Bond's Scottishness has only been used to comic effect until Sam Mendes's *Skyfall* (2012), where Bond's complicated relationship with Scotland emerges through the childhood trauma of parental loss, and its associations with the ancestral family home at Skyfall. The film, which is strewn with Oedipal tensions, sees the simultaneous destruction of Skyfall and the death of M (Judi Dench) in a traumatic, but cathartic, moment whereby Bond is 'reborn' after trauma.

Before this serious treatment of Bond's Scottish identity, David Niven had taken part in the kitsch display of tartanry that is the first section of the 1967 *Casino Royale*, while George Lazenby wore a kilt in his dubious disguise as Sir Hillary Bray in *On Her Majesty's Secret Service* (Hunt 1969). The performance of Sir Hillary's Scottishness provides an opportunity for the inevitable smutty references to the rumoured nudity under the kilt, while, upon arrival at Piz Gloria, Sir Hillary's appearance – pipe in mouth, Ulster coat and trilby hat –

turns the masquerade into a parody of *fin-de-siècle* Englishness. In the novel, however, we are told that the 'real' Sir Hillary Bray is quintessentially English, a descendant of William the Conqueror, though living as a recluse in Scotland. Indeed, dressed up as Hillary Brae, 'bowler hat, rolled umbrella, neatly folded *Times* and all, [Bond] felt faintly ridiculous', later admitting that

> There was nothing of the baronet in him! He really must get rid of the inverted snobbery that, with its opposite, is ingrained in so many of the English! He must stop acting a part, being a stage nobleman! He would just be himself and, if he gave the appearance of being rather a rough-hewn baronet, the easy-going kind, well, that at least was like the real one up in Scotland.
>
> [1963] 2009: 94

Bond's uneasiness about his performance of upper-class Englishness therefore reflects a deeper anxiety about national identity and class. Bond's self-conscious disdain for upper-class snobbery points to his embodiment of post war Britain, allegedly rid of its rigid pre-war class-system and 'in the process of being thoroughly modernized as a result of the implementation of a new, meritocratic style of cultural and political leadership, middle-class and professional rather than aristocratic and amateur' (Bennett and Woollacott 1987: 34–5). Like the nineteenth-century dandy, Bond becomes a liminal figure, 'a bridge between tradition and modernity'; as Pam Cook and Claire Hines note, 'although not a working-class hero, his opposition to the British Establishment was clear in his tendency to break ranks and his disregard for authority' (2005: 148). This is also inscribed in his Edwardian suit, the uniform of the gentleman, but also, because of its concealed weaponry, a gesture towards the razor blades hidden in the Teddy Boys' suit-pockets; as Vivien Goldman reminds us, 'historically, a Ted's suit lapel would hide a tiny pocket for razor blades, with fish hooks stuck around the back to give any hands-on attacker a nasty surprise ... 'Teds were the uncommon man's James Bond' (2004).

Indeed, Bond's class and national identity point to the performative quality of both. Upon his encounter with Griffon Or of the College of Arms in *On Her Majesty's Secret Service*, there is an uncomfortable awareness that Bond's lineage lacks a title, because the baronetcy associated with the surname is linked to an extinct branch of the family. Additionally, while Or refers to his family name as a 'good old English name', Bond's rectification – 'My father was a Scot' (Fleming [1963] 2009: 69) – leaves little ground about any claim to English aristocracy. Bond is in fact painfully conscious of his 'fake' Englishness. In the novel *Moonraker*, he admits 'that there was something alien and un-English about himself. He knew

that he was a difficult man to cover up. Particularly in England' (Fleming [1955] 2004: 34). Boyd refers to Bond's split national identity in his Bond sequel *Solo* (2013), when he learns that Blessing Ogilvie-Grant, a local agent in the fictional African Republic of Dahum, is also half-Scottish, 'as if the fact they were both of mixed nationalities would form an affinity between them' (2013: 62). Even then, however, Bond's awareness of the tenuous significance of such references is barely concealed: 'That old Celtic blood tie established, the homeland noted – however fragile the connection, however meaningless – worked its temporary magic' (2013: 62). In fact, as Blessing turns out to be Alisha Belem, who has impersonated her boss, Edward Benson Ogilvy-Grant, and attempts to kill Bond, her Scottish identity is laid bare as an act, the only purpose of 'her own carefully constructed biography ... the Scottish engineer father, her Celtic colloquialisms' (Boyd 2013: 184), to establish some common ground with Bond.

The evolution of Bond's dress throughout the franchise further cements a notion of Bond's hybrid identity. After Moore's sports jackets in the 1970s and Dalton's 'slim, knitted black ties and structureless suits' in the 1980s (Jones 1999: 62), fashion commentator Simon Werle identifies a landmark change in Brosnan's sartorial performance in the 1990s:

> Bond has fought his battles neither in traditional English-tailored clothing nor in the latest fashions, but in classic Brioni custom-made suits costing five thousand dollars each, as if self-confident masculinity had been transformed into cloth, influenced only by the time's 'minimal chic'.
>
> 2010: 31–2

The use of an Italian luxury fashion house to dress Bond acknowledged Bond's appeal to a global identity, while, arguably, reinforcing the uneasy Englishness which transpires from the novels. Although, 'in several ways Brosnan is the most traditional Bond yet, dressing in beautifully cut three-piece Brioni suits, Church's brogues and Jermyn Street shirts', as Dylan Jones suggests, 'he doesn't look timely as much as rich: his style is unmistakeably synonymous with expensiveness' (Jones 1999: 62). The transformation of Bond from English to international luxury brand continues with Craig, whose suits, from *Quantum of Solace* onwards are made by the American designer Tom Ford: 'The Brioni suits were too relaxed ... the way that Daniel [Craig] wears his clothes required something sharper', commented costume supervisor Lindsay Pugh after the release of *Quantum of Solace* (qtd. in Fellowes 2008). The choice, in fact, reinforces the cross-fertilization between English/global fashions, as Tom Ford was specifically instructed to stylize Craig's suits 'in a Sixties way', as a nod to Bond's cinematic origin (Fellowes 2008).

Looking both at Fleming's fiction and Bond films, Bond's alleged Englishness is less self-assured than his popular reputation would lead us to believe. As an orphan with loose ties with family and homeland, Bond's complex identity undermines the binary hierarchical opposition which places him above the villains, whose foreignness and, as seen below, excessive physicality, threaten to contaminate him.

'Abnormal' bodies

In Fleming's *You Only Live Twice* Blofeld appears 'dressed in a magnificent black silk kimono across which a golden dragon sprawled' ([1964] 2009: 227), and seventeenth-century samurai armour; this is, however, only to disguise himself as Dr Guntram Shatterhand and protect his body from the lethal poisonous plants of his 'garden of death' in Japan. Elsewhere, the apparent neutrality of Blofeld's clothing highlights the abnormal body disguised in well-cut Western clothing, as seen in *Thunderball*:

> Blofeld's body weighed about twenty stone. It had once been all muscle – he had been an amateur weightlifter in his youth – but in the past ten years it had softened and he had a vast belly that he concealed behind roomy trousers and well-cut double-breasted suits, tailored, that evening, out of beige doeskin.
>
> Fleming [1961] 2004: 48

As with many of Bond villains, Blofeld's excessive body serves to define Bond's heroism through the juxtaposition of Bond's seemingly perfect masculine physique to the villain's imperfect body.

In spite of Blofeld's longevity and recurrent presence in the Bond narratives, perhaps topping the monstrosity chart of Bond villains is Hugo Drax, who is 'a little larger than life', and has 'shiny puckered skin', 'the right eye … considerably larger than then left eye' and 'ogre's teeth', in Fleming's *Moonraker* ([1955] 2004: 38–9). With physical attributes reminiscent of the stitched-up creature of Mary Shelley's *Frankenstein* (1818), Drax's features and size expose him as the monster dualistically opposed to the handsome hero, Bond. Drax's 'expensive clothes' and excellent taste ([1955] 2004: 39), however, blur the binary opposition as 'dress … alert[s] us … to our internal plurality and … a basic condition of self-dividedness and fragmentation' (Warwick and Cavallaro 1998: 119). Indeed, clothing would suggest not only the partial erasure of neat demarcations between Bond and the villain, but also the

possibility of an osmotic process of contamination through the porous surface of garments.

Physical imperfections define the body of the villain as the site of abnormality, a form that, exceeding in size and shape the paradigms of the idealized masculine body, incarnates what Bakhtin would call the grotesque body: 'contrary to modern canons, the grotesque body is not separated from the rest of the world. It is not a closed, completed unit; it is unfinished, outgrows itself, transgresses its own limits'. Far from static, the grotesque body, is susceptible to change, and, simultaneously, implicitly threatens to leak into the surrounding environment or even the 'normal body'; 'the emphasis', Bakhtin notes, 'is on the apertures or convexities, or on various ramifications and offshoots: the open mouth, the genital organs, the breasts, the phallus, the potbelly, the nose' ([1964] 1985: 26). These traits belong to many a Bond villain. In *Thunderball*, 'Blofeld's hands and feet were long and pointed', whereas his mouth, 'proud and thin', is 'like a badly healed wound' (Fleming [1961] 2004: 48). In the same novel, Emilio Largo's 'mouth, with its thick, rather down-curled lips, belonged to a satyr' and his 'hands ... [were] almost twice the normal size (Fleming [1961] 2004: 98–9). No amount of money can disguise Goldfinger's 'great brown and red football of a head' (Fleming [1959] 2004: 29), whereas the distinctive feature of Francisco Scaramanga in *The Man with the Golden Gun*, 'a third nipple about two inches below his left breast ... [is] a sign of invulnerability and great sexual prowess' in local Voodoo culture (Fleming [1965] 2012: 32). In *Casino Royale*, Le Chiffre has an 'almost feminine mouth ... small ears with large lobes, ... hairy hands' and *sanpaku* eyes, where the white is visible all around the iris (Fleming [1953] 2006: 148).

In the film *Casino Royale*, Le Chiffre's left eye is affected by haemolacria, a rare condition whereby the eye weeps blood. Induced by tension, the discharge enables Bond to detect Le Chiffre's bluff at the card table, but it is also, simultaneously, an ominous threat to Bond's body, which is indirectly contaminated by Le Chiffre's 'fluid' through a poisoned drink during the game. Indeed, while the protrusion into the 'normal' body disrupts the illusion of its impenetrability, the openness of the grotesque body also conceals the threat of contamination. Gilles Deleuze and Félix Guattari discuss contagion as a non-normative form of reproduction opposed to 'natural' sexual reproduction. Using the vampire as an analogy, they argue that 'the vampire does not filiate, it infects. The difference is that contagion, epidemic, involves terms that are entirely heterogeneous'. As the uncontrollable union between two different beings, who, unlike in typical sexual reproduction, can belong to different species, contagion is a radical threat to the classification of bodies into discreet categories: 'These

combinations are neither genetic nor structural; they are interkingdoms, unnatural participations' ([1980] 2004: 266, 267). The hybridity conjured up by the non-normative process of contagion subverts the threat of miscegenation, which the mixed racial and ethnic background of the Bond villains already imply. Rather than inviting a reading of the villains' hybrid bodies as inferior because of their 'impure' pedigree, contagion in fact encourages an understanding of hybridity as a strategy to question humanist discourse of identity as well as imperial ideology.

Nowhere within the Bond cultural corpus is the discourse of hybridity more visible than in the conspicuous display of technologies of the body. Many of the Bond villains – and their henchmen – present technologically enhanced bodies, particularly in the films. The first glimpse of Dr No, is 'a pair of articulated steel pincers at the end of a metal stalk' (Fleming [1958] 2004: 146). Tee-Hee, Mr Big's henchman, sports a similar device in *Live and Let Die*, both novel and film. In the films *The Spy Who Loved Me* and *Moonraker*, Jaws takes his name from the metal prosthetic teeth he uses as a lethal weapon; gesturing to Jaws, the appropriately nicknamed Mr Bullion, Valentin Zukovski's disloyal servant, showcases a full set of gold-encrusted teeth in *The World Is Not Enough* (Apted 1999). In *Skyfall*, Silva wears a prosthetic jaw to disguise its monstrous deformity after his unsuccessful cyanide suicide attempt. A bullet lodged in Victor Zolkas/ Renard (Robert Carlyle)'s skull, though it will eventually terminate his life, also makes him temporarily immune to pain as it gradually makes its way through the cerebral tissue: 'You can't kill me; I'm already dead' (*The World Is Not Enough* 1999), he claims provocatively when Bond holds him at gunpoint. Paradoxically, the cause for his apparent invulnerability is also his Achilles' heel; the complete absence of sensory function means he is also incapable of experiencing any sensation, including sexual pleasure.

Some of these 'technobodies' hint to the cyborg bodies of the late twentieth-century. Donna Haraway's study of cyborgs celebrates the hybridity of the marriage between human and machine: 'late twentieth-century machines have made thoroughly ambiguous the difference between natural and artificial, mind and body, self-developing and externally designed' (Haraway 1991: 152). Despite their potential to embody a positive post-human identity, as Julie Clarke notes, the partially artificial bodies also speak of human preoccupations about the hybridity of prosthetic bodies:

> The cyborg body, as part human, part machine, exhibits both fragility and strength. The monstrous prosthetic attachments that characterize the cyborg are

often conflated with the rather benign prosthetic limbs allocated to amputees; and the presence of the prosthetic as a distinctly different material to the human body represents the loss not only of the body but also of the self, while simultaneously marking the site of the absent wound.

Clarke 2002: 36

In supporting the human body, prosthetic aids nevertheless draw attention to the different, and, potentially, 'incomplete' body of the wounded, the disabled, and the amputee.

Within the production context of the Bond books and early films, these problematic anxieties about incomplete bodies can be tied to preoccupations about the bodies of Second World War veterans. As the survival rate of injured soldiers increased enormously between the two World Wars (Gerber 2010: 2), so did the visibility of mutilated veterans: 'improved orthopaedic and plastic surgery techniques were available, but so were better weapons, and the amputation rate during the Second World War was 5.3% compared with 2% to 3% in the First World War' (Court-Brown et al. 2006: 482). Discussing depictions of the mutilated face on screen, as seen in *Phantom of the Opera* (Julian 1925), David Skal reminds us that 'wounded men in this condition, often patched together using primitive plastic surgery, would have been a common sight in the streets of Europe ... in the 1920s and 30s' (qtd. in Sabin 2008: 34). To understand the social impact of the larger visibility of disabled, and particularly amputated, bodies after both wars, it is useful to think of the prejudices attached to disabled bodies: 'disabled characters may evoke fear because they are made to be demonic', David Gerber notes, 'or because prejudice leads them to be misunderstood, or because disability itself makes us insecure about our own body integrity' (2010: 6–7).

The long history of prosthetic medicine shows that behind the ancient practice of replacing missing limbs with artificial devices was an important preoccupation about the wholeness of the body; early historical 'prostheses were developed for function, cosmetic appearance and a psycho-spiritual sense of wholeness', notes Alan Thurston, while 'amputation was often feared more than death in some cultures ... [as] it not only affected the amputee on earth, but also in the afterlife' (2007: 1114). Thus 'original' body parts might be 'buried, then disinterred and reburied at the time of the amputee's death so the amputee could be whole for eternal life' (2007: 1114). Indeed, even when actual prostheses had not been in use during a person's life, 'ancient Egyptian embalmers made every attempt to reinstate the completeness of the physical body before burial' (Finch 2011: 549). Prosthetics, therefore, speaks both of human vulnerability and strives

for divine omnipotence, leading Sigmund Freud to talk of modern 'man' as 'prosthetic God':

> Long ago [man] formed an ideal conception of omnipotence and omniscience which he embodied in his gods.... Today he has come very close to the attainment of this ideal, he has almost become a god himself.... Man has, as it were, become a kind of prosthetic God. When he puts on all his auxiliary organs he is truly magnificent; but those organs have not grown on to him and they still give him much trouble at times.
>
> Freud [1930] 1995: 91

In the pursuit of the ideal body, Freud would argue, civilization has in fact led to a problematic manipulation of nature through the aid of technology.

The rise in amputee rates after the Second World War brought these uncomfortable issues home, as the unresolved conflict between the technologically enhanced body and the natural (ideal) body overlapped in the body of the mutilated veterans furnished with prosthetic limbs. Referring to William Sheldon's dubious classification of human types according to their bodily characteristics, David Serlin rightly notes that 'by putting his body on the line ... a soldier could simultaneously represent the mesomorphic ideal *and* be disabled' (2006: 164). Debilitating injuries, then, positioned the formerly fit veteran body into the defective category, which, unsurprisingly, accentuated post-war anxieties about emasculation:

> Traditional war has upset the normal balance of gender expectations. Men, who are supposed to behave courageously and show toughness in war, have been potentially feminized to the extent they may find themselves unable to live up to these expectations. Women have come to take over responsibilities at home, in the workplace, and in society that have been vacated by men serving in the armed forces. When injured or ill, and ultimately disabled, the male veteran moved further on the road toward compromised masculinity.
>
> Gerber 2010: 9

Significantly, in *Trigger Mortis*, Horowitz draws attention to the tension between able/disabled bodies within the Service; here Duty Officer Henry Fraser is a wheelchair user after a spinal cord injury suffered on a professional assignment: 'The British Secret Service is not good at looking after its wounded officers and the first inclination of the top brass had been to pension him off, somewhere out of sight' (2015: 28). *Trigger Mortis* is set in 1957, the publication year of Fleming's *Dr No*, where, referring to the villain's prosthetic hands, Bond comments that 'many men wounded in the war wear [mechanical hands]' ([1958] 2004: 158). That in post-war years concerns with a disabled male body

were framed within wider changing gender politics is also manifest in the propaganda surrounding rehabilitation: 'popular images and narratives [of convalescing veterans] were directly influenced by the fiercely heterosexual culture of rehabilitation medicine, especially its orthodox zeal to preserve the masculine status of disabled veterans' (Serlin 2006: 170). Physical rehabilitation was therefore indissolubly tied to the notion of a restored, fully functional masculinity, regardless of whether the male reproductive system had been affected by the war injury.

Viewed against this problematic post-war discourse on disabled masculinity, physical imperfections and deficiencies – sometimes aided by technology – mark Bond villains' bodies as 'abnormal'. In *From Russia with Love*, it is the incongruence between Red Grant's excessive fitness and his opaque eyes and 'defensiveness in his voice' that remind Bond of the traumatized men of his generation: 'There's madness there all right, thought Bond, startled by the sight of it. Shell-shock perhaps, or schizophrenia. Poor chap, with that magnificent body. One day he would certainly crack' (Fleming [1957] 2004: 225). Significantly, the villains' physical abnormalities are always accompanied by troubled minds, and particularly sexual deviancy, ranging from aberration to apparent asexuality; Le Chiffre, Mr Big and Goldfinger all have excessive sexual appetites, whereas Blofeld has 'never been known to sleep with a member of either sex' (Fleming [1961] 2004: 48). At times, signs of their compromised sexualities are ambiguously inscribed in their bodies; Le Chiffre, for example, has a 'small, rather feminine mouth' (Fleming [1953] 2006: 17), where femininity is synonym for a sexualized body, whereas Scaramanga's 'third nipple' is rumoured to be a sign of sexual prowess. Scaramanga's supposedly enhanced sexuality, however, is undermined by the golden gun 'fetish' that gives him his nickname, as suggested by the amateurishly Freudian reading of his weaponry by 'a former Regius Professor of History at Oxford':

> The partiality of Scaramanga for a particularly showy variation of weapon, and his use of silver and gold bullets, clearly point, I think, to his being a slave to this fetish and, if I am right, I have doubts about his alleged sexual prowess, for the lack of which his gun fetish would be either a substitute or a compensation ... This man cannot whistle. Now it may only be a myth and it is certainly not medical science, but there is a popular theory that a man who cannot whistle has homosexual tendencies.
>
> Fleming [1965] 2012: 38–9

The preposterous blend of science and popular belief here undermines the expert diagnosis, as Scaramanga is deemed to be 'sexually abnormal', though it is

not clear whether this means that Scaramanga is impotent, gay, or both. The conflation of multiple non-normative sexual behaviours into one – as previously seen with regard to racial stereotypes – signals the prejudice against all non-heteronormative practices: a male body can only be normal if able/willing to engage in straight sex. Any variation of this normative formula constitutes a deviation, not only within the personal life of the individual, but also a challenge to the normative values of society.

Bond's damaged body

It would appear then, that the villain's grotesque, incomplete, deviant body is juxtaposed with Bond's ideal, intact, normative body. While Bond's physical strength is in line with the standards of fitness required by any action hero, the notion of Bond's invulnerability has been perpetuated in the earlier films where Bond hardly ever bleeds, even after heavy combat. In his last scene as Q, in *The World Is Not Enough*, actor Desmond Llewelyn tellingly reminds Bond of two important lessons:

> Q: I've always tried to teach you two things. First, never let them see you bleed.
> Bond: And the second?
> Q: Always have an escape plan.
>
> *The World Is Not Enough* 1999

In a film where, as already seen, the villain's inability to feel pain makes him simultaneously 'dead' and invulnerable, emphasis on Bond's own resilient and, most importantly, intact body, comes to the forefront.

Craig's heavily physical performance in *Casino Royale*, however, departs from that of his predecessors, and presents Bond as a vulnerable body, while in *Skyfall* Bond is both physically and emotionally damaged by age and trauma. In this sense, Craig's Bond returns the character to his literary origin; far from being invulnerable, Fleming's Bond is, in fact, damaged goods from the start. This is symbolized by the 'faintly piratical' vertical scar on his right cheek mentioned in *Casino Royale* ([1953] 2006: 59), at the end of which, Bond receives another, more significant, wound:

> There was the click of a knife opening. An arm in some grey material came into Bond's line of vision. A broad hairy hand from a dirty white shirt-cuff was holding a thin stiletto like a fountain-pen. It poised for a moment above

the back of Bond's right hand, immovably bound with flex to the arm of the chair. The point of the stiletto executed three quick straight slashes. A fourth slash crossed them where they ended, just short of the knuckles. Blood in the shape of an inverted 'M' welled out and slowly started to drip on the floor.

[1953] 2006: 145

Later, Bond explains to Mathis that the symbol indelibly marked on his skin is 'the Russian letter for SH', which stands for *shpion* – Russian for 'spy' ([1953] 2006: 157).

The account of Bond's scarification is absolutely central to understand Bond's damaged masculinity. That a decidedly sexually violent tone is conferred on the act is in tune with the targeted torture Bond has just endured at Le Chiffre's hand; sitting naked on a bottomless chair, his genitals have been battered with 'a three-foot-long carpet beater in twisted cane' ([1953] 2006: 131). The sexual sadist undertone is amplified in the film adaptation – which uses a suggestively tied rope in place of the carpet beater – to the point that the British censor deemed one of Le Chiffre's moves as 'too sexual' (Naughton 2015: 230). In the novel, having survived the ordeal, and unaware of Vesper's betrayal, Bond's main preoccupation is about sexual impotence: 'the certainty of impotence had been beaten into him and a scar had been left on his mind that could only be healed by experience' ([1953] 2006: 166). It is within this context that one of the most controversial passages of Fleming's fiction should be read, and, arguably, reassessed:

His feelings for her were confused and he was impatient with the confusion. They had been so simple. He had intended to sleep with her as soon as he could, because he desired her and also because, and he had to admit it to himself, he wanted coldly to put the repairs to his body to the final test . . . Somehow she had crept under his skin . . . He found her companionship easy and unexacting . . . She was thoughtful and full of consideration *without being slavish* and *without compromising her arrogant spirit*. And now he knew that she was profoundly, excitingly sensual, but that the conquest of her body, because of the central privacy in her, would each time have the *sweet tang of rape*.

[1953] 2006: 186

Fleming's infelicitous phrase – and alleged penchant for sadistic sexual practices in his personal life (see Lycett 1995: 86; Flood 2014) – has often led critics to read this problematic passage as evidence of his misogyny. Alex Adams, for example, claims:

Raping women is the truest form of consensual sex, for Fleming, as it expresses not only this original and undomesticated nature of desire but also the political 'truth' underlying gendered relations. This truth, for Fleming, is that men want to, can and should, dominate women, and that both men and women desire this and acknowledge the natural justice of it.

<div style="text-align: right;">Adams 2017: 151</div>

Adams rightly points out that although the notion that Bond is 'an organising principle for desirable, imitable heterosexuality ... is not ... as simplistic or binary as may be assumed' (2017: 141), nevertheless how rape can be reconciled with consensual sex remains unexplained. Moreover, in analysing the passage above, it is not clear how the lack of consent would be part of Bond's 'undomesticated desire', as that erroneously assumes that the oxymoronic 'domestication' of desire – as, presumably, practised in patriarchal societies – would always entail consent. Furthermore, the binary notion that 'men want to ... dominate women' clashes with a more nuanced articulation of Bond's sexual fantasy: 'she would surrender herself *avidly*, he thought, and *greedily enjoy* all the intimacies of the bed *without ever allowing herself to be possessed*' (Fleming [1953] 2006: 187; my emphases). While Bond's impossible conquest of Vesper's 'central privacy' foreshadows the truth about her duplicity, Bond's admission that Vesper has 'crept under his skin', also implies, metaphorically at least, a reverse penetration of female into male. What the scene emphasizes, therefore, is that the complex dynamics of human – rather than domesticated – sexual desire involve shifting patterns of mental and physical engagement, rather than binary male/ female, active/passive patterns of mechanical behaviour.

While Vesper's independence, and her desire to enjoy sex on her own terms, arguably underpins Bond's desire for her, there is another way of considering Bond's problematic sexuality. When reading this passage, it is often forgotten that Bond is still convalescing from the most brutal ordeal. The episode, therefore, should be read as a fantasy first sexual encounter by a man who is afraid of his own impotence, rather than boastful of his power to coerce women into sex. Moreover, the torture scene in *Casino Royale* is but one of a number of occasions where Bond's male attributes are under threat; from the centipede encroaching upon his groin in *Dr No*, to the chainsaw/laser beam simultaneously threatening penetration and castration in the *Goldfinger* novel/film, villains frequently target the site of Bond's virility.

Such assaults expose his vulnerability, but also, more broadly, undermine the foundations of phallic authority. Bennett and Woollacott suggest that 'the villain ... in striking at the very centre of Bond's being, threatens to de-centre him'

(1987: 136), and this is why Bond is typically distracted by the villain, who threatens his phallic authority, before possessing the girl. Significantly, when Bond 'has' other girls before his main confrontation with the villain, their deaths represent a form of punishment the villain inflicts, indirectly, on Bond. This is the case, for instance, in the films *Goldfinger* (Jill Masterson), *Live and Let Die* (Rosie Carver), *Tomorrow Never Dies* (Paris Carver), *Casino Royale* (Solange Dimitrios), *Skyfall* (Séverine), and *Quantum of Solace* (Strawberry Fields). In Boyd's novel, *Solo*, however, the punishment falls back on Bond, as villain Kobus Breed's attempted shot at his groin – 'Let's take the lover out of lover-boy' (Boyd 2013: 175) – makes a direct reference to Bond's sexual liaison with Blessing.

Indeed, in spite of his womanizing reputation, paradoxically, Bond's sexuality can be viewed as his Achilles' heel. As Toby Miller provocatively puts it: 'Bond's penis is a threat to him' (Miller 2003: 233). The systematic threats posed to Bond's sex point to the challenges posed to masculine authority through the growing evidence of male body commodification. As well as drawing attention to his threatened masculine authority, attention to Bond's virility can also, paradoxically, articulate the separation of the phallus – and the authority it symbolizes – from the anatomical penis. This is made evident in a self-referential scene in *Die Another Day* where Jinx (Halle Berry), held prisoner in Graves's lab, is about to be hit by a laser beam which, as in the *Goldfinger* scene, would cut her body in two. By replacing Bond's body with Jinx's, the laser beam ceases to be a distinctly gendered threat to masculine authority, therefore questioning the foundations of gender-based hierarchies.

Notwithstanding the fact that rape fantasy is problematic, especially if there is a sense in which this may be actualized, when looking at Bond's particular predicament in *Casino Royale*, it would be helpful to read this within the politics of post-war veteran rehabilitation. In an attempt to rebuild the confidence of injured soldiers, rehabilitation strategies undoubtedly reinforced conventional attitudes about masculine heteronormativity: 'in the First and Second World Wars, rebuilding the masculine sexuality of the wounded was underpinned by anxieties about impotence, marital fitness, depopulation and unemployment', notes Ana Carden-Coyne, while 'rebuilding muscles was a major focus of that sexualisation' (2012: 92). As Adams suggests, within this context, Bond's brutal treatment through torture exposes him as the heroic victim who eventually wins over the threats posed to his hegemonic masculinity by the non-normative forces of feminism, homosexuality, and Communism (Adams 2017). Nevertheless, underlying Bond's heroism is a profound uncertainty about the foundations of the normative system that Bond's mission is to save. Such

uncertainty is inscribed, from the start, on Bond's wounded body, immaculately clothed to conceal the trauma of damage. It is from this kind of anxiety about the impotent, mutilated, incomplete male bodies – a common sight in post-war Britain – that Bond's defective body and emasculated identity emerge. Stitched up, scarred, and emotionally bruised, Bond's debut in *Casino Royale* demonstrates that his body is only a *superficially* sanitized version of the vulnerable, damaged, imperfect bodies of the villains he fights.

'My body's a mass of scars and bruises': the suit as armour

Symbolic of Bond's broken condition after his traumatic experience in *Casino Royale* is the state of his clothes after the harrowing ordeal: 'nothing survived from his original wardrobe. Every stitch had been cut to ribbons' (Fleming [1953] 2006: 174). Similar attention to the effect of the fight on Bond's protective gear (and disguise) emerges in the original screenplay of *Dr No*, where, as 'Dr No is tearing and slashing with his claws ... Bond's suit and headpiece are now in tatters and fall away' (qtd. in Chapman 2000: 59).

The mutilation of Bond's wardrobe, in other words, is a material extension of the physical damage endured by his body. In *Die Another Day*, a dishevelled Bond, dressed in rags, checks in at the Royal Rubyeon Hong Kong Hotel after escaping MI6 security and eighteen months' captivity in North Korea. His physical rejuvenation is clearly marked by the recuperation of his wardrobe; brand-new shirts in shiny plastic wrappings appear in the foreground of his hotel room where the practice of male grooming – hair-cut, shaving – has restored him to his former impeccable self. While his body still certainly bears the signs of recent abuse, the new wardrobe creates the illusion of well-being, and, more specifically, the masculine toughness that Bond incarnates.

In the Bond narratives, clothes can perform the actual function of modern-day armour; indeed, Bond's attire always accommodates concealed weapons, in both novels and films. In Fleming's *Live and Let Die*, as he puts on his Moccasin casuals, Bond feels 'better equipped to face the evening', because 'under the leather, the toecaps were lined with steel' ([1954] 2004: 36). In *Dr No*, Major Boothroyd advises Bond that his new Walther PPK gun is 'best worn inside the trouser band' (Fleming [1958] 2004: 20). In *Goldfinger*, the heels of his shoes conceal a 'broad double-sided knife' (Fleming [1959] 2004: 180). In the film *On Her Majesty's Secret Service*, Bond rips his trouser pockets and uses them as

protective gloves to hold on to a slippery steel cable; he deploys the same trick in *A View to a Kill* (Glen 1985). In *Licence to Kill* (Glen 1989), a set of abseiling ropes concealed inside his tuxedo cummerbund enables Bond (Timothy Dalton) to place an explosive device on the window of villain Franz Sanchez's hotel room. Weaponry is also embedded in the sartorial portrayal of villains and other characters. In *The Man with the Golden Gun* (Hamilton 1974), the villain ritualistically assembles his golden weapon out of seemingly innocuous gentleman's accessories: cufflinks, cigarette case and lighter. In Horowitz's *Trigger Mortis*, while admiring Sin-Jai-Seong's 'beautifully tailored Brioni Roman dinner jacket', 'the telltale outline of a hard leather shoulder holster', remind us that Bond 'had always preferred chamois which, though less practical when it came to the draw, had one main advantage: it didn't spoil the line of his jacket' (2015: 103).

As seen earlier in this chapter, masculine clothing, and, particularly, the New-Edwardian suit played an important role in the post-war context out of which Fleming's Bond was born. On one hand, the apparently conservative revival of the suit and, more generally, the dandified gentleman, fulfilled the desire to belong in a class of distinguished masculinity such as would befit discontented (upper-class) veterans; on the other, the replacement of the military uniform with the civilian suit, in more general terms, also spoke of a kind of cultural continuity that would be of reassurance to the troubled masculine psyche of the 1950s: 'Well-bred, comfortable and timeless, by the mid-1950s the Englishman's suit had come to signify the reserved stoicism of a nation whose imperial glories lay far into its past' (Breward, 175). Significantly, a connection between men's clothing and morale – both personal and national – had already been central to the Men's Dress Reform Movement in inter-war Britain, although the reformers had failed to spread the popularity of their loose-fitting garments to 'regenerate British men' (Bourke 1996: 27). The return of the traditional suit, therefore, provided the fantasy of a coherent, unchanged and unchangeable identity. This was exemplified by the practice of unaltered clothes worn by amputees; while empty sleeves and trouser-legs were spectral reminders of recent trauma, they would, like the cosmetic adjustments applied by embalmers to mutilated bodies before burial, provide the illusion of physical – and mental – wholeness.

What the suit provided, in a way, was a new kind of *armour*, an apparently secure boundary between a body that inevitably concealed traces of physical and emotional trauma, and a changing social order. In her intriguing study of the history and cultural significance of the suit, Hollander contends that the invention of medieval plate armour, offered a new kind of body image, which

would prove influential to the development of modern fashion and the differentiation between men's and women's clothing in the West:

> The dynamic formal ingenuity of medieval plate armour suggests that it was designed to enhance the articulated beauty of complete male bodies very creatively, in the modern way, with an invented abstract imagery of multifaceted brilliance and unearthly-looking strength.
>
> Hollander 1994: 42

Similarly, it has also been noted that the kind of clothing worn by knights under their armour evolved to facilitate physical movement (McNeil and Karaminas 2009b: 3); the gradual appearance of garments that would display all body parts, and particularly the lower part of the body, previously enshrouded in the genderless robes of medieval dress, produced a dual effect. On one hand, it projected a body image that paid closer attention to the real shape of the body. On the other, however, it gave the impression of coherence, unifying the body's disparate parts into a *uniform* – and apparently seamless – garment (Hollander 1994: 5).

The suit, therefore, reveals two contradictory purposes of dress, which can function as 'framing device' and 'cohesive structure' (Warwick and Cavallaro 1998: 60). As a framing garment, a suit creates the illusion of a boundary, outlining the body's contours, while marking the body as a self-contained entity. As with other, more obviously tight-fitting garments, however, the suit's illusion of 'impenetrability' also reveals – just like plate armour would – the wearer's physical anatomy more visibly than looser-fitting garments: 'blatantly framing styles affectively connect our bodies', argue Warwick and Cavallaro, 'even as they appear to divide them from one another' (1998: 60).

But Bond's clothing, and particularly his suit, can also be read as the 'cohesive structure' that barely separates his ideal body from the aberrant bodies of the villains. While sometimes marked by foreign variations, the villains' attire also blurs the English/foreign, normative/unconventional boundaries that would, according to previous criticism, place Bond in binary opposition to the villains. The traditional suit may remain Bond's trademark, as it serves the purpose of perpetuating the fantasy of unchangeable, impeccable, English masculinity that Bond is constructed to perform; an evident proof is the formulaic visuals of publicity materials featuring Bond inevitably dressed in a dinner jacket. Underlying the suit's veneer of tailored coherence, however, is the stitched-up scar tissue of wounded masculinity.

The fragile liminality of the boundary that clothing represents is particularly evident in Craig's *Spectre* Tom Ford suits. What the tight-fitting suits convey is

the notion of the suit as armour, which, while protecting the body and marking its presence with an apparently impenetrable frame, nevertheless also point to Bond's concealed anatomy and vulnerability: 'my body's a mass of scars and bruises', a body-conscious Bond tells Vesper towards the end of *Casino Royale* (Fleming [1953] 2006: 168). But, like many wounded soldiers, Bond is good at putting on a brave face (and good clothes); heartbroken again, after Gala Brand's engagement to another man at the end of *Moonraker*, he admits: 'he must play the role which she expected of him. The tough man of the world. The Secret Agent. The man who was only a silhouette' (Fleming [1955] 2004: 246).

2

'Dark Continents':
Fashion, Foreignness and Femininity

James Bond is sexist. James Bond is racist. The backward race and gender politics of James Bond, and his world, frequently pop up in popular culture debates alongside claims that the next Bond's actor should be black, female, or even black and female (Chapman and Cobb 2016; Hyde 2016; Malkin 2016; Salmon 2017; Desta 2018). Indeed, the Bond novels and film franchise can present dubious race and gender politics; among others, female characters such as the atrociously named Chew Mee (Françoise Terry) in Hamilton's *The Man with the Golden Gun*, and Kissy Suzuki in the film *You Only Live Twice* (Gilbert 1967), reinforce the stereotypical submissiveness of Asian women.

There is, however, another way to look at the challenges that foreign women pose to Bond and the conservative values he represents. For instance, while Peaceful Fountains of Desire (Rachel Grant), who plays a minor role in *Die Another Day*, masquerades as a 'treat' for Bond, she, in fact, works for Chinese intelligence. Her far from peaceful intentions are symbolized by the gun she carries in her garter, under her traditional *cheongsam*. She may not get to use the gun, but this clearly wrecks Bond's expectation of what her body is for. In fact, her concealed gun is a powerful reminder of the threat she poses to Bond's masculine authority.

Like Bond villains, the majority of Bond Girls are foreign. Eco sees the binary opposition between the Bond Girl's foreignness and Bond's Anglo-Saxon identity as crucial to understand Bond's quest:

> She would appear likely to resolve the contrast between the privileged race and the non-Anglo Saxon half-breed, since she often belongs to an ethnically inferior breed; but insofar as the erotic relationship ends with a form of death, real or symbolic, Bond resumes willy-nilly his purity as an Anglo Saxon bachelor. The race remains uncontaminated.
>
> 1979: 154

Placed in antagonistic opposition to Bond's Englishness, the Bond Girl's 'foreignness' certainly disturbs colonial hierarchy and pollute racial purity through contamination with her 'half-breed'. This is also interlinked with her broken-down lineage. In the film *Casino Royale* (2006), Vesper is, like Bond, an orphan. In Fleming's *Dr No*, after her parents' death, Honeychile is raised by her black Nanny; in the film, she is raised by her father. Also motherless is Teresa (Tracy) di Vincenzo in *On Her Majesty's Secret Service*. In *Diamonds Are Forever*, behind Tiffany's name is a tragic story of parental neglect: 'dear father Case was so sore I wasn't a boy he gave my mother a thousand bucks and a powder case from Tiffany's and walked out' (Fleming [1956] 2004: 193). In *Thunderball*, after her parents 'were both killed in a train crash' (Fleming [1961] 2004: 120), Domino Vitali becomes Emilio Largo's (abused) lover. Bond Girls' non-linear backgrounds invite a reading of their identities at odds with a patriarchal/colonial system.

In fact, race and ethnicity are never simple categories within the Bond narratives. Both the problematic whiteness of English Bond Girls, and the constructed 'exoticism' of Solitaire (Jane Seymour) in Fleming's *Live and Let Die* and film raise questions about the hierarchical structure of the Empire. On the other hand, when looking at ethnic minorities, the physical and sartorial performances of characters such as May Day (Grace Jones, *A View to a Kill*), Rosie Carver (Gloria Hendry, *Live and Let Die*), Séverine (*Skyfall*) and Kissy Suzuki (Mie Hama, *You Only Live Twice*) simultaneously expose and undermine master/slave colonial hierarchies. Similarly, the Soviet/Western fashion opposition in *From Russia with Love* (novel and film) serves to reveal female agency through Tania's resistance to both Bond's and Soviet control.

Femininity, foreignness and fashion

As foreign correspondent for the *Sunday Times*, Fleming travelled around the world in 1959–60 to 'report' back from the globe's 'thrilling cities'. In the 'Author's Note' that accompanied the book of collected articles, Fleming drew a comparison between the excitement of foreign travel and the writing of thrillers:

> All my life I have been interested in adventure and, abroad, I have enjoyed the frisson of leaving the wide, well-lit streets and venturing up back alleys in search of the hidden, authentic pulse of towns. It was perhaps this habit that turned me into a writer of thrillers and, by the time I made the two journeys that produced

these essays, I had certainly got into the way of looking at people and places and things through a thriller-writer's eye.

<div align="right">Fleming [1963] 2013: ix</div>

Drawing attention to the significance of the traveller's gaze and 'frisson' produced by the encounter with the alleged authenticity of off-the-beaten-track tourist destinations, Fleming's perspective is a good introduction to the triangulation of femininity, fashion, and foreignness in the Bond narratives. Writing on Macao, for instance, Fleming is all too aware of the appeal of Eastern women to Western men:

> This was my first experience of Oriental Woman, and this, and my subsequent investigations, confirmed the one great advantage she possesses for Western Man. Oriental ladies have an almost inexhaustible desire to please. They also have the capacity to make the man not only suspect, but actually believe, that he is in every respect a far more splendid fellow than in his wildest dreams he had imagined. Not only that, but the women of the East appear, and in fact actually are, grateful for one's modest favours, with the result that every meeting with them leaves one in good humour and with a better opinion of oneself.
>
> <div align="right">Fleming [1963] 2013: 35–6</div>

Although the idea that 'the women of the East ... are grateful for one's modest favours' reeks with colonial condescendence, Fleming also draws attention to the fact that Western superiority is the joint construct of 'Western Man''s fantasy and the 'Oriental Woman''s (self-conscious) performance of her colonized role. As in the Bond novels, the passage, nevertheless, juxtaposes feminine/exotic with masculine/Western categories, though the notion of Bond's 'pure' or 'clear' national identity does not hold foundations as strong as his performance of Englishness pretends to do.

Questions about the boundaries of national and ethnic identity do come to the fore when the villains' foreignness threatens to 'contaminate' Bond in a variety of ways. The same applies to Bond Girls' foreign femininity. Largely conveyed by way of body/dress references, Bond Girls' exoticism prompts a reading of ethnic/racial/foreign difference – and appeal – in terms of cultural performance. This is channelled through the colonial gaze of Fleming's *Thrilling Cities*, as displayed in his fascination with Hong Kong girls:

> The girls, thanks to the cheong sam [sic] they wear, have a deft and coltish prettiness which sends Western women into paroxysms of envy. The high, rather stiff collar of the cheong sam [sic] gives authority and poise to the head and

shoulders, and the flirtatious slits from the hem of the dress upwards, as high as the beauty of the leg will allow, demonstrate that the sex appeal of the inside of a woman's knee has apparently never occurred to Dior or Balmain.

[1963] 2013: 13–14

At the time of Fleming's visit to Hong Kong, the *cheongsam*, the fitted garment worn throughout urban China in the first half of the twentieth century, was no longer in use after the establishment of the People's Republic in 1949. Afterwards, it continued to be worn by women in the Chinese communities of Hong Kong, Singapore and Taiwan (Steele and Major 1999); as well as documenting this, the film adaptation of Richard Mason's 1958 novel *The World of Suzie Wong* (Quine 1960) was also responsible for making the garment popular in the West.[1] Significantly, in Fleming's view, the erotic appeal of Hong Kong girls is by way of comparison to 1950s Western fashion characterized by a return to longer hems and, consequently, reduced leg display. While Fleming continues his fashion observations to claim that 'even the men, in their spotless white shirts and dark trousers, seem to have better, fitter figures than we in the West' ([1963] 2013: 14), the female body is unmistakeably charged with sexual undertones, though the notion of the 'Oriental Woman''s submissiveness – noted by Fleming when visiting Macao – is, at the same time, diffused by the sartorial detail of the *cheongsam*, where 'high, rather stiff collar … gives authority and poise to the head and shoulders'.

Exoticism, it would appear, enhances the semantic ambiguity of clothing, as foreignness, femininity, and fashion form a critical triangle of reciprocal influences and implications. The cultural reference to the *cheongsam* in *Thrilling Cities* has parallels with Fleming's treatment of Chinese dress in *Dr No* already discussed in the previous chapter. When Honeychile and Bond are captive in Dr No's lair, they have no choice but to wear the clothes they are supplied with. The Chinese dress that Honeychile claims 'felt strange' (Fleming [1957] 2004: 142), is a likely reference to the *cheongsam*; a version of which Honey wears in the film.

An apparent symbol of quintessential Chinese femininity, the complex genealogy of the *cheongsam* undermines, in fact, the East/West divide. Derived from the fusion of both Manchu and Chinese/Han elements, '*cheongsam* … means "long gown", and indeed, in its early form, the garment resembled a Chinese man's long robe' (Steele and Major 1999: 48). The garment is also known as *qipao*, or 'banner gown', a term used to define 'the new style of dress because it somewhat resembled the robe worn by Manchu women, "the women of the

banners"' (Steele and Major 1999: 48; see also Garrett 2007: 147), which reflects a reference to the Manchu military banner organization.

But as well as the 'internal' influences, which contributed to create the sense of a cohesive, and continued Chinese identity, Western fashion also affected the evolution of the *cheongsam*, which became shorter in the 1920s, then more fitted in the 1930s, with longer hems and, occasionally, high side slits that 'accentuated a woman's sexuality, emphasized by legs clad in silk stockings (a recent innovation) and high heels' (Garrett 2007: 147). Featuring elements adopted from traditional Chinese/Manchu dress – knotted buttons and loops/frogs – but also stylized with Western accessories – high-heel shoes and silk stockings – the *cheongsam* epitomizes the multi-layered fabric of 'ethnic' dress and the permeable boundaries of East/West fashions.

Synonymous with the rise of the Chinese middle class, it came to represent 'the female face of a progressive China' (Finnane 1996: 111), and, in spite of its partial disappearance after Mao Zedung's Revolution and the establishment of the People's Republic of China in 1949 (Mei 2010: 140–1; Wu 2009: 4, 111), the *cheongsam* continued to exist, paradoxically, as a representative expression of Chinese femininity on official, and especially, overseas missions.[2] Given the popularity of the *cheongsam* beyond the political boundaries of China, to return to Fleming's *Dr No*, Honeychile's discomfort with the 'Chinese dress' may appear out of place. As Bond astutely notes, what troubles Honeychile, in fact, is not the foreignness of the specific garb as much as the overall strangeness of clothing itself: 'her fear had been drowned in the basic predicament of clothes and how to behave' (Fleming [1957] 2004: 140). In her apparent display of prejudice against the novelty of the Chinese dress, Honeychile's unease, in fact, points to the masquerading function that clothing, *per se*, performs, in subjecting the body to a (temporary) change of appearance.

Orientalist trends in Western fashion allow us to make broader considerations about its ambivalent relationship with foreign sartorial traditions. Although, as Charlotte Jirousek has noted, '*Japonisme* and *chinoiserie* dominated fashion and design during the first quarter of the century' (2004: 249), other theorists make a sharper distinction between fashion and ethnic dress. 'Fashionable dress', Hollander argues, has a different remit, and cultural trajectory, from 'traditional dress', which she identifies as 'non fashion':

> [Traditional dress] creates its visual projections primarily to illustrate the
> confirmation of established custom, and to embody the desire for stable meaning
> even if custom changes – it is normative … But even with considerable change

in the look of traditional clothing over time, the formal relation of new to old is direct, a straightforward adaptation, never a detached commentary of the new upon the old, or a subversive attempt to undermine it.

1994: 17

On one level, ethnic dress exists separately from the market-led mechanics of production that underlie Western fashion: 'Folk dress is sometimes called non-Western dress', Linda Welters observes, 'because it develops outside the realm of the Western European fashion system' (1999: 3). Yet, as Craik suggests, 'rather than being mutually exclusive, western and indigenous clothing systems are dynamic, changing and in competition for cultural allegiances' ([1993] 1994: 36). Indeed, if the evolution of Chinese dress was in many ways interwoven with the country's trading practices with the West, the reverse has also, of course, always been true: 'the Orient has been a source of inspiration for fashion designers since the seventeenth century', explains Patricia Mears, 'when goods of India, China, and Turkey were first widely seen in Western Europe' (2010: 546). By the end of the eighteenth century, the common practice of textile layering in Ottoman fashion gave rise to '[t]he lifted draped overskirt', known as '*Robe à la Turque*' (Jirousek 2004: 249; see also Mears 2010: 546).[3] By the early twentieth century European designers such as Paul Poiret and Jeanne Paquin were distinctly influenced by the Oriental charm of the *Ballets Russes* (see Jirousek 2004: 249; Fukai 2005: 49), which, after the Bolshevik Revolution of 1917, came to Paris, 'where its sumptuous productions featuring Eastern themes electrified French designers and artists' (Jirousek 2004: 249–50). Meanwhile, the Japanese kimono inspired new ways of thinking about the body against the Western model of the fitted silhouette (Fukai 2005: 55). At the end of the twentieth century, and into the new millennium, ethnic styles have seeped into Western fashion, with designers as diverse as John Galliano, Christian Lacroix and Kenzo taking up influences from Africa to Native America, 'creating colourful, syncretic styles evocative of the past or faraway lands' (Mears 2010: 263). Such fusion of ethnic styles is particularly visible, as seen in more detail later, in the sartorial hybridity of Solitaire in the film *Live and Let Die*, but also in Tania Romanova's trajectory from Soviet to Western fashion central to *From Russia with Love*, but novel and film.

As Western fashion attempts to grapple with globalization beyond its exploitative modes of production, it would seem that behind the appetite for ethnic styles lies the old/new fascination with exoticism; as summarized in the words of Dries van Noten for the 1998 exhibition *Touches d'Exotisme, xive–xxe Siècles*:

For me, exoticism is the elsewhere, the other, the difference. It is generally associated with distant countries. But for me, it is rather everything that reroutes us from the ordinary ... from our habits, our certainties and from the everyday to plunge us into a world that is amazing, hospitable and warm.

<div align="right">qtd. in Mears 2010, 264</div>

Viewed in these terms, 'exoticism' moves beyond the colonial trappings and problematic reliance on stereotypes applied to other cultures, to positively embrace a different way of thinking about all that is unfamiliar.

Van Noten's words echo Russian Formalist Victor Shklovsky who, in the first quarter of the twentieth century, praised art for its ability to rekindle human sensations 'anaesthetized' by the routine of modern life: 'habitualization devours works, clothes, furniture, one's wife, and the fear of war', he lamented, 'and art exists that one may recover the sensation of life'. But art's ability 'to make objects "unfamiliar"' ([1917] 1997: 4), he would argue, enables spectators to see ordinary things differently, as if for the first time. Although Shklovsky does not reference fashion directly as a form of art, the principle of defamiliarization is a prominent drive in sartorial practice.

The unfamiliar plays an ambivalent function in fashion. By making the body 'strange' to our eyes, dress allows us to see ourselves differently, fulfilling the temporary fantasy that we are other than ourselves; defamiliarization consequently regulates fashion as a market-led mode of production relying on the perpetual reinvention of its own conventions, patterns and rules. All that is strange, 'Other', and exotic, which stands on the margins of the known and the acceptable, can and does contribute to the cyclical trajectory of changing fashions. As sociologist Georg Simmel suggested, 'the element of demarcation constitutes an important factor of fashion' ([1904] 1957: 545); the introduction of foreign elements in fashion therefore authorizes exclusivity. Paradoxically, the deliberate incorporation of the marginal – or, indeed, that which is beyond the margins – consolidates the cohesiveness of the fashionable elite.

Yet, anxieties about foreignness also emerge in times of crisis. The temporary disappearance, for instance, of Eastern influences from 1940s–1950s Western fashion implied a suspicion of the East during and after the Second World War; the Sinophobia of *Dr No*, for instance, is as clear an example of the 'Yellow Peril' that affected Western perceptions of China. Significantly, this was accompanied by the controversial return of the ultra-feminine styles of Christian Dior's 'New Look' launched in Paris in 1947, provoking criticism from austerity fashion supporters in Britain (Partington 1992), feminist campaigners in America (Palmer 2009: 27),

and the promoters of Soviet fashion in Russia (Bartlett 2004: 136). The simultaneous abandonment of both the foreign and androgynous influences of the previous decades to reposition femininity within the familiar silhouette of Western fashion pointed to the two-pronged anxiety – xenophobia and misogyny – that characterized the post-war period from which Bond emerges. In other words, the fact that the kind of feminine dress that strayed from conventional Western styles ceased to be fashionable points to a reading of subversive femininity as foreign and, potentially, dangerous, unless its inherent difference can be contained and, therefore, controlled; these power struggles are inscribed in the roles of ethnic-minority Bond Girls such as Séverine and May Day, whose ambivalent enslavement to the villains – and subservience to Bond – also reveals symptoms of colonial resistance.

In 'The Question of Lay Analysis' (1926), Freud uses a geographical metaphor in the defensive admission about the inadequate psychoanalytical understandings of female sexuality: 'we know less about the sexual life of little girls than of boys. But we need not feel ashamed of this distinction; after all, the sexual life of adult women is a "dark continent" for psychology' ([1926] 1995: 212). The 'dark continent' metaphor, significantly, merges race and gender into the unknown Other, located at the periphery of Western knowledge and belief-system. In 'The Laugh of the Medusa' (1976) French Algerian feminist thinker Hélène Cixous references Freud to expose the conflation of racial and gender discourse in patriarchal ideology: 'as soon as they [women] begin to speak, at the same time as they're taught their name, they can be taught that their territory is black: because you are Africa, you are black. Your continent is dark. Dark is dangerous' (1976: 878). The phrase 'dark continent', left in English in Freud's original German text, is a reference to Henry Morton Stanley's *Through the Dark Continent* (1878), where the Welsh explorer wrote about his attempt to trace the course of the Congo River. This suggests that, rather than merely geographical, the 'dark continent' contains geopolitical and cultural connotations, implicating the notion of the feminine Other within the broader context of colonialism and, more specifically, the British Empire. The metaphor remains, nevertheless, significantly elusive, suggesting that 'the "dark continent" . . . is indefinable, and it is primitive, but it allows its explorers a heroic narrative of discovery and a feminization of the land', argues Ranjana Khanna (2003: 52). Indeed, the dualisms of colonial ideology – white/black, master/slave, colonizer/subject – which supported the Empire, overlapped with the binary structure of gender hierarchy in the construction of British/European colonizers 'as masculine, while the colonized were cast as sensual, childlike and irresponsible, and hence were

feminized' (Woollacott 2006: 4; see also Levine 2007a: 7). Needless to say, although male colonized and female colonizers might share certain similarities, their status would remain very different, as shown by the social connotations of interracial sex offences, and overt anxieties about miscegenation (see Levine 2007b). Within this colonial context, then, the colonized woman suffered the double bind of colonialism and patriarchy, which would place her at the bottom of the social ladder under male colonizer, female colonizer, and colonized man. It is therefore important, in this analysis, to take into account the intersectionality of identity, that is, to consider simultaneously multiple ideological frameworks, as these are reflected in the composite identity of the foreign/non-white Bond Girl (see Wagner 2015: 52).

Black and white vision

Although it may have entered the Second World War as a colonial power, Britain 'emerged, severely shaken, six years later, confronted by its decreasing status in the world and the almost immediate dissolution of the Empire' (Berberich 2012: 13). There is no doubt that the legacy of colonial ideology permeates Fleming's works and many of the Bond films, and that race and ethnicity serve to convey the novels' unsettled postcolonial subtext. In *Dr No*, for instance, Colonial Secretary Pleydell-Smith gives Bond a lesson on the multiracial structure of Jamaica: 'The Jamaican is a kindly lazy man ... the Portuguese Jews ... spend too much of their fortunes on building fine houses and giving dances ... the Syrians, very rich ... but not such good businessmen'. He then continues to describe the most dangerously influential ethnic group of Jamaica:

> Finally, there are the Chinese, solid, compact, discreet – the most powerful clique in Jamaica.... They keep to themselves and keep their strain pure ... Not that they don't take the black girls when they want them. You can see the result all over Kingston – Chigroes – Chinese Negroes and Negresses. The Chigroes are a tough, forgotten race. They look down on the Negroes and the Chinese look down on them.
>
> [1957] 2004: 57–8

The loss of racial purity seems less of a concern when applied to the fusion of Chinese and black blood, but the racial hybridity of Chigroes – and the implicit miscegenation threat they embody – heightens their menace to white colonizers. The killing of a British Secret Service secretary, 'the significantly named and

sexually attractive Mary Trueblood' (Parker 2014: 232), therefore, resonates with the racial dualism that underpins the novel's colonial discourse:

> A man stood in the doorway ... It was *a big Negro with yellowish skin and slanting eyes*. There was a gun in his hand. It ended in a thick black cylinder.
> Mary Trueblood opened her mouth to scream.
>
> The man smiled broadly. Slowly, lovingly, he lifted the gun and shot her three times in and around the left breast.
>
> Fleming [1957] 2004: 8–9; my emphasis

The sexual connotation of the murder points to the symbolic rape of the white woman by the racially hybrid Chigro, 'an expression that seems to be the invention of Fleming' (Parker 2014: 234), but was in fact a suggestion by his Jonathan Cape editor, William Plomer, in a letter sent to Fleming on 18 June 1957: 'Isn't there some local slang word for a cross between a Chinese & a Negro? Or why not invent one? ... some word like *dago* or *mestizo* – *chigro*' (Fleming 2015: 175). As the racial impurity of the Chigro is emphatically captured in the compound word that defines his mixed race, his violation of the white body becomes an even more serious act of subversion against the colonizers' prior invasion – and exploitation – of colonial land and people.

Indeed, the violence against a white female body by a black Chinese man disturbs the colonial/racial ideological structure of Fleming's novels where foreign female bodies are sexually active and available, but British/white women are presented as virginal or unobtainable. In *Moonraker*, for instance, Bond muses over Loelia Ponsonby's unconquerable body: 'unless she married soon, ... or had a lover, her cool air of authority might easily become spinsterish and she would join the army of women who had married a career' ([1955] 2004: 6). Loelia's sexual unavailability is perceived in terms of 'cool motherliness', pampering the male agents 'with small attentions and kindnesses to show that it was really her fault and that she forgave them'. Simultaneously, however, her asexualness is defined as 'frigidity', even if this is just 'to salve their egos' (Fleming [1955] 2004: 6), while dress style endorses her undisputed Englishness; the privileged Principal Secretaries are collectively known as '"The Pearls and Twin-set" ... with ironical reference to their supposedly "County" and "Kensington" backgrounds' (Fleming [1955] 2004: 7).

In the same novel, the sobriety of Hugo Drax's secretary, Gala Brand, reveals an association between Englishness and authoritativeness, which also translates into Bond's inability to conquer the female British body:

There was authority in the definite line of the profile, but the long black eyelashes over the dark blue eyes and the rather wide mouth might have been painted by Marie Laurencin. Yet the lips were too full for a Laurencin and the dark brown hair that curved inwards at the base of her neck was of a *different fashion*. There was a hint of *northern blood* in the high cheekbones and in the very slight upward slant of the eyes, but the warmth of her skin was *entirely English*.

[1955] 2004: 105; my emphases

Although Gala's skin is significantly 'entirely English', her association with the artwork of French painter Marie Laurencin, whose work self-consciously addresses the representation of femininity, makes her at once foreign and queer, as Laurencin was (Khan 2003). As *Moonraker* is particularly concerned with Bond's problematic national identity, it is significant to see how Gala's authoritative demeanour serves to demonstrate the inexpugnability of her English body, and, by extension, Britain, in spite of her 'foreign' semblance. That Gala's Englishness is linked to her unavailability emerges from her sartorial performance, which is suggestive of the sober elegance of British austerity fashion; from the 'cheerless jacket of her policewoman's uniform' to the 'rather severe evening dress' she wears out ([1955] 2004: 97, 105–6), Gala's uncompromising resistance to Bond's sexual interest speaks of her loyalty to Britain. Significantly, the only time Bond catches a glimmer of hope is signalled by Gala's temporary change of clothes (Fig. 3):

The *exotic* gaiety of her clothes, a black and white striped cotton shirt tucked into a wide hand-stitched black leather belt above a medium length skirt in shocking pink, seemed to have *infected* her and it was impossible for Bond to recognise the chilling woman of the night before who now walked beside him and laughed happily at his ignorance of the names of the *wildflowers*.

[1955] 2004: 144; my emphases[4]

The replacement of her professional uniform with fashionable leisure wear in bright colours is simultaneously defined in terms of 'exoticism' and 'infection'. This suggests that, in order to be conquered, the female British body must engage in colonial masquerade, but also reinforces the correlation between 'foreignness' and the threat of infection. The openness of the countryside setting – 'as far as the eye could reach the eastern approaches of England were dotted with traffic plying towards near or distant horizons, towards a home port, or towards the other side of the world' ([1955] 2004: 144) – becomes the liminal space temporarily occupied by Bond and Gala. It is only in this borderline territory, that Gala's body can become temporarily, and only as a fantasy, available, because made Other.

Figure 3 Page from Ian Fleming's MS 'The Moonraker' (Courtesy of Lilly Library, Indiana University, Bloomington, Indiana)

In a similar fashion, Bond can only kiss Mary Goodnight while they are both engaged in a foreign mission in Jamaica in *The Man with the Golden Gun*:

> She hadn't changed. Still only the faintest trace of make-up, but now the face was golden with sunburn from which the wide-apart blue eyes, now ablaze with the moon, shone out with the challenging directness that had disconcerted him when they had argued over some office problem.... But *now the clothes were different*. Instead of the severe shirt and skirt of the days at Headquarters, she was wearing a single string of pearls and a one-piece short-skirted frock in the colour of a pink gin with a lot of bitters in it – the orangey-pink of the inside of a conch shell.
>
> <div align="right">Fleming [1965] 2012: 53; my emphasis</div>

Bond's admission that 'now the clothes were different' draws attention to the implicit exoticism that makes the sexual encounter with an Englishwoman possible for him. The short, bright-coloured dress, suggestively reminiscent of the 'inside of a conch shell', is, as Mary reveals, 'standard uniform for a tropical station' (Fleming [1965] 2012: 53), but this is enough to make her 'different'. Yet, at the end of the novel, Bond cannot help but note that 'despite the Jamaican heat, she was looking fresh as a rose' (Fleming [1965] 2012: 205), a simile loaded with political significance, and a reminder that Mary remains, after all, an 'English rose'. In the film, Bond tells Mary Goodnight (Britt Ekland) that he approves her frock because it is 'tight in all the right places' and has 'not too many buttons' (*The Man with the Golden Gun* 1974). The dress has a homing device in one of the back buttons, however, and this reinforces her in-between position, with one foot in the foreign South-East Asian locale and the other in the British homeland.

A more complicated situation occurs with Miss Moneypenny, the bastion of white Englishness in the novels and films until *Skyfall*, when black British actor Naomie Harris takes over the role. In Fleming's *Live and Let Die*, Moneypenny is introduced as 'the desirable Miss Moneypenny, M's all-powerful private secretary' ([1954] 2004: 12). As Bennett and Woollacott suggest, 'Miss Moneypenny ... functions as an object of desire, chiefly because she basks in the power that radiates from M ... but, since she belongs to M, she is placed under an interdiction (Bond's playful flirtation with her is destined to remain forever playful)' (1987: 129–30). While the level of flirtation persists throughout the films precisely because the relationship is never consummated, in *GoldenEye*, Moneypenny (Samantha Bond) puts Bond back in his place:

> Bond: I've never seen you after hours, Moneypenny. Lovely.
> Moneypenny: Thank you, James.

Bond: Out on some kind of professional assignment? Dressing to kill?

Moneypenny: I know you will find this crushing, 007, but I don't sit at home every night praying for some international incident so I can run down here all dressed up to impress James Bond. I was on a date, if you must know, with a gentleman. We went to the theatre together.

Bond: Moneypenny, I'm devastated. What will I ever do without you?

Moneypenny: As far as I can remember, James, you've never had me.

GoldenEye 1995

On this occasion, elegantly clad in a black lace dress, Moneypenny nevertheless remains as chaste as her long sleeves and her carefully done-up hair suggest. She remains, in other words, a wittily flirtatious – albeit untouched – English rose.

Skyfall functions as a Moneypenny reboot through the casting of Harris for the role, and distinctive change of style; as *Vogue* commented, 'Moneypenny's staid motif of pussy-bow blouses and secretary chic ... has been upended entirely via Harris's modern portrayal' (Carlos 2015). Indeed, Moneypenny's office and evening wear offer a clear departure from her white predecessors, as bright colours replace the more muted tones mostly associated with previous actors Lois Maxwell (1962–85) and Caroline Bliss (1987–89), and the monochromes of Samantha Bond (1995–2002). While the choice of bold colours was, as costume designer Jany Temime confirmed, dictated both by ethnicity as much as character, her costumes are also firmly rooted in Western/British *haute couture* down to her Jimmy Choo and Louboutin footwear (Press 2012), and the Amanda Wakeley peridot gown of the casino scene.

In comparison to her predecessors, the new Moneypenny projects a much more sensual look, with dresses enhancing her feminine silhouette. Indeed, Moneypenny's sexual attractiveness – and potential availability – is further conveyed in the *Skyfall* hotel room scene, where she gives Bond a 'close shave' wearing an orange belted outfit, which, again, highlights the contours of her body, as well as her skin tone. It could be argued that in the scene 'Moneypenny helps Bond return to his suave, "cool" self, internalizing her own colonization in the face of Bond's privileged body' (Wagner 2015: 58), and that the scene captures the way in which the black agent is disciplined for injuring and challenging the white agent (Bond)'s central position. Read in these terms, the scene would reframe Moneypenny as a subservient sidekick (and eventually repositions her behind her desk) (Shaw 2015).

A closer analysis of Moneypenny's performance in *Skyfall*, however, also offers an alternative reading. It is certainly true that Harris's sensuality is uneasily disassociated from her racial background, and that the sexuality of black women

is frequently portrayed as (problematically) wild and unrestrained in the Bond narratives. Nevertheless, although the shaving scene is loaded with an unresolved sexual tension, which distances Harris's performance from her white predecessors, at no point does Moneypenny act out of control. In fact, as she remains unattainable – in line with the previous incarnations of her character – Harris's Moneypenny displays a sexuality that is at once active and controlled, pointing to a black Bond Girl who resists racial clichés; as confirmed by Harris:

> I'm not interested in playing roles that stereotype me as a woman or as a black woman. I grew up with incredibly strong, powerful women around me who were highly intelligent and doing their own thing, and those are the women I'm interested in portraying because that's what I know to be the truth. A woman who waits around for a man, pines after them ... I don't have any experience of that kind of woman, so I don't think I'd be very good at playing that kind of character.
>
> qtd. in Lewis 2016

As her character development in *Spectre* suggests, far from being relegated to the role of Bond's submissive servant, Moneypenny, no longer the desperate single woman of Maxwell and Bliss's scripts, instead picks up her role where Samantha Bond left it, moving it increasingly closer to the centre of the action.

But the problematic hierarchy of colonial ideology does emerge elsewhere, and particularly in Fleming's books. In *Live and Let Die*, perhaps Fleming's most problematic novel with regard to race, the overlap of race and gender is channelled through the colonial gaze Bond casts, at the very beginning, on the social changes of post-war America. Bond, notes, for instance, 'the number of women at the wheel, their menfolk docilely beside them' ([1954] 2004: 4), and specifically, 'a smart, decisive bit of driving ... a fine-looking negress in a black chauffeur's uniform' ([1954] 2004: 5–6). Bond's 'startled' response to this particular driver, whose only distinguishing factors are the colour of her skin and her employment as a chauffeur, seems to reveal colonial prejudice.

In the ensuing scene at Sugar Ray's Bar, the frisson of racial difference is even more explicitly linked with visual pleasure:

> Opposite him, leaning forward with concern on her pretty face, was a sexy little negress with a touch of white blood in her. Her jet-black hair, as sleek as the best permanent wave, framed a sweet almond-shaped face with rather slanting eyes under finely drawn eyebrows. The deep purple of her parted sensual lips was thrilling against the bronze skin. All that Bond could see of her clothes was the bodice of a black satin evening dress, tight and revealing across the firm, small

breasts. She wore a plain gold chain round her neck and a plain gold band round each thin wrist.

[1954] 2004: 42

The overt racialization of the young woman, expressed in terms which appear to fetishize certain physical qualities such as her 'slanting eyes' and 'parted sensual lips', contrasts with a sense of hybridity, suggested both by the notion of her mixed race, but especially the lack of ethnic detail in her sartorial appearance.

This is also apparent when compared to the representation of black men, such as the lady's companion:

A handsome young negro in an *expensive fawn suit* with *exaggerated shoulders* ... His head rested on the back of the booth just behind Bond and a whiff of *expensive hair-straightener* came from him. Bond took in the *artificial parting* traced with a razor across the left side of the scalp, through the almost straight hair which was a tribute to his mother's constant application of the hot comb since childhood.

[1954] 2004: 42; my emphases

Both the cut of the suit and the reference to Afro-hair grooming practices place an emphasis on Bond's awareness of racial and cultural difference. Walking through the streets of Harlem, Bond's attention is again drawn to the different fashions in menswear – 'fantastic men's snakeskin shoes, shirts with small aeroplanes as a pattern, peg-top trousers with inch-wide stripes, zoot suits' ([1954] 2004: 45). These stylistic departures from Bond's Savile Row reflect awareness of the cultural boundaries being crossed.

A product of 1930s American urban communities, the *zoot* suit 'was both a symbol of racial tension and the focus of racial conflict ... a means of expressing resistance to white culture and of rebellion' (Craik [1993] 1994: 39). Its flamboyant accessories – 'two-tone leather shoes, a wide-brimmed and perhaps feathered hat and long gold chains that drooped from the belt line to shin level' – and excessive use of material were an outrageous attack on wartime austerity (Bruzzi 1997: 102, 103). But it also signified a distinctive 'badge of defiance and community' (Breward 2016: 134), and the 'aggressive assertion of black identity' (Bruzzi 1997: 102), destined to become the 'uniform' of a popular look infused with proto-subcultural subversiveness 'popularized as the look of black music and radical nightclub sounds' (Craik 2005: 212).

Bond's ambivalent stance on cultural difference emerges in a more problematic fashion in relation to Haitian Voodoo practices, which he dismisses as 'a powerful weapon on minds that still recoiled at a white chicken's feather or crossed sticks

in the road – right in the middle of the shining capital city of the Western world' ([1954] 2004: 45). While Bond's disregard for Voodoo exposes a Eurocentric sneer at Other customs, arguably his cynicism also diffuses the white/Other tension, by rejecting 'the thing that made Haiti appear to be an excessive and singular place', and positions Bond within the boundaries of cultural relativism (Gelder 2000: 91). This is in line with Bond's admission, after eavesdropping into the conversation between the girl and her male companion at Sugar Ray's Bar, that it 'seems they're interested in much the same things as everyone else – sex, having fun, and keeping up with the Joneses' ([1954] 2004: 43).

Indeed, throughout the novel, there is an unresolved tension between the re-entrenchment of colonial ideology, and the dismissal of the presumed primitivism of the colonial Other. This emerges particularly strongly in the scene set at 'The Boneyard', one of Mr Big's venues. Here, a Haitian Voodoo drum band is described as 'four grinning negroes in flame-coloured shirts and peg-top white trousers ... all gaunt and stringy' ([1954] 2004: 52). Bond's gaze betrays racial prejudice as the continuous emphasis on the racial grouping – 'the negroes' – creates, along with the ethnic connotations of their attire, more distance between the white observer and the black object of his gaze.

This is even more manifest when the gaze is directed at Sumatra, the dancing girl who follows the drummers' act, carried on stage by 'two huge negroes, naked except for gold loin cloths' ([1954] 2004: 52). Both the large male bodies accompanying her and Sumatra's 'tiny figure' speak of the racial clichés attached to colonial bodies, seen, simultaneously, as excessive and deficient. In racial terms, Sumatra's diminutive body exposes her perceived weakness, due to her seemingly underdeveloped body. This puts her in the same category as the pretty mixed-race girl in *The Man with the Golden Gun*, whom Fleming refers to as 'octoroon', a term which, simultaneously draws attention to a dubious notion of racial impurity as well as deficiency:

> She was an octoroon, *pretty* as, in Bond's imagination, the word octoroon suggested. She had bold, brown eyes, slightly uptilted at the corners, beneath a fringe of silken black hair. (Bond reflected that there would be Chinese blood somewhere in her past.) She was dressed in a *short frock* of shocking pink which went well with the coffee and cream of her skin. *Her wrists and ankles were tiny.*
>
> [1965] 2012: 62; my emphases

As much as Bond might feel physical attraction to these women, his fascination is also a way of placing distance between his white gaze and the exotic Otherness

of racial-minority women. The girl's 'short frock' doubly exposes her to the gaze, a simultaneous unveiling of sexual/racial difference.

Similarly, in *Live and Let Die* the men's 'gold loin cloths' and Sumatra's 'black ostrich feathers' costume are suggestive of the primitiveness inscribed in their racialized bodies (Fleming [1954] 2004: 52). Indeed, while one of the meanings of the word 'exotic' – 'pertaining to strip-tease or a strip-teaser' (*OED* 2019) – exposes the sexual exploitation of female migrants in mid-1950s America, the exoticism of Sumatra's eroticized black body is enhanced in her strip-tease performance:

> She was naked except for a brief vee of black lace and a black sequined star in the centre of each breast and the thin black domino across her eyes. Her body was small, hard, bronzed, beautiful. It was slightly oiled and glinted in the white light.... The girl's naked stomach started slowly to revolve in time with the rhythm. She swept the black feathers across and behind her again, and her hips started to grind in time with the bass drum.... Her lips were bared slightly from her teeth. Her nostrils began to flare. He eyes glinted hotly through the diamond slits ([1954] 2004: 53).

Sumatra's race dehumanizes her, as Bond's gaze can only see her features in animalistic terms: 'It was a sexy, pug-like face – *chienne* was the only word Bond could think of' ([1954] 2004: 53). Like Vesper, who, at the end of *Casino Royale*, is angrily dismissed by Bond – 'The bitch is dead now' ([1953] 2006: 213) – Sumatra is also derogatively called a 'bitch', the use of the French term amplifying the notion of her foreignness. But whereas Bond's misogyny against Vesper is dictated, arguably, by the rage of betrayal, in this instance, the derogatory expression derives from Sumatra's racial Otherness, and specifically her blackness which, significantly, glints 'in the *white* light' (my emphasis).

The overall implication seems to be that behind the all-black establishment is, as bell hooks suggests of real-life black performers, the millennial control of the white gaze, which is responsible for this treatment of 'black female sexuality ... made synonymous with wild animalistic lust' (hooks [1992] 2015: 67). This is also in line with the treatment of other black Bond Girls in the film franchise, starting with the first black Bond Girl, 'Thumper', played by Trina Parks in *Diamonds Are Forever* (Hamilton 1971). Featuring in a brief fight scene with her white partner Bambi (Lola Larson), the origin of their names rooted in Walt Disney's animated feature *Bambi* (Algar 1942), simultaneously infantilizes and sexualizes the two women. Their physical strength and implied homoeroticism certainly pose a threat for Bond, and the heteronormative values he stands for.

On the other hand, the problematic eroticization of Thumper's body, semi-naked with gold shackles on her neck and arm, is evocative of the black slave, and the scene conveys an impression of feral behaviour; when Bond arrives on the scene, Thumper lies down on a rock, and her feline physicality, elongated claw-like fingernails, and wordless grunts indicate that she *is* the savage Other. By the end of the scene, inevitably, Bond has seemingly tamed her. This view of the black woman as wild is also foreshadowed, in the same film, by the brief scene in which Zambora, 'the gorilla' woman, performs a pseudo live transformation from human to animal as part of a circus freak show; the woman is, of course, black, semi-naked, voiceless and, what is worse, kept in a cage.[5]

In *Live and Let Die*, the material of Sumatra's costume also reveals the ambivalent politics of colonial ideology; while ostrich feathers endorse the performer's 'savage' nature, they are also a reminder of Western fashion's exploitation of developing countries. The fetishized exoticism conjured up by ostrich feathers has been synonymous with authority, as well as luxury, since antiquity. Their increased popularity and wider use in fashion and especially carnival/burlesque costumes – such as the one worn by Sumatra – has resulted in disastrous effects on local North African economies; throughout the nineteenth century, 'by expanding the local European luxury consumption of the African ostrich feather', Aomar Boum and Michael Bonine explain, 'France and Britain transformed the ordinary indigenous consumption of the ostrich egg, leather, and feather into a cash crop' (2015: 8). Wearing ostrich feathers, then, Sumatra ambiguously partakes in the politics of Western fashion consumption, while, thus packaged, turning herself into a commodity for the Western gaze.

In spite of the problematic colonial references, the racial politics of Sumatra's scene, and the overall novel and film, are not so clear-cut. Indeed, what the performance brings home is the unsettling proximity of self/other, highlighting the novel's pervasive anxiety about racial purity (see Kristeva 1982: 207). This sense of unease runs throughout the scene and is captured in the strange tricks played by 'some of the lights [which] 'turned the girls' lipstick black, others lit their whole faces in a warm glow on one side and gave the other profile the luminosity of a drowned corpse' ([1954] 2004: 50). While the corpse is one of the archetypal abject manifestations discussed by Julia Kristeva (1982: 3), the girls' half-white, half-black faces are here indicative of Bond's concerns with the insecure boundaries of racial differentiation.

Significantly, the motif is taken up in the film adaptation, where the face of Baron Samedi (Geoffrey Holder), the alleged zombie, is half-painted in white, to highlight the multiple sets of duplicities – living/dead, black/white, real/fake – he

embodies. The same ambivalence emerges from the sartorial portrayal of CIA agent Rosie Carver (Gloria Hendry), whose first appearance is in white, a colour that, with its association with Voodoo, whose beliefs Rosie shares, suggests her double-agency. Her white racerback dress, a style that originated in swimwear and became popular in the 1960s (Meyer 2016: 149), while exposing the muscular tone of her back, also emphasizes her skin colour, thus pursuing the same black/white motif that characterizes the zombie iconography of Baron Samedi. In the novel, the black/white coalescence also points to ideas of miscegenation; Bond's telling observation that his fractured finger 'was nearly black' ([1955] 2004: 78), after Tee-Hee broke it on Mr Big's order, is suggestive of his anxiety over racial difference and hierarchy. While this might be another manifestation of the kind of 'contagion' with which foreign bodies menace Bond, it is also possible to suggest that what is at stake here, in fact, is a problematic notion of whiteness as absence, or even, lack. As Ken Gelder claims:

> Perhaps not enough attention has been paid to the kind of postcolonial configuration that sees ethnicity represented not as a lack but as a surplus – in which case, one might resent it not because it is something less than whiteness, but rather because it can seem like that something extra of which whiteness has been dispossessed.
>
> 2000: 89

Such racial tensions, and, particularly, a sense of white marginalization, have in fact emerged earlier in the novel, when Bond gains a closer introduction to the black scene in New York, courtesy of CIA agent Felix Leiter, whose commentary draws attention to the racial tensions in post-war America:

> Harlem's a bit of a jungle these days. People don't go up there any more like they used to. Before the war, at the end of an evening, one used to go to Harlem just as one goes to Montmartre in Paris. They were glad to take one's money. One used to go the Savoy Ballroom and watch the dancing. Perhaps pick up a high-yaller and risk the doctor's bills afterwards. Now that's all changed. Harlem doesn't like being stared at anymore.
>
> [1954] 2004: 36–7

Leiter's nostalgia for the pre-war Harlem, as a place where interracial contact was tolerated is tinted with the uncomfortable awareness that exploitation occurred, from either side, at both commercial and sexual levels. The racial tension, implicit in the notion that Harlem is 'a bit of jungle' and the reference to the potentially infectious body of 'high-yaller', suggests a destabilizing move towards decolonization. Previously commodified as a spectacle for the white gaze in search

for visual pleasure, Harlem now resists the gaze. Moreover, there is an active stare directed back at the white intruders of this eminently black space, as reinforced by the communication network which alerts the community – and Mr Big – of the movements of 'the Limey with the scar' and his team mates ([1954] 2004: 39).

Such subversive use of the gaze is indeed at play in the scene of Sumatra's performance. Here, as the representation of the black woman is problematic, so is the reaction of the male 'audience panting and grunting like pigs at a trough', and Bond himself must acknowledge the effect of the performance on his own senses: 'he felt his own hands gripping the tablecloth. His mouth was dry' ([1954] 2004: 54). Yet, as the outcome of the scene reveals, the act is, at least on one level, meant to manipulate the male gaze, as Bond, clearly too engrossed in the performance, lets his guard down; following an audience request that the dancer remove her g-string, the lights are switched off and Bond and Leiter's table disappears into Mr Big's basement lair. In the film cabaret scene, in place of Sumatra's strip-tease, a black soul singer (Brenda Arnau) performs the film's theme song, Paul McCartney's 'Live and Let Die'. Although not as overtly sexual as Sumatra's performance, Arnau's 'final costume … made with eye-catching, shimmering sequin stripes … distracts Bond just before he unexpectedly disappears through a trapdoor into Mr Big's underground room' (Simmonds 2015: 126). Undermining the power dynamics traditionally associated with patriarchy/colonialism, such manipulation of the male/colonial gaze, is particularly significant in a novel/film where the ability to see things is central to the theme of the story.

In both the novel and the film, the main spotlight is on Solitaire, an enigmatic tarot reader who is initially affiliated with Mr Big/Kananga, and who later switches sides and becomes Bond's lover. Her character is ambiguously positioned within the Voodoo culture of Haiti. In the novel, as the white descendant of a French slave owner, she exploits her 'second sight' within the superstitious environment of Haiti for commercial gain. As she admits to Bond:

> I can often see what's going to happen, particularly to other people. Of course I embroider on it and when I was earning my living doing it in Haiti it was easy to turn it into a good cabaret act. They're riddled with Voodoo and superstitions there and they were quite certain I was a witch.
>
> [1954] 2004: 92

Solitaire's suspect claims to a belief-system she is not born into is conveyed through her physical description which places her, undeniably, on the colonizer side of the master/slave divide:

Her face was pale, with *the pallor of white families* that have lived long in the tropics. . . . She had high cheekbones and a wide, sensual mouth which held a hint of cruelty. Her jawline was delicate and finely cut. It showed decision and an iron will which were repeated in the straight, pointed nose. Part of the beauty of the face lay in its lack of compromise. *It was a face born to command.* The face of the daughter of a French Colonial *slave-owner.*

[1954] 2004: 65; my emphases

Her European origins are also visible in her sophisticated sartorial appearance; when Bond first sees her, she wears 'a long evening dress of heavy white matt silk whose classical line was broken by the deep folds which fell from the shoulders and revealed the upper half of her breasts'. The ensemble's expensiveness is also suggested by her 'diamond earrings, square-cut in broken bands, and a thin diamond bracelet on her left wrist' ([1954] 2004: 65); later, in the train scene, she wears a 'black tailor-made' outfit, accessorized, Bond 'cynically' notes, with a diamond studded platinum watch (Fleming [1954] 2004: 89, 91). Significantly, the colours of Solitaire's clothes are manifest references to the binary black/white coalescence that runs deeply throughout both novel and film. But while her debut in white endorses the notion of her virginal condition, her subsequent appearance in black foreshadows her loss of innocence subsequent to her sexual encounter with Bond.

The film re-invents Solitaire as a much more exotic figure and, in doing so, creates the illusion of ethnicity. Sporting the most spectacular costumes to date, Seymour's maxi-dresses are as much a tribute to 1970s bohemian styles and Western fashion's cyclical flirtation with the Orient. The sprawling quality of the embellished dresses and capes, are reflective of an ambivalent relationship with the space Solitaire's body occupies; as Warwick and Cavallaro comment, 'flowing, "baggy" and marginally shapeless clothes may seem to operate as a cohesive tissue in so far as they blur the body's boundaries and thus enable it to diffuse itself through its environment' (1998: 60). Ideas of cohesiveness are particularly relevant with regard to folk-dress, defined, at its most basic level, as the dress that expresses belonging within a distinctive cultural or ethnic group (Eicher and Sumberg 1999: 301).

More specifically, Solitaire's earlier costumes gesture to European/Anatolian folkloric dress, which, Linda Welter notes, 'offers human beings a way to negotiate the invisible influences on their natural and social environments' (1999: 1). Indeed, the magical qualities associated with some of these folk-dresses also confer an aura of sacred untouchability on Solitaire: 'dress serves a dual purpose in the magical thinking of folk cultures. It may bring positive results as well as

protect against negative influences' (Welters 1999: 7). This is particularly visible when looking at Solitaire's dress in relation to the preoccupations with her virginity in the film, as this might take her second sight away from her (in the novel, instead, Mr Big claims he is to marry her, because 'she is too valuable to remain at liberty'; see Fleming [1954] 2004: 64). The emphasis on Solitaire's chastity is conveyed, to begin with, by the high neckline of her first appearance in ethnic dress, and the colour red, which, with its associations with blood, and, in turn, menstruation and childbirth, is simultaneously used to foreshadow a bride's loss of virginity and future fertility in ethnic bridal gowns (Welters 1999: 9). Later, in St Monique, the bridal motif is pursued through a more revealing red dress, elaborate headdress, and a green cape studded with red

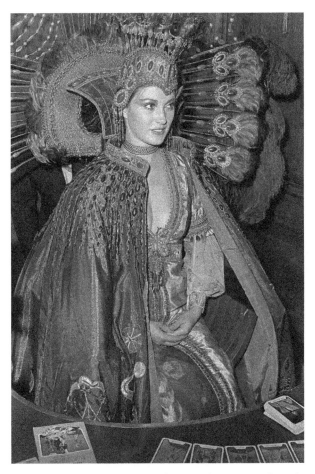

Figure 4 Jane Seymour as Solitaire, *Live and Let Die* (Courtesy of REX)

stones; since Solitaire is about to lose her virginity to Bond, her neckline has dropped. Back in New York, the neckline plunges down to a butterfly appliqué stitched on the high waist of the red and gold dress she wears on her last tarot-reading session (Fig. 4).

Rather than consolidating her dubious Voodoo credentials, Solitaire's elaborate costumes are a multi-ethnic pastiche. Her first tarot reading gown is inspired by the traditional Ottoman red velvet *bindalli* gown 'that in the nineteenth century came to be defined as the "traditional" garb of the Ottoman bride' (Faroqhi et al. 2004: 32). The ceremonial significance of the dress is here complicated by the conflict of interest generated by Solitaire's first encounter with Bond, which occurs soon afterwards. Solitaire's ethnic 'bridal' outfit, then, assumes a double meaning, as the magic garment that supports her occultist powers, as well as the bridal gown that foreshadows her later sexual union with Bond, which, in turn, marks the end of her clairvoyance days.

At the end of the film, the headdress and the decorative snake *bindi* adornment reflect a move from European/Anatolian to South-Asian and Indian cultural references. The cultural mix is also endorsed by the peacock feathers adorning Solitaire's throne, which, implicitly referencing the theme of sight in the 'eye' motif that naturally occurs in the bird's plumage, are also a good omen among many cultural groups from Africa to India and China (Nair 1974: 154; Mei 2010: 99). Such cultural appropriation of multiple ethnic styles points to a view of ethnicity not as innate, but as performative: 'fashion appropriations ... express a complex relationship with other cultures and other times: a desire to "be" someone else, somewhere else – in fact, to be "other"' (Cook 1996: 45). In this sense, her sartorial hybridity – and not her race – teases out racial stereotypes attached to the ethnically marked women in the Bond novels and films.

But it is precisely because of her whiteness that such performance also signals a troubling sense of 'lacking' ethnicity. Solitaire's manufactured hybridity frames her ethnicity as a dubious form of cultural appropriation, exposing her problematic lack of authenticity through her ungrounded affiliation with Voodoo. Such problematic sartorial performance points to whiteness as potentially unmarked, or even, deficient ethnicity. This is particularly interesting within the 1970s Blaxploitation film context, against which *Live and Let Die* is also dubiously situated, as David Walker notes:

> In a society inundated with pop culture icons that were white, the black heroes of the Blaxploitation films provided a needed respite from characters like James Bond and cinematic icons like John Wayne. For arguably the first time since the

invention of motion pictures, there were finally larger-than-life black heroes who saved the day, often by standing up to the dominant oppressor.

<div align="right">Walker et al. 2009: ix</div>

Although later subject to criticism precisely because of the replacement of stereotypical black roles with alternative 'archetypes including drug dealers, pimps, and hardened criminals' (Walker et al. 2009: ix), the relevance of Blaxploitation cannot be dismissed: 'Big bad soul brothers and super sexy sisters, their afros picked to spherical perfection and their guns blazing, lit up the silver screen in a dynamic cinematic explosion that forever changed Hollywood' (Walker et al. 2009: vii). *Live and Let Die* attempted to bridge the gap between white pop culture and the increasing popularity of Blaxploitation movies.

This is particularly visible in the presence of a black Bond Girl, Rosie, albeit in the role of henchwoman, as Andrew Rausch comments: 'This is significant because it marked Bond's first intimate scenes with an African American woman, further demonstrating the impact that the blaxploitation [sic] films were having on mainstream cinema' (Rausch 2009: 93). The casting of Gloria Hendry as Rosie Carver was surprising because, as the actor admits: 'I didn't meet any of the criteria: tall, voluptuous, and white. And I was totally ethnic and not very tall at all. And wore an afro!' (qtd. in Rausch 2009: 95). Significantly, in the film, Rosie wears an afro wig, reifying the performative quality of her African Blackness, and, more broadly, the fluid boundaries of ethnic identity. Therefore, while the film remains problematic in the treatment of race, it nevertheless demonstrates a conscious preoccupation, as already noted of Fleming's novel, with the unstable hierarchies of colonial ideology.

A composite system of fashion references also frames the performance of Bond Girl Villain May Day (Grace Jones) in *A View to a Kill*. Here racial preoccupations are barely veiled behind villain Max Zorin's birth as a result of a breeding experiment in a Nazi concentration camp. Much like other racialized henchmen, such as *Goldfinger*'s Oddjob, May Day's performance is largely physical; Jones's muscular figure is showcased in partial nudity in the martial arts training session with Zorin, and the sex scene with Bond, when the audience catch a glimpse of her androgynous naked body from behind.

Jones's subversive androgyny is a reminder of the incongruous gender discourse inscribed in the body of the female slave, whereby 'the black woman not only carried out the physical labor demanded by plantation economy', Carla Peterson argues, 'she also performed the sex work that satisfied the slaveholder's lust as well as the reproductive labor of breeding that ensured the replenishment

of his slave stock' (2000: x–xi). Jones's self-reflective performance of her own 'strangeness', deploys the disorientating effect of her unintelligibility 'to critique and to express anger and ultimately agency' (Royster 2009: 79). The result can be described, as Peterson says, as 'eccentric' black femininity; it is the empowered 'oddness' of the black female body that pushes white colonial authority away from the centre (Peterson 2000: xi–xii; see also Royster 2009: 79).

Jones's 'eccentric' black femininity is supported by the sculpted signature designs of Azzedine Alaïa, whom Jones introduced to the film production team (*Designing 007* 2012). Alaïa's distinctive tailored designs revolutionized 1980s fashion scene beyond the power-dressing vogue. As a result of his early interest in sculpture – he was enrolled to study fine art at the *Ecôle des Beaux-Arts* in Tunis – and his work experience in midwifery (see Beaudot 1996), Alaïa's designs display a deep fascination with shape, and respect of the female body. One of the strengths of Alaïa's way of designing fashion was not only that it would let the female form coexist, organically, within a structured garment, but that the body itself gave the garment its structure. As Georgina Howell explains:

> He worked out dress in terms of touch. He abolished all underclothes and made one garment do the work. The technique is dazzling, for just as a woman's body is a network of surface tensions, hard here, soft there, so Azzedine Alaïa's clothes are a force field of give and resistance.
>
> 1990: 457

Adopting the rigorous tailoring technique into the soft materials of women's fashion, Alaïa's contribution to fashion was to draw attention to the female body in all its strength, with 'dresses … [which] didn't cling, as Sophie Hicks commented, [but] floated around the body' (qtd. in *Azzedine Alaïa* 2017). While his designs paid heed to the female body, they also underpinned the wearer's confidence, demonstrating a modern consciousness of femininity characterized, as Suzie Menkes puts it, 'by strength, and the ability to express your sexuality' (qtd. in *Azzedine Alaïa* 2017).

Confident, strong, and sexual are suitable descriptors for May Day's performance in *A View to a Kill*. In particular, what her collaboration with Alaïa achieved was to construct May Day's character on a dual notion of superhuman strength on one hand, and indecipherable mystery on the other. Where the latter is largely conveyed by the hooded garments which partially cover her head, the former is achieved through the over-emphasized shoulders of May Day's costumes (Fig. 5): 'I worked on the silhouette … [so] that you could see [me] coming. Here comes trouble!', recalls Jones of the collaborative designs (*Designing*

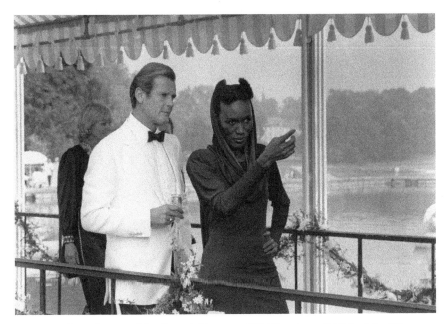

Figure 5 Grace Jones as May Day, *A View to a Kill* (Courtesy of AF Archive/Alamy Stock Photo)

007 2012). That her clothes are visually responsible for the threat she poses to Bond is made clear by the disruption her presence creates within the space she shares with him. Juxtaposed with the white – and definitely paler – Bond Girl, Stacey Sutton (Tanya Roberts), May Day repeatedly attempts to control Bond's gaze of the white woman, who is also trying to unveil the secret behind Zorin's winning horses: 'Bond's classical (white) male gaze, trained voyeuristically . . . on a "woman as image", is disrupted . . . by May Day, a woman of color, who turns the gaze upon himself' (Burnetts 2015: 64).

That May Day's strength is ambiguously linked to Jones's personal background also emerges from her autobiography, where Jones explains how her difficult relationship with her step-grandfather, Mas P, and her subversive rebellion against his disciplinarian methods underpin her performance as May Day: 'in the Bond film, playing the ruthless dominatrix in catsuits, mad hats, and flamboyant capes, taming a wild horse with a sneer, parachuting from the Eiffel Tower, I began to emulate Mas P, to copy his intense scowl' (Jones and Morley 2016: 273). Behind May Day's gaze, then, is the disciplining eye of the figure Jones associates with patriarchal control in her personal life. As Jones explains:

Everyone in a position of male authority in the church was a mas because they were a master, and *mas* was short for *master*. Master, massa, a name rooted in the history of slavery itself, from the masters of the estate. He was Mas P because he was Peart and you used the first letter of their name. This in itself turned him into a kind of gothic monster with an ugly, stunted name.

<div align="right">Jones and Morley 2016: 17</div>

Jones's reflection on the Jamaican social system reveals the paradoxical pervasiveness of the colonial mindset; even after their emancipation from slavery, black men in a position of authority – such as Jones's step-grandfather – would adopt the 'Master' title that white slave-owners would have once used to indicate their power over black people.

Although subversive on many levels, May Day's performance also reinforces certain stereotypes about black women. For instance, her aggressive sexuality foreshadows Jinx Johnson's sexual behaviour in *Die Another Day*, which, significantly, shares with *A View to a Kill* a clinically modified Aryan-looking villain, and a veiled anxiety about themes of racial inferiority and degeneracy. May Day's costumes, though supporting her character's strength and assertiveness, also cast her as a kind of cartoonish anti-hero, as reflected in the hooded cowl-neck dresses she helped design for the film: 'I knew what I wanted, how I was going to look as a Bond girl', Jones claims, 'I looked at Disney colors, because I figured being a Bond girl was like being in a cartoon' (Jones and Morley 2016: 276). While her costumes may be reminiscent of some of Disney's memorable villains – her high-set bicorn hairstyle certainly evokes *Sleeping Beauty* (Geronimi 1959)'s Maleficent – they also diffuse the threat she is meant to pose. In this way, although her clothes do not racialize May Day in any explicit way, they nevertheless downplay the threat of her 'strangeness'.

This is also reinforced by her troubling lack of articulate language throughout the film, where her performance largely relies on her facial expressions or physical stunts. The absence of language underscores May Day's untamed Otherness, in opposition to both Zorin and Bond, the white men whose authoritative voices compete over her submissive loyalty. Yet, May Day's silence also 'echoes' postcolonial theorist Gayatry Chakravorty Spivak's claims about the problematic neglect of women of colour's voices. In 'Can A Subaltern Speak?' (1988), she draws attention to the problematic position of 'third-world' women's (self-) representation:

Between patriarchy and imperialism, subject-constitution and object-formation the figure of the woman disappears, not into a pristine nothingness, but into a

violent shuttling which is the displaced figuration of the 'third-world-woman' caught between tradition and modernization.

<div align="right">1988: 306</div>

Indeed, while May Day's performance bears the traces of patriarchal and colonial history – and the racial discourse attached to it – it also simultaneously speaks of the violent rebellion against it: 'in the political world of Bond, where codes and conventions clearly demarcate good and evil', Funnell argues, 'May Day is a symbol of transgressive female identity that both upholds and subverts the sexist ideology of the franchise' (Funnell 2011a: 206). Significantly, at the end of the film, May Day's longest speech also marks her sacrificial demise in order to save Bond and avert Zorin's destructive apocalypse. Though her death could be easily read as paradigmatic of the wider dismissal of black female characters in the Bond cultural productions, her *choice* to die is also an act of revenge against all of her 'masters', and therefore, liberating.

Orientalisms

In the film *The Man with the Golden Gun*, a belly dancer entertains Bond in Lebanon, topless Asian women serve drinks behind a bar in the Hong Kong 'Bottoms Up' club, the nimble fingers of Thai masseuses nearly send Bond into ecstatic oblivion, while graceful dancers provide dinnertime entertainment in Thailand. So far, so stereotypical; Asian women appear beautiful and willing to please. The film, however, also offers a glimpse of redemption; to the rescue of Bond from his captivity at Hai Fat's martial arts school, come Thai agent Hip and his teenage nieces whose karate moves prove to be crucial to Bond's safe escape. Dismissing Bond's patronizing advice – 'Stand back, girls!' (*The Man with the Golden Gun* 1974) – they proceed to fight the male attackers without getting as much as a crease on their crisp school uniforms.

A clear master/slave pattern of dominance also emerges strongly in *Skyfall*, where Séverine, a former sex slave in Macao, is at the service of Silva, who executes her early on in the film. The problems with Séverine start with her name, which evokes that of the bored housewife (Catherine Deneuve) involved in a sadomasochistic affair in Louis Buñuel's *Belle de Jour* (1967), and is also loosely derived from Leopold von Sacher-Masoch's novella *Venus in Furs* (1870). The central theme – a submissive sexual relationship between a young man, Severin, and Wanda, his mature, fur-clad dominatrix – led to the coinage of the

term 'masochism'. The novella has inspired a number of adaptations, including Lou Reed's *Venus in Furs* song for Velvet Underground (1967), where the opening lines reflect the fetishistic desire central to Severin's story:

Shiny, shiny,
Shiny boots of leather
Whiplash girl
Child in the dark
Comes in bells,
Your servant,
Don't forsake him
Strike, dear mistress,
And cure his heart

Venus in Furs 1967

A disturbing variation on Sacher-Masoch's adult dominatrix, the song's 'girl child' brings to the foreground the manipulative aspect of the apparently submissive behaviour of the 'servant'. Likewise, the film adaptation by Roman Polanski, *Venus in Fur* (2013) based on the play by David Ives, and starring Emmanuelle Seigner and Mathieu Amalric, points to the shifting dynamic at the heart of the unstable active/passive, assertive/submissive binary oppositions which, in turn, raises questions about agency and control.

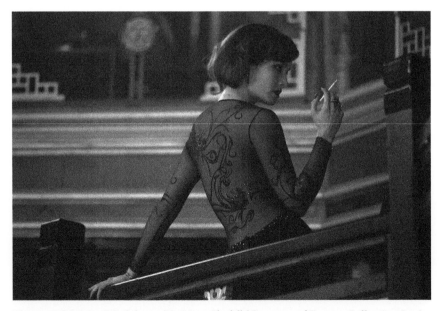

Figure 6 Bérénice Marlohe as Sévérine, *Skyfall* (Courtesy of Everett Collection Inc/ Alamy Stock Photo)

In *Skyfall* such shifting patterns are implied in the triangulated assertive/ submissive relationship that tie Silva to the archetypal mother figure of M (Judi Dench) and the 'whiplash girl child' that is Séverine; after her death, the Oedipal triangle accommodates Bond, who, in Silva's eyes, is also a victim of M's bad 'mothering', and a rival for her love. Such shifting dynamics are important to understand the character of Séverine, who simultaneously embodies a darkly glamorous woman, dressed – literally – to kill, and a disenfranchised pawn in Silva's hands.

Racial difference amplifies *Skyfall*'s sadomasochistic subtext, made more complex by the implied control that both white men – Silva and Bond – exercise on the Asian woman. Although played by a mixed-race actor, Séverine's Chineseness is over-emphasized through make-up and costume. Like Miss Taro (Zena Marshall) in the film *Dr No*, Séverine plays the part of the 'Dragon Lady', 'a figure of the underworld who is cunning, aggressive, and sexually alluring, particularly to white men' (Funnell 2015: 80). Significantly, in both cases the characters' Chineseness is accentuated through enhanced sexual lure which, in turn, is qualified in ethnic terms. Thus, Zena Marshall plays the part in 'yellowface' – make-up worn by white actors to reproduce the stereotyped features of an Asian person – and wears a *cheongsam* (Fig. 2). Similarly, while Séverine's Asian features are over-emphasized by make-up, her long nails in black nail polish draw attention to the dark sensuality of the dragon lady. Moreover, in a fashion evocative of Miss Taro's *cheongsam*, the figure-hugging dress (Fig. 6), so tight that it had to be sewn onto the actor for each scene (Karmali 2012), is emblematic of Séverine's status within the film storyline; although apparently dangerous – she is directly involved in the murder of an art dealer towards the beginning of the film – her position as *femme fatale*/dominatrix is however undermined by her subjugation to Silva; prefigured in the tight fit of the dress is her bloodied body, minutes before her execution, bound to a dilapidated statue, itself another visual representation of Séverine's broken, immobile condition.

Relevant to her captive position are the tattoo references in Séverine's body and dress. Her wrist tattoo is a reminder that, as a sex slave, her body was the 'property' of one of the Macao prostitution houses; such 'branding', commonly practised on sex slaves even in recent times (Kelly 2014), underpins Séverine's captivity, presenting her 'as one of the most tragic and disempowered women not only in the Craig era, but the franchise at large' (Funnell 2015: 86). Juliet Fleming notes how tattoos capture identity on the surface, rather than depth, of the tattooed person; in some cases, the tattoo can therefore become 'a poisoned (that is poisoning) name: like other names, it wounds by threatening to reduce the

subject to a function of itself' (2000: 63). In the case of 'branding', this is even more problematic, as the act of 'naming' through tattooing seals effectively the external ownership and control over the branded body. Furthermore, the practice of enforced branding eschews the already complicated relationship tattoos establish with the concept of property: 'tattoo announces itself as ... a property that is at once mobile and inalienable' (J Fleming 2000: 67). In other words, the impossibility of exchange implicit in the inscription of a tattoo on one's body makes it a contradictory kind of property, at once mobile and 'inalienable'. The practice of branding, paradoxically, transfers the notion of 'inalienability' from the tattoo to the body itself, whereby the tattoo symbolizes the sex slave's body's 'inalienability'; the tattoo announces that the body does not own itself.

But while her captive condition is literally inscribed in her body, there is a more nuanced way of looking at the tattoo motif in Séverine's dress. The lyrics from Adele's theme song, *Skyfall* – 'You may have my number/ You can take my name/ But you'll never have my heart' *Skyfall* (2012b) – suggest that, although Séverine is a disenfranchised victim of Western/patriarchal control, her story speaks also of rebellion. Even if her reliance on Bond for deliverance re-entrenches problematic colonial ideas about her emancipation, her own act of rebellion is inscribed in the other (crystal) tattoo that decorates the see-through material of the back of her dress. Foreshadowing Bond's fight with the komodo dragons in the subsequent scene, the dragon motif reminds us that Séverine is indeed a 'dragon lady'. If, as Craik argues, 'tattooing is a form of "dress"', the reverse is here also true; the dragon embellishment functions as a mock tattoo 'that provides both a badge of identity and a personal signature' ([1993] 1994: 25).

In Chinese dress history, significantly, the dragon has signified status since the Ming dynasty period, when 'elite women also wore dragon robes corresponding in rank to those their husbands wore' (Steele and Major 1999: 29); moreover, in Chinese art 'far from being the virgin-devouring treasure-guarding monster of European medieval romances, the Chinese dragon is a benevolent creature' (Nickel 1991: 139). Such positive readings of dragon symbolism are relevant to the implicit notion of self-rebranding which,[6] in the context of Séverine's prostitution-house tattoo, is here suggestive of her (temporary) emancipation from Silva. Séverine's dragon tattoo is only a superficial effect created by the embellishment on her dress; as such, therefore, while the symbolism retains a notion of self-redemption, this is admittedly bound to the ephemeral quality of dress.

Séverine's apparent passivity has led to criticisms of *Skyfall* (Funnell 2015) for its reinstatement of regressive views of female characters, and particularly

Asian women. The case for this argument is particularly strong when drawing comparisons with Wai Lin (Michelle Yeoh) in *Tomorrow Never Dies*. A star of Chinese action film, Michelle Yeoh brought to the role a dynamic energy unseen since Jones's performance in *A View to a Kill*, and enhanced by her own physical stunts. As well as when she defeats a dozen men in a fight, this is particularly visible in the motorbike chase scene, where Lin and Bond, handcuffed to each other, are forced to share the controls. While Bond bullies Lin to 'get on the back', it is clear throughout the scene, that she actively manages the ride, not only because she uses the clutch, but also because she effectively navigates the streets of Saigon and uses her inventiveness to disrupt the enemy's course. As Funnell notes:

> Over the course of the scene, Lin constantly shifts her position on the speeding bike to maintain a tactical advantage over their pursuers. These stunts help foreground the nerve and agility of Lin at the expense of Bond, who remains stationary on the bike, and present the impression that Lin is a far more effective agent (and action hero) than James Bond.
>
> Funnell 2014: 44

When Lin moves to face backward, she literally straddles Bond on the bike, opening the scene up to an erotic reading; but, as Bond smirks knowingly, Lin reproaches him: 'Don't get any ideas' (*Tomorrow Never Dies* 1997). The scene's sexual potential is completely overshadowed by the emphasis placed on Lin's action, because 'even [when Bond] tries to seduce Lin, she remains focused on the job at hand and continually turns him down' (Funnell 2015: 84). That she rejects the conventional 'damsel in distress' model is also clear when, as Bond asks her to return to the back of the bike, Lin resentfully asks, 'Are you trying to protect me?' (*Tomorrow Never Dies* 1997), even though, by this time, Bond has realized she needs no protection. Rather than playing Bond's love interest – despite the formulaic surrender to Bond's charm at the end of the film – Lin's performance is entirely mission-centred, and her clothes – which stay on throughout the film – reflect her active role.

In undermining the active/passive, masculine/feminine binary assumptions, Lin's role radically redefines the gender attributes conventionally attached to Bond Girls and, particularly, Asian women. With the exception of her first appearance in a metallic silver evening gown at Carver's reception, she is never seen in the conventionally feminine decorative dress throughout the film. That she is not the passive recipient of the male gaze is also reinforced by the fact that the role, as Funnell claims (2015: 84), is fulfilled by Paris Carver (Teri Hatcher),

Figure 7 Michelle Yeoh as Wai Lin, *Tomorrow Never Dies* (Courtesy of Everett Collection Inc/Alamy Stock Photo)

who first appears in a strapless Oscar Versolato black evening dress and, later, lingerie for Bond's benefit. In contrast, Lin's halterneck dress, less revealing of the woman's décolletage, emphasizes, instead, her toned shoulders, while the reflective quality of the metallic fabric acts as a screen from which light – and, consequently the gaze – bounces off. Her jewellery also conceals more than a purely decorative function; after the motorbike chase, her earring serves to unlock the handcuff that binds her to Bond. This also foreshadows her later use of a Japanese *shuriken* (throwing star) concealed within her jumpsuit, an echo of Bond's concealed weapons; like Bond's, her clothes constitute a form of armour, making Lin a warrior on equal terms as Bond.

Within the global context of *Tomorrow Never Dies*, Lin is nevertheless cast as a Chinese agent with strong anti-capitalist views, and her ethnicity comes through in some of the sartorial choices made for her costumes (Fig. 7). Hemming's sketch for the motorbike scene calls for a red Prada jacket with black 'Chinese style' trousers (Simmonds 2015: 247). China had, by the time of the film release, been open to Western fashion influences for some time, so that the combination of Chinese and Western fashion is in line with these developments in international politics. For the subsequent scene, Hemming's concept-drawing of a Chinese head in an Asian rice hat (*dǒulì* in Chinese) reveals that ethnic

connotations were a distinct consideration at design stage (see Simmonds 2015: 247), though the final screen version, a SportMax fifties-style shirt with a bamboo-leaf pattern, only subtly convey the Vietnamese locale of the scene, and Lin's ethnicity. Placed against other non-ethnic costumes worn by Lin in the film, these references do not necessarily imply, as some critics have suggested, that 'Yeoh's Chineseness is incessantly highlighted' throughout the film (Chu 2013: 25). In fact, Lin's ethnicity is one – not the primary – aspect of the character's identity. Moreover, these ethnic references do not place her within either of the two Asian female stereotypes. Her good intentions set her apart from the 'Dragon Lady', such as Miss Taro and, to an extent, Séverine, while her assertiveness casts her out of the 'Lotus Blossom', the virginal, submissive Asian woman partly embodied by the Japanese characters of Aki and Kissy Suzuki in the film *You Only Live Twice* (see also Funnell 2015: 80–2).

In the Japanese context of *You Only Live Twice*, the theme of the Asian woman's submissiveness bares links to the double bind of colonial/patriarchal ideology through the use of traditional clothing. The Asian woman's obedience to Western Man comes to the foreground, for instance, when, before sleeping with Bond, Ninja agent Aki (Akiko Wakabayashi) pronounces 'I think I will enjoy very much serving under you', a statement which clashes with the confident professionalism displayed in previous scenes. As the scene is largely set in Japan, kimonos are worn by both Aki and Kissy Suzuki. Whereas Tokyo-based Aki is a secret agent and helps Bond with his Japanese training, Kissy is an Ama girl, who, however, is also a willing accomplice in Bond's mission against Blofeld. The East/West divide is played out in the clear alternation of Western and Eastern costumes (kimonos); when Aki first meets Bond – and drives him to his rescue – in Tokyo, she wears Western clothes, whereas she changes into the traditional kimono at Tiger Tanaka's estate and ninja training camp.

As Penelope Francks reminds us, 'after the Second World War, "traditional" dress was . . . relegated to a niche role, as Japan enthusiastically embraced Western fashion to the extent that eventually Japanese designers became some of its leading exponents' (2015: 333). This is also confirmed by Fleming, who travelled to Japan as part of his *Thrilling Cities* world tour. In his feature article on Tokyo, Fleming's remark on the popularity of 'facial surgery to remove the Mongolian fold and widen the eye' ([1963] 2013: 65), reveals the problematic appeal of Western culture in Japan, displaying a troubling desire to 'look' European:

> The girls are *aping* the West in countless other fashions. Long legs have become desirable, and those *hideous* wooden clogs have been exchanged for stiletto

heels. The Eastern hair-dos, which I find enchanting, are going out in favour of permanent waves and other fuzzy fashions. Traditional dress – the kimono and the obi, the complicated bundle of silk in the small of the back – is disappearing fast and is now worn, so far as the towns are concerned, only in the family circle, together with the giant cake of hair and *monstrous* hair-pins in the Madame Butterfly fashion.

<div align="right">Fleming [1962] 2016: 65; my emphases</div>

In spite of some appreciation for indigenous dress, Fleming's colonial bias is here barely suppressed. Tellingly, the replacement of certain aspects of traditional Japanese attire – 'those *hideous* wooden clogs' – with Western fashion is constructed as an act of colonial mimicry, where Japanese girls 'ape' Western trends.

The introduction of Western fashion between the latter half of the nineteenth century and the turn of the century, in fact, encountered at least some degree of suspicion in Japan. Although 'Western dress was progressive, cheap, healthy, safe, and convenient ... the kimono embodied the Japanese sense of beauty and femininity and was held to suit both the body and the appropriate behavior of the Japanese woman' (Francks 2015: 337). As the acknowledged distinction between *wafuku* (Japanese clothing) and *yōfuku* (Western clothing) persists in contemporary language (Assmann 2008: 361; Dalby [1993] 2001: 9), it seems evident that the survival of the kimono has had a lot to do with the preservation of a 'distinctive Japaneseness' (Assmann 2008: 361), in spite of the fact that the roots of the kimono are, in fact, not native to Japan, but China (Dalby [1993] 2001: 10). Rather than the garment *per se*, the actual techniques associated with kimono production – kimonos were always hand-sewn – and care – kimonos would be unstitched for cleaning, and sewn back together at home – point to the distinctly performative aspect of Japanese traditional dress and, by extension, identity.[7]

It makes sense, on every level, that Kissy wears an elaborate kimono in the masquerade that is her fake wedding to Bond (Fig. 8). This is to sanction that their union – and therefore Bond's stay within the Ama community on the island – abides by Japanese customs, of which the ceremonial dress is a powerful signifier, although the false pretences and, as seen in the previous chapter, Bond's 'yellowface' performance, simultaneously undermine the authenticity of the ceremony. In line with tradition, Kissy's kimono is white, with gold decorations; like the white kimono enshrouding a corpse, the bridal white kimono signifies the rite of passage from one life to the next (Dalby [1993] 2001: 191). This is a relevant reference to the film, and even more to Fleming's novel, haunted,

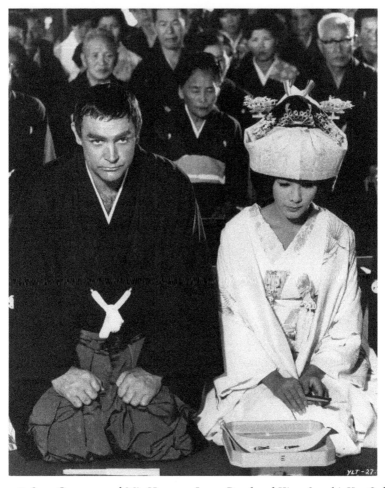

Figure 8 Sean Connery and Mie Hama, as James Bond and Kissy Suzuki, *You Only Live Twice* (Courtesy of GETTY/MOVIEPIX)

throughout, by death and mortality. The loose fit of the kimono, as well as being an important symbol of Kissy's identity, serves the purpose of screening her body from Bond's voyeurism. Her progressive undressing in the film, Funnell argues, coincides with her descent into the Lotus Blossom role, which relegates her to the object of Bond's gaze and desire (Funnell 2015: 83).

A more complex character emerges from the novel *You Only Live Twice*, which offers a more nuanced articulation of femininity in the context of Japanese identity, as well as exploring the question of foreignness. Kissy's first detailed description reveals the East/West divide with a strong degree of racial generalization:

Bond smiled into her *almond eyes* and had his first close-up of her *snub nose* and *petalled mouth*. She wore no make-up and did not need to, for she had that *rosy-tinted skin on a golden background* – the colours of a golden peach – that is quite common in Japan.... Her teeth were even and showed no more prominently between the lips than with a European girl, so that she avoided the toothiness that is *a weak point in the Japanese face*. Her arms and legs were longer and *less masculine than is usual with Japanese girls* and, the day before, Bond had seen that her breasts and buttocks were firm and proud and that her stomach was almost flat – a beautiful figure, equal to that of any of the star chorus girls he had seen in the cabarets of Tokyo.

<div align="right">Fleming [1964] 2009: 176–7; my emphases</div>

Kissy's beauty is stereotypically marked by her racial and ethnic identity, and, simultaneously, made to stand out over and above her race. In being depicted as 'Japanese', her Asian look is, however, 'mitigated' by European traits which make her (problematically) more attractive in Bond's eyes. Her body, similarly, is worryingly compared to the bodies on display in Tokyo cabarets. Significantly, however, Bond continues her description by noticing that 'her hands and feet were rough and scarred with work, and her fingernails and toenails ... were broken' ([1964] 2009: 177). That Bond finds these less than perfect aspects of Kissy's physical appearance 'endearing', along with 'the charm and *directness* of her eyes and smile as well as her complete *naturalness*' ([1964] 2009: 177; my emphases), however, invites a more complex reading of her character, and the kind of foreignness Kissy embodies.

Fleming's 1959 trip to Japan provided the cultural basis for the novel; the names of his chaperones – Australian Dick Hughes and Japanese Tiger Saito – are reflected in those of the novel's characters. Anecdotes such as the visit to the public bath-house, in particular, provide further insight into Fleming's fascination with the Asian woman and, more broadly, Eastern attitudes to sex. After receiving a massage by a twenty-one-year-old Brigitte Bardot look-alike Japanese girl in 'the shortest and tightest of white shorts' (Fleming [1963] 2013: 62), Fleming dispels any doubts about the moral boundaries of this Japanese custom:

> I may say that any crude Western thoughts I might have entertained during these processes were thoroughly washed from my mind by the general heat and exertions I was put through, but that is not to say that I was not vastly stimulated and intrigued by the whole performance.

<div align="right">[1963] 2013: 63</div>

The experience – and the girl's candid admission that 'bad men' would attend 'places on the Ginza' (Fleming [1963] 2013: 63) – leads to the conclusion that 'in

the East sex is a delightful pastime totally unconnected with sin – a much lighter, airier affair than in the West, where ... this account of my Japanese bath may shock' (Fleming [1963] 2013: 63). The 'cleansing' innocence of the Japanese public bath is, in his words, 'like going to the dentist. Pleasanter, of course' (Fleming [1963] 2013: 64).

In *You Only Live Twice*, similarly, in spite of Bond's 'crude Western thoughts' (Fleming [1964] 2009: 107), the bath experience retains a sense of innocence, further conveyed by Tiger's promise that 'you will arise from it what is known as "a new man"' ([1964] 2009: 106). This sense of rejuvenation returns when Bond travels to Kuro Island, to live with the Ama fishing community, and accomplish his mission to put an end to Blofeld's evil schemes on a nearby island. Upon first witnessing the simplicity of the Ama girls, Bond reflects that 'it all seemed ... as the world, as life, should be, and he felt ashamed of his city-slicker appearance, let alone the black designs it concealed' (Fleming [1964] 2009: 166). While this could be read as a conservative Western attitude towards this less developed corner of Japan, the idealized 'authenticity' of the Ama's rural lifestyle also poignantly offsets the forgery that is Blofeld's exotic 'garden of death', its deadly flora designed to exploit Japan's soaring rates of suicides.

Blofeld's introduction of non-native plants exported to Kyūshū under false pretences, signals the novel's concern with a problematic notion of foreign intrusion, and 'foreignness' as untrustworthy. This kind of foreignness is expressed, as already noted of the villains in the previous chapters, as excessive and potentially contagious if uncontained. Juxtaposed with Blofeld's aberration, and the distorted version of Japanese identity he performs, is the idealized 'exoticism' of the Ama diving women, who, significantly, have always occupied a special position in the construction of Japanese identity. As Tanaka explains to Bond:

> The Ama are a tribe whose girls dive for the *awabi* shells – that is our local abalone ... They dive naked. Some of them are very beautiful. But they keep themselves very much to themselves and visitors to their islands are completely discouraged. They have their own primitive culture and customs. I suppose you could compare them to sea-gipsies. They rarely marry outside the tribe, and it is that which has made them *a race apart*.
>
> Fleming [1964] 2009: 153; my emphasis

To the gaze of Japanese urban men such as Tanaka, the charm of the Ama rests on a romanticized view of their 'primitive' tribal lifestyle. The idealization of the Ama as 'a race apart', however, points to one of the inherent paradoxes pertaining the

Ama's position within Japanese society; while the Ama have been regarded as racially distinctive, they have also been heralded as quintessentially Japanese, precisely because of their distinctiveness. Yet, the suspicion that some of them might have in fact migrated from Korea signals an understanding of the Ama's Japanese identity based on the 'Japanese notion of race (*minzoku*), a term which can also be translated from the Japanese as "tribe" or "ethnos"'(Martinez 1999: 79). Inscribed in the Ama's naked bodies, it would seem, is the projection of a constructed cultural identity which, in turn, forms the basis of Japan's perceived racial difference from its neighbouring nation (Martinez 1999: 80). With ethnic dress and body adornment being one of the most common markers of ethnic differentiation, the Ama's naked body becomes its own ethnic signifier: nudity becomes clothing.

As Warwick and Cavallaro remind us, 'in the West, nakedness has been construed as proverbially disturbing, primarily because it acts as a particularly unsettling reminder of the body's boundlessness and diffusion' (1998: 139); similarly, Martinez notes that in Japan 'total nakedness (save in the bath) is taboo and ... the wearing of clothing appropriate to one's status in life is important' (Martinez 1999: 79). Yet, the Ama girls, as observed by Bond, 'wear' their nakedness in a way which speaks of the idealized simplicity of their lifestyle. Whether bare-skinned, covered by a loin-cloth or the 'rough brown kimono' Kissy keeps in her boat (Fleming [1964] 2009: 182), her nakedness speaks of the aestheticized nudity of visual art, where 'nudity stands for a successfully sanitized, refined and legitimately displayable material structure, safely emptied of all troubling vestiges of carnality' (Warwick and Cavallaro 1998: 139).

It is in these aesthetic terms that Kissy's nudity can also be read against the complex aesthetics of Japanese *iki*. Its most prominent theorist, Kuki Shūzō, suggests that *iki* is a set of aesthetic norms associated with the subtleties of Japanese 'coquetry'. As a flirtatious mode of performing chic, the emphasis on 'connoisseurship' and 'discretion', which make elegance less conspicuous but by no means less expensive (Dalby [1993] 2001: 59–61), shares similarities with the English dandy's 'conspicuous inconspicuousness' (Vainshtein 2009: 94). Although linked to the material and surface aspects of elegance, and especially associated with the geishas' fashionability of the Edo period (1603–1868), *iki* encompasses a more holistic, and deeper, approach to elegance which centres on a distance from the 'real' in favour of the ideal; as Kuki explains, for example, of the importance of slenderness to *iki*:

> The formal cause of '*iki*' is anti-realistic ideality. In general, were we to try and
> objectively express anti-reality and ideality they would tend to adopt a long slim

form. In addition to revealing the weakening of the flesh, the long slim form speaks of the power of the soul. . . . To the extent that 'iki' is spiritualized coquetry, its pose must be slender.

Kuki [1930] 1980: 27

In this sense, then, Kissy's slenderness, and her discreet beauty, can be framed by *iki* aesthetics, as can her nudity in conjunction with her diving; *iki*, Kuki explains, is also the sensual image of '*just having left the bath*. In carrying the recollection of the nude in its near past and having just casually dressed in a simple bath robe, this pose completes the expression of coquetry and its formal cause' ([1930] 1980: 26).

It is in this form of 'indirect' sexuality, that Kissy's nudity is constructed simultaneously as highly idealized and yet apparently natural. In this sense, too, Kissy's nudity is situated in direct contrast to Blofeld's body deceitfully camouflaged in a samurai costume. Instead, Kissy's lack of artifice signifies a kind of integrity, Bond fears, lost in the West, as reinforced by Kissy's rejection of the seediness of the Hollywood film industry which she experienced as a younger woman: 'they were all disgusting to me in Hollywood', she recalls of her acting days, 'they thought because I am Japanese I am some sort of animal and that my body is for everyone' ([1964] 2009: 179). In this context, it is telling that, when out fishing for the first time with Bond, she claims to be wearing a 'ceremonial dress for diving in the presence of important strangers', though Bond understands this is to do with her fear that her 'nakedness might arouse dishonourable thoughts in my impious Western mind' ([1964] 2009: 173).

While these conjectures may still point to the Ama girl as a Japanese incarnation of the 'noble savage' of Romantic philosophy and art, Kissy's nakedness is not the static nudity of visual art. Rather, it is the functional nakedness of a working body, which brings it back to the treatment of Kissy's ethnicity. While ethnic considerations pointing to the Ama's distinctive status in Japan include matriarchal customs and non-normative marriage conventions, theories about the Ama's racial distinctiveness have emphasized their physical prowess and underwater endurance (Martinez 1999: 88). Their physical abilities – joined with their matriarchal rule – contributed to a view of Ama womanhood in sharp contrast with the allegedly more submissive femininity of Japanese women. Until the mid-1980s, Ama divers 'were seen to be totally different from the ideal of modern womanhood: they were often described . . . as loud, big, brash, and bossy women' (Martinez 1999: 88–9). While not loud, in the novel Kissy is described as tall and direct, qualities which Bond admires,

but which also challenge patriarchal gender roles. Additionally, her physical superiority to Bond is demonstrated when he suffers from stomach cramps after a day's work with her. Furthermore, as Bold argues, it is she 'who steers Bond to and rescues him from Blofeld's Garden of Death' (Bold [1993] 2003: 172). Since her strength is bound with her Ama/Japanese (performative) identity, Kissy's foreignness marks her out not simply as different from, but in fact superior to Bond. Far from embodying the Lotus Blossom, the literary Kissy is a precursor of the empowered Asian woman, exemplified, four decades later by the cinematic Wai Lin.

'That would not be kulturny': fashion at the time of socialism

Fleming's early Bond reflects, as well as Fleming's own fascination with Soviet Russia, the polarized politics of the earlier Cold War; it is Bond against agents from SMERSH (Smert Shpionam), 'Death to Spies', the Soviet counterintelligence agency working against the British Secret Services. Later, however, Fleming 'invented SPECTRE as an international crime organization which contained elements of SMERSH and the Gestapo and the Mafia' (Fleming 1964: 106), in answer to the shifting political climate of Soviet Russia under Nikita Khrushchev's leadership. While some of Khrushchev's policies aimed to mitigate the rigidity of Stalin's rule and launch a partial opening to the West, his attitude to the arts, and the state's control of fashion remained largely in place.

Fashion had been a controversial subject in Soviet Russia since the Bolshevik Revolution of 1917. Having rejected Western fashion as the deprecated symbol and practice of backward gender politics and bourgeois mentality, Constructivist artists attempted to design new clothes in the name of rational dress; in particular, the designs by Varvara Stepanova aimed to showcase the mechanics of production, so that a new kind of dress, industrial, mass-produced and functional, would, in itself, embody modernity and the departure from complex and craft-based clothing: 'the constructivists shared with their Western contemporaries an urge for change, a drive toward novelty' (Bartlett 2010: 18). Indeed, the aesthetics of early Soviet dress had much in common with the principles behind the futurist designs of the West, such as Thayaht (Ernesto Michahelles)'s *TuTa*, the cost-effective one-piece overalls presented in Italy in 1919 (Gnoli 2014: 42). Soviet dress was also influenced by the 'fashionable cubist-style Western dress' (Bartlett 2010: 18), echoing other collaborations between art and fashion in the works of Elsa Schiaparelli and Coco Chanel (Gnoli 2014: 41).

Evoking the Futurist notion, claimed by Volt's *Manifesto della moda femminile futurista* (1920) that 'fashion is the female equivalent of Futurism' (qtd. in Braun 1995: 39), Bolshevik fashion challenged the conventional view of femininity allegedly endorsed by Western fashion: 'feminized bodies, and femininity itself, were considered to be not only bourgeois, but alienated in the ontological sense because they were artificial in the first place', writes Bartlett (2010: 33). Being fashionably feminine in 1920s Soviet Russia, therefore, was a self-conscious act of political negotiation, as 'the feminine woman was forced into the position of a permanent Other' (Bartlett 2010: 34). Subsequent phases in Soviet fashion complicated the regime's approach to Western fashion and the construction of Soviet femininity. Under Stalin, Soviet Russia established its own fashion regime, which, in line with wider isolationist politics, relied on a centralized approach to the industry, 'conservative aesthetics and traditional femininity' (Bartlett 2004: 128). After Stalin's death in 1953, while Khrushchev attempted to relax the Soviet bloc's antipathy to Western fashion, his project was, nevertheless, stuck between the desire to maintain a Soviet identity in fashion and the temptation to open up to the West.

Published in 1957, Fleming's *From Russia with Love* is situated precisely within this shifting context. This was also the year that Moscow hosted the Eighth Fashion Congress, an event in which six socialist countries participated, and which represented the Soviet Union's cultivation of the loyalties of its middle class through some strategic concessions to its desires, including, fashion. That things changed visibly throughout the 1950s is also demonstrated by the contrasting accounts of Western reporters. American journalist John Gunther, who visited Russia in 1935, 1939 and 1956, on his last visit noted that, although clothes 'have certainly improved in the last few years ... they are still revolting' (1958: 65). Gunther provided an admittedly contradictory analysis of the development of a Soviet fashion consciousness; while noting that 'Russians are ... acutely conscious of the clothes foreigners wear' (1958: 65), he also claimed that Russian drabness is a matter of national pride:

> Clothes are bought for utility, not for looks; pretty colours show dirt more than black, which is why black predominates. Clothes have no shape; but then neither have most Russian women. Moscow would look a hundred per cent better if every citizen lost thirty pounds.
>
> Russians may be jealous of the clothes Western visitors wear, but seldom admit it ... Some dedicated Russians are, I would say, actually proud of their plainness, even of their poverty. They *like* hardship. That mildewed suit is a badge of honour, because it proves virtue and sacrifice.
>
> 1958: 65

It is difficult to agree that anybody would, given the choice of an easier lifestyle, 'like *hardship*', and even Gunther noted the sense of jealousy towards the luxuries of the West. Such cravings are in fact well captured in the account of Harrison Salisbury, whose last visit to Russia in 1959 just a few years after Gunther's, proves certain things were already changing in conspicuous ways. While, in the late 1940s, the Eastern bloc had rejected Dior's 'New Look' as 'tasteless and anachronistic' (Bartlett 2004: 136), by the time the House of Dior presented its first collection in Russia in 1959, the reception could not have been more enthusiastic:

> Within a week or two you began to see girls on Gorky Street wearing imitations of the more simple Dior styles. Spike heels appeared, dreadfully expensive, in the new House of Shoe Styles. The demand for sheer Western nylons became greater than ever. On the bathing beaches Russian girls began to wear dressmaker suits, of good quality, form-fitting, rubberized silk.
>
> Salisbury 1959: 47

In *From Russia with Love*, Tatiana (Tania) Romanova belongs precisely to this nascent middle class: well-educated, with a good professional job, and the material aspirations of a deprived *bourgeoisie*.

The novel's important fashion subtext frames Tania's defection as an act of emancipation dictated by material needs and appetite. Despite her status, Tania still needs to skip dinner to save money and replace her 'well-worn Siberian fox' (Fleming [1957] 2004: 67). While her taste for fur marks her adherence to the politics of official socialist dress – the fur trade being one of the celebrated points of the Soviet clothing industry (Bartlett 2004: 135) – she is also sensitive to the appeal of Western fashion, as referenced by her attempt to model her hair like Greta Garbo's: 'fine dark brown silken hair brushed straight back from a tall brow and falling heavily down almost to the shoulders, there to curl slightly up at the ends (Garbo had done her hair like that and Corporal Romanova admitted to herself that she had copied it)' (Fleming [1957] 2004: 68). Later, when she sneaks into Bond's hotel room (and bed), her flirtatious question – 'Am I as beautiful as Western girls? I was once told I look like Greta Garbo' (Fleming [1957] 2004: 180) – further confirms that her fashion compass is orientated towards the West. Stuck between her duty to the Soviet State, and the desire to take control, Tania's sartorial trajectory in both novel and film is representative of the frustrations and aspirations of Soviet fashion, and its ambiguous dealings with the stylistic temptations of the West.

In a typical demonstration of the inconsistent approach to the non-linear progression that regulates fashion change, at the end of the 1950s Soviet Russia

rejected the excessiveness of the designs of Dior and Balmain – and the conservative type of femininity they allegedly represented – in favour of Chanel's more streamlined style. Simultaneously, however, the regime also favoured 'timeless' classic designs, drawing, for inspiration, from ancient Greece:

> Official socialist dress had an exclusive task: to develop a new sartorial classic, which would fulfill the laws of classical beauty and harmony. Socialist fashion would then escape the constant change of decadent bourgeois fashion and become as eternal as classical art.
>
> Bartlett 2004: 140

With some variations, these processes applied not just to Russia, but all nations within the Eastern bloc. Though set three decades after the establishment of such guidelines in Soviet fashion, such penchant for the classic designs of ancient Greece is visible, for instance, in *The Living Daylights* (1987), where Slovakian cellist Kara Milovy (Mariam D'Abo), whose ordinary wardrobe features the plain ensembles of Socialist dress, falls for a blue Greek-style cocktail robe at a Vienna hotel shop. The precious design by Lawrence Easden is embellished with clear glass and blue tasselled beads and a Greek key motif to emphasize its classicism. But Kara's desire is curbed by cost-awareness, as well as class-consciousness and propriety (Gurova 2009: 74):

> Bond: Do you like it?
> Kara: For princess, or wife of commissar?
> Bond: Let's buy it.
> Kara: Don't joke. Who will pay?
>
> *The Living Daylights* 1987

Although, in theory, socialism rejected individualism and social difference, in practice, socialist dress code dictated the appropriate dress for each class, a rule also implicitly put into practice by the cost of luxury items which, effectively priced everybody but the elite out of that market.

That access to more expensive fashion was the privilege of a specific kind of elite is manifestly shown in the contrast between the sartorial glamour of Xenia Onatopp (Famke Janssen) and the plain ordinariness of Natalya Simonova (Izabella Scorupco)'s wardrobe in *GoldenEye*'s post-Socialist Russia; as playfully noted in *Vogue*, '[Natalya] is costumed not in the traditional Lycra catsuit or floss bikini [of a Bond Girl] but in a simple black skirt and one of the little blue French Connection cardigans so widely available in Siberia' (Friend

1995: 170). But on the other side of social divide, Xenia's more extravagant costumes and luxurious Western accessories, which are discussed in more detail in the next chapters, reflect her affiliation with the corrupt military elite led by General Ouromov (Gottfried John).

By the end of the 1950s, Soviet fashion propaganda focused on the establishment of Socialist good taste, a sort of etiquette that would retrain women to dress properly but without following the rules of Western fashion: 'The new rules were simple and were preached by socialist women's magazines ad nauseam', Bartlett reminds us, 'shoes and handbags should match, more than three colors should never be used in an outfit, be pretty but do not overdress' (Bartlett 2004: 148). Such rules – and the pedagogic tone used to convey them – were the legacy of an earlier fashion moment; whereas after the Bolshevik Revolution, the regime had been concerned with taking steps against a lack of hygiene, 'by the 1930s, when elementary rules had been internalized by the majority of people', Gurova notes, 'publications took the next step, to issues of "culturness" [sic] (*kul'turnost'*), explaining how to behave in public, how to use perfume and makeup, and how to dress' (2009: 73).

In her first scene with Bond, when he asks Tania 'did you come down in the lift like that?', her playful response – 'Oh no. That would not have been kulturny' (Fleming [1957] 2004: 179) – suggests that she – and Fleming – is well aware of the cultural etiquette expected of the middle class in Soviet Russia. On the Orient Express, Tania's 'Soviet' sophistication expressed by her matching 'black crocodile belt and shoes' (Fleming [1957] 2004: 189) clashes with Red Grant/ Captain Nash's 'tie with a Windsor knot' (Fleming [1957] 2004: 223); Tania's gut-feeling – 'He's not kulturny. I do not trust his eyes' (Fleming [1957] 2004: 229) – is in fact based on the cultural diktats of the Soviet regime. In the film, whereas Nash makes a passable sartorial impression on Bond, his uncouthness is revealed at the dinner table, when he orders Chianti – the 'red kind' – with his trout.

The clash between the 'excessive' luxuries of the West and a Soviet taste regulated through 'rational consumption' is at the heart of Tania's sartorial evolution in *From Russia with Love*. The position of her superior, Rosa Klebb, lies within the ideological remit of 'rational' consumption, which, following the Soviet strategy of regulating consumption under Khrushchev's leadership, allowed for a partial relaxation of Stalin's austerity. The aim of the domestic advertising in place from the late 1950s, for instance, 'was not to generate inauthentic and insatiable consumer demand, as in the capitalist west', Susan Reid notes, but 'to promote "rational consumption" and to predict and manage

popular desires' (2002: 218). Such notion of 'rational consumption' applied to all fields of consumption, including fashion. It is telling, in the light of these internal political developments, that, when Klebb discusses the delicate task of seducing Bond, she uses the language of property and consumption. While affirming the state's control over the individual – 'Your body belongs to the State' (Fleming [1957] 2004: 82) – Klebb's strategy displays her acute awareness of the nascent appetite for luxury goods: 'You will be equipped with beautiful clothes', she promises Tania (Fleming [1957] 2004: 82).

Pleasure, then, is constructed as the prerogative of Western capitalism, which caters to an individual's appetite for the things the Soviet State controls. By the late 1950s, the Soviet regime had understood that 'the middle class needed symbolical legitimating', Gurova notes, 'and, to remain loyal, it needed a good life, which it was able to acquire through consumption and lifestyle which included ex-bourgeois elements such as fashion, glamour, luxury, coziness, and pleasure' (2009: 77). It follows, then, that in her attempt to convince Tania of the benefits that would come with the mission, Klebb self-consciously constructs the West as the expansive space of consumerist modernity – 'all those beautiful clothes, the jazz, the modern things' ([1957] 2004: 78). The intimate topic of the ensuing conversation, and Klebb's own queer sexual overture at the end of the scene – discussed in more detail in Chapter 4 – signal the convergence of Tania's two kinds of appetite – fashion and sex – into one, hinting to the possibility that the West is able to cater to both.

Indeed, Tania is framed, from the start, as a liminal character ambiguously positioned between East and West in a story initially set in that geographical Euro/Asian borderland that is Istanbul, to gradually travel West through the contested area of former Yugoslavia: 'as she moves from Istanbul to Paris, ... [Tania] is transformed by sex with Bond from an enemy to an *émigré*, a Soviet to a Westerner, and a communist to a consumer' (Barrett 2015: 42). It is, significantly, on the train journey that Tania's appetite for Western things is epitomized by her 'excessive' consumption on every level, including sex with a Western spy, but also food, as made obvious by her comment after a meal of '*tagliatelli verdi* [sic]' and 'a delicious escalope': 'Oh it is so good ... Since I came out of Russia I am all stomach' (Fleming [1957] 2004: 229). Such self-awareness of presumed changes to her body-shape due to the richness of Western food implicate a wider anxiety about uncontrolled Western consumption, in ideological opposition to 'sensible' Soviet restraint.

The film *From Russia with Love*, however, offers a reading of Tania's consumption which challenges both the control strategies of Soviet Russia and its

exploitation by the West. Whereas in the novel, it is Klebb/SMERSH that 'equips' Tania with the right clothes for the job, in the film, it is significantly Bond who, when Tania complains about not having any clothes for their Orient Express honeymoon trip, surprises her with a suitcase full of boudoir fineries. Significantly, while Tania cannot keep her hands off her new garments, Bond's curtness attempts to curb her enthusiasm. Tania's sartorial awakening, however, is such that she appears to temporarily lose her sense of *kulturny*, as shown by her intention to wear a satin and lace negligee 'in Piccadilly'. In keeping with his role as harbinger of patriarchal control, Bond's response – 'They have passed some new legislation about that' – exposes Tania's *faux pas*, but also, tellingly, his anxiety about her 'unrestrained' appetite and carefree disregard for social norms.[8]

The journey may indeed signal Tania's falling for the West while cheating on the East, but her defection has, arguably, more to do with fashion than sex. Tania's coming of age, in this sense, happens in Venice, where she is fashionably clad in a pistachio-green skirt-suit and canary-yellow sleeveless blouse; although we do not see her shop in Italy, we assume that she, rather than Bond, has been responsible for her sartorial choices. Her style distances her from Soviet fashion, which, in the later stage, aimed to orientate women's taste towards safer and more sustainable options than the most outrageous, and fickle styles of Western fashion: 'Bright colors were under suspicion since they were considered more emancipative', Gurova reminds us, 'whereas neutral colors had a more reliable reputation' (2009: 83). Although, by the end of the 1950s, Soviet fashion, through an assiduous campaign in taste education, had been working towards the establishment of a 'controlled version of femininity' (Bartlett 2004: 148), its notion of feminine attractiveness did not, however, impact the importance of female productivity in Soviet society (Reid 2002: 232); not just the passive recipient of the male gaze, women kept a strong active role within the Socialist economic system. While Tania's 'risqué' sartorial experimentation signals – through her assertive consumption of Western fashion – her emancipation from SMERSH and the Soviet Union, she also fulfils, in a way, the active role she has been trained to perform. As she saves Bond's life by shooting Klebb, she effectively emancipates herself from the Western male gaze by paying Bond back for his earlier favours. This is also made clear in the subsequent scene when Tania duly returns her wedding ring, part of the set she and Bond wore on the Orient Express to keep their cover identities as Mr and Mrs Somerset. With an open renouncement of marriage, the formulaic embrace at the end of the film does not leave Tania as the fashion/sex victim of the West/Bond, but as a pleasure-seeking consumer of both (see also Barrett 2015: 41).

Mode sans frontiers?

Bond narratives have often attracted criticism for their regressive treatment of gender and race. On one level, the Bond novels and films are structured around the binary opposition between Bond's white English masculinity and foreign villains and Bond Girls. Although Bond is destined to win – and get the girl – there is another way of reading the politics of gender, race and ethnicity within this formula.

Against the colonial hierarchy that places Bond on top, foreignness in fact poses significant challenges to a system that would put the colonized woman at the bottom of the Empire's political order; ethnic minority Bond Girls expose the white agent's anxiety about the Other, as well as the 'lacking' foundations of white ethnicity. The colonial gaze Bond casts on them, therefore, frequently reveals the blindness of prejudice dictated by fear and uncertainty.

Ethnicity and race are visible features of Bond Girls on both page and screen. While details of ethnic dress and racial traits can be the manifestation of Bond's conservative standpoint, written on Bond Girls' bodies, and their clothes, is also the subversion of his colonial and patriarchal gaze. Mediated through clothing, identity becomes a matter of fluid performance and self-determination, rather than categorical definition, while the multiple fashion systems Bond Girls negotiate encourage a more nuanced reading of 'foreignness' and the function of 'exoticism' in fashion.

3

'Cross-Dressing':
From the Field to the Boardroom

Racy underwear, skimpy bikinis, glamorous evening dresses. That is all, in the popular imagination, a Bond Girl's wardrobe needs to hold; even under the 'Fashion Superstars: Kick-ass Style-Inspiration' heading of a *Vogue* 2003 article, we read that 'Bond Girls favour all things short and sleek' (Comita 2003: 227). Revealing garments certainly have been – and continued to be – a conspicuous part of the sartorial entertainment especially on display in film. In recent years, fashion reviewers have also, however, taken notice, of the twenty-first-century Bond Girls' move away from costumes that would signal their sexual objectification: 'it was no longer enough for a dress to be backless, strapless, slashed down to the navel and up to somewhere south of the upper-thigh', commented Celia Walden, 'instead, producers used military uniforms … and PVC catsuits … to bring the girls into the 21st century' (2008). This is, in fact, nothing new. As women involved in field action and professional assignments, Bond Girls have dressed for mobility and comfort from the start, and trousers, jumpsuits, and professional uniforms are as important a portion of their wardrobes as their sexy little numbers.

The time frame of Fleming's novels and the earlier films makes the presence of trousers an unconventional addition to Bond Girls' wardrobes, and this reflects the history of Western fashion's tense relationship with the feminine adoption of masculine clothing. That such 'cross-dressing' – as trouser wearing would have been thought of throughout the early twentieth century – blurs gender boundaries is demonstrated by cultural debates from the nineteenth-century Women's Dress Reform to the late 1970s power-suit controversies. The phrase 'to wear the trousers' dates back to 1931 (*OED* 2019), when, after the First World War, female emancipation had become associated with bifurcated garments worn by women in a diverse range of contexts, from factory work to bicycle travel. While trousers became an increasingly common feature in women's everyday wardrobes from the late 1960s, literary Bond Girls have sported masculine attire from the 1950s to the present day; from Pussy Galore's

'gangster style' suits to Xenia Onatopp's combat gear, Bond Girls play a vital role in the sartorial journey of fashion's cross-dressing.

A particular aspect of the cross-dressing practice, and as distinctive a legacy of the war, the uniform, though not always strictly unisex, nevertheless interrogates the construction of gender roles based on binary systems of sexual differentiation. Following on from the enhanced female presence in previously masculine domains including factory and armed-forces work during both World Wars, the problematic introduction of women's uniforms goes even further in conveying not only a challenge of gender binarism, but also a departure from patriarchal heteronormativity. The notion of 'sameness' implicit in the uniform can function, simultaneously, as cross-gender and homoerotic transgression, as exemplified in the queer subtext of films such as *Goldfinger* and *Octopussy*.

Reporting from Cannes Film Festival where *The Living Daylights* was presented in 1987, Helmut Newton unveiled 'a clothed but sexy back view of Maryam D'Abo, the new James Bond girl' (Newton 1987: 323). Wearing a Comme des Garçons white shirt, black bow tie and monocle, D'Abo, in fact, is more the Parisian lesbian than the Hollywood 'Bond Bombshell' announced in the headline, a contrast suggestive of the conflict between heteronormative expectations of female sexuality and, simultaneously, its queer subversions. But, as the politics of female dress still affect the lives of Western women from the religious sphere to the corporate world, fashion's vested interest in androgyny continues to be problematic: 'when women are told our new style icon is an adolescent male ... a message is sent that we women will never be worthy, by the sheer and inconvenient facts of our bodies' geographies', laments *Elle* contributing editor Faran Krentcil (2015). Yet fashion's interrogation of gender boundaries continues, today, to take on more pervasive forms of cross-dressing with models such as Casey Legler, Andreja Pejic, and Elliott Sailors breaking through the gender divide on the catwalk. As trousers are now most commonly worn by women worldwide, nevertheless 'there continues to be a fascination with women in "men's clothing"', argues Laura Horak (Horak 2016: 224); Bond Girls are part of this fascination, and a close analysis of their costumes points to a kind of hard femininity made of physical fitness, dynamic action, and professional rigour.

Dressed for action

In *The World Is Not Enough*, Elektra King (Sophie Marceau) jumps off a helicopter to ski down the Caucasian peaks surrounding her family oil pipeline. Her two-

piece burgundy ski suit lined with black fur collar looks expensive – it is inspired, as Hemming's sketch reveals, by popular 1990s designer Sam de Teran (Cosgrave et al. 2012: 184). Most importantly, it draws attention to the effortless elegance of her skiing, as she literally trail-blazes ahead of Bond, who keeps the pace in a less noticeable khaki ski suit. The scene owes much to the ski chase in *On Her Majesty's Secret Service*, where Bond skies down the Swiss Alps near St Moritz with Tracy (Diana Rigg), who is also an accomplished ice skater; in Fleming's novel, it is down at the ice rink that a badly injured Bond is reunited with Tracy, 'a girl in a short black skating-skirt topped by a shocking pink fur-lined parka, [who] sped like an arrow across the ice and came to a crash stop in front of [him]' ([1963] 2009: 208). To Bond, the combination of sophistication and fitness

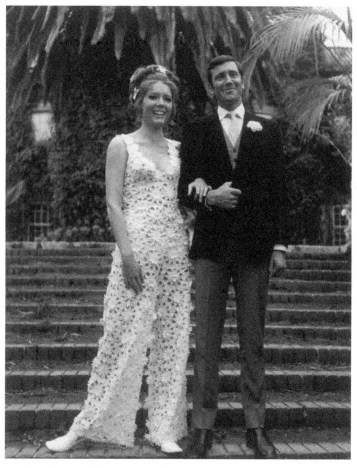

Figure 9 Diana Rigg and George Lazenby, *On Her Majesty's Secret Service* film-set (Courtesy of GETTY/CORBIES HISTORICAL)

in Tracy's style – 'The fur of the parka smelt of Guerlain's "Ode"' – is here less of a frivolous detail, than an essential source of life support after his escape from Blofeld's Piz Gloria's lair: 'What a girl! The thought of her, of having an ally, of not being on his own, of being away from that bloody mountain, revived Bond' ([1963] 2009: 209).

That Bond Girls are athletic and competent sportswomen – in *Dr No* and *You Only Live Twice* Honey and Kissy are both excellent free divers; in the film *Goldfinger* Pussy Galore floors Bond in a judo move – can be traced back to Muriel Wright. Fleming's lover until her death in an air raid in 1944, Wright is the fitting archetype for the combination of style and physical strength that Bond Girls have come to stand for: 'pretty and lively, with a pert figure ... her fresh face reflected her enthusiasm for the outdoor life', writes Lycett. A competitive sportswoman, 'she skied like a dream, rode to hounds and was one of the leading female polo players in Britain' (1995: 82–3). Although endowed with family money, Wright also worked in the fashion industry, displaying a pioneering interest in sports clothing:

> Her speciality was showing off sports clothes, particularly the latest ski fashions. She also did beachwear: photographs of her modelling a bikini on the promenade at Monte Carlo in August 1939 are so unselfconsciously sexy that they might have been shot half a century later.
>
> Lycett 1995: 83

Like the fictional Bond Girls that she would allegedly inspire twenty years later, Wright had courage, as well as physical ability and looks, on her side; during the war she worked as an air warden and, later, as a motorcycle dispatch rider for the Admiralty.

In the 1930s Wright's modelling career saw her as 'one of the first women of her class in this field' (Lycett 1995: 83); interest in sports among middle- and upper-class women was beginning to expand, as the fashion industry acknowledged the enormous influence women's involvement in sports had played on their sartorial and physical habits. Wright's biography and other evidence from the history of dress suggest that the increased mobility afforded to women by sport and transport innovations had influential repercussions on patriarchal social conventions and gender norms: 'it was sports that brought women out-of-doors into new activities that took them away from their housebound roles' Patricia Campbell notes, 'and when sport was mixed into the potent broth of higher education, the heady brew changed women, and certainly their clothing, forever' (2006: 5).

In contrast to the long-lasting effects that the practical requirements of physical exercise had on female dress, ideology-led bifurcated garments at the end of the nineteenth century' were short-lived: 'theoretical garments – the Bloomer, divided skirt, rational, and such like – obtained no large measure of success; they were not necessary' (Hillier 1893: 213). The alternative 'Turkish dress' tag – attached to trousers because of their resemblance to eastern female dress – did not do these prototype trousers any favours, as 'some critics branded the costumes heathenish because of their associations with Islam' (Fischer 1997: 128; see also Kidwell and Steele 1989: 14); in these early days of female Dress Reform, women in trousers were therefore both 'masculine' and 'foreign'. It was the practical needs of movement, rather than feminist ideology, that played an influential role on the historical changes to women's dress; this is why bloomers were quickly supplanted by the invention of the Bessemer steel crinoline, which allowed for a reduction in the bulk of underskirts: 'Amelia Bloomer herself ... [was] converted to this easy compromise of a traditional silhouette and greater ease of movement' (Petrov 2016: 404).[1]

Though later associated with female emancipation, women's appropriation of 'masculine' trousers originates from the requirements of sports and, in particular, riding. In the film *On Her Majesty's Secret Service*, Tracy's physical fitness is showcased in the traditional Portuguese horse-riding outfit, the wide trousers of which evoke the introduction of bifurcated garments in response to the evolution of female 'riding' dress. At the end of the nineteenth century, combining physical exercise and increased mobility, as Helene Roberts reminds us, 'bicycling ... proved to be the most popular and the most liberating sport. It gave women an independence of movement both in the use of their limbs and in the ability to transport themselves over distances' (1977: 568). But the bicycle was, from the beginning, bound up with the question of female dress reform:[2] 'the chief question concerning cycles and women in the late 1800s was not, "Shall they ride?"', Robert Poole notes, 'the question was "How shall they ride?" with their long skirts and frail personages' (1989: 958). Significantly, the link between trousers and mobility would be picked up again by the youth-centred fashion revolution of the 1960s: 'A go-kart is the next best thing to a pair of wings', read the 'Young Idea' section of *Vogue* in 1961, at the same time as it claimed 'there's nothing better than culottes any time of the day, or evening' ('Young Idea' 1961: 47); trousers would become associated with a model of dynamic femininity popular from the 1960s onward.

Trouser-wearing Bond Girls are also unmistakeably connected with action and fitness. In *Thunderball*, Fiona Volpe (Luciana Paluzzi) kills Count Lippe by

firing a rocket from her BSA Lightening motorbike; her leather suit and helmet ensure both anonymity and safety for the success of her assignation. In *Tomorrow Never Dies*, Lin co-rides a motorbike with Bond. Significantly, Martin Asbury's initial storyboards feature a skirt-clad Wai Lin (Simmonds 2015: 244); the display of her naked legs wrapped around Bond's body gives the scene a distinctly sexual focus, which supports a notion of passive female exhibitionism. In the film, however, trousers replace the skirt, giving Lin more mobility, and lending the scene a sharper focus on action (see Funnell 2014: 43), in contrast to the erotic tension of the storyboard. The 'masculinization' of Lin's costume is reminiscent of the transition of female dress from skirts to trousers, as the conscious choice made about her trouser costume is directly linked to female mobility; in doing so, the costume significantly undermines the Bond/Girl divide, gesturing to the fraught gender politics of reform dress, and the links between female mobility and emancipation. It seems hardly a coincidence that in a protest against the proposed admission of women to the University of Cambridge in 1897, male students hung the effigy of a woman on a bicycle, even though – or perhaps especially because – 'by the end of the 19th century, bicycles had become symbolically linked to women's suffrage, in a way that is often forgotten today' (Abrahams 2015).

Precisely because of the resistance they encountered along the way, the revolutionary changes in female dress in the first half of the twentieth century are a tribute to women's agency. While the availability of new products such as the Burberry 'free-stroke coat', especially designed for golfing women, demonstrated women's demand for an active lifestyle (Ewing [1974] 2014: 43), changes to female dress also arose out of female competitive sport. In 1905, tennis player May Sutton risked losing a match because of 'the flash of ankle revealed by a shorter-than-customary skirt, and ... her bare lower arm exposed by a daring short-sleeved blouse' (Warner 2006: 51), whereas in 1919 Suzanne Lenglen famously played in a shorter dress skirt worn with no stockings or petticoat (Craik 2005: 155). Both played against Dorothea Lambert Chambers, who, though retaining a longer skirt on the court, reminded the readers of her manual, *Lawn Tennis for Ladies* (1910), that 'it is essential to ... [have] ... free use of all your limbs; physical action must not be impeded in any way by your clothing' (Lambert Chambers [1910] 1912 64, 69). In other sports, such as hiking and cycling, the shortening of skirts, aiming to bring women's clothes to the same level of modern practicality as men's clothes, eventually paved the way for trousers (see Warner 38, 41), and the sports suit.

Both as an overall garment or two-piece ensemble, in its multiple adaptations as tracksuit, jumpsuit, and leotard, the casual suit was born out of the desire to

create a versatile garment that was both inexpensive to produce and easy to wear. Signalling a break with the fashion excesses at the turn of the century, in its streamlined simplicity, it was the embodiment of modernity and an innovative way of conceiving fashion inspired, simultaneously by social factors and the new *avant-garde* aesthetics. While Thayaht's Futurist *TuTa* soon became associated with the nationalist right-wing politics of fascist Italy, in Soviet Russia similar utilitarian concerns were reflected in the *prozodezhda* models by Varvara Stepanova (see Bartlett 2010: 18 and Martin 1998: 128). Here the emphasis was placed on mobility and comfort: 'The clothing of today', Stepanova argued in an article published in the *Soviet Left Front of Arts* journal (*Lef*, 1923), 'must be seen in action' (qtd. in Bartlett 2010: 18).

While Stepanova and her husband, constructivist artist Aleksander Rodchenko, both rejected fashion as a commodity-led industry of the West, their thinking and designs proved to be influential beyond the Soviet scene. With Elsa Schiaparelli designing *haute couture* boiler suits and jumpsuits in luxury textiles from the 1930s onward, action met elegance in a modern projection of femininity. That Schiaparelli is also regarded as the inventor of the more formal 'power suit', which is discussed in more detail at the end of this chapter, is suggestive of an important link between female empowerment and designs which dress the female body in practical garments designed with movement in mind (Bolton and Koda 2012: 27). By the mid-1960s, the decade's 'youthquake' had conquered the fashion world, and with that, garments which emphasized the legs came to the forefront; alongside miniskirts, trousers, jumpsuits and leotards drew unprecedented attention to women's lower bodies: 'Now the body itself is the great fashion-power – the long flow of the body-line, strong, supple, beautiful – the look of youth; not hampered, but freed by what it wears' ('This is the Body' 1965: 76). Since the 1960s, the aesthetics brought in by jumpsuits, overalls, and tracksuits have become synonymous with an active lifestyle, and a modern elegance, combining the comfort of sportswear with the toughness of combat and industrial gear. Indeed, commenting on fashion's most recent flirtation with the boiler suit, Spry Workwear founder Daisy Bridgewater locates the garment's appeal in its subversive gender politics: '[it] is empowering: wear a boilersuit and you are dressing for yourself, not the male gaze' (qtd. in Ferrier 2019).

In the Bond narratives, casual/sports suits serve to construct Bond Girls' glamour as distinctly active. In *Tomorrow Never Dies*, Lin spectacularly walks down Carver's Danish Headquarters thanks to a special silver bracelet which allows her 'to fire a piton ... with such velocity that its grappling iron claw sticks firmly to a metal post, thus enabling her to walk safely where others would need

to abseil' ('The Legend of Q' 2003). In this and the final scene of the film, where Lin displays her strength and skill in combat, she wears a PVC catsuit and heavy-duty boots inspired by *The Avengers*' Cathy Gale, played by Honor Blackman prior to her role as Pussy Galore in *Goldfinger* (Cosgrave et al. 2012: 164), and reminiscent of the leather suit worn by the preternaturally strong May Day in *A View to a Kill*. Lin's heels, just like Bond's shoes, are not designed for sheer adornment but with the practical requirements necessary in action: they conceal ninja throwing stars. In *Die Another Day*, Jinx's action in Graves's ice palace is facilitated by a burgundy leather 'biker-type suit' accessorized with a knife belt and boots (Cosgrave et al. 2012: 166). The costume worn by actor Maria Grazia Cucinotta in *The World Is Not Enough*, rust leather jacket and matching trousers, though technically not a jumpsuit, achieves the same seamless aesthetics in the fatal speedboat-to-hot-air-balloon chase along the river Thames.

These 'utilitarian' properties of casual/sports clothes gesture to their 'egalitarian' quality: 'like unisex uniforms, they challenge binary gender norms' (Craik 2009: 272). In their negotiation of sexual difference, casual and sports gear can function as a unisex uniform making a claim of gender equality by erasing sexual difference from clothing. In the film *Moonraker*, Dr Holly Goodhead is, in spite of her ridiculous name, a serious scientist. The astronaut uniform she wears when she poses, with Bond, as one of the Moonraker pilots exemplifies the possibility of gender neutrality where the functional quality of clothing supersedes the function of display. Likewise, Xenia's combat outfit at the end of *GoldenEye* displays the robust features expected of modern-day armour: reinforced shoulder pads, wrist and waist leather support and Harley Davidson biker boots (Cosgrave et al. 2012: 148). Apart from the breathable mesh fabric of her top, there is little concession to voyeurism, which is just as well: the pace of the scene does not allow viewers any leisure to contemplate Famke Jansen's body before Xenia is inevitably dispatched.

As sportswear and, in general, trousers, facilitate action, they also project an image of active resilience. The tough outer shell of Bond Girls' costumes, in other words, draws attention to inner strength; the female body becomes armour, and physical strength points to a kind of 'hard femininity' in spite of Bond Girls' 'damaged' condition (see Eco [1979] 2007: 154–5). This is made particularly evident in Fleming's *Diamonds Are Forever*, where Tiffany Case's apparently playful name reveals a history of female abuse and exploitation; abandoned by her father because of her sex, at sixteen, Tiffany is gang-raped, as a consequence of her mother's refusal to pay protection money to the local mob ([1956] 2004: 68). In spite of her difficult background, it is Tiffany's tough resourcefulness that

impresses Bond as she rescues him from Spectreville: 'My God, you're a *girl!*' ([1956] 2004: 170; my emphasis), he praises, drawing attention to her gender as a source of power.

Significantly, in the scene, Tiffany's masculine clothes – 'slacks and a shirt' ([1956] 2004: 170) – blur the Bond/Girl divide, signalling a role reversal. Her sartorial armour sets her against a wounded Bond, whose vulnerability is overtly expressed by the damaged state of his clothes: 'his coat was gone. One of his shirt sleeves hung in tatters' ([1956] 2004: 173). While Bond's 'passport and note-*case*' – the material proof of his identity and status, 'were cracked and dented' ([1956] 2004: 173; my emphasis) – Tiffany *Case* is far from broken by the ordeal. As Bond admits: 'It was the girl who had got him there. But for her he would never have kept a straight course' ([1956] 2004: 178). Momentarily, at least, Tiffany becomes the story's action hero, an idea symbolized by her temporary appropriation of Bond's gun, concealed in her trousers; when he holds his gun again, Bond feels 'the warmth of her on the metal' ([1956] 2004: 170).

The specific combination of clothing designed to support the active body and the notion of a new, hard femininity were central to the 1960s youth revolution as expressed, in particular, by the works of designers such as André Courrèges: 'a woman's body must be hard and free. Not soft and harnessed. The harness – the girdle and the bra – is the chain of the slave', he would say (qtd. in Giraud 1965: 110). The hard/soft binary opposition had a direct effect on the management of the female shape. Whereas at the turn of the century the 's' silhouette still dominated Western fashion, the 1920s dramatically reduced the emphasis on female secondary characteristics and the waist. After a return to the hourglass figure in post-war fashion, the boyish figure became fashionable again in the 1960s, in conjunction with a cultural revolution centred on carefree, energetic youth movements:

> The New look of 1947 which dominated the 1950s was a backward glance at a more 'feminine' time. The 1960s woman, on the other hand, looked firmly ahead. She demanded equal rights and equal pay. She rejected the shackles of voluminous, hampering skirts and the restrictions of corseted waists and high stiletto heels. She wanted to be free, to look young and to have fun.
>
> Peacock 1998: 7

In a nutshell, as costume designer John Peacock suggests, youth and female emancipation went hand in hand with a fashion that liberated the female body from the conventional gender role of wife, home-maker and mother: 'the way to achieve this young look was obvious: straighten the curves and shorten the

skirts. It was a style reminiscent of the 1920s' (Peacock 1998: 7). While feminist campaigners at the 1968 Miss America Pageant demonstration in Atlantic City are erroneously remembered as having burnt their bras in protest against female objectification (see Lee 2014), 1960s designers such as Courrèges did propose dresses that would not contemplate the use of brassieres (Polan and Tredre 2009: 123).

Indeed, nothing could be more fittingly revealing of the intricate relationship between clothing and gender than the history of lingerie, a non-linear trajectory of twists, false starts and u-turns. In Fleming's *Goldfinger*, feminine display and female assertiveness through action are polarized through the Masterton sisters. While 'submissive' Jill appears to Bond 'naked except for a black brassiere and black silk briefs' (Fleming [1959] 2004: 36), assertive Tilly's 'driver's *corset* belt' ([1959] 2004: 148; my emphasis) resonates with more subversive cultural references. Although the term 'corset' is here used to describe an outer garment of functional nature, it in fact points to the evolution of supporting undergarments, both in relation to their aesthetics and functionality.

Conventionally understood as a feminine item primarily associated with Victorian fashion, the gradual transformation of the corset has been the result of increased female mobility encouraged by popular sporting activities such as golf, cycling and tennis. As early as 1897, for instance, in her book *Lady Cycling: What to Wear and How to Ride* (1897), F. J. Erskine advised fellow female cyclists to wear appropriate support when riding:

> Some wise people say that corsets should be discarded for cycling. This is not correct. There should be no approach to tight-lacing, but a pair of woollen-cased corsets afford great support; they keep the figure from going all abroad, and protect the vital parts from chills. Special woollen-cased corsets are made by at any rate two manufacturers, who have spared no pains to provide a safe and good corset for cyclists.
>
> Erskine 1897: 22

As seen with Tilly's driving outfit, here the corset is regarded as a necessary undergarment to ensure safety and, consequently, *enable*, rather than hinder, female mobility. Significantly, while these changes occurred in the world of everyday lifestyle, the world of *haute couture* also toyed with apparently corsetless designs, though these were not at all 'liberating' (Vinken 1999).

In fact, evidence from women's magazines up to the 1950s suggests that the corset, rather than defunct, went through a series of reincarnations led by the developments in the fashion industry. A semantic shift did, however, occur, as,

since the mid-1930s the term 'corsetry' is replaced by 'foundation wear', a phrase suggestive of the renewed emphasis on internal support, rather than external control (Tinkler and Warsh 2008: 121), while the 1960s – when they did not forego bras altogether – proposed lingerie as a source of female emancipation. Adverts for shaping underwear, for instance, would promise a look that would be 'poised, well-groomed, well-balanced – and *ruthlessly* feminine', or hint to a notion of women's empowerment through the achievement of a desired shape: 'Who but Warner's could give you 'Double-Power' . . . ?' (*Vogue* 1 March 1961: 27, 33; my emphasis).[3]

In spite of the shared emphasis on comfort in adverts for foundation garments produced and marketed from the 1920s to the 1950s, the latter decade also signalled a return to a 'traditional' feminine silhouette which emphasized breast curvature and waistline slenderness. From inflatable brassieres to supportive corsets, many undergarments were indeed designed to 'make up' for the lack of a desirable bust, as these adverts from 1953, the publication year of *Casino Royale*, illustrate:

> Tru-Balance Corset by Gossard: 'Tru-Balance controls the way nature intends by patented diagonal control; lifts you in front, while flattening you behind.

> Très Secrète: The Wonderful New Air-Filled Bra: 'Lovely Nylon-and-Rayon fabric covers this delicate answer to all problems of bust deficiency.

> Truline Bra: Gives the accentuated uplift to the most normal of busts.
> *Vogue* January 1953: 6, 9, 19

There is little doubt that 1950s fashion's emphasis on prominent breasts filtered through Fleming's Bond novels. As Amis summarized, the Bond Girl's 'most frequently mentioned feature is her fine, firm, faultless, splendid, etc., breasts' (1965: 44). Similarly, critic Bernard Bergonzi also noted that Bond Girls 'have prominent breasts and outlandish names' (1958: 225), while Mordecai Richler ridiculed the clichéd look of 'the composite Bond girl . . . distinguished by her beautiful firm breasts, each . . . with its pointed stigma of desire' (1971: 343).

As much Bond's gaze dwells on women's busts, he is also equally taken by other, less conventionally feminine physical attributes. Amis, for instance, notes that as well as being voluptuous, the Bond Girl's 'physique is generally good, with some hints of assistance from tennis or swimming. She is tall, five foot seven or above, and not thin' (Amis 1965: 44); in *Colonel Sun* (1968), the first Bond sequel Amis penned under the pseudonym of Robert Markham, while making love to

Ariadne Alexandrou, Bond feels 'the strength of her as well as her softness' (Amis [1968] 2015: 113). Discussing her role in the film *Dr No*, Ursula Andress confirms the idea that in the early 1960s a Bond Girl's physique did not conform to the existing film (and fashion) aesthetics exemplified by the voluptuous Marilyn Monroe; instead, Honey Ryder pioneered a new model of femininity: 'I was a new kind of woman ... an athletic woman, sporty, strong, determined' (*Bond Girls Are Forever* [2002] 2006).

But this was, in fact, already in place in Fleming's *Dr No*, where Bond notes that 'the gentle curve of the backbone was deeply indented, suggesting more powerful muscles than is usual in a woman, and the behind was almost as firm and rounded as a boy's' ([1958] 2004: 78). Famously, Noel Coward teased Fleming on his description of Honeychile's physique: 'I was ... slightly shocked by the lascivious announcement that Honeychile's bottom was like a boy's. I know that we are all becoming progressively more broadminded nowadays but really old chap, what *could* you have been thinking of?' (Fleming 2015: 187). Indeed, Fleming's novels often display 'Bond's penchant for boyish women' (Ladenson 2003: 191; see also Berberich 2012: 21), and, consequently, Bond Girls' combination of 'masculine' strength and 'feminine' softness. The archetypal Bond Girl, Vesper, in *Casino Royale*, for instance, gestures to the androgynous boyishness of the 1960s; although 'the jutting swell of her breasts' ([1953] 2006: 60) hints to a conventional 1950s bust, her 'narrow, but not ... thin waist' projects an image of natural slenderness, rather than artificial compression. Similarly, Bond notes the hard fitness, as well as the firm curves, of Kissy Suzuki's body ([1964] 2009: 177), while ballet training gives Tania's bottom a distinctly masculine muscular tone: 'Its muscles were so hardened with exercise that it had lost the smooth downward feminine sweep, and now, round at the back and flat and hard at the sides, it jutted like a man's' ([1957] 2004: 69). In as much as the literary Bond Girls conform to 1950s voluptuousness, their physical fitness also subverts the decade's current aesthetics, and, while retaining aspects of conventional feminine sex appeal, moves away from a crystallized model of soft femininity to embrace the hard femininity that would be influential in decades to follow.

'She drives like a man': Bond Girls, speed, and modernity

Fleming 'was gripped by the mechanics, the sensation and also the *look* of speed', writes his nephew Fergus in his introduction to *The Man with The Golden*

Typewriter (Fleming 2015: 2). Just like his creator, not only does Bond enjoy driving fast cars, but he also revels in the spectacle of speed, especially when this is combined with the sight of a driving woman:

> Triple wind-horns screamed their banshee discord in his ear, and a low, white two-seater, a Lancia Flaminia Zagato Spyder with its hood down, tore past him, cut cheekily across his bonnet and pulled away, the sexy boom of its twin exhausts echoing back from the border of trees. And it was a girl driving, a girl with a shocking pick scarf tied around her hair, leaving a brief pink tail that the wind blew horizontal behind her.
>
> [1963] 2009: 15

When Bond meets Tracy, the only woman he ever marries in *On Her Majesty's Secret Service*, she is at the wheel of an impressively fast car. But Tracy is not unique in her taste for speed. Most Bond Girls enjoy the thrill of a fast ride, and Bond's belief that 'girls who drove competitively ... were always pretty – and exciting' ([1963] 2009: 15) indicates that fast female drivers are the stuff of Bond's dreams. This is certainly the case with agent Mary Ann Russell in the short story 'From a View to a Kill' (1960):

> She had everything, but absolutely everything that belonged in his fantasy. She was tall and, although her figure was hidden by a light raincoat, the way she moved and the way she held herself promised that it would be beautiful. The face had the gaiety and bravado that went with her driving.
>
> Fleming 2008: 8

While Mary Ann's 'bravado' returns at the end of the story to save Bond's life – she is the only agent with the guts to fire a shot at his assailant – it would be wrong to assume that women's driving is always easily accepted in Bond's world, where speed and women exist in a complicated relationship.

Throughout the film franchise Bond Girls frequently demonstrate their affinity with various transport technologies. Pussy Galore, Helga Brandt (Karin Dor, *You Only Live Twice*), Pam Bouvier, and Xenia Onatopp all fly planes; Naomi (Caroline Munro, *The Spy Who Loved Me*) and Corinne Dufour (Corinne Cléry, *Moonraker*) are helicopter pilots. Even the unnamed 'cigar girl' (Maria Grazia Cucinotta, *The World Is Not Enough*) can outdo Bond in a speedboat chase before her fatal flight in a hot-air balloon.

Significantly, as much as Bond Girls' speed-driving may aid Bond's mission, it often compromises his safety. In *Thunderball*, Fiona Volpe, who drives a convertible Ford Mustang, warns Bond: 'You'd better fasten your safety belt', before taking him

on a speedy trip to Nassau. In response to Fiona's claim that 'Some men just don't like to be driven', Bond's line – 'some men just don't like to be taken for a ride' (*Thunderball* 1965) – demonstrates that women's driving is ostensibly perceived as a challenge to masculine authority. Similar tension occurs in *GoldenEye*, where Xenia Onatopp races with Bond in a vertiginous drive on the Alpes Maritimes at the wheel of her Ferrari F355 GTS, and Bond self-consciously claims, driving his Aston Martin to a sudden halt upon the request of his female passenger, to 'have no problem with female authority' (*GoldenEye* 1995).

The driver's seat is a contentious site, signalling the wider implications that female assertiveness holds for the gender politics of the Bond narratives. The issue of women's self-confidence has been the subject of feminist thought seeking to counter the relegation of women to a submissive position in patriarchy. In 'Sorties', one of the influential essays published by Hélène Cixous and Catherine Clément in *The Newly Born Woman* (1975), the authors' question, 'Where is she?', exposes the impossible positioning of the active woman and assertive femininity within the patriarchal system (Cixous and Clément [1975] 1997: 63). Female assertiveness, indeed, undermines the accepted order of patriarchy and a reading of the female sex, feminine gender and sexuality as fundamentally 'passive' (Cixous and Clément [1975] 1997: 64). Viewed from this subversive standpoint, Bond Girls' dynamic performances threaten to conquer the action field that is the recognized territory of Bond's masculinity.

The prominent position of female drivers within the Bond cinematic and literary narratives places women in an active, if not always readily accepted, role. Their active performance challenges patriarchal gender constructs through the complicated interaction between women and cars, which reflects an ambivalent attitude towards technology and gender: 'by employing cars in a central position for 50 years, Bond films . . . use the multiple meanings of cars to negotiate broader changes in gender ideologies' (Jones 2015: 206). Indeed, just as the over-reliance on technological gadgets frequently undermines – rather than aides – the establishment of Bond's heroic masculinity, the treatment of female drivers plays a similarly ambiguous function with regard to masculine authority. For instance, while Bond Girls can be very proficient drivers, both Tracy and M (Judi Dench) die after being relegated to 'the perilous passenger seat in Bond's enhanced Aston Martin DB5' (Jones 2015: 213). What emerges, therefore, is an unclear message about patriarchal conventions and driving. On one hand, the bodies of female characters in the Bond narratives would appear safer while driving, rather than being driven by Bond; on the other, as a challenge to conventional gender norms, the female driver remains a source of anxiety for Bond's masculinity. Similarly,

Bond Girls' penchant for beautiful, fast cars, appears problematic. There are few exceptions – Mary Ann's 'battered black Peugeot 403' (Fleming 2008: 7), Camille's Ford Ka and Volkswagen Beetle in the film *Quantum of Solace*, and Melina Havelock (Carole Bouquet)'s Citroën 2CV in the film *For Your Eyes Only* (Glen 1981) all come to mind. But Bond Girls mostly drive statement cars, and at the wheel of an expensive, fashionable car, while performing action, they arguably remain the object of the gaze.

Indeed, it is the larger, more functional vehicles – conventionally a masculine domain – that highlight Bond Girls' defiant driving. In *The Spy Who Loved Me*, for instance, when Anya Amasova (Barbara Bach) struggles to control a Leyland Sherpa van, Bond's patronizing language – 'Try the big one' (when Anya gets the ignition key wrong); 'Can it play any other tune?' (when the clutch makes a screeching noise) – comes across as unchallenged sexist banter. But Anya eventually manages to crush Jaws against a scaffolding in a swift reverse manoeuvre: 'Shaken, but not stirred' (*The Spy Who Loved Me* 1977), she pronounces. *Touché*. A similar exchange occurs in *Skyfall*, where Moneypenny drives a Land Rover through the crowded streets of Istanbul's Grand Bazaar quarter; when she breaks one of the side mirrors, Bond's cutting remark – 'It's OK; you weren't using it' – is quickly followed by her own – 'I wasn't using that one either' (*Skyfall* 2012a) – when she breaks the other mirror seconds later. Bond Girls' fast driving, therefore, is less about showing off, and more about getting a job done.

It follows, then, that Bond Girls' driving apparel, which reflects cultural debates about modernity and the mutual exchanges between female emancipation and technological advances, places more emphasis on functionality than display. In the early films, for instance, head gear is as fashionable as it is useful, especially in convertible cars such as those driven by Fiona and Aki in *Thunderball* and *You Only Live Twice*; similarly sensible is the cardigan that Tilly wears over her shoulders as she drives, open top, around the Swiss Alps in *Goldfinger*; likewise, Tracy wears a sable fur coat and hat in *On Her Majesty's Secret Service*, although the roof of her Mercury Cougar stays up. In the more recent films, tougher materials, such as leather, for instance, appear in the costumes worn by Xenia in *GoldenEye* and Jinx in *Die Another Day*.

The design of such costumes reveals an important sense of *continuity* between Bond Girls and their cars. Visually, this is often conveyed through the matching colour of their accessories and vehicles: such is the case with Fiona's blue shawl, Aki's white headscarf, and Xenia's red and black scarf and leather gloves, which match the paintwork of their stylish convertible cars. Even when driving less glamorous vehicles, the films pay attention to pictorial continuity; Camille's gold

necklace, ginger jersey bandeau top, and bronze silk skirt all recall the metallic shade of her Ford KA in *Quantum of Solace*; the colour of Anya's Franka Stael von Holstein dress and that of the van she unexpectedly drives in *The Spy Who Loved Me* share a blue palette. Such aesthetic continuity endorses the women's symbiotic bonds with their vehicles, producing a 'streamlined' image that exceeds mere stylistic preoccupations.

In appearing to be 'at one' with their vehicles, Bond Girls project an image of control in line with the aesthetic preoccupations of the first female drivers in the twentieth century. As car adverts in historical fashion magazines demonstrate, early twentieth-century concerns with the harmony of lines affected, in equal ways, motors and women, especially when the bodily contours of both female and machine frequently intersected in publicity images (Tinkler and Warsh 2008: 122). It is no accident that such preoccupations with the 'silhouette', as a harmonious presentation of the (clothed) body, came to be at a time when women's increased mobility – and interaction within the public sphere – placed more emphasis on a streamlined style: 'a great many of us, indeed, were not aware that we had such a thing as a silhouette at all. Nowadays, a well-dressed woman would rather wear things that go well together than have each thing novel and pretty in itself', commented *Vogue* in 1924 ('The Cloche is Dead?' 1924: 32). As the automobile's aerodynamic contours became synonymous with modernity, so did women's association with cars make the streamlined silhouette synonymous with modern femininity.

As part of this continuum, Bond Girls' clothes gesture to historical debates about women and motors. The introduction of the car caused the popularity of the bicycle to wane, at least as far as the middle and upper classes were concerned, but the new mode of transportation reiterated concerns about women's mobility. As with the bicycle, safety issues to do with women's alleged nervous disposition and physical fragility did nothing but expose conservative gender norms. Nevertheless, female car owners and drivers in Britain gradually increased in numbers, especially after the First World War. As Sean O'Connell rightly reminds us, along with the bicycle, the car brought the 'threat' of female autonomy into the foreground: 'it had the potential to become a very powerful symbol of feminine equality, presenting the opportunity of equal mobility, speed and independence to all who had access to the driving wheel' (O'Connell 1998: 52).

Such anxieties were bound up with patriarchal views about women's bodies and their function in what seemed to be a vicious circle of self-perpetuating gender essentialism. Views from a 1936 correspondent's letter published in *Autocar*, a magazine catering to a male readership but featuring female models

on covers and inside adverts, reveal not only the deeply rooted prejudice against women's ability to concentrate, but the ramifications of the active/passive dualism behind gender norms. The correspondent claimed that unlike a man, who is naturally disposed to provide for his family, 'a woman is naturally and fundamentally inconsiderate and selfish on the road', and that unlike a man, whose mind is ruled by reason, 'the woman motorist is governed largely by instinct and environment'; moreover, he continued, 'woman has not man's power to concentrate as she is continually being mentally sidetracked by such burning questions, prompted by an inflated vanity, as "How do I look?"' ('Letter' 1936: 336). Women's 'inflated vanity', here suggestive of the stereotypical association between women and the frivolities of fashion, by extension points to women as the *passive* objects of the gaze, unable to direct their own gaze at anything other than themselves.

Despite mostly being published two decades later, similar bias with regard to female driving frequently emerges in Fleming's novels. Even when conveying appreciation of Domino Vitali's motoring skills in *Thunderball*, these are measured in masculine terms:

> But *this girl drove like a man*. She was *entirely focused* on the road ahead and on what was going on in her driving mirror, an accessory rarely used by women except for making up their faces. And, *equally rare in a woman*, she took *a man's pleasure* in the feel of her machine, in the timing of her gear changes, and the use of her brakes.
>
> [1961] 2004: 115; my emphases

Framed within a binary understanding of sexual difference, Bond's appreciation of Domino's driving style follows his reflection that 'four women in a car he regarded as the highest potential danger, and two women nearly as lethal' ([1961] 2004: 115). As one cliché leads to another – 'two women in the front seat of a car constantly distract each other's attention from the road ahead' – the unambiguously sexist conclusion is that women drivers 'are very seldom first-class' ([1961] 2004: 115). Bond's attitude, arguably representative of many male drivers at the time, reveals a profound anxiety around female emancipation, which the advent of the car facilitated.

As previously seen with the evolution of women's sportswear, rather than merely passive consumers of new designs in both motors and clothes, evidence suggests that women took an active role in fashioning their new bodies in motion. In *The Woman and the Car: A Chatty Little Handbook for All Women Who Motor or Who Want to Motor* (1909), Dorothy Levitt, a promoter of female motoring

and the first British woman to take part in car races (O'Connell: 47), laments that, although 'automobilists are nowadays more careful in the choice of their attire,... there are still a goodly number who seem to imagine it is impossible to look anything but hideous when in an automobile' (1909: 23). Levitt's recommendations thereon all focus on the practical aspects of adapting female clothing to the car, without compromising the driver's presumed desire to still look feminine. Levitt consequently discourages the impractical use of 'lace or "fluffy" adjuncts', while she recommends the use of a well-fitting cap and a crepe-de-chine veil, not out of vanity, but functionality; appropriately twisted and knotted, 'the veil ... helps to keep the hat securely in place' (1909: 26). That Levitt, while dress-aware, is more preoccupied with safety than vanity is also made clear by the reference to the hand mirror, as an essential item to carry in the car:

> The mirror should be fairly large to be really useful, and it is better to have one with a handle to it. Just before starting take the glass out of the little drawer and put it into the little flap pocket of the car. You will find it useful to have it handy – not for strictly personal use, but to occasionally hold up to see what is behind you.
>
> Levitt 1909: 29

Read against the sexist remarks of the *Autocar* contributor a few decades later, as well as Fleming's notion that 'the driving mirror ... [is] an accessory rarely used by women except for making up their faces', Levitt's ingenuity turns the notion of female exhibitionism on its head, constructing women as active controllers – rather than objects – of the gaze. Moreover, Levitt's advice that solo female drivers should always carry a small revolver, advocates independent and resilient female drivers – precursors to the Bond Girls of later decades.

If we return to the image of Domino Vitali, it is possible to identify such qualities in Bond's description of the girl's attire:

> She wore a gondolier's broadbrimmed straw hat, tilted *impudently* down her nose.... She wore no rings and no jewellery except for a rather *masculine* square gold wrist-watch with a black face, her flat-heeled sandals wore of white doeskin. They matched her broad white doeskin belt and the *sensible* handbag that lay, with a black and white striped silk scarf, on the seat between them.
>
> [1961] 2004: 114; my emphases

Domino's 'flat-heeled sandals' and 'sensible handbag' are reminiscent of the practical compromises with fashion advised by Levitt in her manual for female drivers; rather than merely decorative, such items speak of the importance of safety and comfort in the car. There is maybe a hint of feminine exhibitionism – and male voyeurism

– in the display of 'her thighs under the pleated cream cotton skirt' ([1961] 2004: 111). Yet, her 'rather masculine square gold wrist-watch' and 'gondolier's broadbrimmed straw hat' accentuate a certain degree of cross-dressing. It is, intriguingly, precisely this breakdown of the active/passive, feminine/masculine dualisms that attracts Bond, recurrently, to assertive women such as Domino:

> This was ... *a girl of authority and character.* She might like the rich, gay life, but so far as Bond was concerned, that was the right kind of girl. She might sleep with men, obviously did, but it would be on *her terms and not theirs.* ... She had a gay, to-hell-with-you face that, Bond thought, would become animal in passion. In bed she would fight and bite and then suddenly melt into hot *surrender.* He could almost see the *proud,* sensual mouth bare away from the even white teeth in a snarl of desire and then, afterwards, soften into a half-pout of *loving slavery.*
> [1961] 2004: 115–16; my emphases

This passage encapsulates Bond's complex – and frequently misunderstood – sexuality. While the oxymoronic 'loving slavery' apparently reeks of sexism, it in fact hints at Bond's sadist fantasy rather than actual gender politics. In fact, far from submissive, his imagination of Domino's sexuality – assertive, just like her driving – constructs her as an active lover.

Cross-dressing and female driving may, in fact, point to more manifest challenges to Bond's masculine charm. His run-up with Tilly Masterton, in the novel *Goldfinger* shares a similar tension to his encounter with Domino; Bond's musing that 'there was the *authority* of someone who is used to *being admired,* combined with the *self-consciousness* of a girl driving alone and passing a man in a smart car' ([1959] 2004: 140; my emphases), points, simultaneously to the male gaze and Tilly's knowing manipulation of it. But the reader gains a stronger sense of her presence, and its disrupting function to the gender politics of Bond's world, when Bond causes her car to go off the road:

> She wasn't wearing the uniform of the seductress. She wore a white, rather *masculine* cut, heavy silk shirt. It was open at the neck, but it would button up to a narrow military collar ... Her shoes were expensive-looking black sandals which would be comfortable and cool for driving. ... It all looked very attractive. But the get-up reminded Bond more of an equipment than a young girl's dress. There was something faintly *mannish* and open-air about the whole of her behaviour and appearance.
> Fleming [1959] 2004: 148; my emphases

Much like her driving, Tilly's attire wrecks the expectations of the male gaze, and the active/passive binary structure that the gaze simultaneously derives from and endorses: concealed behind 'the white motoring goggles' is 'the blur of a pretty

face ... a slash of red mouth and the fluttering edge of black hair under a pink handkerchief with white spots' ([1959] 2004: 140). Tilly's beauty is barely registered in the 'blur' of her speedy motion, suggesting the spectacle of femininity collides with Mulvey's '*to-be-looked-at-ness*'; in being 'blurred', Tilly's image rejects the stasis that ought to keep her still within the frame of the male gaze.

As seen with Domino, Tilly's assertiveness appears to be – figuratively, as well as literally – linked to her mobility, both in terms of her ability to go places and her determination to do so: 'Now then, you handsome bastard, don't think you can "little woman" me. You've got me into this mess and, by God, you're going to get me out! ... I've got my life to run, and I know where ... I'm going', Bond imagines her saying ([1959] 2004: 148). While Bond briefly deludes himself that 'their eyes met and exchanged a flurry of masculine/feminine master/slave signals' ([1959] 2004: 149), Tilly's sartorial look does not concede much to the heteronormative desire implied in Bond's gaze. The masculine deviations of her driving ensemble in fact give Tilly a 'mannish' look, even though the masculine cut and military look of her shirt and comfortable sandals are partly dictated by the practical requirements of driving; indeed, Bond describes Tilly's outfit as 'more of an equipment', drawing attention to the *functional*, rather than *seductive* effect of her sartorial presentation.

The bride and the gangster

The appropriation of masculine clothing, in addition to supporting Bond Girls' active missions, also undermines accepted narratives of female sexuality. Following the launch of Christian Dior's 'New Look' in 1947, women's fashion turned, again, to the traditional hourglass figure; with the exception of holidays and sports, trousers almost disappeared from female wardrobes even though they would still be worn by film stars such as Marlene Dietrich and Greta Garbo.

While in 1964, *Life* would still ask whether trousers 'are ... suitable for sophisticated social rounds in the city' (qtd. in Walford 2013: 80), in 1969 Tracy wears a trouser bridal garment to marry Bond in the film *On Her Majesty's Secret Service* (Fig. 9). The trousers are truly only visible in some of the publicity scenes, as the camera focuses on Tracy's upper body throughout the sequence. But that Bond's only bride wears them is nevertheless a radical choice by costume designer Marjory Cornelius (Laverty 2011). There are some concessions to tradition; white in colour, the traditional lightness of Tracy's bridal wear is achieved through the garment's extensive use of crochet work. The revealing

effect, 'cobwebby enough to be scandalous today' (Laverty 2011), in fact, pushes aside any notion of bridal modesty. But the unconventional trouser design bestows an unquestionable reference to cross-dressing upon the bridal ensemble, as it signals a level of equality in the fact that both bride and groom wear trousers.

Such is the power of the romantic fantasy of the white wedding dress, that bridal trousers still remain unusual. On a rare occasion, Nadja Auermann wore a white tuxedo in the bridal finale of Anna Molinari's 1991 fashion show in Milan. Accompanying her was Claudia Schiffer, wearing a more traditional white lace dress, albeit cut short and accessorized with black tights: 'Auerman's "demi-drag" made a nod to the contemporary vogue for so-called lipstick lesbianism', Rebecca Arnold suggests, 'it represented the blurring of sexual and gender boundaries; it was ... teasingly ambiguous, deliberately evasive' (2001: 109).

Significantly, when looking at Tracy's costume, it is precisely the fusion of masculine and feminine sartorial elements in one garment which makes this bridal design radically subversive against the conservative gender politics embodied by the white bridal dress. As a cross-dressed bride, Tracy's fashion statement pronounces the end of Bond's patriarchal status, which she undermines the moment she walks down the aisle 'wearing the trousers'. But the marriage only lasts a few hours, and while Bond returns to his carefree bachelorhood, the ghost of his dead bride, discussed in more detail in the next chapter, is also the spectre of female emancipation that keeps haunting his stories.

The teasing out of gender duality at the heart of fashion's relationship with sexual difference, emerges in the numerous fashion strategies deployed to convey its ambivalent approach to the 'natural' body. In resisting an easy alignment with binary structures of sexual differentiation, 'fashion represents the unrepresentability of sexual difference, the impossibility ... of not wearing a mask. ... Fashion is ... cross dressing' (Vinken 1999: 41). In fashion's masquerade, gender roles are constantly being undone in ways that signal the instability of fixed categories. Elements derived from men's fashion have therefore self-consciously made their way into women's fashion. It would be wrong, however, to assume this is a recent phenomenon. Paul Poiret had already attempted – albeit unsuccessfully – to introduce harem pants into women's fashion before the First World War, while Chanel allegedly described her work as a deliberate attempt to make 'the English masculine ... feminine', and claimed to be 'dressed like the strong independent male she had dreamed of being' (Dalí and Parinaud [1973] 2004: 225).

The potential transgenderness of trousers relies, of course, on performance. This is well captured in a 1953 advert for Cavalry Twill 'breex', 'the handsome

belted slacks which bolster a man's confidence and minimise a woman's silhouette' (*Vogue* March 1953: 99). Intriguingly, the same garment could simultaneously 'minimise a woman's silhouette', while also being capable of 'bolstering a man's confidence'; reinforcing binary sexual difference, the trousers' adaptability also foreshadows the next decade's fascination with androgyny and unisex styles. In doing so, the garment's flexibility underscores the performative quality not just of clothing, but of the clothed body: 'clothes are activated by the wearing of them just as bodies are actualised by the clothes they wear' (Craik 1993: 16). In other words, the interdependence between clothes and the bodies who wear them means that identity, as engendered by clothes, is entirely dependent on performance.

No character embodies the ambiguous gender/sexuality politics of the Bond narratives more than Pussy Galore, whose name was nearly changed to 'Kitty Galore', so as to avoid censorship issues (Ladenson 2003: 1998–99). Anecdotes report a publicity stunt involving a staged photograph of actor Honor Blackman and Prince Philip at a charity ball in February 1964. Published in *The Daily Mail* on 25 February 1964 with the caption 'Pussy and the Prince', the tag reached enough popularity for the character's name to stick.

As a gangster in cahoots with Goldfinger, Pussy Galore's presence in the highly masculine worlds of both Bond and Goldfinger is problematic from the moment she enters the latter's boardroom wearing 'a black masculine-cut suit with a high coffee-coloured lace jabot' (Fleming [1959] 2004: 196), a detail that evokes a distinctly camp masculinity. While ties, especially within the context of masculine professional uniforms, may signal the desire to conform to sartorial conventions, 'choosing a different type of neckwear – for example, a bowtie or cravat – may indicate a different set of attributes, such as an artistic temperament or effeminacy' (Craik 2005: 8). Worn by a woman over a 'masculine-cut suit', the jabot becomes doubly symbolic of deviancy, creating a ripple-effect of sartorial and gender transgressions, locating Pussy Galore in the undefined area between male and female, straight and gay.

Attention to detail, as sported in Pussy Galore's attire, links the stylized glamour of cinematic (male) gangsters to the impeccability of the English dandy (Gamman 2008: 220), and the two styles coexist in the cinematic Pussy Galore; the streamlined elegance of her sober black trouser-suit is only subtly disrupted by the flash of gold from her metallic waistcoat,[4] while the brushed velvet material accentuates her stylistic departure from the mainstream. Nevertheless, while in making himself a spectacle of the gaze, the male gangster simultaneously exposes himself and, by implication, his lack of status (Gamman 2008: 220),

Pussy Galore's sartorial performance produces a radically different effect. Female, lesbian, criminal, Pussy Galore's marginal identity operates shadily along the multiple edges of gender, sexuality, and the law. In drawing attention, charismatically, upon herself, nevertheless, she resists being boxed within the framework of Goldfinger and Bond's patriarchal world, keeping, instead, full control of the gaze, as seen in her grand entrance: 'She walked slowly, unselfconsciously down the room and stood behind the empty chair. Goldfinger had got to his feet. She *examined* him carefully and then ran *her eyes* round the table' (Fleming [1959] 2004: 196; my emphases).

In the film, Pussy Galore's resistance to the gaze is primarily displayed through her consistent deviation from conventional feminine display. Unlike the vast majority of Bond Girls before and after her, legs, arms and cleavage are barely visible throughout the film, with her body only discreetly flattered by the contours of her tailored suits. In spite of her name, Pussy Galore's costumes clashed with the 'bombshell' expectations her name might have set, especially when compared with some of the much racier outfits worn by Blackman who played Cathy Gale in *The Avengers* (Ashley 1964: 12). But what could be perceived as frumpiness in fact gives a different meaning to the purpose of a leading woman in a Bond film. Rather than simply 'look' beautiful, Pussy Galore performs a crucial part in wrecking Goldfinger's plan. The caramel outfit – blazer, jockey trousers, polo neck jersey – she wears at Goldfinger's Kentucky stud farm, leaves almost everything to the imagination. But this is precisely the point: her masculine look places her in control of the equestrian environment, while gesturing to the sartorial revolution brought in, among others, by Chanel in the 1920s and 1930s, when women's sportswear was a form of cross-dressing imported from English gentlemen's dress codes, sailor suits and men's jumpers (Craik 2005: 156). Even when, asked by Goldfinger to fulfil the more conventional 'honeytrap' role by wearing 'something more suitable' to please Bond, her only concession to conventional femininity is a low-cut lilac wraparound top worn over trousers in matching colour.

Wearing the same: queer sisters

In the film, the literary Pussy Galore's 'Cement Mixers' gang is replaced by her 'Flying Circus' of women pilots, who dress in identical tight-fitting belted leotards (Fig. 10). The seriousness of female professionalism, according to some readers, is here compromised by 'the title of the group ... , by their costumes –

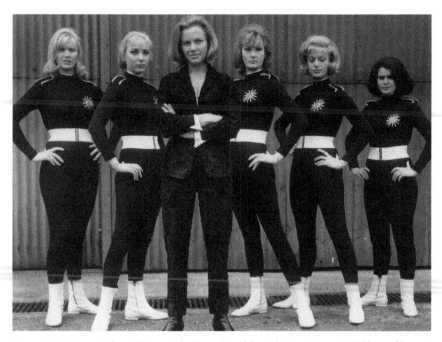

Figure 10 Pussy Galore (Honor Blackman) and her Flying Circus, *Goldfinger* film-set (Courtesy of Everett Collection Inc/Alamy Stock Photo)

they look more like Barbie dolls than pilots – by the implication . . . that they are lesbians' (Thumim 1992: 195). The assumption that 'few female readers would be tempted to identify with such exemplars', leaves worryingly unclear whether the irreverent title, the playful costumes, or the implied homosexuality of the pilots might in fact prevent identification from female 'readers' of the film. It is in fact the 'uniformity' of their costumes that makes the pilots resemble each other and, consequently, reinforces the notion of pervasive 'sameness' and repetition that run throughout both novel and film. Undermining the binary structures of differentiation – Bond/Girl; Bond/villain; straight/gay; British/foreign – that pervade the Bond narratives, sameness channels a subversion of the identity models in which Bond's masculinity is rooted.

Indeed, the all-girl action led by Pussy Galore offers a model of resistance against heteronormativity. It seems hardly a coincidence that Fleming also describes Pussy Galore's sartorial appearance in military terms, when she wears 'a black Dacron macintosh with a black leather belt', and Bond thinks she looks 'like some young S.S. guardsman' ([1959] 2004: 225). While uniforms may connote discipline and conformity, they can also be subversive symbols of disobedience and disregard for conventions: 'much of the transgressive use of

uniforms in culture occurs as the "not" statement of social rules and everyday conventions', as demonstrated, for example, by "'camp" parody in the military' (Craik 2005: 211). In Pussy Galore's cross-dressing, the reference to the S.S. uniform acts as a self-reflective articulation of the *deviant* sameness she incarnates; not only is the uniform, *per se*, a symbol of sameness, but here, as a garment historically associated with the Nazi paramilitary, that notion of sameness is, by extension, linked to the aberration of Nazi practices, delivering an uncomfortable comparison, in Bond's eyes, between Nazi ideology and non-normative sexual practices.

Sameness foreshadows, in the novel, Tilly's homoerotic attraction for Pussy Galore, whose 'hair was as black as Tilly Masterton's, . . . worn in an untidy urchin cut' ([1959] 2004: 197); in turn, their shared black hair also establishes an association with Bond himself: 'black hair and blue eyes appear to be a sign of attractive masculinity, in whichever sex, in the novel', adds Ladenson, 'whereas blonde hair in women is an accoutrement of femininity' (2003: 193). But in establishing a triangle of internal cross-gender references, 'sameness' unsettles the polarized gender politics of Bond's world. This is fully revealed in a passage where Bond's misogyny and homophobia are barely disguised:

> Bond came to the conclusion that Tilly Masterton was one of those girls whose hormones had got mixed up. He knew the type well and thought they and their male counterparts were a direct consequence of giving votes to women and 'sex equality'. As a result of fifty years of emancipation, feminine qualities were dying out or being transferred to the males. Pansies of both sexes were everywhere, not yet completely homo-sexual, but confused, not knowing what they were. The result was a herd of unhappy sexual misfits barren and full of frustrations, the women wanting to dominate and the men to be nannied. He was sorry for them but he had no time for them.
>
> Fleming 1959 [2004]: 221–2

Jointly misled by essentialist arguments about the hormonal make-up of queer women such as Tilly and Pussy, and a patriarchal bias against female emancipation, along with the ambiguous treatment of 'rape fantasies' discussed in Chapter 1, this passage could be easily dismissed as the blatant manifestation of homophobia.[5] Nevertheless, given the power commanded by Pussy throughout *Goldfinger*, what is at stake here is not the oppression of homosexuality, but the crumbling down of patriarchal straight masculinity, simultaneously affected by women's emancipation and the progressive acceptance of queer sexual practices.

Therefore, what Pussy Galore stands for is the threat of the most equal match to Bond's power:

> Pussy Galore is the hottest seduction in all of Bond precisely because she refuses to completely give in until the final moments of the film, insisting on her intellectual, physical, sexual, and gender equality, and her status as foil and competitor to Bond in every endeavor, including the seduction of women.
>
> Hovey 2005: 51

Although her last-minute tumble with Bond could be read as Bond's desire to put 'the girl back into her place' (Bennett and Woollacott 1987: 116), Pussy Galore's last-minute choice ought not to be read as definitive – and defining – of her sexuality. It is telling that, in Fleming's novel, as she is about to consummate her affair with Bond, she is wearing 'nothing but a grey fisherman's jersey that was decent by half an inch' ([1959] 2004: 263); rather than portrayed as conventional spectacle for the male gaze, her body is enshrouded in a garment borrowed from a masculine wardrobe. Her appropriation of masculine clothing throughout her literary and cinematic representations points to Pussy Galore's sexuality as dynamically performative. As Jaime Hovey suggests, 'Pussy has many voices – gangster, lesbian, girl. But this number of personas means that none of them is authentic, or all of them are' (2005: 52).

Pussy Galore's switching positions and allegiances throughout both novel and film suggest a fluid identity, something which should certainly apply to her sexuality, as illustrated in Horowitz's *Trigger Mortis*, where fellow MI6 agent Charles Henry Duggan – who is openly gay – spells out the fallacy of Bond's backward outlook on sexuality:

> The trouble with you, James, is you're basically a prude. I bet half the boys at that bloody public school of yours were buggering each other blind and you didn't even notice or looked the other way. Anyway, the service is crawling with sisters. You know it and I know it. Look at that dreadful man Burgess. It's a gift to the Soviets, letting them set up their honeytraps, snaring civil servants who are too young and too scared to know better. God knows how many secrets we've lost that way. Change the law and let people be what they want to be – that's what I say. And as for you, maybe you should try to be a bit less of a dinosaur. This is 1957, not the Middle Ages! The second half of the twentieth century!
>
> Horowitz 2015: 146

While the passage functions as a direct response to Bond's homophobic rant in *Goldfinger*, its position in the plot of *Trigger Mortis* is doubly ironic, placed as it

is after Bond's multiple sexual debacles. His failed opportunity to seduce Jeopardy Lane, comes after his loss of Logan Fairfax, the female race driver hired to train him, to Pussy Galore.

Like Domino, Logan is an impressive driver, although Bond is here less dismissive of women's driving: 'There was a lightness of touch about her driving. As she swung round the corner, she barely touched the apex. It was as if she was flicking ash off the shoulder of a man's coat. Only a woman drove that way' (Horowitz 2015: 42). Although not androgynous, her body displays the conventional masculine quality of muscular athleticism – 'the strong, rather muscular, arms and legs' – combined with more eminently feminine attributes – 'the shape of her breasts, the full hips', 'chestnut hair that fell carelessly down to her shoulders'. Logan's accessories, too, contribute to her gender hybridity. Her Omega Gold Seamaster, which Bond classifies as 'a man's watch' (Horowitz 2015: 43), has indeed been the cinematic Bond's watch of choice since 1995, when Hemming explained that 'Commander Bond, a naval man, a diver and a discreet gentleman of the world would wear the Seamaster with the blue dial' (Olson 2018).[6] On the other hand, Logan's driving goggles are a nod to Tilly's own driving attire in *Goldfinger*. Indeed, as with Tilly, Bond notes, her 'deep brown eyes . . . were all the more enticing because they looked at him with such scorn', and 'she had the hard edge and the self-confidence of a woman in a man's world' (Horowitz 2015: 42–3). Moreover, the seamless continuity with the mechanical body of the car – 'her affinity with that beautiful machine' – confirms that she is neither the passive object of Bond's gaze, nor a spectator to Bond's undisputed masculine heroism. Rather, her competition with Bond's skills, with cars as with women, is on an equal footing.

Logan meets Pussy Galore after the latter is attacked by Goldfinger's associates willing to give her the *same* symbolic treatment received by Jill Masterton in Fleming's *Goldfinger*: death by asphyxiation by a coat of gold paint over her whole naked body. That the two become lovers when Logan looks after a convalescing Pussy Galore in hospital is suggestive of a notion of 'sisterhood' which Fernardo Pagnoni Berns puts forward in relation to films such as *For Your Eyes Only* (Glen 1981) and especially *Octopussy* (Glen 1983), where the presence of multiple female characters can be read as a response to the experimental radical feminist communities of the early 1980s (Pagnoni Berns 2015: 119). *Octopussy* initially sets up this concept of increased female presence through the duplication of Miss Moneypenny (Lois Maxwell) in the form of a younger assistant, Miss Penelope Smallbone (Michela Clavell), whose similar costumes, the conventional blouse and skirt uniform of secretarial staff, amplify the scene's doubling effect. Such doubling serves the purpose of outlining the female duplication at the heart of

Octopussy, which, unusually, sees two Bond Girls working on the same side and sharing the same agenda: Octopussy (Maud Adams), the leader of an international criminal organization, and her henchwoman, Magda (Kristina Wayborn).

Just like Pussy Galore, and as her equally suggestive name would signal, on the surface Octopussy evokes a male fantasy. This is emphasized by the sensual design of an octopus, which features as a decorative motif on her dressing gown, the fluid lines of which produce a conventional feminine look. Most suggestively, the octopus returns in the carved shape of her bed; evocative of the influential tentacle erotica of Japanese artist Hokusai's woodblock-printed design *The Dream of the Fisherman's Wife* (1814), here the octopus becomes an ambiguous symbol of female eroticism. But Octopussy's name derives from Fleming's eponymous short story (although the film is based on 'Property of a Lady'); the 'octopussy' of the short story, is an actual octopus, partly responsible for the death of the story's villain, British war veteran – turned murderer and gold smuggler – Major Dexter Smythe. Viewed in this light, the octopus motif in the film *Octopussy* becomes suspiciously symbolic of a potential threat to Bond's masculinity. Octopussy may well be a good match for Bond, but only, as the film's lesbian subtext suggests, in a stylized feminine role.

The octopus reappears in the form of a tattoo on Magda's hip, suggesting a relationship of ownership to Octopussy and her 'house'. Magda's queer subversion of conventional femininity is strongly conveyed through her sartorial performances. Behind her sexual encounter with Bond, is her intention to steal the Fabergé egg, and in her spectacular abseil from the balcony of his room, the fabric of her sari literally unravels the conventional feminine role she has only temporarily impersonated. Pointing to Magda's seduction of Bond as a masquerade of heteronormative desire, the event consequently undermines Bond's sex appeal as it becomes apparent that he has, in fact, been 'used'. Magda's 'butch' role is played out in her later appearance at the circus dressed up in a cabaret tuxedo costume, complete with a top hat and white bow tie. The costume gestures to Marlene Dietrich's queer androgyny in *Morocco* (Sternberg 1930), where the show-woman, cross-dressed in black tailcoat, bowtie and top hat, after accepting a glass of champagne from a man in the audience, kisses, instead, his female companion (Horak 2015: 1).

Yves Saint Laurent introduced 'Le Smoking', a tuxedo for women, in his 1966 Fall/Winter collection, which was followed by trouser-suits in the 1967 Spring/Summer collection: 'with these masterstrokes, Saint Laurent effectively created a contemporary uniform for a woman that was neither futuristic fancy dress nor asexual garb' (Bowles 2008: 18). Like the uniform, 'Le Smoking' imports 'cross-

dressing' into the world of women's *couture*. While some of the women who wore YSL's newly launched trousers were denied access to public places – as was the case with Nan Kempner at Le Côte Basque in Manhattan (Fraser-Cavassoni 2015: 50; Newbold 2014) – 'Le Smoking' allowed for other thresholds to be crossed. As the garment also signalled the rise of *prêt-a-porter* in 1966 – it sold more in Saint Laurent's newly opened Rive Gauche boutique than it did as *haute couture* – it became the symbol of a multiple barrier breakdown to do with fashion's ways of constructing gender, sexuality, and class.

That the female tuxedo, through Magda's playful cross-dressing, is an overt attack on the stability of gender and class is underscored by her mock pickpocketing among the army officers at the Berlin circus show; the pretend criminal offence draws attention to the multiple transgressions and masquerades at play in the scene. More than anything, Magda's appropriation of Bond's evening dress of choice, albeit in the form of a sartorial parody, points to the interchangeable permeability of their roles as competitors over Octopussy's attention.

The queer subtext of *Octopussy* is foregrounded by the all-female commune Octopussy runs in her Udaipur floating palace; her team of 'lovelies', as Bond patronizingly refers to them, is in fact a posse of highly skilled women trained in various combat disciplines. Reinforcing the notion of 'sameness' is the set of uniforms the women wear 'on duty'. The palace guards wear leotards in bright red, a colour which, as already mentioned in Chapter 2, is typically associated with blood and, by extension, women (it is not a coincidence that red is, for instance, the colour of the handmaids' uniforms in Margaret Atwood's 1985 novel *The Handmaid's Tale*). When, towards the end of the film, the women attack Kamal Khan's palace, cape and headdress are added to the uniformed warriors, some of whom wear black bikinis and gladiator sandals; with no close-ups of the women's bodies, their uniforms, revealing as they might be, do not concede much to the male gaze. Instead, the overall effect is one of trans-gender camp theatricality, supported by the hybrid sartorial influences – part comic super-hero, part ecclesiastical, part ancient fighter – on the women's uniforms.

Octopussy's crew remain dynamic throughout the scene, their constant movement a symbolic representation of their fluid identities. While the capes and headdresses keep the women's identities anonymous, they also reinforce the pervasive sense of their undistinguished sameness and implied homoeroticism. The crew and Octopussy exist in a symbiotic regime, albeit with a suspicious colonial undertone; talking of her recruits, Octopussy admits to Bond, 'there are many of them all over Southeast Asia, looking for a guru, spiritual discipline,

who knows what. I train them. Give them a purpose, a *sisterhood* and a way of life' (*Octopussy* 1983; my emphasis). But just as she gives them purpose, they reciprocate with their support.

The film's final scene underscores the challenge posed to Bond's masculinity throughout the film. As his convalescing body – 'still not fit enough to travel' – is transported on board a vessel solely powered by Octopussy's all-female crew, it is, significantly, to the assertive 'In-Out! In-Out!' shout of the female coxswain that Bond might just about manage to perform his statutory boudoir duties (*Octopussy* 1983).

Women's cross-dressing and female appropriation of (men's) uniforms have been the subject of controversy throughout the twentieth century, in spite of the fact that 'the seventeenth and eighteenth centuries saw numbers of women masquerading as men in armies and navies and performing as valiant soldiers and sailors' (Craik 2005: 84). Forced by the necessity of wartime and the austerity of post-war rationing, women's dress, particularly in Britain, has had a discontinuous love affair with uniforms: 'the story of women's uniforms was somewhat disjointed, typical of an era of spasmodic efforts, of high hopes and anxious fears, progress and failure, false starts and brave endeavours, all overtaken by the Holocaust of World War Two' (Ewing 1975: 102). Central to the question of women's uniforms in the early twentieth century, was the notion, already foreshadowed in Dress Reform debates, of the impact of clothing on gender and sexuality. As Antonia Lant argues:

> It was feared that legislating women's dress, by equipping them with practical uniforms in order to unify them, might have the power to disguise, alter, or even reconstruct their real selves. The connotations of male strength attached to a military uniform might permanently empower a female wearer. The question was, 'What would be the effect of the uniform on the "real" woman underneath? Would it promote lesbian relations among other women?'
>
> Lant 1991: 107

The main concern with the appropriation of men's uniforms was to do with its potential effect on women's minds. In other words, a change of clothes could in fact lead to a more radical change in personal habits, cultural practices and political mindsets. This is because clothing produces, as Craik observes, a *habitus*, a set of 'specialised techniques and ingrained knowledges which enable people to negotiate different departments of existence' (Craik [1993] 1994: 4). In particular, with their apparent emphasis on conformity and discipline, uniforms draw attention to the function of clothing in the

construction of gender roles, raising a question – 'do people wear uniforms or do uniforms wear people?' (Craik 2005: 7) – about the subject's agency in this process of negotiation. In making a statement about categorical distinctions, uniforms in facts draw attention to the performative and arbitrary quality of such demarcations.

Such tensions are at play in Fleming's *From Russia with Love*, where Tania notes the potential clash between her uniform and conventional gender roles: 'the [MGB] uniform put you apart from the world. People were afraid, which didn't suit the nature of most girls' (Fleming [1957] 2004: 67). The potential gender subversiveness of Tania's uniform is also reinforced by the reference to her resemblance to Greta Garbo,[7] whose masculine attire, both on and off-set, was to be simultaneously emulated by other women and looked upon with suspicion by the censor in the film industry, 'prompting vigorous debates in the popular press over women's trousers'. The association between her uniform and Garbo simultaneously positions Tania within the controversial space of 'sexual deviance, [as] trousers and other masculine styles continued to symbolize modernity, autonomy, and disregard for convention' throughout the early twentieth century (Horak 2016: 170).

As well as a symbol of categorical distinction and ranking, uniforms, paradoxically, also announce the possibility to debunk, particularly through their implied cross-dressing potential: 'one of the most important aspects of cross dressing is the way in which it offers a challenge to easy notions of binarity', reflects Marjorie Garber, 'putting into question the categories of "female" and "male", whether they are considered essential or constituted, biological or cultural' (Garber [1991] 1992: 10). In the film *Moonraker*, the two approaches to gendered uniforms are at play, making the contrast more visible. On one hand, the astronauts all wear the same, gender-neutral uniforms, which function to define their professional role. On the other hand, the 'breeders', who have been eugenically selected by Hugo Drax to populate the new world in outer space, wear significantly gendered uniforms, trousers for men and miniskirts for women: this is because their biological sex and heterosexuality are fundamental to the success of the scheme.

In *GoldenEye*, a film which, as discussed in more detail in the last section of this chapter, takes issues with gender equality in the workplace, the differences between Colonel Ourumov's and Xenia's uniforms are dictated by ranking rather than gender. A more fitted cut to the jacket, which is also embellished with polished brass buttons, hints at subtle elements of feminine display, but the important point is that, when employed in action, Xenia wears a trouser uniform, which enables her to engage in very physical combat scenes. Sexual difference

has not been erased, but gender does not impact their 'professional' roles; as such, Xenia is able to impersonate one of the male Tiger helicopter pilots simply by slipping into his uniform.

From female exhibitionism to 'power dressing'

At the beginning and the end of the film *Diamonds Are Forever*, Tiffany Case (Jill St. John)'s appearances in lingerie and a bikini showcase her body as spectacle of Bond's and the public's gaze. Her state of undress, however, can reveal more complexity in context.

In her debut scene, within a space of minutes, Tiffany transforms her looks through changes of costumes – a see-through negligee, a vertiginously low-cut black dress – and wigs. The effect is destabilizing, though Bond claims not to have a preference 'providing the collars and cuffs match' (*Diamonds Are Forever* 1971). Against a notion of static 'natural' femininity implied in Bond's sexual innuendo, however, Tiffany's masquerade exemplifies a dynamic performative femininity. Much like fashion, her performance teases out gender authenticity, to enable Tiffany to manipulate Bond's wondering eye: 'I don't dress for the hired help', she says dismissively, of Bond's 'approval' of the 'nice little nothing, you're almost wearing' (*Diamonds Are Forever* 1971). But Tiffany's exhibitionist parade is in fact part of her own control strategy; all along she has distracted Bond to check his identity through a fingerprint-reading machine concealed in her wardrobe. Rather than voyeur, Bond becomes, once again, the unwitting object of the Bond Girl's gaze.

Sadly, Tiffany's ingenuity is lost throughout the film, and particularly in the final section, where her bikini outfit leaves little to the imagination. Blofeld's warning – 'I'd put something on over that bikini … I've come too far to have the aim of my crew affected by the sight of a pretty body' (*Diamonds Are Forever* 1971) – prefigures the fallacy of inopportune display. This echoes, in *The Man with the Golden Gun*, Scaramanga's explanation for forcing Mary Goodnight to wear a skimpy bikini: 'I like a girl in a bikini. No concealed weapons' (*The Man with the Golden Gun* 1974). Veiled in these seemingly sexist lines are the shortcomings of female exhibitionism, for the female power it produces here is but an illusion.

In the novel, Tiffany's first appearance is also in a state of *déshabillé*, a fact that might frame her as conventional spectacle of feminine beauty:

> She was sitting, half naked, astride a chair in front of the dressing-table, gazing across the back of the chair into the triple mirror. Her bare arms were folded

along the tall back of the chair and her chin was resting on her arms. Her spine was arched, and there was arrogance in the set of her head and shoulders. The black string of her brassiere across the naked back, the tight black lace pants and the splay of her legs whipped at Bond's senses.

[1956] 2004: 33

Yet, the passage also foreshadows Tiffany's resilience discussed earlier: 'this girl was tough all right, tough of manner', Bond notes, 'but whatever might be the history of her body, the skin had shone with life under the light' ([1956] 2004: 34). Moreover, her position as the object of the gaze is challenged by 'the rare quality of chatoyance', of her eyes, whereby 'the colour in the lustre changes with movement in the light' ([1956] 2004: 35). A feature of some precious stones, such as aquamarine and tiger's eye – chatoyance creates an optical effect which, like a cat's eye, appears to project its own light; in this way, Tiffany's gaze reflects back the light cast on her eyes.

The light associated with Tiffany's eyes is also reflected into the glimmer of her jewellery – 'slim gold wrist-watch ... heavy gold chain bracelet ... one large baguette-cut diamond ... [and] flat pearl ear-ring[s] in twisted gold' – and her 'pale gold hair ([1956] 2004: 34–5). If these details could be read as a sign of excessive vanity – something which Bond's penchant for sartorial moderation would frown upon – they are also mitigated by the sober elegance of her attire: 'a smart black tailor-made over a deep olive-green shirt buttoned at the neck, golden-tan nylons and black, square-toed crocodile shoes that looked very expensive' ([1956] 2004: 34). Acting as the feminine counterpart to Bond's tailor-made style, stylish without being unnecessarily showy, Tiffany's elegance points, as Beau Brummel would put it, to the 'conspicuous inconspicuousness' (Vainshtein 2009: 94) of the dandy:

She was very beautiful in a devil-may-care way, as if she kept her looks for herself and didn't mind what men thought of them, and there was an ironical tilt to the finely drawn eyebrows above the wide, level, rather scornful eyes that seemed to say, 'Sure. Come and try. But brother, you'd better be tops'.

[1956] 2004: 35

Tiffany's sartorial style signals her own self-reliance, as made clear by her professional attitude towards her mission, which displays independence and awareness of her own ability on the same level as Bond – 'don't "little girl" me ... And I can take care of myself.' ([1956] 2004: 38) – or higher: 'I can do anything better than you can' ([1956] 2004: 38), she protests when Bond offers her his protection.

When women began to play an increasing role in the professional environment, their apparel, with its traditional emphasis on display, raised questions of propriety and functionality. A 1907 article from the *Ladies Home Journal*, for instance, barely concealed anxieties about the potential gender transgression of women's appropriation of masculine styles. The shortcomings of women's cross-dressing were significantly highlighted through a comparison between a woman dressed in feminine garments (feminine hat, long hair, dress and matching jacket, dainty shoes, small purse) and another in 'masculine' attire (boater hat, short hair, blazer, mismatched jacket and skirt, boots, medium-size case, walking stick):

> The woman on the right is undoubtedly clever and capable, undoubtedly has brains – but why she should choose to dress in this *absurd anomalous* fashion is more than any one could say. She has lost all her feminine appearance, she is only *a feeble imitation of a man*, that curiosity commonly known as a "he-female" – neither fish, flesh nor fowl. She illustrates perfectly that *fallacy* so prevalent among her kind that pretty hats and becoming gowns are beneath the dignity of an intellectual woman.
>
> 'As Businesswomen Should and Should not Dress' 1907: 25

'Only a feeble imitation of a man', the cross-dressed businesswoman is explicitly cast in terms of abnormality; the 'he-female' is the freakish 'curiosity' derived from the sartorial aberrations of 'cross-dressing'. Worryingly, the concession to the woman's intelligence hints to her brains as the actual cause of her bad dress sense, and, consequently, an inhibiting factor for her femininity.

The two World Wars ushered in changes to social fabric and work structure, especially in Europe and America, but concerns about femininity in women's professional clothing remained. Costume designer Edith Head, for instance, recalls her mid-century promotion of the professional American woman's masculine look: 'The severe tailored suit got to be a sort of uniform, Hollywood convincing the working girl everywhere that she would be identifiable at more than ten paces' (Head and Ardmore [1959] 1960: 221). When, however, European designers noted that 'American women – the way they dress – frighten men off', Head had a change of heart:

> I saw the light. My businesswomen on screen began looking more like women. I don't mean peek-a-boo blouses or a rose between the teeth, but softly tailored dresses, feminine dresses of wool and silk; and I began making suits that didn't look as if they were screaming for two pairs of matching pants.
>
> Head and Ardmore [1959] 1960: 222

It is hardly surprising, in the context of her own work, and the wider mid-century cultural scene, that Head would identify trousers with a step too far into the masculinization of women's wear; elsewhere, discussing Marlene Dietrich's own cross-dressing habits, she admits that 'she and Roy Rogers are the only two living humans who should be allowed to wear such [sleek leather] trousers' (Head and Ardmore [1959] 1960: 11). Despite the fact that Western women had been wearing trousers, on and off, for half a century, such bias against them persisted, after the Second World War, as a latent anxiety about female emancipation.

The trouser/skirt divide has played a complex role in the non-linear trajectory traced by the development of women's professional clothing. The prejudice against bifurcated garments for women was only briefly put aside throughout the 1960s, a decade which attempted, without lasting success, to introduce purely unisex clothing; as Claudia Kidwell and Valerie Steele remind us, however, 'as the unconventionality of the late 1960s gave way to a more conservative social climate, women began to return to skirts' (Kidwell and Steele 1989: 87). That the trouser-suit might be too masculine for the business woman was emphatically reinstated in the late 1970s, and skirt-suits made a noticeable comeback in the 1980s professional women's wardrobes, although skirt-wearing did not necessarily mean a return to the more conservative fashion politics of the 1950s.

In the Bond films the sartorial effect of the skirt-suit is accordingly never clear-cut. In *A View to a Kill*, for instance, in the course of a meeting held on board Zorin's airship, May Day wears a pinstripe skirt-suit. The costume gestures to masculine tailoring, but also departs from its conventions in the bias cut of the batwing sleeves, exaggerated shoulders, fitted waist, and low-cut jacket to expose a bare *décolletage*. The skirt may also appear to re-emphasize sexual difference in place of the trouser-suit's gender neutrality. Such change, however, while apparently proposing a return to the past, does not necessarily take power away from the female wearer, as Hollander claimed of the late 1970s skirt-suit revival: 'A skirt is conventional evidence of straightforward femaleness, now devoid of connotations of sexual bondage or sexual threat' (1977: 27).

Hollander's defence of the skirt made specific reference to 'power dressing', a concept that came into the fashion foreground in the last quarter of the twentieth century as a new generation of ambitious, educated women entered professional spheres previously the exclusive domain of men. Following his successful dress manual for professional men, *Dress for Success* (1975), one of the earliest, and certainly one of the most influential contributions to female 'power dressing' discourse is John Molloy's *Women's Dress for Success* (1977). Molloy's research

had initially focused on the shortcomings on male business wear, but his later work reiterated the notion that 'most women dress for *failure*' (Molloy 1980: 17). Rather than offering radical sartorial advice for women in business, Molloy's work worryingly echoed the anxieties exposed in the *Ladies Home Journal* at the beginning of the twentieth century, warning 'professional women against trying to imitate men' (Garber 1992: 41):

> The 'imitation man' look does not refer to looking tough or masculine. The effect is more like that of a small boy who dresses up in his father's clothing. He looks winsome, not authoritative. Rather than making him look larger and more grown-up, the father's clothing only draws attention to his smallness and childishness. The same applies to women.
>
> Molloy 1980: 28

Molloy's justification against the potentially sexist readings of his work is the admission that 'it is a stark reality that men dominate the power structure – in business, in government, in education' (Molloy 1980: 30); consequently, his 'wardrobe engineering' did not aim to promote a radical rethinking of gender roles, but a controlled negotiation of 'failing' female bodies in the assertive environment of the masculine boardroom.

As fashion history suggests, nevertheless, the evolution of power dressing speaks both of persistent (male) anxieties about women's bodies in the workplace, and female desire to subvert the norm. Though warning women against the perils of an overt masculine look, Molloy also advised against the excess of feminine detail in women's professional dress. The appropriation of classic, timeless tailoring advised by Molloy's self-help-books, invited women to abandon their feminine interest in – and consumption of – change-led fashions, as 'the executive and business woman is ... called upon to reject the derisive "frivolity" of fashion' (Entwistle 2007: 217). This was not a new concept, but rather echoed Edith Head's advice to executive women in her own *How to Dress for Success* (1967).

From the 1980s, however, the female tailored suit acquired a more complicated meaning, as showcased by Katharine Hamnett's 'Power Dressing' 1986 Spring/ Summer collection: 'the phallic power of the streamlined, tailored silhouette and the perfectly groomed hair and make-up were at once alluring and threatening', comments Rebecca Arnold, 'the skirts may have been short, but the message was far from submissive' (2001: 106). These tailored looks, while gesturing towards a conservative, masculine tradition, were significantly re-interpreted to incorporate traditional elegance with sexy femininity, pointing to

the rise of a hybrid style that mitigated the masculinization of female professional attire:

> Dark-hued, comparatively severe, male-styled jacket and straight, lowered hemline skirt accompanied by attaché case; in all, a figure suggesting masculinity but leavened by such feminine touches as silk blouses, soft bow ties, earrings, clutch handbags, manicured nails, and Chanel-style link necklaces and belts.
>
> Davis 1992: 48–50

As explored below, the ambivalent gender politics of 'power dressing' are well reflected in the Bond franchise.

Around the release of *Licence to Kill* (1989), *Vogue*'s 'Suitable Girl' article on Carey Lowell had a visible focus on the ambiguous gender boundaries of power dressing, announcing that 'the best jackets and suits around still have menswear tailoring. They also have a softer edge' (Starzinger 1989: 484). Wearing suits by Romeo Gigli, Donna Karan and Ronaldus Shamask, actor Carey Lowell, the article suggested, 'would rather be James Bond than his plaything' (Starzinger 1989: 486). This tension is mirrored in the film, where CIA informant and pilot Pam Bouvier resents Bond's expectation that she must act as his executive secretary on the basis that Panama is 'a man's world', and that she should buy herself 'some decent clothes' (*Licence to Kill* 1989) to play the part. The new wardrobe seemingly enables an effective metamorphosis, as Pam successfully impersonates Ms Kennedy – she insists on not being 'Miss' – Bond's executive secretary, on a visit to the bank. Her costume is a tailored dress which, though imitating a traditional pin-striped man's suit, also deviates from the masculine design in the emphasized white collar and over-sized white buttons. The feminine accent placed on masculine sobriety, however, also threatens to re-entrench the binary masculine/feminine opposition: 'the fear of negating femininity is so pronounced', Davis observes, 'that vestmental means, both subtle and blatant, are constantly being sought to reassure career women and their alters that no *serious* gender defection has occurred' (1992: 50). In this respect then, rather than promoting absolute equality, power dressing has developed as an ambiguous sartorial discourse which, under the pretence of promoting women's career progression, in other ways opens dress codes up to a new level of discriminatory practice.

Yet the effects on professional women's sense of their own *power* to choose how to wear their femininity in the workplace suggest that such sartorial choices may still be empowering because of the self-conscious performative act they entail. If, as Entwistle suggests, 'power dressing constitutes a new "technology" of the feminine self' (2007: 211), it would appear to offer, simultaneously, agency – in

the woman's ability to 'construct' herself – as well as acknowledgement within the work environment still largely dominated by patriarchal rule. Even in the possibly fairer twenty-first-century professional environment, *Guardian* journalist Hannah Marriott's personal power-dressing experience has left her convinced that 'power dressing has its benefits. I don't feel small any more. The finer details of my body shape feel irrelevant, which brings with it a sort of confidence' (Marriott 2017: 87).

These complex negotiations came to the foreground of the Bond franchise with the casting of Judi Dench for the part of M in *GoldenEye*, partly in response to the appointment of Stella Rimington as Head of MI5 in 1992. Significantly, the term 'butch' appeared in more than one film review; elsewhere, her characterization was described as that of an 'iron maiden' (Kunze 2015: 237), suggesting unease about the break with tradition and the potential subversion of gender normativity posed by female authority. Moreover, her physical attributes, and particularly her short hair, point to 'the aberrant female villains Rosa Klebb and Irma Bunt' (Patton 2015: 253), the 'short, stocky, middle-aged white women who are conservatively dressed and appear androgynous' (Funnell 2011a: 203). In this new, female embodiment, M departed from her male predecessors in ways that clearly exceeded biological sexual difference.

M's gender switch is simultaneously emphasized and challenged by the sartorial choices made to fashion Bond's new boss, and a completely new embodiment of femininity in the Bond film franchise. M's costumes depart from *both* the mainstream power-dressing discourse *and* its 'ultra-feminine' responses; her sartorial performance comprises tailored pieces with a strong masculine influence (padded shoulders, muted colours, long sleeves) in line with conventional 'power dressing' advice; there is not, however, any evidence of the stylized feminine excess of its later reincarnations. Indeed, low heels, signature short hair, and minimalist make-up signal a rejection of the stylistic overcompensations outlined above.

Overall, M's sartorial performance unapologetically challenges the simplistic assumption that she is merely buying into a passive mimicry of masculine *habitus*, but points to the notion that she self-consciously wears her own (feminine) presence in an environment overpopulated by masculine figureheads. When, in *Tomorrow Never Dies*, Admiral Roebuck patronizingly warns her she may not 'have the balls for this job', her witty response – 'Perhaps. But the advantage is that I don't have to think with them all the time' (*Tomorrow Never Dies* 1997) – is as explicit of her challenge to patriarchal authority as her (sparse) references to her personal life as a wife and mother. Rather than a reductive

'mother figure' or sexy villain, 'as a strong-willed matriarch', Lori Parks claims, 'she provides a complex representation of female authority' (2015: 255).

In attempting to erode simplistic male/female binary structures, M's costume grapples with other binary ideologies in place in the Bond books and films. In the early films, the absence of lapels in the blazers worn by Dench as M signals a departure from the traditional cut of Western men's single- or double-breasted suits. Instead, her jackets gesture, from *GoldenEye* onward, to a high-collared version of the Nehru jacket (Fig. 11), a design which, with its associations with the first prime minister of independent India, indicates a sartorial digression from Western masculine sartorial tradition. In crossing gender boundaries, the foreign influence on M's suit – unlike the quintessentially English tailoring worn by her predecessors – also significantly subverts the us/them binary that emerges in Bond's colonial stance and distrust of foreignness. Indeed, in her overt *antagonism* to Bond – and the binary politics that he still, anachronistically, embodies the style of her jacket sits closer to that of the cinematic Dr No. Rather than paying homage to the straightforward English masculinity of her predecessors, M's *own* version of 'power-dressing', therefore, overtly subverts its traditional sartorial *lines* to support of her own *line* of management.

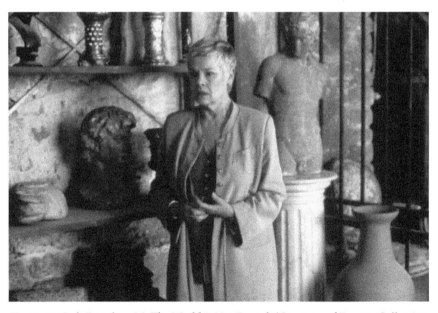

Figure 11 Judi Dench as M, *The World Is Not Enough* (Courtesy of Everett Collection Inc/Alamy Stock Photo)

As the 'glass-ceiling' remains an unresolved issue, the ongoing discourse on 'power dressing' draws attention, time and again, to women's sartorial practices – and their bodies – as sites of required discipline and self-control. In the 1980s, Molloy warned secretarial staff not to make a self-fulfilling prophecy of their office wear: 'if you are a secretary or a general clerical worker, don't dress like one unless you have no further ambitions' (Molloy 1980: 119). But career progression would, especially in the past, involve a more delicate negotiation of female sexuality and lead, in relation to secretarial staff, to the burning question of office romance. In mid-century America and Europe sexual attractiveness was a desired complement to female employers' office skills: 'It was not so much that an employer actually expected to have sexual relations with "his" secretary', Kidwell and Steele explain, 'but it was nevertheless sexually gratifying to "have" such an attractive subordinate' (1989: 85). That this was a matter of tricky negotiation also emerges in self-help manuals of the era; in Head's *Dress for Success*, for instance, we read that 'you should look your *best* – but your *business* best rather that your beau-catching best' (Head [1967] 2009: 10). Nevertheless, while secretaries may only expect to be working before settling down, the prospect of marriage may well come from the workplace, as 'movies and popular fiction often promoted the ideal of marrying the boss' (Kidwell and Steele: 1989: 85).

The tense negotiation of female desire in the workplace is well reflected in Moneypenny's office talk with Bond in the early films. In *For Your Eyes Only*, a filing cabinet drawer concealing a hidden dressing table allows Moneypenny (Maxwell) a quick beauty touch-up before seeing Bond (Moore). In response to his initial comment – 'Moneypenny! A feast for my eyes!' – her witty reply – 'What about the rest of you?' – hints to her awareness of the male gaze and, simultaneously, her desire for closer intimacy (*For Your Eyes Only* 1981). In *Diamonds Are Forever*, Moneypenny (Maxwell) asks Bond (Connery) to bring her back a diamond ring from Amsterdam; he settles for a tulip, but not before making a flirtatious remark on her customs officer uniform: 'Anybody seeing you in that outfit would be discouraged to leave the country', he says (*Diamonds Are Forever* 1971). In *A View to a Kill*, when Moneypenny (Maxwell) is dressed up for a horse race in a pink dress and matching hat, Bond (Moore) lends his critical eye, 'Don't you think that's little over the top for the office?' (*A View to a Kill* 1985). As most of Bond's interaction with Moneypenny revolves around her physical attractiveness, their harmless office banter nevertheless draws attention to the problematic dynamics in place.

It follows, then, that Moneypenny's early renditions manifest a complex and changing attitude towards the notion of 'power dressing'. Maxwell's performance as Moneypenny displayed a consistently sober and traditional feminine look –

silky blouses, occasionally adorned with frills or pussy-bows, and modest dresses – throughout the first fourteen films of the franchise. Unashamedly open about her attraction for Bond, her unmarried status positions her, especially in Maxwell's later movies, between the potential for sexual liberation and the curse of spinsterhood, even though she was the same age as Roger Moore, who starred in her latter films. Such liminal condition may be empowering, in that 'Moneypenny does not allow the male/female, active/passive binary to stand' (Brabazon 2003: 207). Nevertheless, her progressively more matronly style, and overall 'soft femininity' conveyed by the pearls and silk scarves that frequently adorn her neck expose a gap between her and her male colleagues. But even in the 1980s, Moneypenny retains her overtly submissive behaviour with regard to Bond's sexual innuendoes, which, in *The Living Daylights*, go as far as bottom-patting, although this is only heard, rather than seen, on screen.

When Samantha Bond took over the role in *GoldenEye*, her debut scene, as already discussed in chapter 2, displayed some continuity with tradition:

Bond: Out on some kind of assignment? Dressing to kill?
Moneypenny: I know you'll find this crushing, but I don't sit at home praying for an international incident so I can run down here all dressed up to impress James Bond. I was on a date with a gentleman. We went to the theatre together.
Bond: Moneypenny, I'm devastated. What would I ever do without you?
Moneypenny: As far as I can remember, James, you've never had me.
Bond: Hope springs eternal.
Moneypenny: This sort of behaviour could qualify as sexual harassment.
Bond: Really? What's the penalty for that?
Moneypenny: Someday you have to make good on your innuendoes.

GoldenEye 1995

Showcasing Moneypenny in a black lace evening dress which, as she explains, is not intended for the office, her (clothed) body becomes, once again, the focus of debate. In spite of her 'dressed to kill' moment, Samantha Bond's Moneypenny reiterates the emancipatory function of 'power-dress'; having left behind her predecessors' pussy-bow blouses, her tailored trouser-suits match M's in their subdued soberness: 'her clothes … signify a desiring and desirable woman, who is able to demand rights in the workplace', Brabazon comments, while 'her availability, yet distance from Bond, is reinforced by Moneypenny's recognition that she has never been "had"' (Brabazon 2003: 211).

In this respect, she is in line with other professional women, whose tailored suits, while signalling their professional duties, do not hinder their desirability. This is the case, in *You Only Live Twice*, with Helga Brandt (Karin Dor), whose red skirt-

suit hints to her *femme fatale* role behind the façade of her professional engagement at Osato Chemicals; she sleeps with Bond in between her attempts to kill him. In the Rio de Janeiro scene of *Moonraker*, high heels sex up Dr Holly Goodhead (Lois Chiles)'s Givenchy black satin jumpsuit (Walsh 2012). An ice-grey suit serves to convey Miranda Frost (Rosamund Pike)'s cold allure in *Die Another Day*. In *Spectre*, psychologist Madeleine Swann (Léa Seydoux) wears a collarless blazer, the structured shoulders of which contrast with the more feminine sharp cut of the open-front signalling, simultaneously, the character's edginess and sex appeal.

In both *Skyfall* and *Spectre*, the Moneypenny reboot through the casting of Naomie Harris pinpoints the coming of age of female professional wear; a combination of distinctly feminine looks conveyed by office dresses as well as evening gowns and fieldwork action clothes propose a composite, dynamic look that encapsulates the modern working woman. Sexual tension with Bond persists, but Moneypenny always appears to be in control of her sexuality, and 'has a life' outside the office, marking clearer boundaries in her relationship with Bond. Embodying neither the soft femininity of the submissive secretary or the tough hypermasculinity of the female executive, Moneypenny's multifaceted femininity succeeds in conveying the gender complexity of Bond Girls.

Cross-dress for success

Looking beyond the provocative glamour of their lavish evening dresses and skimpy swimwear, the selection of action wear, (unisex) uniforms and professional clothes in which Bond female characters perform a large part of their roles, points to a more complex reading of these characters' involvement in both Bond's missions and their own. Underpinning their desire – and ability – to be involved in action is a constant reference to fashion's discourse on cross-dressing. The appropriation of masculine clothes in the forms of casual, sports, and professional wear speaks of a long trajectory of fashion's attempts to grapple with sexual difference from the nineteenth-century dress reformers on both sides of the Atlantic to twenty-first-century high-heeled power-dressers. With the fashion industry still struggling with the unisex concept even in children's clothing, and androgyny primarily relegated to the catwalk, mainstream characters such as Bond Girls also continue to be heralded as the epitome of conventional feminine display. Yet, what emerges from the cross-dressing at play in the novels and films is not a regressive celebration of conventional gender norms, but the dynamic picture of a clash between Bond's vulnerable masculinity and the Girl's hard femininity.

Dressed to Kill:
Power, Knowledge, Desire

The whole point of Bond Girls was that they wore nothing: all they got to wear was 007. The occasional girl lucked out and got a lick of gold paint or a deadly snake to protect her modesty – but that tended to come at a price.

Langmead qtd. in Walden 2008

Bond Girls dress to kill. Sex and violence are captured in their iconic costumes. It seems strange, then, that on the occasion of a Bond-theme party he organized, *Esquire* editor Jeremy Langmead would dismiss the central role played by costume in the Bond films. Even 'chaste' Moneypenny, as seen in the previous chapter, makes an impression on Bond when she turns up at the office 'dressed to kill' in *GoldenEye*. Pictures of Bond Girls frequently appear in fashion spreads, film magazines, and lifestyle blogs; even men's monthlies such as *GQ* – and as his own *Esquire* – have filled their pages with the iconic women in glamorous clothes.

It is, indeed, clothing, rather than nudity, that performs an erotic function, even when that is 'a lick of gold paint' (arguably still a form of clothing); 'whereas love and lust can be quite separate from dress', comments Colin McDowell in his discussion of fetishistic fashion, 'sex and clothing are inextricably linked' (1992: 11). Though rooted in sexuality, fetishism also permeates sartorial performance outside the bedroom. As Valerie Steele reminds us, 'leather, rubber, "cruel shoes", tattoos, and body-piercing – all the paraphernalia of fetishism have been increasingly incorporated into mainstream fashion' ([1996] 1997: 9). *Elle's* 1995 'Who's Shocking Whom?' photo-story, for instance, blurred the mainstream fashion/subcultural dress boundaries through 'images . . . of models in designer fetish-wear, chained to chairs, enclosed in box-like spaces, the slippery shine of their rubber corsets, dresses and trousers offset with spike heels and padlock jewellery' (Arnold 2001: 77). Some readers' experience of fetish wear would have been limited to cinema and TV – 'the camp catsuits worn by Emma Peel in the 1960s television series *The Avengers*, or the futuristic costumes worn by Jane

Fonda in *Barbarella* of 1968' (Arnold 2001: 77). To others, however, these images would have echoed first-hand experience of 1970s punk fashion.

While 'dressed to kill' conventionally translates into fetish wear and, in particular, S&M costume, the commodification of fetish fashion points to a more nuanced relationship between dress, sexuality, and power in the Bond narratives, where the sexualisation of women's bodies occurs in multiple ways and to different effects. Although this has led to reading the narratives as clichéd manifestations of female oppression, naivety and victimhood, their costumes in fact expose the permeability of the assertive/submissive, knowing/innocent, perpetrator/victim categories, as the ambivalence of fetish dress serves to undermine the stability of such binary distinctions.

Psychoanalytical theory has helped to draw attention to the complex function clothes play in the erotic context. Nineteenth-century psychoanalyst Richard von Krafft-Ebing first explored the significance of particular kinds of fashion, which, by enhancing secondary sexual characteristics, trigger sexual fantasies. Fascination with particular items of clothing turns, in its most extreme manifestations, into fetishistic sexual practices, where pleasure is no longer immediately linked to sexual anatomy or intercourse but is mediated by clothes; as Krafft-Ebing explained: 'Culture and fashion have ... endowed woman with artificial sexual characteristics, the removal of which, when woman is seen unattired, in spite of the normal sexual effect of this sight, may exert an opposite influence' (Krafft-Ebing [1886] 1906: 247). Clothes, then, play a vital role in the construction of sexual desire and its intricate ramifications.

The erotic charge of dress emerges most powerfully in sado-masochistic practices. To some fetishists, pleasure is never without pain, be this physical or emotional, and specific types of clothing can elicit both sensations; one of Krafft-Ebing's patients whose 'ideal was the female form in bathing costume, with silk stockings and corset, and clad in a mourning-dress', exemplifies the arousal of the fetishist's desire by the morbid coexistence of sex and death. What the history of fetishism reveals, too, is the fluidity of the power dynamics in place; while a male patient would take pleasure in wearing a corset, pleasure could also be displaced on other bodies, as 'the pain of tight lacing, experienced by himself or induced in women, was a delight to him' (Krafft-Ebing 1906: 252–3).

Though easily dismissed as a misogynistic tool in the hands of patriarchal culture, fetishism can, in fact, be subversive. Nineteenth-century corsets and tight lacing, discussed in more detail later in this chapter, have often attracted criticism as instruments of female oppression. These critical responses, however, frequently derived from conservative sectors of society that regarded

the non-normative sexual practices associated with tight lacing as highly suspicious (Steele 2013: 45–9). In the twentieth and twenty-first centuries, the ambiguous function clothes still play in the display and displacement of desire serves to expose Bond Girls' 'knowing' sexuality, and the conservative attempts to control it.

'Sex, snobbery and sadism'

Violence and misogyny regularly crop up in Bond commentaries, with or without feminist credentials. In his 1958 article 'Sex, snobbery and sadism', Paul Johnson's scathing review of Fleming's *Dr No*, drew attention to the problematic violence in the Bond books:

> It has become easier … to make cruelty attractive … Recently I read Henri Alleg's horrifying account of his tortures in an Algiers prison; and I have on my desk a documented study of how we treat our prisoners in Cyprus. I am no longer astonished that these things can happen. Indeed, after reflecting on the Fleming phenomenon, they seem to me almost inevitable.
>
> Johnson [1958] 2007

The glamorization of violence, Johnson felt, was key to Fleming's popularity in a society that had developed a worrying taste for it. As Johnson's review established a line of criticism still pursued today, Fleming found himself justifying the violent aspects of his work on a number of occasions. In the last interview he gave in 1964, he simply claimed that Bond was a product of his times:

> We live in a violent era, perhaps the most violent man has ever known. In our last War, thirty million people were killed. Of these, some six million were simply slaughtered, and most brutally. I hear it said that I invent fiendish cruelties and tortures to which Bond is subjected. But no one who knows, as I know, the things that were done to captured secret agents in the last War says this. No one says it who knows what went on in Algeria.
>
> Fleming 1964: 102

Violence belongs to Bond as it did – and still does – to the world of his readers. Although violence on women does appear throughout the Bond narratives, it would be reductive to read this in terms of female oppression, *tout court*. To do so, would be to oversimplify the ambiguities concealed in the treatment of female sexuality, and its relationship to the violence in the novels and films.

Fleming's alleged penchant for non-normative sexual practices further muddles the waters of this argument. Lycett, for instance, notes that a female visitor to Fleming's Ebury Street apartment was shown 'books about women dressed up in lace collars, standing over manacled men with a whip' (1995: 86). Though this may be proof of Fleming's interest in the female dominatrix – and a submissive male behaviour – elsewhere, a letter to Edith Morpurgo reveals the assertive side of his sexuality:

> I will say nothing more to you – only that I ... you. If I were to say 'love' you would only argue, and then I would have to whip you and you would cry and I don't want that. I only want for you to be happy. But I would also like to hurt you because you have earned it and in order to tame you like a little wild animal.
>
> qtd. in Flood 2014

Such insights into Fleming's biographical details might propose an awareness of desire's shifting patterns, inconsistencies, and ambiguities. They also point to the centrality of fantasy to the contrasting impulses of sexual desire.

This is important to bear in mind when reading Vivienne Michel's paradigmatic account of her affair with Bond in *The Spy Who Loved Me* (1962), the only Bond novel Fleming wrote from a female point of view. In a frequently quoted passage, Vivienne draws from her sexual experience with Bond an uncomfortable generalization about female sexuality:

> All women love semi-rape. They love to be taken. It was his sweet brutality against my bruised body that had made his act of love so piercingly wonderful ... There might be many consequences for me – not the least that I might now be dissatisfied with other men.
>
> [1962] 2009: 170

It is difficult, here, to take the reference to 'semi-rape' literally, as Vivienne is a consenting participant. Indeed, the concern that she 'might now be dissatisfied with other men' puts the accent on female pleasure, the pursuit of which Vivienne is actively involved in.

Vivienne's attitude, too 'wayward and independent' for the finishing school – 'Women should be willows, Vivienne. It is for men to be oak and ash' ([1962] 2009: 17) – emerges in her disregard for sartorial advice – imparted by the English girls at her boarding school – that she 'must wear a tighter bra' ([1962] 2009: 17), which makes her akin to the free-spirited 1960s go-go girl clad in one of Courrèges's bra-less designs (Giraud 1965: 110). Years later, on the stormy

night of the attack by thugs Sluggsy and Horror, her choice of clothes hints to a pleasure-seeking approach to her body and sexuality:

> On an *impulse*, I put on the best I had in my tiny wardrobe – my black velvet toreador pants with the *rather indecent* gold zip down the seat, itself *most unchastely tight*, and, *not bothering with a bra*, my golden thread Camelot sweater with the wide floppy turtleneck. *I admired myself in the mirror*, decided to pull my sleeves up above the elbows, slipped my feet into my gold Ferragamo sandals, and did the quick dash back to the lobby.
>
> Fleming [1962] 2009: 15; my emphases

The dressing-up ritual here echoes Bond's sartorial fastidiousness. On one hand, Vivienne's self-assuredness is conveyed by way of a modern, fashionable femininity rooted in the youthful emphasis on comfort, nonchalance, and a hint of 'not-bothering-with-a-bra' sexual emancipation of the 1960s. As with Bond, however, Vivienne's sartorial 'armour' also conceals her scars, evoking the sense that 'clothes are a shield, covering a woman's imperfections' (Giraud 1965: 110), as François Giraud wrote of Chanel's designs; behind this vespa-riding young woman's devil-may-care attitude is a bitter sense of disillusion and the emotional trauma of a recent abortion.

Vivienne's feminine act of 'dressing-up', followed by the masculine consumption of tobacco and Bourbon, is significantly not for the benefit of anybody else but herself – 'Why had I dressed up to kill if I had expected to be alone?' ([1962] 2009: 95). Her concerns about the authorities' potentially unsympathetic response to her assault reveals the fear, frequently shared by feminist critics, that 'women who dress to flaunt rather than disguise sexual difference ... [collude] in their own oppression' (Bruzzi 1997: xix). Yet the fact that she, admittedly, 'dresses to kill' on a night when, in fact, she gets close to being raped and murdered, is suggestive of a complex femininity, simultaneously naïve and knowing, desiring and sentimental, impulsive and reflective. Though waxing lyrical about Bond's 'authority, ... [and] maleness' and the fact that 'like the prince in the fairy tales ... he had saved me from the dragon', she also admits that 'he was just a professional agent who had done his job' ([1962] 2009: 170). When contextualized within the rest of the narrative, therefore, Vivienne's statement that 'all women like semi-rape' might sound less of a confessional revelation about female submissiveness and more of a statement about the complexity of desire. What Vivienne's first-person narrative, therefore, produces, is an insight into the overlaps between female sexuality and power, a central theme throughout the Bond novels and films.

Fetishism and castration anxiety

Mulvey's study of the male gaze stems from the theory of castration, according to which, to put it simply, the male unconscious develops a fear of emasculation from the confrontation with sexual difference, as exemplified, in childhood, by the absent penis in the allegedly castrated body of the mother. The development of confident masculinity relies on the management of castration anxiety, through either a direct confrontation with the female source of fear followed by sadistic vilification to put fears at bay, or the fetishization of the female body which, made into an object of pleasure, no longer poses a significant threat (Mulvey 1975: 14). In dealing with masculine anxieties about female autonomy, the Bond narratives follow both avenues which Mulvey respectively identifies in the visuals of *film noir* and classic Hollywood cinematography.

Starting in reverse order, the fetishistic approach plays a prominent role in the opening credit visuals, which, since *From Russia with Love* consist of animations populated with female bodies. These are often in the form of opaque dark silhouettes, the contours of which stand out against a more colourful background. More specifically, in *From Russia with Love*, the barely visible body of a belly dancer leads to a choreographed series of close-up shots of her abdomen, arms, legs, breasts and torso to the sound of Matt Monro's voice performing the title song. In *Goldfinger*, a golden hand rises on screen, pointing upward, against the initial notes of John Barry's powerful score; the features of Gert Fröbe, who plays the eponymous villain, appear projected on the hand, later replaced by the silhouette of a golden female profile, upon which Connery's face becomes visible. A female torso then appears, with Blackman's face cast on the golden bust, followed by a shoulder, a leg, and then a face, its mouth sealed by the revolving registration plate of Bond's Aston Martin. The eyes, when visible, are always shut, suggesting the body is in fact a gilded corpse; viewers already familiar with the film will acknowledge that these disjointed images of golden body parts refer to the kiss of death received by the 'golden girl' sung about by Shirley Bassey. In both sequences the close-ups of selected parts mean the bodies are never seen in their entirety; in the second one, the fetishistic fragmentation is enhanced by 'the gold color [which] stylizes the body into a luxurious object that one can possess or collect' (Planka 2015: 143).[1]

Elsewhere, female body imagery is intertwined with objects symbolizing luxury and commodity items. In the title sequence for *Diamonds are Forever* two female hands hold a large diamond, before a bejewelled hand points a gun to a female crotch also adorned with diamonds; in *On Her Majesty's Secret Service*, female silhouettes emerge from, and drown into, a martini glass: 'the

female body thus becomes part of a commodity of aesthetics that foregrounds consumption, and turns sex into a consumer product', argues Sabine Planka of the objectification of unrecognizable female bodies in the film title sequences (2015: 142). The fetishistic fragmentation, with the positioning and framing of these selected body parts in isolation, is particularly evocative of Freud's theory of the phallic mother, where the deeply rooted male fear of castration leads to fetishism. In order to avert his castration anxiety allegedly triggered by the sight of the woman's 'missing' penis, male fantasy replaces the female penis with other body parts or objects:

> Yes, in his mind the woman has got a penis, in spite of everything; but this penis is no longer the same as it was before. Something else has taken its place, has been appointed its substitute, as it were, and now inherits the interest which was formerly directed to its predecessor.
>
> Freud [1927] 1995: 154

While the patriarchal foundations of Freud's standpoint point to the woman's 'lack' as problematic for the development of masculine identity, it is extremely significant that castration anxiety implies the mother's knowledge – she knows she never had a penis – against the boy's innocent naivety. This is similarly put by Freud in his 'penis envy' theory: unlike the little girl 'who has seen it and knows that she is without it and wants to have it' (Freud [1925] 1995: 252), 'the little boy ... does not share this immediacy of understanding' (Doane 1982: 79); put in these terms, what threatens the male subject, is the fact that female sexuality is always knowing.

Existing 'outside', or on the margins of, the main narrative, the animated choreographies of the Bond title scenes exemplify the fetishistic avenue pursued in the films. This develops as visual pleasure (scopophilia): 'fetishistic scopophilia ... can exist outside linear time', Mulvey argues, 'as the erotic instinct is focused on the look alone' (1975: 14). The sensual beauty of female bodies exists, if we follow Mulvey's argument, as the passive spectacle of the gaze. The effectiveness of body close-ups, as others have noted, is such that 'the relationship of women to fashion appears in itself to be fetishistic, or at least fixated on certain parts of the female body' (Gamman and Makinen 1994: 61). In turn, however, such self-fetishization also has its commercial implications, as, Craik reminds us, 'one of the most lucrative types of modelling work is done by models who specialise in particular body parts, such as hands, feet, legs or breasts' (1994: 79). As a result of these complex cultural and economic factors, while the beauty of the female form appears crystallized according to these parameters, the consumers of such images 'buy' into an image of themselves that is never whole, but constantly being broken down: 'modern women

often see themselves in fragments' (Gamman and Makinen 1994: 61). Similarly, in the Bond title sequences, these bodies can exists only in their dismembered form, as their reassuringly fragmented condition means they no longer pose a (castration) threat to Bond. This is particularly poignant in *Goldfinger*, a film where the castration threat is exemplified by Goldfinger's laser beam, and Bond's playful admission that he always carries a gun because of 'a slight inferiority complex' (*Goldfinger* 1964). That these fetishized images occupy the threshold of the narrative is significant because they can promote a lasting image of female objectification, which, beyond the world of the story, can be applied, more widely to (gender) politics.

The imagery used to convey a mysterious threat on Western space control at the beginning of the film *You Only Live Twice* is also expressed in castration terms when an American space craft is swallowed up by a much larger spaceship; as the 'mouth' closes, it severs the cable that links one of the astronauts to the smaller craft, leaving him dead in the dark abyss of outer space. The castration threat embodied by the open mouth of the vessel that swallows the phallic rocket references the archetypal myth of *vagina dentata*, 'the [toothed] vagina that castrates' (Campbell 1976: 73), and here also responsible for the deadly cut of a metaphorical umbilical cord. British intelligence suggests the Soviets are not, in this instance, responsible for undermining American control over space. Such intelligence, it segues, is significantly embodied by a post-coital Bond in bed with Ling (Tsai Chin), a Chinese woman hired to stage Bond's fake death in Hong Kong:

> Bond: Why do Chinese girls taste different from all other girls?
> Ling: You think we better, eh?
> Bond: No, just different. Like Peking duck is different from Russian caviar, but I
> love them both.
> Ling: Darling, I give you very best duck.
>
> *You Only Live Twice* 1967

Significantly, Bond's opening line replaces the potential hazard of female sex with the safer pleasure of food consumption; castration fear is at bay, and Western masculinity is safely restored, in spite of the threat visualized in the outer space scene.

Tinged with misogyny are also the fetishistic references in the novel *From Russia with Love*, where Bulgarian assassin Krilencu's shack is hidden behind a bill-board, which, on the night of his assassination, depicts an advert for Henry Hathaway's *Niagara* (1953): 'the vast pile of Marilyn Monroe's hair, and the cliff of forehead, and down the two feet of nose to the cavernous nostrils ... between the great violet lips, half open in ecstasy, the dark shape of a man emerged and

hung down like a worm from the mouth of a corpse' (Fleming [1957] 2004: 173). Grotesquely amplified by the gigantic scale of the female body, the suggestively open female mouth – another overt reminder of the *vagina dentata* archetype – triggers the abject horror of deadly female sex. In the film version, released six years after the novel, to make the reference current, and add self-publicity, *Niagara* is replaced by Gordon Douglas's *Call Me Bwana* (1963), one of the three non-James Bond films produced by EON, and starring Anita Ekberg. In spite of the more light-hearted tone of the scene, the fetishistic response to the female body remains, when, as Krilencu opens the hatch door to leave his hiding-place, Kerim Bey tells Bond: 'She has a lovely mouth, that Anita'. Bond's response – 'She should have kept her mouth shut' – may be dismissed as sexist banter. Significantly, however, the same night, Tania's flirtatious overture – 'I think my mouth is too big' (*From Russia with Love* 1963) – is accompanied by a camera close-up of Daniela Bianchi's parted lips (Fig. 14); 'It's just the right size', Bond tells himself, reassuringly, before kissing her.

Fragmented, distorted and consumed, metaphorically or otherwise, the female body can, at times, function to assuage Bond's bruised masculinity. Rather than reading these scenes as defining of the role played by women in the Bond narratives, these fetishized images of female bodies highlight, in fact, the crumbling foundations of the male ego whose control over these images is only limited to the realm of fantasy.

Sadism: disposable victims?

As a result of their clash with the sources of patriarchal control, Bond Girls can be on the receiving end of violence; 'sadism demands a story . . . a battle of will and strength, victory/defeat, all occurring in a linear time with a beginning and an end' (Mulvey 1975: 14), but violence can also operate a subversive function. In particular, like the *femme fatale* of *film noir*, the Bond Girl Villain's desire, a dangerous threat to Bond's masculinity, is eventually suppressed through sadism.

Yet such sadism does not simply equate to a misogynistic dismissal of female agency. Violence and sadism may in fact raise awareness, particularly among female spectators, of the manipulative ways in which patriarchy can and does oppress women. In response to Mulvey's analysis of Hitchcock's films, Tania Modleski argues that, 'in so far as Hitchcock films repeatedly reveal the way women are oppressed in patriarchy, they allow the female spectator to feel an anger that is very different from the masochistic response imputed to her by

some feminist critics' (2005: 4). On the contrary, the death of a dangerous woman draws attention to the threat she poses to the patriarchal order of both Bond and the villain, especially when, as Modleski implies, she is framed within a 'knowing' position. Rather than reading Bond Girls as disempowered victims, female knowingness and desire become a disorientating force and, consequently, a source of anxiety for masculine authority.

In Fleming's short story 'The Hildebrand Rarity' (1960), the catching of a stingray unveils the abusive relationship between two of the story's main characters:

> The tail was the old slave-drivers' whip of the Indian Ocean. Today it is illegal to possess one in the Seychelles, but they are handed down in the families for use on faithless wives, and if the word goes around that this or that woman *a eu la crapule*, the Provençale name for the sting ray, it is as good as saying that that woman will not be about for at least a week.
>
> 2008: 145

In the story, the millionaire and marine biology enthusiast Milton Krest, who owns the ray whip, claims to have used it only once on his wife, Liz. Mr and Mrs Krest's sadomasochistic relationship is significantly conveyed through their sartorial presentation. Bond notices, for instance, that Milton Krest 'looked hard and fit, and the faded blue jeans, military-cut shirt and wide leather belt suggested that he made *a fetish of doing so* – looking tough', and that his presence produces 'the forced maleness of man' (2008: 149–50, 154; my emphasis). Against Milton's stylized performance of hypermasculinity, Mrs Krest's body is simply clad in 'the pale brown satin scraps of [a] bikini' (2008: 149–50). The illusion of nakedness, and Bond's later observation that 'there was something painfully slavish in her attitude towards him' (Fleming: [1960] 2008: 153), confirm the abusive pattern within the marriage. At the end of the story, however, Milton's 'accidental' fall into the sea suspiciously points to his wife. Given what we know about the shifting power dynamics of sado-masochism, the fetishistic aspect of the characters' sexual relationship underscores an ambivalent reading of Liz's apparently submissive behaviour and naivety. In the end, she displays the knowing assertiveness frequently shared by Bond Girls.

The conflation of the *femme fatale*/sacrificial lamb categories in the Bond narratives questions the clichés attached to women, and the value attached to feminine submissiveness in patriarchy. In her discussion of the origins of sadism in relation to Sade's pornographic novels, *Justine* (1791) and *Juliette* (1797), Angela Carter points to the libertine Juliette as the maker of her own

destiny, showing agency and control in place of the submissiveness and subservience of her sister, Justine. Making sadism her own virtue, Juliette becomes the perpetrator of sadistic violence, whereas Justine is paradoxically trapped in a vicious circle of victimhood. The two sisters, and their predicaments, become paradigms for contemporary women: 'if Justine's image gave birth to several generations of mythically suffering blondes', Carter argues, 'Juliette's image lies behind the less numinous prospect of a board-room full of glamorous and sexy lady executives' (Carter 1979: 102). In the controlling hands of fictional female characters, sadism acquires a different meaning, as it ceases to pigeonhole women in the passive role of the victim, displaying, instead, active resistance to patriarchal control.

But the Bond narratives can be uncomfortably violent. In the film *You Only Live Twice*, Helga Brandt is fed to piranhas for failing to kill Bond; while her execution does not overtly reference Helga's sexuality, viewers know that her failure is partly connected with her own sexual encounter with Bond. Her red suit is a clear indicator of her predatorial sexual nature, which is framed by the real possibility of torture to extract knowledge from Bond. Her chosen tool, a dermatome, a sharp instrument used in plastic surgery, subverts the fetishization of the dismembered female body through her threatened 'cosmetic' surgery on Bond's body: 'I hope you won't force me to use it' (*You Only Live Twice* 1967), she warns him, before her fatal change of heart.

Karl Stromberg's unnamed assistant, played by Marilyn Galsworthy in *The Spy Who Loved Me*, also suffers a memorable death sentence, made to fall into his shark tank and horribly eaten alive by one of the creatures. Dr Bechmann and Professor Markovitz, the inventors of Stromberg's submarine tracking system, are forced to watch the spectacle as it unravels on the dining-room screen, accompanied by the sublime soundtrack of Johann Sebastian Bach's 'Air on a G String'. The scene also makes a clear reference to the spectacle of ideal female beauty captured in the image of Botticelli's *Venus* on the screen blind. Significantly, as the woman falls down a slide leading to the shark tank, her modest beige dress is lifted to reveal her legs and white underwear before the shark attacks the woman's crotch and strips her torso naked; the sexual connotation of the punishment establishes a vivid link between female disobedience and sexuality.

As with Helga's execution, here the feeding of the female body to the aggressive appetites of wild creatures implicates the greed of the victims; both are killed for pursuing their own appetites. Indeed, while the graphic details tint the scene with brutal voyeurism, the assistant's death does not simply stem from sadistic

pleasure. Her punishment is in fact for her disclosure of the project plans which, Stromberg emphasizes, she knew 'intimately'. Insignificant as the character may appear at the beginning of the scene, her death draws attention to her knowledge as a source of danger to Stromberg's project.

In the sense that the threat Bond Girls pose is also intimately linked to their knowledge/knowingness, Stromberg's assistant's indiscretion is also comparable with Corinne's actions – and their fatal consequences – in the film *Moonraker*. The sexual encounter she shares with Bond represents the breach of trust later punished through her graphic assault by Drax's dogs. Her costumes significantly capture her contradictory embodiment of the sexual temptress and innocent virgin. Her revealing nude night-dress in the sex scene is later replaced by a modest pastel dress, with long sleeves and a frilly bib detail, when she runs into the woods, a true damsel in distress with no knight in shiny armour in sight.

Lace motifs feature in both of Corinne's costumes. As a material that plays with the illusion of nudity, the discontinuous visibility allowed by lace can be charged with powerful eroticism. Indeed, reflecting on the partial visibility clothing can produce, Roland Barthes rightly notes:

> Is not the most erotic portion of the body where the garment gapes? ... There are no erogenous zones; it is intermittence which is erotic: the intermittence of skin flashing between two articles of clothing ... between two edges ...; it is this flash itself which seduces, or rather: the staging of an appearance-as-disappearance.
> [1973] 1998: 9–10

Eroticism, in other words, stands in a complex relationship with visibility; a partially seen body is more erotically charged than a fully naked one. This echoes the ambiguous function played by clothes in the covering/revealing of the body. While, as Flügel claims, 'clothes represent a perpetual blush upon the surface of humanity' ([1930] 1950: 21), the opposite drives of modesty and exhibitionism converge in the negotiation of nudity. The possibility of impending revelation implied by the openwork frame of lace is so central to seduction that lace becomes virtually omnipresent in lingerie and bridal gowns. In the latter case, the particular eroticism of lace derives from its interplay with a celebration of virginity, and the awareness of its fragility. It is precisely this form of permeability that the lace worn by Corinne embodies, establishing an important parallel between the penetrability of Corinne's body and that of Drax's dirty secrets; the connection between Corinne's sexuality and knowledge is made quite clear by Bond's exploitation of both.

Desiring and desirable women

Power. Revenge. Or simply pleasure. Bond Girls are desiring women, but in the patriarchal dualism of Bond's world, his authority depends on the desirable Bond Girl, who, simultaneously needs to desire him, to endorse his masculinity. This rise of a desiring woman is, therefore, doubly problematic, because although female desire is necessary to the perpetuation of patriarchy, it must also be controlled.

Set in this ambiguous opposition to the male hero, the tension between Bond Girls' desire and desirability is inscribed in their clothes. Seen through the lens of fetish culture, materials – from lace to leather – and colours – black and red – convey the complex and often contradictory drives that move their stories forward. Their sartorial awareness and knowing exhibitionism, in turn, become an explicit attack on the 'controlling' male gaze. This means that even when death is the final resolution, it may well have been what they had pursued all along.

The fabric of Tracy's bridal garment, crocheted openwork, establishes continuity with the flower motif in the film (Simmonds 2016: 95), and produces, simultaneously, the conventional effect of lightness and 'invisibility' of bridal garments. In Barthes's systematic classification of clothing, light/heavy and opaque/invisible are the oppositions against which a bridal gown can traditionally be associated both with the lightness and discontinuous visibility of lace:

> As a substitute for the body, the garment, by virtue of its weight, participates in man's fundamental dreams, of the sky and the cave, of life's sublimity and its entombment, of flight and sleep: it is a garment's weight which makes it a wing or a shroud, seduction or authority; ceremonial garments (and above all charismatic garments) are heavy; authority is a theme of immobility, of death; garments celebrating marriage, birth, and life are light and airy.
>
> Barthes [1967] 2010: 126

Such lightness, however, can be an illusion, since 'marriage gowns ... project their illusions of luminous evanescence through ponderous layers of cloth and lace' (Warwick and Cavallaro 1984: 64).

Nevertheless, there is a commonplace opposition, in Western wedding attire, between the airy 'transparence' of the bride's gown and the solid opacity of the groom's suit. In his 2006 Spring/Summer collection 'The Widows of Culloden', Alexander McQueen amplified the concept of bridal 'ethereality' by having a spectral hologram of Kate Moss's 'blonde hair and pale arms trailing in a

dream-like apparition of fragility and beauty that danced for a few seconds, then shrank and dematerialized into the ether' (Mower 2006) to conclude his show. Facilitated by McQueen's use of Pepper's Ghost, a Victorian optical illusion technique, Moss's apparition looked 'like a visitor from another world' (Sherman 2015: 243), capturing the designer's fascination 'for the inevitable fate of all natural things, for vulnerability, death and decay' (Edelkoort 2013b: 241). Signalling the morbid coalescence of love and death, McQueen's spectral bride also supports the inherent paradox of the conventional wedding dress, as it captures the illusory incorporeal presence of the bridal body.

The wedding dress can be universally understood as the ultimate liminal garment; in Western culture, the white colour, lightness of fabric and interplay with visibility all point to the transitional space the female body occupies on her wedding day. While her death in her wedding dress plays out some of the ambiguities attached to the liminality of bridal dresses, Tracy's demise at the end of the film is significantly prefigured on her first encounter with Bond, when his 'rescue' of her thwarts her attempted suicide. Tracy's choice to drown herself in the sea, establishes the elemental communion with water persistently shown in a Bond Girl's aquatic continuum from Honey Ryder to Solange Dimitrios (Caterina Murino, *Casino Royale*) (see Funnell 2018: 20). Here, such continuity with the sea is conveyed by the 'scalloped dress in sea green silk' (Laverty 2011); with the sequined surface of the robe evoking the scales of a mermaid's tale, the dress underpins Tracy's conscious desire to pursue the death she has chosen for herself. The romantic rescue that ensues is underscored by the implicit reference to the fairy-tale of Cinderella, as in her attempt to escape from the thugs that want her dead, she leaves her slippers behind. But Bond is no prince charming, and marriage, though on the cards, does not last long.

That Bond's only bride dies in her wedding outfit is significant of the ambivalent function played by desire in the Bond narratives. As Bond admits to Tiffany in the novel *Diamonds Are Forever*, 'most marriages don't add two people together. They subtract one from the other'. While, as Tiffany's response – 'You can't be complete by yourself' (Fleming [1956] 2004: 192)' – bears significance to the psychological void central to Bond's character, it is also true that conventional marriage does not have a place in Bond's world. This is not simply because Bond can be a sexist misogynist. On the contrary, it prefigures a more modern union centred on desire, the fulfilment of which Bond is an active player in; though Bond's prowess in the sexual arena may be the stuff of male fantasy, as Jeanette Winterson playfully observes, 'Bond ... satisfies ... [women] sexually, and any woman in touch with her body will want a lover who does that – and ... she

doesn't have to marry him' (Winterson 2002). On this basis, Tracy's death stipulates the incompatibility of desire with patriarchal marriage; her death is the demise of romance and patriarchal marriage, which does not have a place in Bond's world.

In its place is a more fluid approach to sexuality, often exposing the problematic containment of female desire within an oppressive marriage, through the figure of the *femme fatale*. In *Tomorrow Never Dies* the ostentatious glamour of Paris Carver, who appears in an Ocimar Versolato black gown at her husband's gala reception, is designed 'to demonstrate her wealth, exude sex appeal' (Simmonds 2015: 246). While her husband might be financially responsible for putting her dress on, it is significantly, Bond, who takes it off, displaying Paris's body in seductive lingerie complete with corset and suspender belt. The 'problems' with an active female sexuality are ambiguously inscribed in the body and sartorial look of the *femme fatale*. As Bruzzi has noted, the notion that 'despite her ability to manipulate and seduce the men around her ... the *femme fatale* is somehow impotent and harmless' (1997: 124) is based on a misconstrued understanding of the exaggerated femininity she is often framed within. Indeed, although Paris dies at the hand of her jilted husband, her transgressive behaviour signals, at the very least, resistance against patriarchal oppression. Since clothing becomes the principal tool through which the *femme fatale* manipulates the male gaze to her own advantage, her stylized femininity subverts assumptions about female objectification, pointing to the notion that 'fashion is not inevitably produced to render the wearer attractive to the opposite sex' (Bruzzi 1997: xvii), and that women primarily dress to please themselves.

Such sartorial acuteness emerges in Fleming's description of the first literary Bond Girl, Vesper Lynd:

> Her dress was of black velvet, simple and yet with the touch of splendour that only half a dozen couturiers in the world can achieve. There was a thin necklace of diamonds at her throat and a diamond clip in the low vee which just exposed the jutting swell of her breasts.
>
> [1953] 2006: 60

Clad in the 'splendour' of exclusive *couture*, Vesper, it may be argued, draws attention to herself as commodity, a notion underscored by Bond's invitation that Vesper 'be expensive' in her choice of dinner 'or you'll let down that beautiful frock' (1953] 2006: 62). *Couture* details visible in Vesper's costume for the 2006 film adaptation – her coat's 'peaked shoulders', for instance, are identified as the 'hallmarks of Gucci designer Frida Giannini' (Cosgrave 2006) – unveil her

knowledge of clothes, while simultaneously casting her glamour within the retro allure – 'boned bodice, strapped back … fishtail skirt, … [and] a beaded black lace bolero' (Pîrvu 2012) – of the 1940s *femme fatale*.

Her sartorial knowledge, however, does not simply showcase fashion as display, as the film is highly ambivalent about female exhibitionism. While, 'Vesper so effectively works the rhinestone-studded plunging neckline of an aubergine silk jersey Roberto Cavalli dress that … even his opponent – Russian card sharp Le Chiffre – can't tear his beady grey eyes away' (Cosgrave 2006), the dress, has in fact been picked by Bond precisely with the intention of using her to distract his opponent: 'I need you looking fabulous. So when you walk up behind me and kiss me on the neck the players will be thinking about your neckline and not about their cards' (*Casino Royale* 2006). It is, however, Vesper's fashion awareness – 'there are dinner jackets and dinner jackets' – that trumps Bond's sartorial game, subverting the traditional female body/male commodity identification through clothing. In turn, this exposes her active gaze: 'I had you sized up when I saw you', she explains of the tailored jackets she has ready for Bond in his hotel room (*Casino Royale* 2006). As 'the film … shows Lynd watching Bond admire his new clothes in the bathroom mirror seemingly impressed with the result' (Funnell 2018: 14), the camera also focuses on her looking at herself in the mirror, in the self-conscious make-up reference reminiscent of the performative femininity of *femmes fatales* such as Phyllis Dietrichson (Barbara Stanwyck) and Cora Smith (Lara Turner), in *Double Indemnity* (Wilder 1944) and *The Postman Always Rings Twice* (Garnett 1946) respectively (Bruzzi 1997: 125). Ultimately, she deliberately wrecks Bond's strategy by making her first spectacular entry from behind Le Chiffre, therefore disrupting Bond's gaze, and not his opponent's (see Severson 2015).

Vesper's dark appeal foreshadows her duplicity, captured in the dark shadow of her smoky eyes, and the funereal colours of her dresses. Even the black belt of her cream blazer stands out as the sartorial marker of a woman in mourning. The only concession to brightness, the red dress of the final scene, in its gesture to Nicolas Roeg's *Don't Look Now* (1973) (Swift 2006), also foreshadows Vesper's tragic death, trapped in the lift of a sinking building in Venice. Much like in Tracy's attempted suicide, in rejecting Bond's help, Vesper's 'chosen' death retains control, with her eyes wide-open and fixed on Bond in the underwater scene that marks her demise.

More overtly fetishistic, Xenia's glamour encapsulates the sadistic quality of her excessive appetite. In Hemming's 'Cruella meets Morticia' design (Cosgrave et al. 2012: 82) of the *GoldenEye* casino scene, the neo-Victorian allure of her

black corseted dress retains a touch of subversion in the scalloped edges and upright neckline. Splashes of blood-red lipstick and nail varnish on her manicured fingernails accentuate the dangerous quality of her sexual desire. Contravening the Bond seduction formula, she does not end up in bed with Bond, but with the older, and less attractive, Admiral Chuck Farrell, whom she kills to gain access to the French helicopter she later hijacks with Ourumov. Before the hijack, in order to 'distract' the French helicopter pilots, she looks, again, the part of the glamorous seductress, in a light silver suit and black Philip Sommerville hat (Fig. 12); as her blazer gapes open, before she shoots them, the pilots catch a glimpse of her black corset-top.

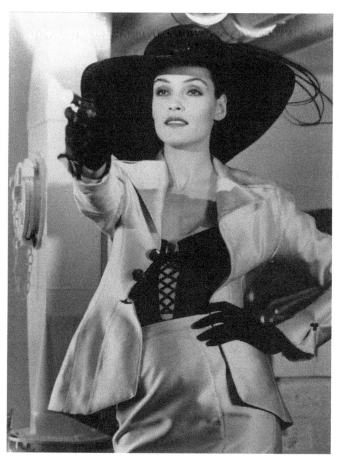

Figure 12 Famke Janssen as Xenia Onatopp, *GoldenEye* (Courtesy of AF Archive/Alamy Stock Photo)

At the end, 'Xenia opts to squeeze Bond to death with her thighs rather than execute him with her machine gun', revealing, according to Tony Garland, 'her inability to separate sex and death' (2009: 185). Yet, arguably, this is precisely what makes her akin to Bond, 'whose interest in sex, according to Garland, 'suggests a humanity and vulnerability that endangers him' (2009: 180). Nevertheless, her assertive sexual preferences – 'Straight up, with a twist' (*GoldenEye* 1995), she says of her Vodka Martini – involve sadistic violence, which threatens Bond, and, indeed, any man who 'gets lucky' with her. Sharing with him a similar disregard for long-term commitment, Xenia promises 'She won't lose sleep over' the fact that Bond won't keep in touch.

In *Quantum of Solace*, Camille's desire is also driven by death, as she seeks revenge against Bolivian General Medrano, responsible for the murder of her parents and sister when she was a child. Though her active role means that she is dressed in casual clothes throughout the film, one of the film's most iconic moments captures her walking through the Bolivian desert with Bond in a black dress: 'black ... spells out night, danger, death and mourning, and is considered both perverse and powerful', Lidevij Edelkoort notes; its 'severe abstraction ... absorbs all other colours and light' (2013b: 9), against the stark scenery of the desert, here doubly evocative of death.

In its sober sophistication, Camille's 'little black dress' captures the long and convoluted history of the twentieth-century iconic garment, and fashion's love affair with black. Historically, the 'popularity' of funereal black increased after Queen Victoria's bereavement for the death of Prince Albert in 1861, the coverage of which had repercussions on existing mourning etiquette: 'her position as a figurehead and international role model glamorized mourning, resulting in a cultlike obsession' (Meyer 2016: 11). The associations between black and women's (mourning) clothes grew exponentially after the Great War, 'when entire nations were in mourning for the indelible loss of lives, and black became the dominant color in fashion' (Meyer 2016: 33); in 1919, after the death of her own Boy Capel, Chanel responded with the emphatic use of black on her person and *couture*. Her penchant for black became associated with the modern sophistication she claimed responsibility for; an apocryphal source tells of Paul Poiret meeting a black-clad Chanel and asking her for whom she was mourning. Her witty response – 'For you, dear Monsieur!' – (Driscoll 2010: 139) is revealing of both Chanel's self-awareness and the modern glamour of mourning black. With this background in mind, Camille's little black dress, significantly, casts her as Bolivia's widow, speaking of the shared mourning of a nation victimized by General Medrano's evil schemes.

Although Chanel cannot take full responsibility for the everlasting presence of black in women's fashion, American *Vogue* nicknamed Chanel's little black dress, 'The Chanel "Ford"' ... the frock that all the world will wear' ('The Début of the Winter Mode' 1926: 69). While the style of Camille's dress gestures to the feminine appeal of 1950s cocktail dresses by Dior and Madame Grès, the shorter length, as confirmed by costume designer Louise Frogley (Braam 2010), evokes the appropriation of the little black dress by designers such as Mary Quant. As 'by the 1960s, black was taken over by youth, and it was often associated with rebellion' (Meyer 2016: 9), it is with this spirit that Camille wears her dress, walking through the desert, court shoes in hands. Her dress is by Prada, responsible, in the 1990s for the revival of the little black dress using leftover nylon stocks from her family's umbrella factory' (Ludot 2001: 12), a gesture reminiscent of the little black dress's humble origins in the fashion shortages of the early twentieth century.

Discussing the fetishistic aesthetics of colour, Edelkoort observes that 'black is only rivalled by red, the blood of passions, the signal of danger, the pain of menstruation' (2013b: 9). The ambiguity of lace-work identified in Corinne's costumes, features in the red costumes of characters such as Lupe Lamora (Talita Soto), wife of villain Sanchez in *Licence to Kill*, and Elektra King in *The World Is Not Enough*, whose active sexualities are central to their resilience. Significantly, both women wear red lace in their respective casino scenes, establishing a close link between the hazard of gambling and the danger they embody, as well as gesturing to the first Bond Girl, Sylvia Trench, and her glamorous red one-shoulder evening gown in the first casino scene in *Dr No*. For Lupe and Elektra, red signals also physical damage, the threat of which is constant in Lupe's relationship with Franz Sanchez. His punishment of Lupe's infidelity with a manta ray tail echoes Fleming's 'The Hildebrand Rarity', and the cruelty of Milton Krest; it is not a coincidence his name reappears as that of a marine researcher and Franz's partner in crime in *Licence to Kill*.

Bodily damage is also inscribed in the mutilated body of Elektra, whose dysfunctional relationship with psychopathic Renard, her kidnapper, suggests a reading of her body and sexuality in sado-masochist terms. Left to fight for her own survival because of her father's refusal – recommended by MI6 – to pay for her ransom, during her captivity her body becomes the only weapon she can use to turn her condition around in her favour: 'I seduced the guards. Used my body. It gave me control', she admits to Bond. Asked what he does 'to survive', his reply, 'I take pleasure ... in great beauty' (*The World Is Not Enough* 1999), hints to the fetishistic subtext of all Bond movies. Yet Elektra is far from being the passive

object of the male gaze, as her knowing use of her sexuality allows her to shift from sacrificial lamb to *femme fatale*, whose *raison d'etre* is to antagonize man (Silver and Ursini 2012: 131). Innocent victim and knowing perpetrator coexist in the desiring/desired body of Elektra, who, like Liz Krest in 'The Hildebrand Rarity', initially appears infantilized in her need for protection both by the maternal M and Bond. But just like Liz, Elektra's character is darker than her apparent fragility. The clash between the two apparently opposite femininities is captured in Elektra's self-harming, and mutilating her own earlobe, to keep up with the pretence of her kidnap, and frame her father and MI6. Her glamorous ear-cuff, designed to conceal her mutilation, becomes symbolic of the pleasure/ pain binary as these coalesce in Elektra's body.

Her sadistic desire reaches its climax when she holds Bond captive in Istanbul's Maiden Tower. Shackled to a torture machine reminiscent of other torture apparatuses available to Bond villains in the past, he is threatened with the prospect of suffocation, which Elektra anticipates in a twisted parody of misogynistic sadism: 'Do you know what happens when a man is strangled?' she asks, as she straddles Bond in the assertive position of the dominatrix; the erotic dimension of the torture scene amplifies the threat to Bond's masculinity, the authority of which is no longer his own since Elektra 'has claimed the phallus as

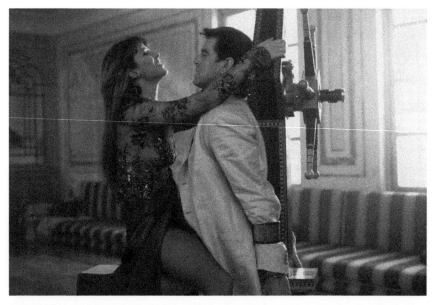

Figure 13 Sophie Marceau and Pierce Brosnan as Elektra King and James Bond, *The World Is Not Enough* (Courtesy of GETTY/SIGMA)

her own and uses it against Bond for her own sadistic pleasure' (Sergeant 2015: 135). Her high-slit satin gown and lace bodice convey the notion of partial nudity (Fig. 13), but the darker colour here hints to the ominous threat Elektra personifies, as it echoes the mourning clothes she wears at her father's funeral at the beginning of the film. Erotic pleasure and death sit uncomfortably together, prefiguring Bond's chilling murder of Elektra with a bullet significantly planted in her heart. The context of the event, with the preceding scene evocative of a reversal of misogynistic sadism, presents Elektra's beauty – and sex allure – as inherently threatening to Bond's existence: 'You wouldn't kill me. You'd miss me', she intimates, provokingly, as he chases her up the stairs of the Maiden Tower. Bond's response – 'I never miss' – is telling of the emasculation anxiety that affects his masculinity; to admit 'lack' against Elektra's 'full' display of female assertiveness would undermine the conservative foundations of his masculine heroism.

Wild things: women and furs

When female desire is out of control, it announces, in the Bond narratives, the presence of the Bond Girl Villain, whose challenging desire – a threat to Bond – is qualified by its untameable nature. In the film *Thunderball*, Fiona delivers some of the most memorable lines in the franchise: 'I forgot your ego, Mr Bond. James Bond, who only has to make love to a woman and she starts to hear heavenly choirs singing. She repents and immediately returns to the side of right and virtue. But not this one. What a blow it must have been, you having a failure' (*Thunderball* 1965). Fiona's pungent sarcasm is a fit riposte to Bond's sexual innuendoes and patronizing attitude to women throughout the franchise. It is *her* desire that threatens Bond, and when he warns her she 'should be locked up in a cage', his anxiety around her sexual assertiveness resonates with the torture scene in *The World Is Not Enough*. Fiona's feral sexuality is conveyed by the glamour of ostrich feathers, a fetishistic reminder of bodily hair, pointing to her unrestrained (animal) sexuality; after all, her surname, Volpe, is Italian for 'fox'.

Like ostrich feathers, luxury materials such as furs have often supported the symbolic display of power.[2] Within the political elite, 'kings and the great men who surround them have always used fur as a symbol of their magnificence' McDowell reminds us, 'in order that they might be viewed by the little people with the same awe with which they would gaze at the lion, tiger, leopard or bear were it alive' (1992: 30). This resonates with the words of Severin, the narrator of Sacher-Masoch's *Venus in Furs*, when he discusses the seductive power of furs:

In the first ages of the world, monarchs adopted it, and tyrant nobles had the arrogance, by means of sumptuary laws, to reserve it to themselves as an exclusive privilege. In the same way great painters made it the distinctive ornament of queens of beauty. So we find Raphael, for the divine shapes of La Fornarine, and Titian for the rosy body of his beloved, unable to find a frame more precious than dark furs.

Sacher-Masoch [1870] 1970: 60

Associated with the force of animal instincts, the fur also literally stands for the corpse of the killed animal, therefore proposing a view of human superiority in the displayed control of wild animals. On a more personal level, Masoch's own 'discovery' of sex occurred through a double act of voyeurism involving his fur-clad aunt with her lover, and, later, beating her husband: 'Sacher-Masoch['s] peculiar obsession was mingled with a kind of fetishism', translator H. J. Stenning notes, 'that of the soft animal fleeces which adorn women. The symbolism of savagery is obvious' (qtd. in Sacher-Masoch [1870] 1970: 7). Not only does *Venus in Furs* equate sex with power and control, but it also adumbrates the shifting roles of sadomasochist practice: 'You must choose to be the tyrant or the slave', Severin says, in hindsight, 'the moment man gives way, his neck is under the yoke, and woman is brandishing the whip' (Sacher-Masoch [1870] 1970: 29). Yet there is pleasure in submission to a woman whose feral glamour exceeds the boundaries of her human condition: 'A woman wearing furs ... is nothing but a big cat' (Sacher-Masoch [1870] 1970: 59); in collapsing the human/animal distinction, the fantasy that fur produces, then, is one in which desire's male/female, active/passive categorical distinctions are thrust in a perpetual game of role reversal.

Though, with the exclusion of leather, the twentieth century has displayed a penchant for man-made fetishistic materials such as rubber and PVC, 'in the nineteenth and early twentieth centuries, the focus was on soft materials such as satin and fur, which are primarily associated with women's clothing' (Steele [1996] 1997: 143). Krafft-Ebing's case studies suggested that fur and velvet fetishism constituted a distinct practice as these materials 'do not have any close relation to the female body; and, unlike shoes and gloves, they are not related to certain parts of the person which have peculiar symbolic significance' ([1886] 1906: 268). But furs are, in fact, reminiscent of the hair that naturally grows on human beings 'and highlights the most secret parts of our anatomy' (McDowell 1992: 30; see also Freud [1927] 1995: 155).

It follows, then, that the appearance of furs and the consummation of sex frequently overlap in the Bond narrative. In *On Her Majesty's Secret Service*, Tracy's fur coat acts as a sensuous blanket when she and Bond 'consummate' their

marriage ahead of their wedding, in a barn where they seek temporary shelter. Grace Jones dons a fur stole around her naked shoulders in a publicity image for *A View to a Kill*; in both cases, the proximity of fur to female skin is suggestive of their sexuality and, with May Day, the threat of the untamed black woman.

Indeed, because of its symbolic association with power, the fur coat easily translates as one of the signifiers of the Bond Girl Villain's dangerous sexuality, as evoked by the sophisticated glamour of the *film noir's femme fatale*: 'an intelligent and powerful woman who inevitably leads men to destruction', with a penchant for 'glittering jewellery, luxurious dresses … designer hats', and especially mink fur coats (Dominková 2008: 138). In the second adaptation of Fleming's *Thunderball*, the non-EON film *Never Say Never Again* (Kershner 1983), a mink fur coat worn by villain Fatima Blush (Barbara Carrera) performs a similar function to Fiona's ostrich feathers; both characters display strong, assertive sexualities, which, significantly, also lead to their deaths.

The association between furs and evil women is not new; commenting on the simplified characterization of Cruella de Vil in the 1961 Disney adaptation of Dodie Smith's *One Hundred and One Dalmatians* (1956), Catherine Spooner notes:

> Her monstrousness is not merely due to the lengths she will go to achieve her sartorial desire, but also to the very nature of that desire – for the extreme – in the first place. This excessiveness, however, is also paradoxically the source of Cruella's charisma: by being "showy" and "noticeable," dressing to stand out, she contravenes the passive feminine ideal.
>
> 2012: 171

As Cruella is ridiculed, and ultimately defeated, so is the unconventional – non-maternal, non-domestic, non-normative – feminine appetite she incarnates.

In particular, the 'vulval symbolism' (Harper 1994: 130) of the fur coat is an outer manifestation of the Bond Girl Villain's dangerous duplicity. In the film *The Spy Who Loved Me*, Bond's lover, who has 'no words' for the alleged ecstasy brought on by Bond's performance between two layers of fur, quickly regains the power of speech when, draped in the same fur, she alerts Soviet assassins to Bond's imminent movements. In *Die Another Day*, Bond has another sexual encounter between the warm layers of fur; this time, his sexual partner, Miranda Frost (Rosamund Pike), is an MI6 double agent, and her symbolic emasculation of Bond is evident when she unloads the gun he slips under his pillow. In the same film, the link between fur and villains is also conveyed by the less conventional use of fur in menswear; Graves's full-length fur coat is a distinct indication of the sartorial excess that pertains to Bond villains' eccentric tastes.

But the significance of fur in the Bond novels and films holds subtler nuances in conveying the complex patterns of fetishistic desire attached to the commodification of animal skin. While, in spite of her name, Fiona Volpe does not wear fox, in Fleming's *From Russia with Love*, Tania saves money on supper to replace her 'well-worn Siberian fox' with a more glamorous sable coat ([1957] 2004: 67). Earlier in the novel, Fleming uses a fox metaphor to praise Grant's instinctive intelligence: 'though his educational standards were hopelessly low, he was as naturally cunning as a fox' ([1957] 2004: 31), which serves to link the two agents to SMERSH.

But fur is only on the surface a signifier of Tania's loyalty to the Soviet Union and its fashion regime. In fact, it prefigures Tania's nascent appetite for European fashion, and her defection to the capitalist West; as she says to Bond, when preparing for her escape, 'I cannot leave my fur coat behind. I love it too dearly' ([1957] 2004: 191). Significantly, too, the same 'long, sleek sable coat' is between them when Bond makes his initial sexual advances on the Orient Express, where fur establishes a tactile boundary which, evoking the sensuousness of Tania's body, also mediates Bond's desire. In delaying his touch, it bestows power on the body of Bond's female lover; as previously seen with Elektra, Tania's sexuality, as indicated by her 'dragging' Bond 'with her', is assertive ([1957] 2004: 191).

As Tania has explicitly been ordered to perform a 'honeytrap' role to facilitate Bond's assassination, her sexuality is, consequently, central to her mission. The set-up is a classic example of the paradoxical function of female desire in the construction of masculinity, whereby Bond's masculine heroism needs to rely on Tania's active desire. Simultaneously, however, this compromises Bond's control over her, pointing, therefore, to a paradoxical conflict of clashing desires:

> Is this wonderful girl a cheat? Is she true? Is she real? ... While his mouth went on kissing her, his hand went to her left breast and held it, feeling the peak hard with desire under his fingers. His hand strayed on down across her flat stomach. Her legs shifted languidly. She moaned softly and her mouth slid away from his. Below the closed eyes the long lashes quivered like humming birds' wings.

> Bond reached up and took the edge of the sheet and pulled it right down and threw it off the end of the huge bed. She was wearing nothing but the *black ribbon round her neck* and black *silk stockings* rolled above her knees. Her arms groped up for him.
>
> [1957] 2004: 185; my emphases

Bond's doubts about the authenticity of Tania's performance are justified by the staginess of their first sexual encounter. Too close a rendition of male fantasy, Tania's body is packaged like an object of desire, down to a piece of black ribbon around her neck, and silk stockings.

In as much as Tania's body is a pleasurable way to obtain the coveted Spektor decoder, a bait hailed by SMERSH to make Tania's fake defection more believable, Bond's body is also 'up for grabs'; 'pimping for England' as he is, he feels uncertain about the exchange value of the transaction: 'perhaps there was an erotic stimulus in the notion that one was ravaging a sack of gold', he reflects, hypothetically, on a man's attempt 'to marry a rich woman for her money ... But a cipher machine?' ([1957] 2004: 116). Coming from an agent prepared to die for queen and country, Bond's feelings about sexual exploitation draw attention to the commodification of his body. Ultimately, the triangulation of desire points, as already seen, to Tania's ultimate desire not to be with Bond, but to fulfil her own material yearnings.

In these terms, Tania's sexual performance is akin to Karl Marx's commodity fetishism, 'which attaches itself to the products of labour as soon as they are produced as commodities, and is therefore inseparable from the production of commodities' (Marx [1867] 1976: 165). In Marx's critique, commodity fetishism is a negative consequence of the distance created by capitalism between the individual producer and the product of their labour-turned-commodity, or, in Georg Lukács's words, 'the split between the worker's labour-power and his personality, its metamorphosis into a thing, an object that he sells on the market' ([1968] 1971: 99). Commodity fetishism can extend to human relationships; Lukács cites Immanuel Kant's definition of sexual relationships in terms of commodity exchange, although this implies a notion of mutual consent:

> [T]his natural 'Commercium' ... is an enjoyment for which the one person is given up to the other. In this relation the human individual makes himself a 'res' [lt. 'thing'] which is contrary to the Right of Humanity in his own Person. This, however, is only possible under the one condition, that as the one Person is acquired by the other as a res, that same Person also equally acquires the other reciprocally, and thus regains and re-establishes the rational Personality.
>
> [1796] 1887: 111

Kant further describes the contract of marriage as 'the obligation that is formed by two Persons entering into a sexual Union solely on the basis of a reciprocal Possession of each other' ([1797] 1887: 113), where the underlying principle is one of (long-term) material exchange.

In the film *From Russia with Love,* the first sex scene with Tania is significantly constructed as a business transaction; after Bond tells Tania her mouth is 'the right size', he swiftly proceeds to interrogate her, between kisses, about the Spektor's whereabouts, while Tania's search for Bond's scar is the guarantee that the 'goods' she is temporarily interested in are authentic. As the interrogation continues, later, on the boat, her own question – 'Am I as exciting as all those Western girls?' – reinforces her awareness of the exchange process in which her sexual performance has been exchanged for the machine – and the importance of the exchange value attached to her sexuality. This is also reinforced in M's cable to Bond: 'merchandise appears genuine, stop. Go ahead with deal' (*From Russia with Love* 1963).

The complex dynamics of this exchange, however, means that Bond – as he has suspected all along – has been used too, as Tania has needed him in order to

Figure 14 Daniela Bianchi as Tania Romanova, *From Russia with Love* (Courtesy of GETTY/MOVIEPIX)

make it to the other side. Their fake marriage is supported by forged documents but, most importantly, 'real' honeymoon fineries, which reify the knowledge that commodity fetishism lies at the heart of the romantic masquerade they both perform, as the silk garments (and her sable fur coat) are *not* a substitute for Tania's object of desire (Bond). They *are* what she has wanted all along: 'more intimately than her knick-knacks, rugs, cushions and bouquets, she [woman] prizes feathers, pearls, brocade and silks that she mingles with her flesh', regretted Beauvoir, 'their shimmer and their gentle contact compensate for the harshness of the erotic universe that is her lot: the more her sensuality is unsatiated, the more importance she gives it to it' ([1949] 2009: 586). Although Beauvoir mostly critiqued fashion for reducing 'woman to a commodity with no intrinsic value' (Bruzzi 1997: 121), paradoxically, the woman's pursuit of sartorial pleasure gives female desire more autonomy in/through her intimate relationship with fashion. Within the context of her impending defection to the West, therefore, Tania's desire for a Western lifestyle unwittingly produces a feminist/socialist critique of what Bond and the West, politically and economically, stand for.

Bondage

Several of the costumes discussed so far have hinted at bondage; on the Orient Express, when Tania complains she has 'nothing to wear' on their (fake) honeymoon, Bond jokingly hands her over her '*trousseau*' – a single piece of black velvet ribbon, before pointing to a suitcase full of sexy nightwear. In returning Tania's ribbon, Bond takes an active role in the bondage of her body, although, the ribbon, in fact, mirrors Bond's own neckwear. In his study of fetishism, David Kunzle draws attention to criticism of men's fetishistic neckwear, seen, like tightly laced corsets, as an aberrant form of bodily 'self-abuse' and non-normative sexuality (1982: 5). Indeed, the neck, and the adornment associated with it, represents a centre of fetishistic attention in both sexes:

> The tenderness of the skin, its vulnerability to cold, the relatively fragile structure of the spine, and the exposure of the jugular vein are all features which make the neck a key area of attention for the comfort and security of the body.... It is not only the 'site' of charms, whether the *cravates*' kerchiefs, religious medals, mementos of self-identity or ornamental rings of beaded strands. The neck is also the object of charms itself: an erogenous zone to be stimulated, stroked and gazed upon.
>
> Shields 2013: 110

Fascination with the neck is central to the English dandy's sartorial habits. While 'the only thing for which he [Beau Brummel] needed a lot of time was the tying of his necktie', designer duo Ravage (Clemens H. B. Rameckers and Arnold van Geun) and art historian John Sillevis relate, Oscar Wilde said 'a well-tied tie is the first serious step in life', reminding us that 'the only weapon a dandy possessed was his power to seduce' (Edelkoort 2013a: 109).

Bow ties, however, embody an ambivalent master–slave narrative, being worn both by gentlemen (dinner jackets) and servants (butlers' uniforms): 'the bow tie is ... heavily overcoded with signifiers of both arrogance and enslavement; of both masculinity and femininity; of both nobility and servitude' (Shields 2009: 108). Bond's bow tie, then, is both a status symbol, and a sign of his fetishized desirability. It is also a mark of his dependency, because in his service duty to MI6, Bond is yoked to M, who also, occasionally wears a bow tie; like the corset, the symbolism of the bow tie is entirely constructed through performance and context (Shields 2013: 114; Steele 2013: 47). Such shifting power dynamics are particularly visible in *From Russia with Love*, which points to the ambiguous narrative of objectification in which Bond and Tania are both imbricated. While Bond muses over Tania's submissive femininity captured in 'the steady slow throb of the pulse in the offered neck' – the reader is aware that, in Tania's mind, 'it was only a way for her to get to England' (Fleming [1957] 2004: 199, 180).

Elsewhere in the Bond narratives, neck adornments are less ambiguous figurations of female oppression. In the film *Casino Royale*, Vesper's Algerian love-knot necklace is symbolic of her attachment to Yusef Kabira (Simon Kassianides), her lover, who, unbeknown to her, is involved with Quantum. While the awareness of the sentimental value of the necklace is not lost on Bond, its removal is significantly timed when, in Venice, Vesper has second thoughts about her betrayal of Bond and Britain. That Yusef has, in fact, used her all along, becomes apparent in *Quantum of Solace*, where Bond avenges Vesper's death and rescues Corinne Veneau (Stana Katic), a Canadian agent, from the same fate, as foreshadowed by an identical necklace placed around her neck. In the same film, Camille, who is under the influence of villain Dominique Greene, wears a chunky gold necklace, unambiguously evocative of a chain, around her neck.

Statement jewellery, such as the diamond/ruby chokers worn by Domino in the casino/Junkanoo scenes of *Thunderball*, and the diamond necklace worn by Paris Carver the night of her death, are also significant of the women's attachments to the rich and powerful men who subjugate them – and whom they betray. Similarly, in *Never Say Never Again*, Maximilian Largo (Klaus Maria Brandauer) gives Domino (Kim Basinger) a 'Tears of Allah' necklace, claiming that 'it is the

most valuable thing . . . I have ever possessed. Except you'. Presented as a sign of his romantic commitment, Maximilian's ownership claim is in fact a mark of patriarchal control, and comes with a warning – 'I cut your throat' (*Never Say Never Again* 1983) – should Domino ever leave him. There is also a double intention behind the gift – and the warning it comes with – as the pendant contains a small diamond marking the location of a bomb concealed in a North African underwater cave. By the same logic, the gold paint that suffocates Jill in *Goldfinger* is the tragic consequence of her dangerous closeness to the villain's money: 'He pays me', she says to Bond, when he questions her affiliation with Goldfinger, whose 'Midas' touch' literally asphyxiates her.

The villains' deployment of constrictive clothing for the bodies of antagonizing women features heavily in the Bond franchise, starting with Honey who, in the film *Dr No*, is made to wear a tight-fitting Chinese garment by the villain. The parallels in *Spectre* are evident; here Oberhauser/Blofeld also gives Madeleine a fitted dress: 'it is not her personal choice. It had to be intriguing and powerful – like him', explains *Spectre* costume designer Jany Temime (2015). With its strong sequined pattern accentuating the contours of her body, and the high collar reminiscent of Honey's *cheongsam*, 'Venus' by Australian label Lover evokes the aesthetics of tight lacing. While, as explored in more detail below, corsets and lacing can also perform a subversive function, it is telling of Blofeld's desire to control Bond through Madeleine that he chooses to fashion her in this style. In contrast, the train scene's dusty green Ghost dress expresses a more relaxed femininity. The garment, meant to be part of her own wardrobe, softly drapes the contours of Madeleine's figure, while it still reveals the shape of her body. In this sense, it evokes the flowing style of 1920s designs: 'fabrics that slide over skin give the viewer a strong sense of their surface effect on the wearer' (Hollander 1994: 132). Indeed, though the trace of a high waist remains, the fluidity of the lines of Madeleine's dress produces an effect similar to the aesthetics of Patou, Chanel, and Vionnet, where 'the ... silks clinging to the yielding figure seemed at last to confess that a woman could feel her own body; and they straightforwardly invited others to grasp and stroke her as a physically responsive living creature' (Hollander 1994: 132). The two dresses point to two versions of femininity – oppressed/constructed by masculine authority, and emancipated/constructed by female self-awareness. The villain's attempt to 'contain' and constrain the Bond Girl, then, reveals more than the work of misogynistic oppression; in fact, the coexistence of clashing sartorial discourses proposes a more dynamic understanding of femininity rooted in its resistance to patriarchal control.

The aesthetics of tight lacing hold, indeed, ambiguous meanings in the Bond narratives. In the film *The Spy Who Loved Me*, Stromberg's sadistic tendencies take on a more obvious fetishistic inclination when Anya is in his detention. His choice of a costume for her is suggestive of the sexual sadism he previously exercised on his assistant's execution. In a burgundy shade suggestive both of her sexuality and the threat of physical harm, Anya's catsuit, through the lateral cut-outs and deep low-cut at the front, exposes her body to the villain's gaze, while the cross front-straps accentuate the aesthetics of bondage. Even more so than with Honey and Madeleine, the villain's choice highlights her captive condition and his desire to subjugate her. Similarly, in the Bahamas casino scene of *Casino Royale*, the tight-lacing motif in Solange's coral dress references her submissiveness, also reflected in the means of her death at the hand of her betrayed husband; like a trapped animal of prey, her tortured corpse is found hanging in the net of a hammock.

But Solange's tight-laced body/corpse clashes with her earlier apparition as a free-spirited woman, whose actively sensual nature is captured in the sequined green bikini and mini sarong she wears horse riding; as Steele notes, 'the horsewoman or amazon may be considered a subcategory of the dominatrix' ([1996] 1997: 40). Moreover, in the scene female exhibitionism is considerably toned down through the display of Bond's own body, which places Solange in the active position of the gaze. Solange's costumes, therefore, point to an ambiguous reading of tight lacing, viewed in this instance both as a reflection of her oppressive marriage, but also pointing to her transgressive sexuality. As with Jill in *Goldfinger* and Corinne in *Moonraker*, her death appears to be a direct consequence of her sexual trespass, which is also, significantly, linked with the leakage of information to Bond.

More examples reinforce the idea that corsetry and tight-lacing references retain semantic ambiguity in Bond Girls' attire. In the film *Thunderball*, Domino is placed between her controlling guardian – Emilio Largo – and Bond, who is attempting to uncover a SPECTRE plot in which Largo is involved. Given the Bahamas setting of the film, Domino's wardrobe is distinctly dominated by swimwear. In particular, the swimsuit worn by the swimming pool hints, in the decorative motif at the front and the hips, at corset-style lacing. When diving in the sea, however, Domino wears one of Cole of California's 1965 'Scandal suits' (Fig. 15), with fishnet panels exposing 'considerable flesh and cleavage' (Walford 2013: 78). Both Claudine Auger and Martine Berswick, who plays agent Paula Kaplan in the film, modelled Cole of California swimsuits for US *Vogue* ('Bond Girls come up for air' 1966: 100–1). Inspired by Rudi Gernreich's truly scandalous

1964 monokini – 'a topless knitted bathing suit consisting of a pair of high-waisted trunks with shoulder straps' (Walford 2013: 76–7) – Margit Fellegi's designs for Cole of California captured the liberated sexuality of the 1960s, as 'the dalliance with nudity inspired designers to play with illusion, including mesh fabrics and cutouts in dresses' (Walford 2013: 77). A 1965 advert for 'The Great Cole Scandal Suit': 'New but not nude', depicted an unmade bed in the middle of a stormy ocean, and the captions 'Ho hum, isn't it lovely weather for a scandal? … And isn't it time somebody created an absolutely wild scandal for nice girls?' ('The Great Cole Scandal Suit' 1965: 43–7).

In its self-conscious dualism – *wild* scandal vs. *nice* girls – the 'Scandal Suit' offered an alternative evocation of nudity that spoke of a self-conscious (and active) female sexuality, but also captured the ambiguities implicit in the fetishistic approach to the female body. Partial nudity, as suggested by women in a state of semi-dress, establishes a parallel with the fetishistic attitudes towards the corset: 'part of the appeal of the corset clearly derived from its status as underwear', Steele notes, 'a category of clothing that complicates the traditional

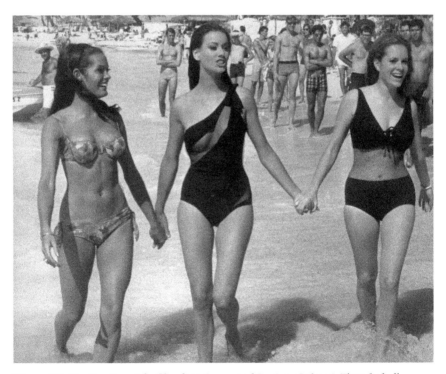

Figure 15 Martine Beswick, Claudine Auger and Luciana Paluzzi, *Thunderball* film-set (Courtesy of Danjaq/EON/UA/Kobal/REX/Shutterstock)

paradigm of the naked and the clothed, since a person in underwear is simultaneously dressed and undressed' (2001: 114). This may have been particularly true of the 1870s cuirasse bodice. Worn over a dress, it allowed for tighter skirts and sat closer to female anatomy; evocative of the corset worn underneath (Summers 2001: 152), it in some ways foreshadowed much later uses of the corset as outerwear.

If corset-wearing is not necessarily a sign of female oppression, the reverse is also true: the removal of tightly fitting clothes, can be too easily associated with emancipation. As with Solange and Domino, in *Spectre* Bond's dubious seduction of Lucia Sciarra aims to extract valuable knowledge for his mission; the unveiling of sensitive information is parallel to the unveiling of the female body as Lucia spills the beans while her sharply tailored dress – inspired by Italian film star Sophia Loren (Davidson 2015) – drops to the floor.

Bellucci has appeared in two 1990s Dolce and Gabbana adverts directed by Sicilian director Giuseppe Tornatore. Against the nostalgic Sicilian background, the adverts play on the fetishistic allure of lingerie. As in her *Spectre* role, the 1996 advert revolved around a widow; here, after spying on the undressing woman, an admirer steals her slip. Later, upon recognizing him in the funeral cortege, the widow faints, and is carried away in the admirer's arms, while other young men sniff the lace slip dropped out of the admirer's pocket. Death and desire coexist in the semi-dressed body of the widow, evoking the nineteenth-century eroticization of the fainting corseted woman; 'to the extent that "swooning" is perceived as related both to orgasm and to death', Steele notes, 'fainting also seems to support a romantic and morbid ideal of femininity' (2001: 70–1). Indeed, such connections between love and death perpetuated a patriarchal view of women's fragility, as, Summers observes, 'women fainted into the arms of men, and in conditions that glamorized their vulnerability, vulnerability so perfect that it mimicked the complete passivity of death' (2001: 137).[3]

Historically, the narrative of women's physical fragility was facilitated by the corset; the seventeenth-century English term 'stays' implies that the naturally weak female body required artificial support (Steele 2001: 16; see also Summers 2001: 5). Paradoxically, extreme tight lacing itself could be responsible for respiratory difficulties and, in turn, lead to fainting. While 'corsetry operated as a powerful and multi-faceted signifier of both transgressive and normative femininity' (Summers 2001: 7; see also Craik [1993] 1994: 121), the extreme practice of tight lacing was more restricted than common corset-wearing (Steele 2013: 45); moreover, as a practice linked to sexuality, 'it is tight lacing, rather than the corset as such, that enjoys a rich range of metaphorical and symbolic

associations' (Kunzle 1982: 9). Historical nineteenth-century sources, such as *The English Woman's Domestic Magazine*, report comments on 'discipline', 'suffering', and 'submission', as well as the 'exquisite', 'exciting', and 'pleasurable' responses to the tight lacing practices (Steele 2001: 92). This suggests that the tightly laced body was both the site of pleasure and pain: 'women endured the discomfort, physical manipulation, deformation, side effects, and permanent disabilities as a consequence of the pleasures associated with tight lacing' (Craik 1994: 123–4). Tight lacing, then, was defined both as a form of female oppression, and therefore criticized by feminists, and a display of female sexual perversion, and therefore criticized by more conservative sectors of society, including select members of the medical profession campaigning against other female 'vices' such as drinking and masturbation (see Steele 2001: 77).

The practice, and the ambivalent sensations attributed to tight lacing expose the problems with interpretations of the corset that do not take into account historical and personal habits. David Kunzle, for instance, draws attention to the different meanings a corset holds for male/female fetishists: 'to the female, it is the armour of virtue (like the chastity belt, but avoiding or denying its technical function), to the male it is a symbol of his dominance and desire' (1982: 10). Yet, this binary reading of the corset clashes with the emphasis placed on female sexual pleasure central to nineteenth century tight-lacing debates, and the garment's use in modern fetishistic practices and *performance*. In the 1990s, as *haute couture* introduced an interpretive shift towards corsetry by designers such as Dolce & Gabbana and Jean Paul Gaultier, pop-icon Madonna 'subverted stereotypes of objectified femininity, using flaunted sexuality as an assertion of strength rather than submissive invitation' (Arnold 2001: 63; see also Craik [1993] 1994: 123).

Madonna (Fig. 16) makes a cameo appearance in *Die Another Day*, as Verity, Graves's fencing instructor in a Whitaker Malem 'crocodile skin cuirasse' (Cosgrave et al. 2012: 169). The scene makes a deliberate reference to corset fetishism, as Verity asks Bond to lace her up. Coming after sexual innuendoes hinting at Bond's sexual prowess – 'I see you handle your weapon well' (Verity)/ 'I've been known to keep my tip up' (Bond) – the scene would appear to position Verity in the submissive role, supported by 'the symbolism of lacing as surrogate intercourse' (Steele 2001: 20).

The phallic undertones of Bond's flirtatious innuendoes with Verity, as well as in the ensuing fencing contest with Graves, would suggest a fetishistic reading of the corseted woman as symbolically placed to represent phallic embodiment: 'the phallic symbolism of the corset may have been a major source of its erotic

Figure 16 Madonna as Verity, *Die Another Day* (Courtesy of AF Archive/Alamy Stock Photo)

fascination, at least for some male enthusiasts', Steele reminds us, as 'phallic fantasies almost certainly lie behind the phantasmagoric image of the stiff, hard corset that measures about 13 inches' (Steele 2001: 98). As already seen, Freud claimed the roots of sexual fetishism derived from the male unconscious's castration anxiety, itself the effect of the mother's absent penis: 'the fetish is a substitute for the woman's (the mother's) penis that the little boy once believed in and ... does not want to give up' (Freud [1927] 1995: 152–3). In this context, female genitalia can also be held responsible for castration, the fear of which is only disavowed 'by erecting a fetish in its place' (Creed [1993] 2007: 158).

What fetishism highlights, in psychoanalytical terms, is that the phallus is not necessarily identified with the anatomical penis. In fact, Jacques Lacan detaches the phallus from its literal identification with male genitalia, defining it instead as 'the signifier of the desire of the Other' (Lacan [1958] 2001: 321). Crucial to Lacan's understanding of the phallus is the notion of 'lack', which refers to both men and women's perceived inadequacy of and consequent longing for the phallus in their search for either feminine or masculine identity (Lacan [1958] 2001: 291). The female subject, however, performs an ambiguous role within the economy of phallic desire. While she impersonates the 'phallus', in order to be the man's object of desire, she also simultaneously seeks the phallus, for herself, in

the male subject. Significantly, because of its symbolic value, Lacan draws attention to the fact the 'the phallus 'can play its role only when veiled' (Lacan [1958] 2001: 319), and this leads to a definition of femininity as 'masquerade', which deliberately obfuscates a woman's 'essential' (i.e. biological) femininity:

> In order to be the phallus, the signifier of the desire of the Other, . . . a woman will reject an essential part of her femininity, namely all her attributes in the masquerade. It is for that which she is not that she wishes to be desired as well as loved. But she finds the signifier of her own desire in the body of him to whom she addresses her demand for love.
>
> Lacan [1958] 2001: 321

Thus masqueraded, the phallic woman becomes the object of male desire, not because man is interested in her but because she personifies the authority he lacks/longs for.

To return to *Die Another Day*, what (Bond's) male unconscious desires, really, is the phallus, as a symbol restorative of his 'lacking' power, which is temporarily displaced in the hardness of Verity's corseted body. But the scene's more radical shift puts the spotlight on Verity's own desire. Clad in a black leather corset, and gesturing to the self-referential performance of fetishism in her own work, Madonna's role is that of 'the dominatrix who wears her corset as armour', as Stephanie Jones explains, 'its extreme and rigid curvature the ultimate sexual taunt at the slave who may look but not touch' (qtd. in Steele [1996] 1997: 63). That the garment may be symbolic of an assertive, pleasure-seeking – rather than the pleasure-giving – female body, also transpires from Flügel's reading of the phallic symbolism attached to clothes:

> The pleasure seems to be derived, partly from a displacement of muscle eroticism on to tight fitting and 'supporting' clothes (belts, corsets, well-fitting boots, etc.) . . . partly from an unusually strong emphasis upon the phallic symbolism of clothes and from the potency associated therewith.
>
> [1930] 1950: 99

The supple hardness of leather, which makes it preferable in male homosexual fetishism (Kunzle 1982: 8), may place Verity in a transgender position, especially when her dismissal of men – 'I don't like cockfights, she claims' – is reinforced by an open admission of her own homoerotic interests, as she invites Bond to 'feast . . . [his] eyes on the club's finest blade' (*Die Another Day* 2002), Miranda Frost.

Verity's phallic embodiment, therefore, as well as foreshadowing Miranda's own phallic threat to Bond's authority, complicates both psychoanalytical readings about phallic women as well as cultural understandings of the shifting

gender/sexuality paradigms at work in fetish wear/practice. This is also underpinned by parallels with the interrogation of normative sexuality and gender roles found in Madonna's own work, as exemplified by the video *Express Yourself* (1989), where physical display of the female body is as explicit as it is ambiguous. Throughout it, Madonna changes costumes, impersonating femininity as simultaneously submissive and assertive, straight and queer, while her body appears 'soft' and curvy, as well as hard and muscular. Indeed, Madonna's 'internal corset of muscles' (O' Brien 2007: 434) reflected a shift in feminine beauty parameters initiated by the 'emancipation' from the corset in the first quarter of the twentieth century. The 1920s' 'naturally' toned female body 'was to be constructed as a cultural commodity', Arnold notes, 'by the internalised corsetry of exercise and, as a quick route to the figure of slender youth, diet pills' (Arnold 2001: 65–6).

Rooted in the late twentieth-century emphasis on female fitness, Madonna's muscular carapace also reiterates the anti-corset debates led by some Victorian sportswomen, who already promoted non-normative sexuality: 'the bodies of women who had undergone rigorous exercise routines, signified and actualized a deviance from imperatives which would otherwise determine them as "breeders"' (Summers 2001: 154, 155; see also Gamman and Makinen 1994). Yet, her performance also, simultaneously, reinforces self-determination in her desire-led choice to wear her hard femininity, outward, in a sartorial corset. Facilitated by the corset and fetishistic tight lacing as well as the modern woman's muscular corsetry, Verity's performance disrupts Bond's world and its norm on multiple levels.

Phallic girls

Although theories about (female) phallicism may attract some resistance, phallic imagery is, in fact, suggestively present in a range of cultural contexts. As Steele notes, while 'not everyone believes that a gun can symbolize the penis ... phallic symbolism ... has some psychic reality' ([1996] 1997: 15). The works of Surrealist photographers, for example, reflected a definite preoccupation with the phallic woman, seen as 'a way of configuring male castration anxiety' (Jobling 1999: 161); in transforming the female body into evocative phallic shapes, Surrealist photography exemplifies the kind of fetishism of the Bond title sequences which, by blending female body parts with other objects of desire, pre-empt the threat of the dangerous woman Bond is confronted with.

The multiplicity of manifestations and longevity of the phallic woman archetype – 'the woman who is actually a man, the woman who impersonates a man, the woman who appropriates the penis in fantastical or plastic form' (Brooks 2006: ix) – reflects both the pervasiveness and the semantic fluidity of its embodiments. In response to Freudian and Lacanian psychoanalysis, Judith Butler identifies the phallic woman with misogynist discourse, as the subversion of heteronormativity implied by the female appropriation of phallic attributes, following the disavowal of their castrated status, can only ever exist in violent terms: 'there is no other way for women to assume the phallus except in its most killing modalities' ([1993] 2011: 66); in this sense, the phallic woman archetype, is 'perfectly illustrated in the long fingers and nose of the witch' (Campbell 1976: 73), but also the 'accessories' between her legs (broomstick) and on her head (pointy hat).

Other examples of female phallicism in popular culture, however, signal a third way of looking at the phallic woman, who is simultaneously subversive of patriarchy and assertively feminine. 'The reversal of gender roles and the transgressive play on power and identity that the phallic woman implies', Jobling claims, 'does not necessarily have to result in negative images of women' (1999: 62). Carellin Brooks reaches similar conclusions, as she discusses, for instance, popular representations of Rosie the Riveter, whose portrait was produced by the US government as part of its Second World War political propaganda. Rosie was presented as an ambiguously gendered body; while her headscarf and make-up may convey traditional femininity, the pose she strikes and the muscular arm she exposes – accompanied by the slogan 'We can do it!' – redefine femininity in terms of physical strength and moral assertiveness. Rosie the Riveter's message that 'femininity is both challenged and challenging' (Carellin: xii), is also made clear by its recent reappearance in Pink's video *Raise your Glass* (2011), which interrogates, rather than endorses, conventional gender roles and sexuality, and is framed by Pink's own 'Rosie-the-Riveter' renditions.

Manifestations of female phallicism pervade the Bond narratives from the start. In the film *Dr No*, the camera reveals Sylvia Trench's presence in Bond's house as his gaze captures a pair of bare female legs, feet in high heels, and a golf club in between. The delayed identification, along with the fact that she has borrowed one of Bond's shirts to cover her upper body, assuages Bond's fears; what Bond is looking at, effectively, is a mirror image of himself, where the reassuring presence of the phallic woman keeps the fear of castration away. There is, however, another important detail in the scene; the 'hole' Sylvia is aiming for, in her improvised golf-course, is Bond's bowler hat, placed upside down on

the floor. In the symbolic structure of the image, this hints to a further gender reversal, which would make Bond the passive recipient of the female phallus. Rather than reassurance, Sylvia's phallicism prefigures, in fact, the recurrent threat to Bond's masculinity in *Dr No* and subsequent films.

Indeed, phallic women are not always friendly. The 'strange' femininity of the female villain is, for instance, central to *From Russia with Love*. Here SMERSH Planner Kronsteen describes Rosa Klebb as 'short' and 'squat' with 'thick legs' 'very strong [calves] for a woman', and a bosom like 'a badly packed sandbag' (Fleming [1957] 2004: 63). Her military uniform, 'drab khaki stockings', and 'obscene bun' ([1957] 2004: 63, 64) contribute to create the overall impression of a grotesquely deviant femininity. Indeed, although classified as a 'neuter' ([1957] 2004: 63), her sexuality functions as a manipulative weapon, which she can deploy on men as well as women.

Klebb's sexual shiftiness is foreshadowed in her butch look and the lesbian undertones of her speech. Her garments and accessories are suggestive of both emasculating power (brass knuckleduster) and a grotesque parody of lesbianism, visible, in particular, when she attempts to lure Tania. In the pseudo-seduction scene, Klebb offers Tania chocolate and champagne and feigns feminine weakness as she attempts to open the bottle: 'We girls really need a man to help us with that sort of work, don't we?' ([1957] 2004: 77). It is, therefore, unsurprising that Klebb's sexual advances are framed as a self-conscious masquerade of stylized femininity:

> Colonel Klebb of SMERSH was wearing a semi-transparent nightgown in orange crêpe de chine. It had scallops of the same material round the low square neckline and scallops at the wrists of the broadly flounced sleeves. Underneath could be seen a brassiere consisting of two large pink satin roses. Below, she wore old-fashioned knickers of pink satin with elastic above the knees. One dimpled knee, like a yellowish coconut, appeared thrust forward between the half open folds of the nightgown in the classic stance of the modeller. The feet were enclosed in pink satin slippers with pompoms of ostrich feathers. Rosa Klebb had taken off her spectacles and her naked face was now thick with mascara and rouge and lipstick.
>
> [1957] 2004: 84

Such parody of fashion and fetishized femininity amplifies the notion that Klebb's sexual ambiguity represents a threat to heteronormativity, as her body is able to perform both the 'butch' and the '*femme*' roles. Klebb's phallicism is more overt than her lesbianism in the film: as well as a knuckleduster, she carries a stick, the snapping of which punctuates her discussion with Tania.

Klebb's deviant femininity is reinforced when she camouflages as an old woman (in the film she impersonates a hotel maid): 'the old-fashioned black dress with the touch of lace at the throat and wrists, the thin gold chain that hung down over the shapeless bosom and ended in a folding lorgnette, the neat little feet in the sensible black-buttoned boots that barely touched the floor' ([1957] 2004: 253). The chapter title – '*La Tricoteuse*' – signals a darker side to the old woman's knitting needles, foreshadowed in Kronsteen's earlier comment that 'the *tricoteuses* of the French Revolution must have had faces like hers' ([1957] 2004: 64), and in the setting of the Ritz in Rue Cambon, 'named after a famous French revolutionary elected to the National Convention whose father was a fabric manufacturer' ('31 Rue Cambon' 2011).[4] It is the needles – 'the ends … discoloured as if they had been held in fire' ([1957] 2004: 254) – that alert Bond to the impending actualization of Klebb's phallic threat: 'like a long scorpion's sting' each has been dipped in poison ([1957] 2004: 256). Famously, Klebb's 'sensible black-buttoned boots' also conceal a lethal weapon, a 'tiny steel tongue', which, as explained in the subsequent novel, *Dr No*, injects Bond with a paralyzing dose of '*fugu* poison' ([1958] 2004: 15).

With her 'slimy lips' and 'shapeless mouth' (Fleming [1957] 2004: 255, 257), the misogynist subtext of the scene also conveys Bond's homophobia, reminding us that Klebb's is the subversive queer phallicism of 'women wishing to have the phallus for other women' (Butler [1993] 2011: 67). Although in the film Tania rescues Bond by taking a shot at Klebb, in the novel Bond's wound is almost lethal. The origin of the poison – the ovaries of a Japanese globe fish – and, after Klebb's assault, the replacement of Bond's old Beretta, dismissed as a 'Ladies' gun' by armourer Major Boothroyd ([1958] 2004: 18), with a bigger, more masculine, Walther PPK, dispels any doubts about Klebb's phallic threat.

In a novel that self-consciously undermines the foundations of fairy-tale romance, Klebb's lethal shoe, a parody of Cinderella's seductive glass slipper, reflects the cultural anxieties about the most controversial shoe of the 1950s – the stiletto. As Caroline Cox reminds us, 'high spiked heels spelled danger – even the name was derived from a knife, the stiletto traditionally being a stealthy and dangerous blade favoured first by Renaissance assassins and later by the criminal underbelly of Sicily' ([2004] 2005: 11). On one level, the stiletto incarnated the return to a very traditional model of femininity epitomized by the post-war designs of Christian Dior. Stilettos were not designed to protect and support the foot, but for the visual pleasure produced by the emphatic display of a woman's arched foot, slender ankle, and shapely calf muscle.

As with the corset, critics of the stiletto came from different corners of society, including members of the medical profession and fashion experts. A photo article in *Life* compared the stiletto to footbinding in China, and photographer Jim Burke's central question, 'Why must a woman suffer to get a man to admire her legs?' ('Speaking of Pictures' 1960: 14), echoed Beauvoir, who, in signalling the patriarchal drive of the fashion industry, argued that 'high-heeled shoes impede walking' ([1949] 2009: 586). Writing in 1949, de Beauvoir had yet to see the most impractical six-inch heel which would not be available for another decade, but her criticism centred on the literal and figurative immobilization that high heels produced, entrapping woman in her 'vocation as sex object' ([1949] 2009: 586).

Yet, as Lee Wright notes, 'it was precisely this *appearance* of impracticality that made the 1940s Utility styles look totally outdated' (2007: 200). The high heels' lack of a practical quality spoke to women who did not wish to be identified with the prevailing 'home-maker' role-model, as stilettos would be associated not with housework, but 'glamour ... [and] rebellion' (2007: 203). The technological evolution of the stiletto heel, which meant higher, but more reliable heels, suggests that the style, rather than rejected, was embraced by women, to whom it represented a new, modern way of being feminine, against the austerity of wartime fashion: 'by wearing them [stiletto heels], women succeeded in being both the bearers and the creators of beauty, both inside and outside the home' (Cox [2004] 2005: 38–40). Moreover, as manufacturers developed new techniques to make a heel with a metal core, which would be simultaneously beautiful and reliable, these innovations signalled their response to the requirements of a modern femininity combining mobility with glamour.

In a fetish context, as seen with the corset, the stiletto heel suggests further ramifications within the realm of female sexuality, encompassing the notions of female empowerment – when 'used as punishment, trampling or penetrating a slave' (Edelkoort 2013b: 6) – and pleasure – 'when a woman orgasms, her feet extend; hence, high heels put the woman in a perpetual state of pleasure' (Rooji 2013: 201). Consequently, the late twentieth-century reappropriation of the stiletto does not imply young women's desire 'to be viewed as available or submissive', but their 'challenge to the soft sentimentality usually assigned to female teenagers' (Arnold 2001: 77). For these reasons, the punk reinvention of a powerful femininity, symbolized by the adoption of previously 'oppressive' fashion styles including the stiletto, 'was to resurface in the "girl power" movement of the 1990s' (Cox [2004] 2005: 15).

Conjuring up the image of a sexually liberated woman, Wright notes how the removal of the stiletto in 1950s film hints to a sexual experience (Wright 2007: 204); the cinematic stiletto pointed to a kind of femininity clashing with conventional readings of the decade's pervasive centrality of the home-maker and housewife. Stilettos have, in fact, become synonymous with 'hard' femininity. It is the heel of Hedra Carlson (Jennifer Jason Leigh)'s stiletto that kills Sam Rawson (Steven Weber) in Barbret Schroeder's 1992 thriller *Single White Female* (see Bruzzi 1997: 139). In *The Dark Night Rises* (Nolan 2012), Catwoman (Anne Hathaway), whose costumes are designed by Hemming, digs her stiletto into Stryver (Burn Gorman)'s calf, to make a point that stilettos can be dangerous, but not necessarily to the woman who chooses to wear them. On Catwoman's feet they become 'weapons' (Weintraub 2012), much like Klebb's poisoned urchins. More recently, in *Atomic Blonde* (Leitch 2017), British spy Lorraine Broughton (Charlize Theron), who, according to a reviewer, 'makes Bond look arthritic' (Robic 2017), uses her red stiletto heel to stab a male opponent in the first fight scene in the film. That Theron wears a corset over her shirt in the same scene, as well as grounding the film within 1980s fashion, is also suggestive of a subversive reading of the fetishized female body; Lorraine is not a passive recipient of sadistic voyeurism and violence, but a strong female agent able to control her male opponents within and outside her organization.

While Klebb's poisoned shoe, read against the subversive history of the stiletto heel, is evocative of the anxieties produced by the *femme fatale*'s non-normative sexuality, it also points to other kinds of 'phallic heel' imagery used in the Bond narratives. In 'Woke Woman', Gemma Arterton's contribution to *Feminists don't wear Pink* (2018), the actor reimagines her role as a post #MeToo Bond Girl; not only does she not succumb to Bond's charms, but she also, at the end of the story, defends herself against three male attackers: 'Thank God I wore flats', she concludes, 'Although a stiletto may have come in handy' (Arterton 2018: 245).

Fatima Blush's first sighting in *Never Say Never Again*, as with the archetypal phallic mother, is a close-up of her feet in high-heel boots. Alongside her mink-coat, this confirms Fatima's affiliation to the *femme fatale* of *film noir*; in *Double Indemnity*, for instance, 'the fatal approach of the phallic woman', Phyllis, is signalled when 'the camera focuses on her legs, anklet and high-ended shoes' (Wilson 2008: 16). The identification of the high heel with the *femme fatale*'s dangerous sexuality is captured in the delayed identification of the woman's face, as 'the tracking shot from the heel of the shoe to the top of the thigh had become something of a cliché, signalling a sexually desirable woman' (Cox [1994] 1995: 75). That her high heels symbolize, simultaneously, Fatima's dangerousness *and*

assertive sexuality is made clear by the pride – her fatal flaw – she takes in her sexual performance. 'You're quite a man, Mr James Bond. But I am a superior woman ... You know that making love to Fatima was the greatest pleasure of your life', she claims, as she points a gun at Bond (Connery), sitting vulnerably with his legs apart, before ordering him to write that 'the greatest rapture in my life was afforded me in a boat in Nassau by Fatima Blush' (*Never Say Never Again* 1983). In order to annihilate Fatima, Bond, significantly deprived of his gun, uses an explosive pen, which, in its diminutive scale, and Union Flag motif, is but an ironic statement on the diminished 'mightiness' of British masculinity. After the explosion, all that is left of Fatima are her high-heel shoes. The Bond Girl Villain is dead, but her phallic threat remains.

Elsewhere, the emergence of phallic empowerment is conveyed through the emphatic positioning of weaponry in the proximity of Bond Girls' naked skin. The most iconic Bond Girl moment – the rise of Honey Ryder from the Caribbean Sea – must be read as another manifestation of the phallic woman (Fig. 17). The scene is self-consciously framed by the mechanics of the male gaze, 'introducing Honey in a voyeuristic manner whereby Bond gazes at her before she is aware that she is being watched' (Chapman 2000: 66). When Honey asks Bond whether he is also 'looking for shells', his response, 'No, I'm just looking' (*Dr No* 1962), apparently summarizes the active/passive, voyeurism/exhibitionism binary of the male gaze (Parks 2015: 256–7). Andress's bikini appearance in *Dr No*, 'wearing a scrap of bikini and a sharp knife in her tight belt', as American *Vogue* remembered in 1965 ('People are Talking about' 1965: 130), 'established the enduring visual image of the "Bond girl"' (Chapman 2000: 66), and became an iconic Bond Girl moment in both fashion and film industry (Craik 2009: 252).

The bikini has *per se* 'explosive' connotations; the name of a two-piece swimsuit launched in 1946 by Jacques Heim, 'Atome', reflected its smallness, although it was a lot less revealing than Louis Réard's skimpy triangle design which he named 'bikini', 'thinking it a bombshell in swimwear design analogous to the recently exploded atomic bomb on Bikini Atoll' (Craik [1993] 1994: 147; see also Schmidt 2012, 15).[5] Indeed, 'during the 1930s, the term bombshell ... and other terms such as a *knockout* or *dynamite* woman also followed the pattern', Tricia Jenkins reminds us, and 'all marked the increasing recognition of female sexuality as powerful and explosive' (2005: 315). While American pilots named their bombers after their female loved ones – famously, Hiroshima pilot Paul Tibbets called his plane Enola Gay after his mother – the modern bikini was, in all likelihood, both the practical result of fabric shortages and the signal of

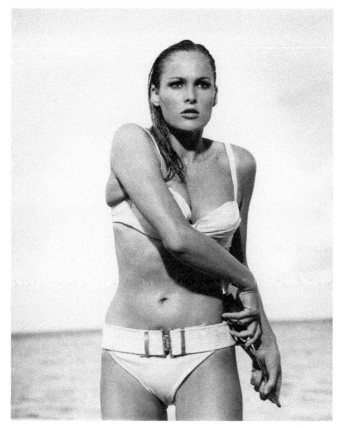

Figure 17 Ursula Andress as Honey Ryder, *Dr No* (Courtesy of GETTY/MOVIEPIX)

changing attitudes towards female sexuality. The bikini's figurative explosiveness was literally rendered in another film featuring Ursula Andress in a memorable white bikini, Elio Petri's *La Decima Vittima* (1965). Here the bikini bra accommodates a deadly weapon that the woman uses to kill her target at the end of a strip-tease dance: 'from a weapon of seduction, the bikini bra turns into a murder weapon' (Battista 2008: 46).[6] Prior to the shooting, the removal of her mask – a metaphorical unveiling of female identity – is not followed by the horror of female castration, but a lethal set of phallic double-guns.

In *Dr No*, Andress's weaponry, though still disturbingly associated with the eroticism of her semi-nakedness, moves to another erogenous area of her body. The presence of the diving knife hanging at her hip, 'positioned in close proximity to her hand ... to give a threatening edge to a feminine bikini' (Severson 2015: 178), disturbs the scene's complacent display of the female body. In fashioning the iconic bikini, costume designer Tessa Prendergast had to create a concept

which did not exist in Fleming's original description of Bond's first sighting of Honeychile Rider:

> She was not quite naked. She wore a broad leather belt round her waist with a hunting knife in a leather sheath at her right hip. The belt made her nakedness extraordinarily erotic ... She stood in the classical relaxed pose of the nude, all the weight on the right leg and the left knee bent and turning slightly inwards, the head to one side as she examined the things in her hand.
>
> <div align="right">Fleming [1958] 2004: 78</div>

In the absence of clothes, the scuba-diving belt and hunting knife produces a disruption in the naked body with tremendous erotic effect, reminding us of the potent appeal of partial nakedness: 'nakedness ... has its own fierce effect on desire', Hollander argues, 'but clothing with nakedness underneath has another, and it is apparently even more potent' (1976: 644). Such is the power of the clothed image that even in nude representations of the body, clothes still 'haunt' it: 'all nudes in art since modern fashion began are wearing the ghosts of absent clothes – sometimes highly visible ghosts', continues Hollander (1976: 645). The reference to Honeychile's classical nude stance exposes precisely the shift from the 'natural' naked body to the stylized nudity of the body clad in the spectre of clothing.

The classic aesthetics of the feminine nude were to be captured in the dust jacket of the first edition of Fleming's *Dr No*, with Honeychile 'standing on a Venus Elegans shell' (Fleming 2015: 180), but the concept was never used; the cover depicted, instead, a naked woman in the stylized pose described in the novel. As Fleming requested, however, the image did not include 'the diving mask or the belt as these would take away from the Botticelli point' (Fleming 2015: 180–1), though this, in fact, took away from the 'Honeychile point'; the diving knife – significantly hanging from her hip and not, as customary among divers, secured to her leg – is evocative of the phallic power and threat she embodies. In both novel and film, Honey(chile) is constructed simultaneously as a phallic woman and 'castrating'; she is, after all, responsible for murdering the landlord, who abused her, by dropping a female black widow spider in his bed: 'He took a week to die. It must have hurt terribly', she tells Bond 'happily'. His bland response – 'It's not a thing to make a habit of' – downplays the real threat she poses (Fleming [1958] 2004: 116), even though, Honeychile's sadism worryingly prefigures Dr No's attempted murder of Bond with a tarantula.

Before Craig's re-enactment in *Casino Royale* (2006), the iconic bikini scene was revisited in *Die Another Day*, with Halle Berry in the part of Jinx Johnson.

Over an orange La Perla bikini, Jinx wears a belt with a knife, the unveiling of which is significantly delayed, like that of the Freudian/Lacanian phallus, as Jinx emerges from sea. In this scene, the Whitaker Malem belt buckle is shaped like the letter 'J' (Landis 2012: 73), endorsing Jinx's identification with the phallic weapon, which she brings to bed: 'Who says I'm good?', she warns Bond (*Die Another Day* 2002). The sex scene, then, suggests that Bond 'has finally come up against a woman who is his equal in bed and on the job'; as director Lee Tamahori confirms, '[Jinx] seems to be Bond's nemesis, but she winds up being kind of like a female James Bond' (qtd. in Meter 2002: 274). Ultimately, the knife's phallic associations – reinforced by the self-referential prop of Klebb's shoe found in Q's laboratory earlier in the film – intimate that Jinx is, in fact, Bond's replacement; it is no coincidence that Jinx's knife, rather than Bond's gun, fatally penetrates Bond Girl Villain Miranda.

Of the 'deadly *femme fatale* of *film noir*', Barbara Creed reminds us that 'the woman who carries a gun in her purse is regarded as a classic example of the phallic woman' ([1993] 2007: 157). This is certainly the case with Bond Girls, whose elegant evening gowns and purses frequently conceal weapons. Both Pam Bouvier and Peaceful Fountains of Desire 'wear' guns in their garters in *Licence to Kill* (1989) and *Die Another Day* (2002) respectively, while Anya Amasova carries a small gun in her evening bag in the film *The Spy Who Loved Me*. In *You Only Live Twice*, it is Helga's lipstick bomb that evokes the lipstick pistol used by Cold War KGB spies (*C.I.A. Sexspionage* 2002).

Discussing the cultural significance of weapons and armours in historical dress, Ruel Macaraeg reminds us of the 'two ways weapons can be socially functional: as instruments of violence, and as symbols of violent capacity displayed to pre-empt the need for actual violence' (2007: 45). To Bond Girls, weapons can indeed serve as accessories to symbolize their potential threat; other times, however, their phallic threat is reified. This is the case with Melina Havelock who, in *For Your Eyes Only*, uses her crossbow to avenge her parents' death, or Domino, who ends up killing the villain, Emilio Largo, literally penetrating him with a spear gun, and thus saving James Bond, at the end of *Thunderball* (novel and film).

But weapons can function, symbolically, on another level, to convey status: 'like other clothing accessories, weapons could indicate status by style and expense', Macaraeg suggests, and 'when people are relatively equal in status, they are similarly armed and have a similar capacity for physical violence' (2007: 46, 49). In *Skyfall*, when Bond notes that 'only a certain kind of woman wears a backless dress with a Beretta 70 strapped to her thigh', Séverine admits

that she 'feel[s] naked without it' (*Skyfall* 2012), echoing his exact words in *From Russia with Love* (Fleming [1957] 2004: 233). According to this 'grammar of ornaments', the comparable presence of concealed and visible weaponry in Bond Girls' attire blurs gender boundaries; weapon proximity to female body/dress, translates 'the appropriation of male strength (weapons/phallic symbols) into a reconstructed image of empowered femininity' (Macaraeg 2007: 58).

'Dressed to die'

A euphemism for the ecstasy of sexual orgasm, the French phrase *la petite mort* – 'small death' – evokes the eroticized swooning of nineteenth-century tight lacers. While fetishism has almost universally been linked to male sexuality, the cultural history of fashion reveals alternative insights. Rather than speaking of female oppression and misogyny, the contextual use of controversial items such as corsets, stiletto heels, and furs, points to narratives of female desire, pleasure and, ultimately, agency.

Though fear of castration and the 'phallic mother' are themes which, symbolically, occur in the Bond narratives, there are other ways of thinking of fetishism which may pave the way for alternative interpretative avenues; as Edelkoort proposes:

> We are all born in bondage with a cord around our baby body. An umbilical cord that is the lifeline of gestation and that bonds us to our mother in the most direct and intimate way, connected as we will never be again after birth. The separation anxiety we feel throughout life begins here. This is where the human quest for other forms of connections and bonds starts; unable to replace it, we will try to re-enact or at least remember the primal bond of life.
>
> 2013b: 5

To think of fetishism as rooted in an innate bondage-instinct, replaces the patriarchal phallic model and translates the male-centred understanding of fetishism into a genderless umbilical discourse: 'most babies are given a safety blanket that is meant to be a partner and protector, a cuddle to be cherished' Edelkoort continues, 'therefore this first encounter with fibre and weave is responsible for many of our future encounters with fabric' (2013b: 5). The negotiation of desire, through a strong, even visceral, attachment to items of clothing, therefore, conceals not only the antagonistic anxieties produced by sexual difference, but also individual mechanisms of self-determination.

Blurring the masculine/feminine, assertive/submissive binary categories, Bond *femmes fatales* self-consciously manipulate the male gaze that frames femininity as passive spectacle. Dressed to kill – and, at times, die – Bond Girls and female villains twist the known paradigms of the male gaze, restoring power to its fetishized object. Dead or alive, desired and desiring, rather than an assuaging strategy in support of the masculine ego, the unveiled phallicism of Bond female characters exposes the deep scars of Bond's wounded masculinity.

CONCLUSION

Are Bond Girls Forever?

Just like every man wants to be James Bond, clearly every woman wants to be a Bond girl!

Packham qtd. in 'Be a Bond Girl this Christmas' 2006

Caterina Murino's *Casino Royale* coral lace-up dress turned British fashion designer Jenny Packham into a global hit after the 2006 film release: "There seems to be a bit of a global obsession with the dress', she told *Vogue*, 'as women from Los Angeles to Japan are contacting our headquarters to try and get hold of it' ('Be a Bond Girl this Christmas' 2006). The use of fashion tie-ups in film dates back to 1930s Hollywood (see Breward 2003: 135), so there may be nothing new to the fashion references and product placements in the Bond films, and their impact on the sales of high-end couturiers such as Givenchy, Tom Ford, and Prada. But what the 'global obsession' for Packham's design exemplifies is the additional function *haute couture* plays in film; unlike ordinary costumes, 'iconic clothes serve a proclamatory function in film, they collide with the sequences in which they are placed because they carry an alternative, independent meaning' (Bruzzi 1997: 17). If the dress steals the show, its glamour exceeds the confines of the film, encouraging the spectator to become the active consumer of a product other than the film itself; the iconic dress becomes more than a piece of *couture*. As film triggers a process of identification, the dress gains additional value from being part of a specific performance in which the spectator can participate through the shared consumption of a fashion item. Dress becomes fantasy.

The Bond Girl *couture* fantasy, however, predates, the Bond films. As this book has demonstrated, a distinctive attention to female dress emerges in the complex interaction between Bond's voyeurism and the exhibitionism of the female characters in Fleming's novels. American author Andrea Lee, for instance, recalls falling for the sartorial world of the literary Bond Girls:

My love affair with clothes in books began, as many passions have, with James Bond ... I was fascinated by Fleming's heroines, who, for all their comic monikers of high-class hookers – Pussy, Kissy, Solitaire, Domino – were not simple sex-pots but ruling-class goddesses, with their voluptuous but athletic bodies, superbly cut hair, and, especially, their exquisite clothes, described by Fleming's usual fetishistic meticulousness.

2002: 88

Though part of the intellectual experience of reading Fleming's novels, the sartorial fantasy it produces has material ramifications, as, by Lee's admission, 'a number of Ian Fleming-type clothes have found homes in my closets over the years. And there are evenings when I get into a black suit, add a wide belt and experience a certain frisson that tells me secretly I am a Bond Girl' (2002: 92).

More efficiently than literature, the film medium can translate the spectator's identification fantasy into actual consumption. Indeed, as Craik has rightly noted, 'the popular series of James Bond films ... not only constitutes a record of changing women's fashions but undoubtedly influenced the fashions and lifestyles of the moment' (Craik 2009: 252). There seems to be growing evidence that film and fashion industries have jointly exploited female spectators' responses to Bond Girls, and the identification fantasies the characters' sartorial styles engender. When journalist Celia Walden was given the opportunity to try on an authentic Bond Girl costume available for purchase from Angels Fancy Dress in London's Shaftesbury Avenue, she admitted that 'dressing as a real Bond Girl did make me feel enjoyably wicked' (Walden 2008). With prices in the excess of £1,500, however, these garments remain the privilege of the fashionable elite. Nevertheless, the strong marketing campaigns attached to the Bond industry guarantee access to a broader consumer target; for example, while Sophie Harley's Algerian knot in *Casino Royale* and *Quantum of Solace* may still only attract an exclusive clientele, the Swarovski *Skyfall* collection launched after the film's release constituted a more affordable commercial option.

If a woman may be more likely the recipient – rather than the direct buyer – of an expensive piece of jewellery, other commercial enterprises unambiguously centre on a female consumer. Debenhams blogger Anita's 2015 shopping-list targeted female customers willing to replicate affordable Bond-Girl styles ranging from the Jill Masterson-inspired 'Golden Goddess', to Lupe Lamora's 'Lady in Red' and Elektra King's 'Femme Fatale' (Anita 2015). Meanwhile, nail varnish manufacturer OPI launched two limited series of shades named after Bond film titles in 2012, and Bond Girls in 2013; while 'Pussy Galore' was strangely cast in pastel pink, all of the OPI Bond Girls products had a 'liquid

sand' gritty finish, perhaps to invoke Bond Girls' tough femininity. For younger girls, in 2012 Mattel launched a limited 007 Barbie Doll collection, which included doll-size replicas of iconic Bond Girls Honey Ryder, Solitaire, and Pussy Galore.

Given the broad appeal of the Bond cult, the Bond-Girl fantasy is increasingly associated with the Bond-Girl actors, rather than their characters. In the popular press, beauty tips instruct women on how to recreate Bond-Girl make-up with the aid of well-chosen products: 'Forget 007 – the real star of *Spectre* is set to be Léa Seydoux', pronounces the beauty editor of the London *Evening Standard*, before listing tips to achieve 'her subtle, smoky eyes, matte berry-red lips and 1940s-style curls in golden blonde' (Newman 2015: 63). The erasure of multiple boundaries – character/actor/spectator – is facilitated by the borderline position of film costume, which acts as a bridge between normally separate spheres of action: 'the fusion of fact and fantasy, role and reality' [is] rooted in the cult of female stars' (Landis 2003: 7–8).

Indeed, the extensive popularity of the Bond films exists in a reciprocal relationship with the celebrity cult attached to the Bond female actors. More so than with the male actors playing Bond, continuity exists between the female actors' cinematic and sartorial performances on the red carpet and publicity events. This is also not something new to the film industry: 'it was through the media coverage lavished on the stylish off-screen personalities and tastes of women like Grace Kelly and Audrey Hepburn that the fashion houses ensured publicity, rather than via direct tie-ins with the films themselves' Breward reminds us (2003: 139). As much as Bond Girls' *haute couture* styles have trickled down to the high street, so have the actors been the object of the sartorial gaze of EON's publicity teams, film critics, and the general public. Actor Tania Mallet, who played Tilly Masterson in *Goldfinger*, complained about the producers' overbearing control over her lifestyle during/after production:

> Acting in *Goldfinger* involved everything I most hated . . . I felt totally owned by the film makers. I wasn't even allowed to ride in case I broke a leg or something. They would ring me up, send around a dress and tell me to turn up at a premier [sic] or a party I had to go. Before that I had been a free-living girl. The whole razzmatazz made me feel impossibly restricted.
>
> 'What has happened to the Bond Girls', 11–12

The erasure of the film/real world boundaries demanded by the Bond Girl 'status', it would appear, did not only bring glamour and fame, but also lifestyle restrictions which, paradoxically, would clash with the Bond Girl's devil-may-care fantasy.

But glamorous the Bond world is. No expense was spared in the glitzy performance of *Goldfinger*'s London premiere on 17 September 1964: 'the film reels arrived in gold canisters ... [and] Honor Blackman ... wore a 22-carat gold finger – a pinkie adornment that cost £10,000 and also bore a large diamond' (Fig. 18) (Rothman 2012a). Almost fifty years later, the excessive glamour of *Goldfinger* still worked its magic; a playfully self-referential Shirley Eaton attended the '*glittering* affair' that was the *Skyfall* premiere at London's Royal Albert Hall on 23 October 2012 entirely draped in gold, while the film's female actors '*dazzled* in front of the flashbulbs' in *couture* dresses ranging from Marlohe's red Vivienne Westwood's gown to Harris's sequined blue Marios Schwab's dress (Kilcooley-O'Halloran 2012; my emphases). More cohesively than the Academy Awards, what such occasions produce is continuity between the glamour of the film

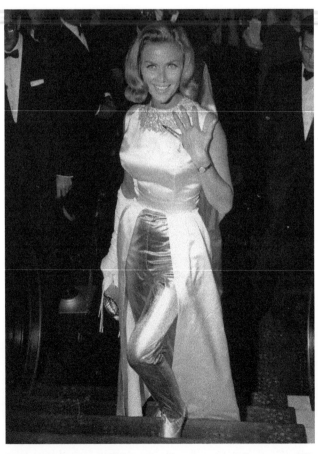

Figure 18 Honor Blackman, *Goldfinger* London Premiere (Courtesy of Keystone Pictures USA/Alamy Stock Photo)

characters' costumes and the elegant styles modelled by the film stars: 'both events [film and ceremony] . . . are shows, or one big show' (Munich 2011: 1). In doing so, while they would appear to perpetuate the myth of woman as spectacle, the mechanics of fashion consumption do not necessarily frame the female consumer as passive victim, but as an active player in the ambivalent game that is fashion. Among the befrocked female guests, one guest stood strikingly out of the *Skyfall* premiere *glitterati* crowd: Naomi Campbell, who walked down the red carpet in a black Alexander McQueen trouser-suit with white lapels. Referencing Bond, rather than the Bond Girl, Campbell made a conscious fashion statement gesturing to the cross-gender appeal of the secret agent's sartorial look.

Suave, sharp, sophisticated. These adjectives populate descriptions of James Bond in blogs, film reviews, popular and academic writing. They all point to the all-important – and recognizable – secret agent's 'look', a trademark of the longest film franchise in the history of cinema. In 2015, Bloomberg analysts reported that out of a total fifty-one hours, nearly eighteen feature Bond in a suit or dinner jacket, with Connery topping the dapper chart in *From Russia with Love* (Glassman et al. 2015; see also Carvell 2015), where he wears a suit or dinner jacket for three quarters of the film. Indeed, what captured readers' interest, when Fleming's novels began to attract more critical attention, was a distinct formula of thrill and style: 'The combination of sex, violence, alcohol and – at intervals – good food and *nice clothes* is, to one who leads such a circumscribed life as I do, irresistible', commented Hugh Gaitskell, then the leader of the Labour Party, confirming the links between consumption and the particular brand of escapism that Bond offered (qtd. in Pearson [1966] 2013: 437; my emphasis).

The exposure to fineries offered by the bespoke tailors of Savile Row significantly triggered Connery's own appetite for a fashionable style he had been – albeit unwittingly – responsible for: 'Connery was clearly impressed by Sinclair's tailoring skills', Mason reminds us, and 'he had over 100 suits made by him for his personal and professional wardrobes' (qtd. in Stempien 2015). Commenting on a picture of Sean Connery among a crowd at Cannes Festival in 1965, Tim Adams notes that for all of Connery's 'reluctance to identify with his character', the 'Bond look' was unmistakably still there, 'keeping his head and his tailoring on point, while all around him were losing theirs' (Adams 2018: 3). Connery's professional relationship with Sinclair would last until 1971; even with 'seven or eight suits ... from the films', Connery would buy more, out of pleasure: 'a moment of weakness', he told *Playboy*, 'Something came over me and I went out one day and spent £300' [equivalent to almost six thousand pounds at the time of writing] (Connery 1965: 80).

Connery's 'moment of weakness' reinforces fashion's facilitation of fantasies of self-determination. If in the post-war climate of the early novels, 'nice clothes' might still be a fantasy for most, the increasingly exaggerated accent on luxury is particularly important in the more recent films, where it establishes a significant, and recognizable reciprocity between Bond's world and the consumer market of *haute couture* (as well as expensive watchmakers and car manufacturers): 'for high-end clothiers like Brioni and Tom Ford, which provided suits for Brosnan and Craig, the films are an opportunity to showcase their brands' (Glassman et al. 2015). Indeed, discussing Pierce Brosnan, who was cast as Bond after the less glamorous Timothy Dalton, Alex Jones signalled the all-important return of the Bond/luxury coupling:

> The ironic spy/hoodlum/gangster film is now such a popular cliché, abused by everyone from Mike Myers to Quentin Tarantino, that one of the ways in which the Bond films can convincingly lift themselves above the morass of tongue-in-cheek, self-referential movie iconography is by looking lush. And that means luxurious locations, bigger explosions, state-of-the-art transportation, *well-groomed women*, and – of course – *fabulously expensive clothes*. The name is Bond. Bond Street.
>
> Jones 1999: 62

As Jones concluded in his article published in the 1999 James Bond *Guardian* collector supplement, the perpetuation of the Bond myth owes much to the continued emphasis on luxury consumption throughout novels and films.

While Craig – short-sightedly dismissed as 'James Bland' by the *Daily Mirror* ahead of his debut in *Casino Royale* (Cummins 2005) – has restored Bond to the dark edginess that belongs in Fleming's novels, this may have been in response to the successful Jason Bourne films based on Robert Ludlum's character. In truth, Bond and Bourne have very little common ground, and it is very hard to imagine the two characters moving in the same circles. Indeed, the distinct lack of glamour in the Bourne's world sets it apart from Bond's realm of exclusive fineries; the unlikely event of a Jason Bourne-themed party would definitely not entail a black-tie dress code (or the consumption of champagne). Put it differently, no male spectator would think twice about his outfit before attending a screening of a Bourne movie. But dress up they might, the same male spectators, in mothball-scented dinner jackets and bow ties, heading to one of the sold-out general-release Bond premieres, the extravaganza of which increasingly emulates the glamour of the VIP premieres.

In between films, an affordable fee allows fans to channel their 'inner Bond' at the recently launched 007 Elements, a James Bond cinematic experience hosted in *Spectre*'s 'Hoffler Klinik' on the summit of Söndrian, Austria. Those with more eccentric tastes – and larger pockets – can place bids at exclusive auctions where the sale of Bond 'original' pieces, including first editions of Fleming's novels and film artefacts, fetch astronomical sums. Craig's La Perla blue trunks as worn in *Casino Royale* and 'unwashed', as Judi Dench announced in her sales pitch, attracted £44,450 at Christie's 2012 charity auction. The costume's ironic subversion of the conventional male gaze did not get lost on the auction organizers, and the money went to the charity Women for Women ('Bond Auction' 2012). In comparison, however, original Bond Girl costumes, though still lucrative for both charities and private auction houses, have attracted lower figures; at the same auction, Kurilenko's Prada dress worn in the *Quantum of Solace* desert scene sold for a mere £9,375.

While owning an original piece of Bond merchandise is the exclusive privilege of a few, 'Bondiana' reproductions have provided affordable ways of catering to the demands of fans since the franchise's early days. The Bond brand grew exponentially throughout the 1960s, when it gave rise to one of the biggest marketing exercises to date (see Moniot 1976), and Bond-branded gadgets, cosmetics, and children's toys were available for sale in thousands of licensed worldwide stores. While, in Australia, dubiously named 'Fit for Bond' female underwear might have targeted women buyers, most products, including the dinner jackets, shirts and cufflinks on sale at the Galeries La Fayette's 'James Bond Boutique' (see Moniot 1976 and Chapman 2000: 92) addressed Bond's largely male fandom. Five decades later, Bond-mania has not stopped; gentlemen can purchase Connery's Anthony Sinclair Conduit Cut suit from Mason and Mason, while online blogs such as Matt Spaiser's *The Suits of James Bond* or Remmert van der Braam's *James Bond Lifestyle* offer painstaking advice to fans willing to emulate the Bond look.

In targeting a male clientele, however, the Bond brand's emphasis on consumption challenges, paradoxically, the heteronormative masculinity that Bond apparently stands for, as the male consumer's sartorial performance points, in fact, to a traditionally 'feminine' mode of consumption by virtue of its relationship with fashion. Rather than a recognizable masculine archetype, Bond, then, becomes a mere stylistic place-holder; what he stands for is not 'masculinity' at all, but a 'look', which is simultaneously exciting, effortless, and impeccably sharp. Significantly, Bond's combination of sharp tailoring and modern comfort was directly referenced in Katharine Hamnett's Spring/Summer

1986 collection, which invited people to look 'refined, comfortable, easy, ... sharp, ... pressed and starched, and yet like James Bond ... [who] jumps off a two-floor balcony, lands on a lorry and never even undoes his suit-button (qtd. in *Millennium Fashion* 2016). The Bond look, Hamnett's collection implied, captured the impossible made possible, through clothes that retained a sharp image under all circumstances.

Bond style was also behind Hamnett's 1986 Autumn/Fall Collection, this time looking to the women in the Bond films as a source of inspiration. Showcased by models dancing to a medley of Bond film tunes, the 'Bond Girls' collection presented, among torn denims and khaki casual wear, a combination of fun, figure-hugging jersey catsuits reminiscent of Pussy Galore's Flying Circus, and tailored pencil-skirts à-la-Moneypenny. Such variety of styles has also emerged in Diane von Fürstenberg's more recent 2003 'Licence to Thrill' collection, as reported in *Vogue*:

> Intriguingly mismatched color combinations – peach with rust, pink with brown and blue – gave the show a distinctly '70s flavor, while the breadth of the collection means Bondettes of all stripes will find something to suit them. Daredevils will go for the giddy peacock-blue velvet minidress; double agents will slip by in the ladylike white flannel coat; and undercover types will cozy up to the rainbow-hued fringed sweater worn over skintight jeans.
>
> Ozzard 2003

Launched twenty years apart from each other, Hamnett's and Fürstenberg's collections make an important point about the diverse range of sartorial looks Bond Girls have inspired, and their persistent influence on the fashion industry. Such developments significantly overturn the odd perception towards the beginning of the film franchise that the Bond formulaic appeal rested on the female characters rather than the main hero:

> Although the image of Bond changes from film to film, the Bond Girl remains the same, apparently, in all movie-makers' minds. She is rangy, sexy, languid, cool, "slightly sunburned", and looks at the world through honey-coloured hair in spite of the fact that Ian Fleming sometimes specified raven black. She has always a low and double-loaded gaze.
>
> 'James Bond's Girls' 1964: 76

In fact, unlike the 'James Bond' look, which, in its unchangeability, nostalgically holds on to the hard masculinity myth, it is impossible to identify a single 'Bond Girl' look. The Bond Girls' multiplicity of sartorial performances, which range from practical action gear to fetish wear, speaks of a dynamic femininity, which,

not chained to static gender roles, reflects fashion's postmodern deconstruction of fixed identities:

> Postmodernism, with its eclectic approach to style might seem especially compatible with fashion; for fashion, with its constant change and pursuit of glamour enacts symbolically the most hallucinatory aspects of our culture, the confusions between the real and the non-real, ... and the nihilistic critical stance towards authority, empty rebellion almost without political content.
>
> Wilson [1983] 2017: 63

Characterized by its fluid trends and ability to accommodate clashing concepts, as the love-child of feminism and postmodernism, in Elizabeth Wilson's view, fashion becomes 'a focus of liberation, a site of opposition and a complex signifier of gender and sexuality' (Street 2001: 3).

In her multiple changes of costume, a Bond Girl will simultaneously embody the seductive *femme fatale*, the athletic field agent, or the professional career woman. Her identity does not stick to any of these archetypes, but is constantly done and undone. Her femininity is not prescriptive, but a performative masquerade facilitated by costume. In reminding us that 'the etymology of the word fashion derives from the French word façon – a "way" of doing something', Claire Pajaczkowska and Barry Curties reinforce the multiple layers of the performative complexity of film costume: 'With façon, as with fashion, the meaning is to be found in the way something is used or done, rather than in the object or in the action itself' (2008: 62). Adopting and adapting the mechanics of fashion to her own mission, the Bond Girl cultivates an image that, while self-referential, also keeps changing. Unlike Bond, she is never the same.

Capturing the 'effeminacy' that the English dandy was teased with throughout the cultural history of British men's fashion, Bond's polished sartorial look also evokes the cinematic stylization of the gangster, 'ultimately striving for a stereotyped, idealized and unattainable image of masculinity' (Bruzzi 1997: xviii). To paraphrase Bruzzi's analysis of the gangster, '[Bond]'s consciously repetitive and self-reflective wardrobe suggests a perpetual need to define and redefine himself against such an image, to create his identity by comparing itself to past icons' of himself (Bruzzi 1997: xviii). Consequently, as Judith Roof proposes, 'Bond's style is always retro because the Bond figure always refers to its entire fractured history' (2005: 85). The unchangeability of Bond's look, crystallized since his mid-century literary and cinematic debuts, is made more obvious through the vivid contrast with the Austin Powers Bond-pastiche.

Embodying the ephemeral 1960s Peacock Revolution when 'men grew their hair long, donned pretty, printed shirts worn open at the neck ... skintight trousers ... as well as frills, bows and lace' (Peacock 1998: 8), the Powers look is firmly rooted within a very localized, historical moment in British fashion. As such, it is destined to be a passing fad. The pervasive longevity – and broad appeal – of the classic Bond look, demonstrates the transience of extreme trends, and the weak foundations they provide for the perpetuation of the unchangeable masculinity myth that Bond incarnates.

Yet the impeccable suit is but a mere illusion, projecting an image of wholeness whereas, as discussed in Chapter 1, Bond's is a deeply damaged kind of masculinity. This is evoked, repeatedly, in the multiple literal and metaphorical castration anxiety manifestations throughout the Bond narratives; reading Bond's gun-fetish as fashion accessory, Craig Owen suggests that Bond remains 'a figure of decentered masculinity', while his maleness moves from the interior ... to the surface ... and thence to the commodity marketplace of the post-modern male subject' (Owen 2005: 124). That Bond is, indeed, a hollow signifier of maleness and masculinity is ironically captured in the presumed post-coital scene at the end of *Die Another Day*. Jinx's words to Bond – 'It's the perfect fit' (*Die Another Day* 2002) – do not refer, as a segue from Moneypenny's simulated Bond sex experience might infer, to Bond's sexual endowment, but rather, to the luxury object of her desire, one of Graves's conflict diamonds temporarily lodged in her navel. Bond, then, is literally replaced by the luxury of which he has been a symbol from the start.

Bond Girls may well be forever, but they will not be *the same* forever. If Bond's superficial unchangeability signals a fraught relationship with the 'eclectic approach to style' of postmodernism, the Bond Girl's dynamic changeability is, instead, a source of empowerment, in that it does not bind her to a single model of femininity. Unlike the excessive parody of Austin Powers' 'peacock' parade, her sartorial games skilfully manipulate the conventional models of feminine body and fashion both subtly and effectively. Speaking to Seydoux, *Vogue*'s journalist Giles Coren notes that 'most women love a Bond girl. They don't care about the politics. They like how she looks, what she wears' (Coren 2015: 219). Resonating with the separation of the political from the sartorial in this generalized statement are old arguments about the objectification of women with no agency. In fact, as Seydoux's more nuanced understanding of her Bond Girl role confirms, '*Spectre* is more about the women ... [who] have to fight against something ... to find ... freedom' (Coren 2015: 219). Accordingly, the article's accompanying photographs capture Seydoux/Bond Girl's multifaceted femininity, in a

contrasting juxtaposition of modestly demure and unquestionably sexy ensembles (Coren 2015: 214–25).

What the apparently incongruous combination of feminine looks demonstrates, in fact, is the plurality of Bond Girls' sartorial performances both in their textual and cinematic renditions; they are not aligned to either pole of the 'innocent angel/sexual demon' opposition, and yet, they can embody both, *and* the grey areas in between. Though, like Bond's, their bodies are scarred and carry the traumas of the past, the hardness of their muscular physiques resists a patriarchal notion of feminine fragility; even if they fall victim to sadistic foul play, their ill treatment is more an exposure of masculine anxieties about female empowerment, than a display of feminine victimhood. Their sartorial styles operate a knowing resistance against stereotypes of femininity as Other, passive, or victim of male desire. Self-consciously 'exotic', 'cross-dressed', or even 'dressed to kill', their femininities are never monolithic, never static. Bond Girls refuse to sit still and look pretty. They move fast, and they kick ass.

Notes

Chapter 1: 'Bond. James Bond': Masculinity and Its Discontents

1 After Restoration, David Kuchta explains, fashion had attracted critics from the political, religious and economic sectors of society:

> Political critics of court luxury saw conformity to fashion as incompatible with traditional English liberties. Religious critics condemned the idolatry of 'soft clothes' and called for a display of modesty. Economic critics promoted the consumption of manly English wool over presumably immoral and effeminate imports.
>
> Kuchta 2009: 44

2 Although *El día de Muertos* has been a long-standing family tradition, a public parade was only performed in Mexico City for the first time after the release of *Spectre* (Agren 2016). While the 're-invention' of tradition is a manifest example of the fast workings of globalization, the event also produces another layer in the simulated culture of reproductions that the Bond phenomenon seems to foster. The huge scale of the scene, which involved the participation of 1,500 extras in costume and the construction of original artefacts, conveys the carnivalesque atmosphere with a cornucopia of sensory detail: 'I wanted the audience to be dropped right into the middle of a very, very specific, very heady, rich environment', said Mendes of the scene ('*Spectre*: New Day of the Dead featurette' 2015).

3 The material – homespun khadi (undyed cotton) – and tailored style of the Nehru jacket, based on the Kashmiri *sherwani*, rejected the English sartorial codes that would have dictated Nehru's wardrobe during his time as a student and trainee barrister in Britain in the early twentieth century (Breward 2016: 96). In his 2002 state visit to India, Tony Blair was the first foreign prime minister to wear a Nehru jacket designed by British Indian African designer Babs Mahil (Shome 2014: 91).

4 As Breward explains, the introduction of the so-called' Mao suit' was based on Su Yat-sen's *Zhongshan zhuang* – 'blue, grey or olive-green khaki cotton or wool, five buttons, four symmetrically placed patch pockets and square-cut trousers' (2016: 96) – but also related to the student suit or *qiling wenzhuang*, characterized by a 'standing collar and matching pockets', which Sun Yat-sen had seen during his 1890s exile in Japan (2016: 97–8). The design was later adapted by Tian Atong, master tailor to Mao Zedung, to create the style later associated with the 'Mao suit', which incorporated

specific symbols to represent the 'Guanzi principles of propriety, justice, honesty and shame' in the jacket's four pockets, the Communist government's five branches (legislation, supervision, examination, administration and jurisdiction) in the five front buttons, and 'Sun's principles of nationalism, democracy and the people's livelihood' in the three cuff buttons; additionally 'the purity of the jacket's construction from a single piece of cloth echoed the unity and peacefulness of China, and thus its symbolic simplicity defied any possibility of dissent' (2016: 100).

Chapter 2: 'Dark Continents': Fashion, Foreignness and Femininity

1 After the establishment of the People's Republic of China in 1949, the Chinese tailoring industry largely moved to Hong Kong, where the *cheongsam* continued to thrive, and became influential on Western fashion designers: 'Dynasty's stylist Dora Sanders merged high fashion ideas with the cheungsam [sic], adjusted proportions for the ideal hourglass-shaped Western figure, and created a variety of cocktail and evening-gown styles as well as late day suits' (Walford 2013: 13).

2 Ahead of the model workers' conference in the Soviet Union in 1951, China's first female tractor driver and national model worker Liang Jun was instructed by the Party to have a *cheongsam* specially made for the event (Chen 2001: 151).

3 In more recent times, a form of re-appropriation of Ottoman motifs has also emerged in the works of contemporary Turkish designers including Cemil Ipekçi, Atıl Kutoğlu, and Dilek Hanif, whose 'Ottoman Fairytale' collection (2009) featured 'a stylised kaftan, cut in European lines and decorated with tinsel floral motifs'; far from reinforcing Eurocentric/colonial attitudes towards Other cultures, as Şakir Özüdoğru argues, such strategies can and should be read against their grain: 'although self-Orientalism is often presented as a way of accepting Western hegemony and internalizing it, one should keep in mind, however, that the same ideology could serve as a process of self-empowerment' (Özüdoğru 2016: 137).

4 The manuscript of *Moonraker* held at the Lilly Library shows this passage was added subsequently to the first draft, suggesting that Fleming thought this was an important detail about Gala's changed behaviour towards Bond during their mission (Fig. 3).

5 Although rather shocking when placed in a 1970s context, the ape-girl had been a staple part of circus sideshows on both sides of the Atlantic for a long time. Particularly relevant for the purposes of this discussion was the case of Krao who, at the age of seven, was captured in Sri Lanka, to become part of a successful 'freak show' backed by her captor/adoptive father G. A. Farini. What made Krao special was the fact that her hairy body was presented under the pseudo-scientific rubric of

'Darwin's missing link'. Her acute hypertrichosis became the foundation for a familiar argument on the backwardness of colonized people, and, when Krao was older, the dangerous sexuality of women of colour (see Durbach 2010).

6 In reaction against the practice of sex-slave branding in contemporary America, charities such as Survivors Ink founded by the late Jennifer Kempton, a former victim of the prostitution slavery trade in America, have encouraged and supported previously branded women to cover up their previous marks of ownership with designs of their choice (*Rebranded* 2014): 'I was so grateful to be alive; but having to look at these scars, you wonder if you'll ever be anything else', recalled Kempton in a video promoting the initiative.

7 Although kimonos have been progressively relegated to minor and mainly formal use, their ceremonial aspect has enjoyed a renaissance in the latter half of the twentieth century (Dalby [1993] 2001: 3). In the twenty-first century, the performative quality of kimono-wearing is apparent in the type of events at which kimono enthusiasts choose to wear their kimonos – tea ceremonies, shopping for kimono accessories – as well as the training required to wear a kimono in the appropriate fashion: specialized *kitstuke* academies and clubs fulfil these social practices by catering to the different needs of kimono wearers in Japan (Assmann 2008: 362).

8 Piccadilly, symbolic centre of Britain, and its Empire, is also, historically, a central queer location, a fact that may, implicitly, emphasize Tania's desire and non-normative sexuality (see Houlbrook 2005).

Chapter 3: 'Cross-Dressing': From the Field to the Boardroom

1 Bloomers were erroneously named after Amelia Bloomer, although the dress was first worn by Elizabeth Smith Miller on a visit to her cousin Elizabeth Cady Stanton in Seneca Falls in 1851 (Kesselman 1991: 498).

2 In 1893 sixteen-year-old Tessie Reynolds caused a sensation after she completed her Brighton to London return ride in eight hours and thirty-eight minutes. Reynolds had agreed to 'discard for cycling purposes the conventional skirt' ('Miss Tessie Reynolds' 1893: 210), and wore a riding costume comprising a long jacket over knee-length breeches. Hailed as 'the forerunner of a big movement – the stormy petrel heralding the storm of revolt against the petticoat' (Hillier 1893: 213), her 'cross-dressing' for sport was paradigmatic of women's desire to move – both literally and figuratively – beyond the domestic sphere.

3 Since the 1920s, the design of women's bras has responded to the demands of fashion 'to flatten the breasts (1920s); to enhance the contours (1930s and 1950s); to minimise and naturalise (1960s); to contain the breasts (1970s and 1980s); and to

highlight attributes (1990s)' (Craik [1993] 1994: 129). Twenty-first century lingerie signals, instead, a playfulness which speaks of fashion's increasing desire to blur gender boundaries, as exemplified by Agent Provocateur's launch of Les Girls Les Boys, 'a range of "shareable, swappable pieces"' ('Les Girls Les Boys' 2017: 14).

4 The gold-theme, which obviously symbolizes Pussy Galore's allegiance to Goldfinger, is a pervasive motif throughout the book and the film. Costume designer Bumble Dawson integrated the motif in the gold cropped top worn with a sarong skirt with gold trimming by flight-attendant Mai Lee (Simmonds 2015: 41). The more revealing display of midriff in Mai Lee's costume serves here a dual purpose: as it pretends to fulfil the desire of the male gaze, the revealing uniform manipulates the gaze, and, simultaneously, inverts it, following Pussy Galore's request that Mai Lee 'keep an eye on [Bond]' (*Goldfinger* 1964).

5 Ian Fleming defended his choice to 'turn' Pussy Galore into a straight woman in a letter to Dr G. R. C. D. Gibson, who noted that 'it is slightly naughty of you to change a criminal Lesbian into a clingy honey-bun (to be bottled by Bond) in the last chapter'. Fleming's reply that 'Pussy only needed the right man to come along and perform the laying on of hands in order to cure her psychopathological malady' would suggest that his ideological position on homosexuality sits quite closely to Bond's (Fleming 2015: 206–7).

6 Since 2018 Daniel Craig has been Omega Seamaster Diver Ambassador, appearing in the iconic watch advertising campaigns where Bond, in the customary tuxedo, emerges from an underwater scene wearing the Seamaster Diver 300 on his wrist (Dezentjé 2018).

7 Consider, for instance, this description of Greta Garbo's private wardrobe by Rilla Page Palmborg: '[Garbo] always wore heavy, low-heeled slippers. Oftenest these were the smallest size obtainable in men's low shoes. . . . She wore men's tailored shirts. She owned dozens of men's silk ties, in all colors. At night she wore men's pajamas, in soft shades of silk and in stripes. Her hats were of soft felt in mannish style. When her manservant brought her shoes, she would laugh and say, "Just the kind for us bachelors, eh?"' (qtd. in Horak 2016: 178).

Chapter 4: Dressed to Kill: Power, Knowledge, Desire

1 So iconic was the image of Jill Masterson's golden corpse, that statuettes were produced as keepsakes for film fans (Eaton 1999). Such fetishistic 'pick 'n mix' attitude to the female body is also reflected in the use of a body double for publicity posters, and the post-production dubbing of Shirley Eaton's voice, and the fact that both decisions were not shared with the actor (Eaton 1999): 'denied her own voice, the girl is, literally, reduced to the level of an object only to be looked at' (Chapman 2000: 66).

2 Among Krafft-Ebing's case studies, a patient revealed that 'Feathers in women's hats, fans, etc., have the same erotic fetichistic [sic] effect on me as furs and velvet (similar tactile sensation of airy, peculiar tickling)' (Krafft-Ebing [1886] 1906: 272).

3 While not strictly caused by tight lacing, there are moments where a female character rescued by Bond's 'kiss of life' is suspiciously reminiscent of the Victorian swooning woman. Such is the case with Jinx Johnson, who nearly drowns in Gustav Graves' ice lair in *Die Another Day*, or even Wai Lin, who is similarly trapped underwater in Elliot Carver's stealth ship in *Tomorrow Never Dies*; both scenes seem at odds with the film narratives, as previously fit Bond Girls are portrayed as incongruously vulnerable women, desperate for Bond's aid. Significantly, in *Tomorrow Never Dies*, this represents the romantic turning point, where Bond wins over the (dying) girl.

4 The act of knitting, like weaving, is suggestive of the double meaning of the word 'plotting', and of the duplicitous role implied in the apparently innocent act of dress-making. As Warwick and Cavallaro put it:

> Whilst weaving and other germane operations may evoke the image of a connecting and potentially harmonizing network, they simultaneously suggest the figure of the tangle, a random and rebellious mingling of threads, or even that of the web, as a structure that is both symmetrically contrived – and hence symbolic of order – and intended to entrap – and therefore evocative of a perilous loss of control.
>
> 1998: 169

5 While, even before the First World War women's swimming was first included in the 1912 Olympic Games, two-piece swimsuits had appeared on the market in the 1930s, with *Vogue* featuring them for the first time in 1935 (Craik [1993] 1994: 147). In June 1935, US *Vogue* featured Cecil Beaton's photograph of Countess di Zoppola wearing a cropped top and matching bottom wrap ('Beauty Barometer for Sun or Shade', 1935: 43). A year before *Casino Royale* was published, seventeen-year-old Brigitte Bardot starred in *Manina, la fille sans voiles* (Rozier 1952), released in the United Kingdom as *The Lighthouse-Keeper's Daughter* in 1959. The film was also released in the United States as *Manina, The Girl in the Bikini* in 1958, in spite of contravening Motion Picture Production regulations knowns as Hays' Code about navel display (see Vincendou 2005), after Bardot's reputation was consolidated with *And God Created Woman* released in 1956 (see Breward 2003: 136).

6 The Austin Powers films play on the association between the two characters played by Ursula Andress, as they feature 'fembots' – first seen in *The Bionic Woman* (1976–78) – female-looking androids clad in sexy clothes and equipped with breast-mounted guns. While the machines have been devised by Blofeld to fatally chastise Austin's libido, he manages to 'outsex' them by performing a sexual strip-tease which has a fatal impact on their circuits. In showing the female robots succumbing to their desire for Austin, the film undermines the power of the fembots, who are reduced to little more than sex dolls.

Works Cited

'31 Rue Cambon: The Story Behind the Façade' (2011), *Chanel News*. Available at: http://chanel-news.chanel.com/en/home/2011/02/31-rue-cambon-the-story-behind-the-facade.html (Accessed: 16 April 2018).

Abrahams, J. (2015), 'Freewheeling to equality: how cycling helped women on the road to rights', *The Guardian*, 18 June. Available at: www.theguardian.com/lifeandstyle/womens-blog/2015/jun/18/freewheeling-equality-cycling-women-rights-yemen-bicycle-liberation (Accessed: 10 September 2017).

Adams, A. (2017), '"The sweet tang of rape": Torture, survival and masculinity in Ian Fleming's Bond novels', *Feminist Theory*, 18(2): 137–58.

Adams, T. (2018), 'The Big Picture', *The Observer*, Review Section, 6 May: 3.

Agren, D. (2016), 'Mexico City's James Bond-inspired Day of the Dead parade gets mixed reviews', *The Guardian*, 30 October. Available at: www.theguardian.com/world/2016/oct/29/day-of-the-dead-parade-james-bond-mexico-city (Accessed: 8 May 2017).

Bambi (1942), [Film] Dir. J. Algar, Walt Disney.

Amies, H. ([1994] 2009), *The Englishman's Suit*. London: Quartet Books.

Amis, K. (1965), *The James Bond Dossier by Kingsley Amis*. New York, NY: The New American Library.

Amis, K. ([1968] 2015), *Colonel Sun*. London: Vintage Classics.

Anita (2015), 'Dressed to Kill: How to Dress like a Bond Girl'. *The Debenhams Blog*. Available at: http://blog.debenhams.com/fashion/dressed-to-kill-how-to-dress-like-a-bond-girl/(Accessed: 10 September 2017).

Arnold, R. (2001), *Fashion, Desire and Anxiety: Image and Morality in the Twentieth Century*. London: I. B. Tauris.

Arterton, G. (2018), 'Woke Woman', in S. Curtiss (ed), *Feminists don't Wear Pink*. London: Penguin, 242–5.

'As Businesswomen Should and Should Not Dress' (1907), *Ladies Home Journal*, 24 November: 25.

Ashley, I. (1964), 'Cathy Galore!', *The Daily Mail*, 25 February: 12.

Assmann, S. (2008), 'Between Tradition and Innovation: The Reinvention of the Kimono in Japanese Consumer Culture', *Fashion Theory*, 12(3): 359–76.

Atomic Blonde (2017), [Film] Dir. David Leitch, Focus Features.

Atwood, M. (1985), *The Handmaid's Tale*. London: Vintage, 2010.

A View to a Kill (1985), [Film] Dir. John Glen, Eon.

Azzedine Alaïa (2017), [Film] Dir. Joe McKenna. Available at: www.joesfilm.com/

Bakhtin, M. ([1965] 1984), *Rabelais and His World*, trans. H. Iswolsky, Bloomington, IN: Indiana University Press.

Bancroft, A. (2012), *Fashion and Psychoanalysis: Styling the Self*. London; New York, NY: I. B. Tauris.

Barrett, T. M. (2015), 'Desiring the Soviet Woman: Tatiana Romanova and *From Russia with Love*', in L. Funnell (ed), *For His Eyes Only: The Women of James Bond*. New York, NY: Wallflower Press, 41–50.

Barthes, R. ([1967] 2010), *The Fashion System*, trans. M. Ward and R. Howard, Berkeley, CA: University of California Press.

Barthes, R. ([1973] 1988), *The Pleasure of the Text*, trans. R. Miller, New York, NY: Hill & Wang.

Bartlett, D. (2004), 'Let Them Wear Beige: The Petit-Bourgeois World of Official Socialist Dress', *Fashion Theory*, 8(2): 127–64.

Bartlett, D. (2010), *FashionEast: The Spectre that Haunted Socialism*. Cambridge, MA: MIT Press.

Battista, A. (2008), 'The Killing Game: Glamorous Mask and Murderous Styles in Elio Petri's *La Decima Vittima*', in M. Uhlirova (ed), *If Looks Could Kill: Cinema's Images of Fashion, Crime and Violence*. London; New York, NY: Koenig, 40–51.

Baudot, F. (1996), *Alaïa*. London: Thames & Hudson Ltd.

Baudrillard, J. ([1981] 1994), *Simulacra and Simulation*, trans S. Glaser, Ann Arbor, MI: University of Michigan Press.

'Be a Bond Girl this Christmas' (2006), *Vogue*, 13 December. Available at: www.vogue.co.uk/article/be-a-bond-girl-this-christmas (Accessed: 10 April 2018).

'Beauty Barometer for Sun or Shade' (1935), US *Vogue*, June: 43–45.

Beauvoir, S. D. ([1949] 2009), *The Second Sex*. London: Jonathan Cape.

Belle de Jour (1967), [Film] Dir. Louis Buñuel, Allied Artists.

Bender, M. (1965), 'Fashion Had its Go-Go Fling During 1965', *The New York Times*, 31 December: 24.

Bennett, T. and J. Woollacott, (1987), *Bond and Beyond: The Political Career of a Popular Hero*. Houndmills, Basingstoke, Hampshire: Palgrave Macmillan.

Berberich, C. (2012), 'Putting England Back on Top? Ian Fleming, James Bond, and the Question of England', *The Yearbook of English Studies*, 42: 13–29.

Berger, J. ([1972] 1990), *Ways of Seeing*. London: Penguin Classic.

Bergonzi, B. (1958), 'The Case of Mr Fleming', *Twentieth Century* (March): 220–8.

Berry, S. (2000), *Screen Style: Fashion and Femininity in 1930s Hollywood*. Minneapolis, MN: University of Minnesota Press.

Bold, C. (2003), '"Under the very skirts of Britannia": re-reading women in the James Bond novels', in C. Lindner (ed), *The James Bond Phenomenon: A Critical Reader*. Manchester; New York, NY: Manchester University Press, 169–83.

Bolton, A. and H. Koda (2012), *Schiaparelli & Prada: Impossible Conversations*. New York, NY: Metropolitan Museum of Art.

'Bond auction brings double-o heaven for bidders' (2012), *The Telegraph*, 6 October. Available at: www.telegraph.co.uk/culture/film/jamesbond/9591428/Bond-auction-brings-double-o-heaven-for-bidders.html (Accessed: 4 May 2018).

Bond Girls Are Forever (2002), [TV Programme] Prod. M. D'Abo, MGM.

'Bond Girls come up for air' (1966), US *Vogue*, January: 100–1.

Boum, A. and M. Bonine (2015), 'The Elegant Plume: Ostrich Feathers, African Commercial Networks, and European Capitalism', *The Journal of North African Studies*, 20(1): 5–26.

Bourke, J. (1996), 'The Great Male Renunciation: Men's Dress Reform in Inter-war Britain', *Journal of Design History*, 9(1): 23–33.

Bowles, H. (2008), 'A Mirror to His Time', in *Yves Saint Laurent: Style*. New York, NY: Harry N. Abrams, 15–19.

Boyd, W. (2013), *Solo: A James Bond Novel*. London: Jonathan Cape.

Braam, R. van (2010), 'Prada dress and Gina Paris shoes'. *Bond Lifestyle*, 25 February. Available at: www.jamesbondlifestyle.com/product/prada-dress-and-gina-paris-shoes (Accessed: 29 April 2018).

Brabazon, T. (2003), 'Britain's Last Line of Defence: Miss Moneypenny and the Desperations of Filmic Feminism', in C. Lindner (ed), *The James Bond Phenomenon: A Critical Reader*. Manchester; New York, NY: Manchester University Press, 202–14.

Brand, K. (2012), '*Skyfall*: Forget gender politics – 007 is a Bonding experience for all', *The Telegraph*, 13 October. Available at: www.telegraph.co.uk/women/womens-life/9606379/Skyfall-Forget-gender-politics-007-is-a-Bonding-experience-for-all.html (Accessed: 1 May 2018).

Braun, E. (1995), 'Futurist Fashion: Three Manifestoes', *Art Journal*, 54(1): 34–41.

Breward, C. (2003), *Fashion*. Oxford; New York, NY: OUP Oxford.

Breward, C. (2016), *The Suit: Form, Function and Style*. London: Reaktion Books.

Brooks, C. (2006), *Every Inch a Woman: Phallic Possession, Femininity, and the Text*. Vancouver: UBC Press.

Bruzzi, S. (1997), *Undressing Cinema: Clothing and Identity in the Movies: Clothes, Identities, Films*. London; New York, NY: Routledge.

Burnetts, C. (2015), 'Bond's Bit on the Side: Race, Exoticism and the Bond "Fluffer" Character', in L. Funnell *For His Eyes Only: The Women of James Bond*. London; New York, NY: Wallflower Press, 60–9.

Call Me Bwana (1963), [Film] Dir. Gordon Douglas, EON.

Campbell, J. (1976), *The Masks of God: Creative Mythology: Creative Mythology*. Harmondsworth: Penguin.

Carden-Coyne, A. (2012), 'Gendering the Politics of War Wounds', in A. Carden-Coyne (ed), *Gender and Conflict since 1914: Historical and Interdisciplinary Perspectives*. Basingstoke; New York, NY: Palgrave, 83–97.

Carlos, M. (2015), '*Spectre*'s Bond Leading Lady and Her 35 Red Carpet Looks: Meet the New Moneypenny', *Vogue*, 5 November. Available at: www.vogue.com/article/naomie-harris-james-bond-spectre-valentino-dior-thierry-mugler (Accessed: 1 September 2017).

Carter, A. (1979), *The Sadeian Woman: An Exercise in Cultural History*. London: Virago.

Carvell, N. (2015), 'All of James Bond's best black tie moments', *British GQ*, 22 October. Available at: www.gq-magazine.co.uk/gallery/james-bond-best-black-tie-eveningwear-tuxedos (Accessed: 22 October 2017).

Casino Royale (1967), [Film] Dir. John Huston, Ken Hughes, Val Guest, Robert Parrish and Joseph McGrath, MGM.

Casino Royale (2006), [Film] Dir. Martin Campbell, Eon.

Chapman, J. (2000), *Licence to Thrill: A Cultural History of the James Bond Films.* New York, NY: Columbia University Press.

Chapman, J. and S. Cobb (2016), 'The name's Bond, James Bond ... or should it be Jane?', *The Conversation*, 10 June. Available at: http://theconversation.com/the-names-bond-james-bond-or-should-it-be-jane-60650 (Accessed: 18 March 2018).

Chen, T. M. (2001), 'Dressing for the Party: Clothing, Citizenship, and Gender-formation in Mao's China', *Fashion Theory*, 5(2): 143–71.

Chu, Y.-W. (2013), *Lost in Transition: Hong Kong Culture in the Age of China.* SUNY Press.

Church-Gibson, P. (2000), 'Redressing the Balance: Patriarchy, Postmodernism and Feminism', in S. Bruzzi and P. Church-Gibson (eds), *Fashion Cultures: Theories, Explorations and Analysis*. London; New York, NY: Routledge, 349–62.

Churchwell, S. (2008), 'The enduring thrill of sex, sadism and snobbery', *The Independent*, 28 May. Available at: www.independent.co.uk/voices/commentators/sarah-churchwell-the-enduring-thrill-of-sex-sadism-and-snobbery-835155.html (Accessed: 1 May 2018).

C.I.A. Sexpionage (2012), [TV programme] Discovery Channel. Available at: www.youtube.com/watch?v=QPKJmkNcGzY (Accessed: 26 November 2018).

Citron, M. J. (2011), 'The Operatics of Detachment: Tosca in the James Bond Film *Quantum of Solace*', *19th-Century Music*, 34(3): 316–40.

Cixous, H. (1976), 'The Laugh of the Medusa', *Signs*, 1(4): 875–93.

Cixous, H. and C. Clément ([1975] 1997), *The Newly Born Woman*, trans. B. Wing, London: I. B. Tauris.

Clarke, J. (2002), 'The Human/Not Human in the work of Orlan and Stelarc', in J. Zylinska (ed), *The Cyborg Experiments: The Extensions of the Body in the Media Age*. London; New York, NY: Continuum, 33–55.

Comita, J. (2002), 'Vogue/VH1 Fashion Superstars: Kick-ass Style-Inspiration', US *Vogue*, 1 November: 223–7.

Connery, S. (1965), 'Playboy Interview', *Playboy*, November: 75–84.

Cook, P. (1996), *Fashioning the Nation: Costume and Identity in British Cinema*. London: British Film Institute.

Cook, P. and C. Hines (2005), '"Sean Connery *is* James Bond": Re-Fashioning British Masculinity in the 1960s', in R. Moseley (ed), *Fashioning Film Stars: Dress, Culture, Identity*. London: British Film Institute, 147–59.

Coren, G. (2015), 'The Spy who Loved Me', *Vogue*, November, pp. 214–25.

Cosgrave, B. (2006), 'The name's Cavalli', *Financial Times*, 17 November. Available at: www.ft.com/content/694e83c8-75a9-11db-aea1-0000779e2340 (Accessed: 10 April 2018).

Cosgrave, B., L. Hemming and N. McConnon (eds) (2012), *Fifty Years of Bond Style*. London: Barbican International Enterprises.

Cosgrave, B. (2012), 'Golden Style', in B. Cosgrave, L. Hemming, L. and N. McConnon (eds), *Designing 007 – Fifty Years of Bond Style*. London: Barbican International Enterprises, 11–13.

Court-Brown, C. M., M. M. McQueen and P. Tornetta (2006), *Trauma*. Philadelphia, PA: Lippincott Williams & Wilkins.

Cox, C. ([2004] 2005), *Stiletto*. London: Mitchell Bizley.

Cox, K. (2013), 'Becoming James Bond: Daniel Craig, Rebirth, and Refashioning Masculinity in *Casino Royale* (2006)', *Journal of Gender Studies*: 1–13.

Craig, D. (2008), 'Playboy Interview', *Playboy*, November: 57–64.

Craik, J. ([1993] 1994), *The Face of Fashion: Cultural Studies in Fashion*. London; New York, NY: Routledge.

Craik, J. (2005), *Uniforms Exposed: From Conformity to Transgression*. Oxford; New Your, NY: Berg.

Craik, J. (2009), *Fashion: The Key Concepts*. Oxford; New York, NY: Berg Publishers.

Creed, B. ([1993] 2007), *The Monstrous-Feminine: Film, Feminism, Psychoanalysis*. London; New York, NY: Routledge.

Cummins, F. (2005), 'The Name's Bland … James Bland', *The Daily Mirror*, 15 October: 1, 8–9.

Dalby, L. ([1993] 2001), *Kimono: Fashioning Culture*. London: Vintage.

Dalí, S. and A. Parinaud ([1973] 2004), *Maniac Eyeball: The Unspeakable Confessions of Salvador Dali*. London: Creation Books.

Davidson, K. (2015), 'How the Bond Girls Got a Modern Reboot for *Spectre*', *StyleCaster*, Available at: http://stylecaster.com/jany-tamime-spectre/ (Accessed: 12 November 2017).

Davis, F. (1992), *Fashion, Culture, and Identity*. Chicago, IL: University of Chicago Press.

Deleuze, G. and F. Guattari ([1980] 2004), *A Thousand Plateaus: Capitalism and Schizophrenia*. London: Continuum.

Designing 007 (2012), [Exhibition] Cur. Bronwyn Cosgrave and Lindy Hemming.

Desta, Y. (2018), 'Idris Elba: The Next James Bond Should Be a Woman', *Vanity Fair HWD*, 22 January. Available at: www.vanityfair.com/hollywood/2018/01/idris-elba-james-bond-woman (Accessed: 18 March 2018).

Dezentjé, P. (2018), 'The Omega Seamaster Diver 300m returns – on the wrist of Daniel Craig'. Available at: www.fratellowatches.com/seamaster-diver-300m-daniel-craig/ (Accessed on 23 November 2018).

Diamonds Are Forever (1971), [Film] Dir. Guy Hamilton, Eon.

Die Another Day (2002), [Film] Dir. Lee Tamahori, Eon.

Doane, M. A. (1982), 'Film and the Masquerade: Theorising the Female Spectator', *Screen*, 23(3–4): 74–88.

Dominková, P. (2008), 'I Want That Mink! *Film Noir* and Fashion', in M. Uhlirova (ed), *If Looks Could Kill: Cinema's Images of Fashion, Crime and Violence*. London: New York, NY: Koenig, 138–43.

Don't Look Now (1973), [Film] Dir. Nicolas Roeg, Casey.

Double Indemnity (1944), [Film] Dir. Billy Wilder, Paramount.

Dr. No (1962), [Film] Dir. Terence Young, Eon.

Durbach, N. (2010), *Spectacle of Deformity: Freak Shows and Modern British Culture.* Berkeley and Los Angeles, CA: University of California Press.

Eckert, C. (1990), 'The Carole Lombard in Macy's Window', in J. M. Gaines (ed), *Fabrications: Costume and the Female Body.* New York, NY: Routledge, 100–21.

Eco, U. ([1979] 2007), *The Role of the Reader: Explorations in the Semiotics of Texts.* Bloomington, IN: Indiana University Press.

Edelkoort, L. (2013a), 'Fascination: Interview with Ravage and John Sillevis', in L. Edelkoort (ed), *Fetishism in Fashion.* Amsterdam: Frame Publishers, 108–11.

Edelkoort, L. (2013b), *Fetishism in Fashion.* Amsterdam: Frame Publishers.

Eicher, J. B. and B. Sumberg (1999), 'World Fashion, Ethnic and National Dress', in J. B. Eicher and B. Sumberg (eds), *Dress and Ethnicity: Change Across Space and Time.* Oxford: Berg, 295–306.

Entwistle, J. (2007), '"Power Dressing" and the Construction of the Career Woman', in M. Barnard (ed), *Fashion Theory: A Reader.* London; New York, NY: 208–19.

Erskine, F. J. (1897), *Lady Cycling: What to Wear and How to Ride.* London: Walter Scott Limited.

Ewing, E. ([1974] 2014), *History of 20th Century Fashion.* London: B T Batsford.

Ewing, E. (1975), *Women in Uniform Through the Centuries.* London: B T Batsford.

Faroqhi, S. and C. K. Neumann (eds) (2004), *Ottoman Costumes: From Textile to Identity.* Istanbul: Eren.

Faulks, S. (2008), *Devil May Care.* London: Penguin.

Fellowes, J. (2008), 'James Bond week: 007 and his girls are back with a crisp new look'. *The Telegraph*, 22 October. Available at: http://fashion.telegraph.co.uk/news-features/TMG3365681/James-Bond-week-007-and-his-girls-are-back-with-a-crisp-new-look.html. (Accessed: 8 March 2019).

Ferrier, M. (2019), 'Part uniform, part armour: Functionality over faff as trend for boilersuits hots up', *The Guardian*, 9 March: 23.

Finch, J. (2011), 'The Ancient Origins of Prosthetic Medicine', *The Lancet*, 377(9765): 548–49.

Fischer, G. V. (1997), '"Pantalets" and "Turkish Trowsers": Designing Freedom in the Mid-Nineteenth-Century United States', *Feminist Studies*, 23(1): 111–40.

Fleming, F. (ed) (2015), *The Man with the Golden Typewriter: Ian Fleming's James Bond Letters.* London; Oxford; New York, NY: Bloomsbury Publishing.

Fleming, I. ([1953] 2006), *Casino Royale.* London: Penguin.

Fleming, I. ([1954] 2004), *Live and Let Die.* London: Penguin.

Fleming, I. ([1955] 2004), *Moonraker.* London: Penguin.

Fleming, I. ([1956] 2004), *Diamonds are Forever.* London: Penguin.

Fleming, I. ([1957] 2004), *From Russia with Love.* London: Penguin.

Fleming, I. ([1958] 2004), *Dr No.* London: Penguin.

Fleming, I. ([1959] 2004), *Goldfinger.* London: Penguin.

Fleming, I. ([1961] 2004), *Thunderball.* London: Penguin.

Fleming, I. ([1962] 2009), *The Spy Who Loved Me*. London: Penguin.

Fleming, I. (1962), 'How to Write a Thriller', *Books and Bookmen* (May): 14–19.

Fleming, I. ([1963] 2009), *On Her Majesty's Secret Service*. London: Penguin.

Fleming, I. ([1963] 2013), *Thrilling Cities*. London: Vintage Classics.

Fleming, I. ([1964] 2009), *You Only Live Twice*. London: Penguin.

Fleming, I. (1964), 'Playboy Interview: Ian Fleming', *Playboy*, December: 97–106.

Fleming, I. ([1965] 2012), *The Man with the Golden Gun*. London: Penguin.

Fleming, I. (2008), *Quantum of Solace: The Complete James Bond Short Stories*. London: Penguin.

Fleming, J. (2000), 'The Renaissance Tattoo', in J. Caplan (ed), *Written on the Body: The Tattoo in European and American History*. London: Reaktion, 61–82.

Flood, A. (2014), 'Shaken and stirred: letters reveal Ian Fleming's tempestuous first love', *The Guardian*, 26 March. Available at: www.theguardian.com/books/2014/mar/26/letters-ian-fleming-first-love (Accessed: 26 March 2018).

Flügel, J. C. ([1950] 1930), *The Psychology of Clothes*. London: Hogarth Press, and the Institute of Psychoanalysis.

For Your Eyes Only (1981), [Film] Dir. John Glen, Eon.

Francks, P. (2015), 'Was Fashion a European Invention? The Kimono and Economic Development in Japan', *Fashion Theory*, 19(3): 331–61.

Fraser-Cavassoni, N. (2015), *Vogue on: Yves Saint Laurent*. London: Quadrille Publishing.

Freud, S. ([1925] 1995), 'Some Psychical Consequences on The Anatomical Distinction between the Sexes', in *The Standard Edition of the Complete Psychological Works of Sigmund Freud*. London: The Hogarth Press, 241–58.

Freud, S. ([1926] 1995), 'The Question of Lay Analysis', in *The Standard Edition of the Complete Psychological Works of Sigmund Freud*. London: The Hogarth Press, 183–258.

Freud, S. ([1927] 1995), 'Fetishism', in *The Standard Edition of the Complete Psychological Works of Sigmund Freud*. London: The Hogarth Press, 147–57.

Freud, S. ([1930] 1995), 'Civilisation and its Discontent', in *The Standard Edition of the Complete Psychological Works of Sigmund Freud*. London: The Hogarth Press, 57–145.

From Russia with Love (1964) [Film] Dir. Terence Young, Eon.

Fukai, A. (2005), 'The Kimono and Parisian Mode', in A. V. Assche (ed), *Fashioning Kimono: Dress and Modernity in Early Twentieth-Century Japan*. Milan: 5 Continents, 49–55.

Funnell, L. (2008), 'From English Partner to American Action Hero: The Heroic Identity and Trans-National Appeal of the Bond Girl', in C. Hart (ed), *Heroines and Heroes: Symbolism, Embodiment, Narratives & Identity*. Midrash Publications, 61–80.

Funnell, L. (2011a), 'Negotiating Shifts in Feminism: The "Bad" Girls of James Bond', in Waters, M. (ed) *Women on Screen: Feminism and Femininity in Visual Culture*. Basingstoke; New York, NY: AIAA, 199–212.

Funnell, L. (2011b), '"I Know Where You Keep Your Gun": Daniel Craig as the Bond–Bond Girl Hybrid in Casino Royale', *The Journal of Popular Culture*, 44(3): 455–72.

Funnell, L. (2014), *Warrior Women: Gender, Race, and the Transnational Chinese Action Star*. Albany, NY: State University of New York Press.

Funnell, L. (2015), 'Objects of White Male Desire: (D)Evolving Representations of Asian Women in Bond Films', in L. Funnell (ed), *The Women of James Bond*. London; New York, NY: Wallflower Press, 79–87.

Funnell, L. (2018), 'Reworking the Bond Girl Concept in the Craig Era', *Journal of Popular Film and Television*, 46(1): 11–21.

Gaines, J. M. (1990), 'Fabricating the Female Body', in J. M. Gaines and C. Herzog (eds), *Fabrications: Costume and the Female Body*. New York, NY: Routledge, 1–27.

Gaines, J. M. and C. Herzog (eds) (1990), *Fabrications: Costume and the Female Body*. New York, NY: Routledge.

Gamman, L. (2008), 'On Gangster Suits and Silhouettes', in M. Uhlirova (ed), *If Looks Could Kill: Cinema's Images of Fashion, Crime and Violence*. London: New York, NY: Koenig, 218–29.

Gamman, L. and M. Makinen (1994), *Female Fetishism: A New Look*. London: Lawrence & Wishart Ltd.

Garber, M. (1991), *Vested Interests: Cross-Dressing and Cultural Anxiety*. New York: Routledge.

Garland, T. W. (2009), '"The Coldest Weapon of All": The Bond Girl Villain in James Bond Films', *Journal of Popular Film and Television*, 37(4): 179–88.

Garrett, V. M. (2007), *Chinese Dress: From the Qing Dynasty to the Present*. Tokyo; North Clarendon, VT: Tuttle Publishing.

Gelder, K. (2000), 'Postcolonial Voodoo', *Postcolonial Studies*, 3(1): 89–98.

Gerber, D. A. (ed) (2012), *Disabled Veterans in History*. Ann Arbor, MI: University of Michigan Press.

Giraud, F. (1965), 'After Courrèges, What Future for the Haute Couture?', *New York Times*, 12 September: 50–51, 110.

Glassman, M., C. Illick, S. Diamond, and C. Whiteaker (2015), 'James Bond Index: From gadgets and tuxes to cocktails and quips', 6 November. Available at: www.bloomberg.com/graphics/2015-bond-james-bond/ (Accessed: 5 May 2018).

Gnoli, S. (2014), *The Origins of Italian Fashion 1900–1945*. London: V & A Publishing.

Goldman, V. (2004), 'Jeepers Creepers', *The New York Times*, 29 August. Available at: www.nytimes.com/2004/08/29/magazine/jeepers-creepers.html (Accessed: 26 April 2018).

Goldfinger (1965), [Film] Dir. Guy Hamilton, Eon.

GoldenEye (1995), [Film] Dir. Martin Campbell, Eon.

Gray, A. (2014), 'Keira Knightley Channels A Bond Girl in Chanel's Coco Mademoiselle Advert', *Marie Claire*, 18 March. Available at: www.marieclaire.co.uk/news/celebrity-news/keira-knightley-channels-her-inner-bond-girl-in-this-glam-new-chanel-video-1-91232 (Accessed: 3 May 2018).

Gunther, J. (1958), *Inside Russia Today*. London: Hamish Hamilton.

Gurova, O. (2009), 'The Art of Dressing: Body, Gender and Discourse on Fashion in Soviet Russia in the 1950s and 1960s', in E. Paulicelli (ed), *The Fabric of Cultures: Fashion, Identity, Globalization*. London; New York, NY: Routledge, 73–91.

Halloran, V. (2005), 'Tropical Bond', in E. P. Comentale, S. Watt, and S. Willman (eds), *Ian Fleming and James Bond: The Cultural Politics of 007*. Bloomington, IN: Indiana University Press, 158–77.

Haraway, D. (1991), *Simians, Cyborgs and Women: The Reinvention of Nature*. London: Free Association Books.

Harling, R. (1963), 'The Ian Flemings', US *Vogue*, 1 September: 222–7, 239–41.

Harper, S. (1994), *Picturing the Past: The Rise and Fall of the British Costume Film*. BFI Publishing.

Hastings, C. (2008), 'James Bond girls are Feminist Icons', *The Telegraph*, 20 September. Available at: www.telegraph.co.uk/news/celebritynews/3024355/James-Bond-girls-are-feminist-icons-says-Cubby-Broccolis-daughter.html (Accessed: 1 May 2018).

Head, E. and Jane Kesner Ardmore ([1959] 1960), *The Dress Doctor*. Kingswood: The World's Work.

Hellman, G. T. (1962), 'Bond's Creator', *The New Yorker*, 21 April: 32–4.

Hemming, L. (2006), '*Casino Royale* Costume Designer Interview *MI6: The Home of James Bond*. Available at: www.mi6-hq.com/sections/articles/bond_21_lindy hemming_interview.php3 (Accessed: 10 April 2018).

Hillier, G. L. (1893), 'Rational Dress for Ladies', *Bicycling News*, 30 September: 213–14.

Hollander, A. (1976), 'Fashion in Nudity', *The Georgia Review*, 30(3): 642–702.

Hollander, A. (1977), 'The Issue of Skirting', *The New Republic*, 17 December: 27–8.

Hollander, A. ([1978] 1993), *Seeing Through Clothes*. Berkeley, CA: University of California Press.

Hollander, A. (1994), *Sex and Suits*. Brinkworth: Claridge Press.

Hoof, J. (2005), 'Living the James Bond Lifestyle', in E. P. Comentale, S. Watt and S. Willman (eds), *Ian Fleming and James Bond: The Cultural Politics of 007*. Bloomington, IN: Indiana University Press, 71–86.

hooks, bell ([1992] 2014), *Black Looks: Race and Representation*. New York, NY: Routledge.

Horak, L. (2016), *Girls Will Be Boys: Cross-Dressed Women, Lesbians, and American Cinema, 1908–1934*. New Brunswick, NJ: Rutgers University Press.

Horowitz, A. (2015), *Trigger Mortis: A James Bond Novel*. London: Orion.

Houlbrook, M. (2005), *Queer London: Perils and Pleasures in the Sexual Metropolis, 1918–1957*. Chicago, IL: University of Chicago Press.

Hovey, J. (2005), 'Lesbian Bondage, or Why Dykes Like 007', in E. P. Comentale, S. Watt and S. Willman (eds), *Ian Fleming and James Bond: The Cultural Politics of 007*. Bloomington, IN: Indiana University Press, 42–54.

Howell, G. (1990), 'The Titan of Tight', US *Vogue*, March: 456–63 and 524.

Hyde, M. (2016), The name's Elba, Idris Elba – and he must be James Bond, *The Guardian*, 20 May. Available at: www.theguardian.com/lifeandstyle/lostinshowbiz/2016/may/20/idris-elba-must-be-james-bond-tom-hiddleston-daniel-craig (Accessed: 18 March 2018).

It's a Man's Man's Man's World (1966), [Music Recording] Comp. James Brown, Betty Jean Newsome, King.

It's a Man's Man's Man's World (2004), [Live Recording] Comp. James Brown. Betty Jean Newsome, Joss Stone, Virgin.

'James Bond's Girls' (1964), US *Vogue*, 1 July: 74–7.

Jeffries, S. (2007), 'He's the Bond girl, not me', *The Guardian*, 26 January. Available at: www.theguardian.com/film/2007/jan/26/jamesbond (Accessed: 2 May 2018).

Jenkins, T. (2005), 'James Bond's "Pussy" and Anglo-American Cold War Sexuality', *The Journal of American Culture*, 28(3): 309–17.

Jirousek, C. (2004), 'Ottoman Influences in Western Dress', in S. Faroqhi and C. K. Neumann (eds), *Ottoman Costumes: From Textile to Identity*. Istanbul: Eren, 231–51.

Jobling, P. (1999), *Fashion Spreads: Word and Image in Fashion Photography Since 1980*. Oxford: Berg Publishers.

Johnson, P. ([1958] 2007), *Sex, Snobbery and Sadism*, 5 February. Available at: www.newstatesman.com/society/2007/02/1958-bond-fleming-girl-sex (Accessed: 26 March 2018).

Jones, D. (1999), 'Dressed to Kill', *Sunday Times*, 7 November: 62.

Jones, G. and P. Morley (2016), *I'll Never Write My Memoirs*. Simon & Schuster UK.

Jones, S. (2015), '"Women Drivers": The Changing Role of the Bond Girl in Vehicle Chases', in L. Funnell (ed), *For His Eyes Only: The Women of James Bond*. New York, NY: Wallflower Press, 205–13.

Kahn, E. L. (2003), *Marie Laurencin: Une Femme Inadaptée in Feminist Histories of Art*. Farnham: Ashgate.

Kant, I. ([1796] 1887), *The Philosophy of Law*. Translated by Hastie, W. Edinburgh: T and T Clark.

Karmali, S. (2012), '*Skyfall*'s Designer On Dressing A Bond Girl', *Vogue*, 25 October. Available at: www.vogue.co.uk/gallery/skyfall-costume-designer-jany-temime-on-dressing-bond-girl-berenice-marlohe (Accessed: 26 June 2017).

Kelly, A. (2014), '"I carried his name on my body for nine years": the tattooed trafficking survivors reclaiming their past', *The Guardian*, 16 November.

Kesselman, A. (1991), 'The "Freedom Suit": Feminism and Dress Reform in the United States, 1848–1875', *Gender and Society*, 5(4): 495–510.

Khanna, R. (2003), *Dark Continents: Psychoanalysis and Colonialism*. Durham, NC: Duke University Press.

Kidwell, C. B. and V. Steele (1989), *Men and Women: Dressing the Part*. Washington, DC: Smithsonian Institution Press.

Kilcooley-O'Halloran, S. (2012), '*Skyfall* Royal World Premiere', *Vogue*, 24 October. Available at: www.vogue.co.uk/gallery/skyfall-royal-world-premiere (Accessed: 5 May 2018).

Krafft-Ebing, R. von ([1886] 1906), *Psychopathia Sexualis*. New York, NY: Rebman.

Krentcil, F. (2015), 'Here's the Problem with Fashion's Androgyny Obsession', *ELLE*, 2 September. Available at: www.elle.com/fashion/a30209/the-problem-with-fashions-androgyny-obsession/ (Accessed: 17 March 2018).

Kristeva, J. (1982), *Powers of Horror: An Essay on Abjection*. New York, NY: Columbia University Press.

Kuchta, D. (2009), 'The Three-Piece Suit', in P. McNeil and V. Karaminas (eds), *The Men's Fashion Reader*. Oxford; New York, NY: Berg, 44–53.

Kuki Shūzō ([1930] 1980), *The Structure of 'Iki'*, trans. J. Clark, London: British Library.

Kunze, P. C. (2015), 'From Masculine Mastermind to Maternal Martyr: Judi Dench's M, *Skyfall*, and the Patriarchal Logic of the James Bond Films', in L. Funnell (ed), *For His Eyes Only: The Women of James Bond*. New York, NY: Wallflower Press, 237–45.

Kunzle, D. (1982), *Fashion & Fetishism: Corsets, Tight-Lacing & Other Forms of Body-Sculpture*. Totowa: Rowan and Littlefield.

Lacan, J. ([1958] 2001), 'The Signification of the Phallus', in J. Lacan *Ecrits: A Selection*, trans. A. Sheridan, London: Routledge, 311–22.

Ladenson, E. (2003), 'Pussy Galore', in C. Lindner (ed), *The James Bond Phenomenon: A Critical Reader*. Manchester; New York, NY: Manchester University Press, 185–201.

Lambert Chambers, D. K. D. ([1910] 1912), *Lawn Tennis for Ladies*, London: Methuen.

Landis, D. N. (2003), *Costume Design*. Burlington, MA: Focal Press.

Landis, D. N. (2012), *Costume Design*. London: Ilex Press.

Lant, A. C. (1991), *Blackout: Reinventing Women for Wartime British Cinema*. Princeton, NJ: Princeton University Press.

Laverty, L. C. (2011), 'Diana Rigg in *On Her Majesty's Secret Service*: To Die For'. *Clothes on Film*. Available at: http://clothesonfilm.com/diana-rigg-in-ohmss-a-wedding-ensemble-to-die-for/20920/ (Accessed: 19 September 2017).

Lee, A. (2002), 'Fiction Fashions', US *Vogue*, 1 May: 88, 90, 92.

Lee, J. (2014), 'Feminism Has a Bra-Burning Myth Problem', *Time*, 12 June. Available at: http://time.com/2853184/feminism-has-a-bra-burning-myth-problem/ (Accessed: 5 March 2018).

'Les Girls Les Boys get intimate' (2017), *The Guardian*, The Fashion Issue, Autumn/Winter: 14.

'Letter' 1936, *Autocar*, 21 August 1936: 336.

Levine, P. ([2004] 2007a), 'Introduction: Why Gender and Empire?', in P. Levine (ed), *Gender and Empire*. Oxford: Oxford University Press, 1–13.

Levine, P. ([2004] 2007b), 'Sexuality, Gender, and Empire', in P. Levine (ed), *Gender and Empire*. Oxford: Oxford University Press, 134–55.

Levitt, D. (1909), *The Woman and the Car: A Chatty Little Handbook for All Women Who Motor or Who Want to Motor*. London: John Lane.

Lewis, T. (2016), 'Interview with Naomie Harris: "I portray strong women because that's what I know"', *The Observer*, 1 May. Available at: www.theguardian.com/film/2016/may/01/naomie-harris-interview-our-kind-of-traitor-bond-moneypenny (Accessed: 1 September 2017).

Licence to Kill (1989), [Film] Dir. John Glen, Eon.

'License to Thrill' (1999), US *Vogue*, 1 May: 262–75.

Lindsey, L. L. ([1990] 2005), *Gender Roles: A Sociological Perspective.* Upper Saddle River, NJ: Pearson.

Live and Let Die (1973), [Film] Dir. Guy Hamilton, Eon.

Ludot, D. (2001), *Little Black Dress: Vintage Treasure.* New York, NY: Assouline Publishing.

Lukács, G. (1968), *History and Class Consciousness: Studies in Marxist Dialectics,* trans. R. Livingstone, Cambridge, MA: MIT Press.

Lycett, A. (1995), *Ian Fleming.* London: Hachette.

Lycett, A. (2012), 'Mr Ian Fleming', Mr Porter: *The Journal,* 3 July. Available at: www.mrporter.com/journal/journal_issue71/1 (Accessed: 22 April 2018).

Macaraeg, R. A. (2007), 'Dressed to Kill: Toward a Theory of Fashion in Arms and Armor', *Fashion Theory,* 11(1): 41–64.

McDowell, C. (1992), *Dressed to Kill: Sex, Power and Clothes.* London: Hutchinson.

McNeil, P. and V. Karaminas (2009), 'The Field of Men's Fashion', in P. McNeil and V. Karaminas (eds), *The Men's Fashion Reader.* Oxford; New York, NY: Berg, 1–11.

Malkin, B. (2016), 'It's Bond, Jane Bond: Gillian Anderson throws hat into the ring to be next 007', *The Guardian,* 24 May. Available at: www.theguardian.com/film/2016/may/24/jane-bond-gillian-anderson-next-007-twitter (Accessed: 18 March 2018).

Marriott, H. (2017), 'Taking Care of Business', *The Guardian,* The Fashion Issue, Autumn/Winter: 86–8.

Martin, R. (1998), *Cubism and Fashion.* New York, NY: Metropolitan Museum of Art.

Martinez, D. P. (1999), 'Naked Divers: A Case of Identity and Dress in Japan', in J. B. Eicher (ed), *Dress and Ethnicity: Change Across Space and Time.* Oxford; Washington, DC: Berg, 79–94.

Marx, K. ([1867] 1976), *Capital: A Critique of Political Economy,* Vol. 1, trans. B. Fowkes, London: Penguin.

Mason, R. ([1958] 2012), *The World of Suzie Wong.* New York, NY: Penguin USA.

Meter, J. van (2002), 'Solid Gold', *US Vogue,* 1 December: 260–75, 338.

Meyer, S. (2016), *Little Black Dress: From Mourning to Night.* St Louis, MO: Missouri History Museum Press.

Miers, P. (2010), 'Orientalism', in V. Steele (ed), *The Berg Companion to Fashion.* Oxford; Washington, DC: Berg, 546–9.

Millennium Fashion (2016), [Video Recording] Available at: www.youtube.com/watch?v=tfrdqU2Ngdg (Accessed: 9 March 2018).

Miller, T. (2003), 'James Bond's Penis', in C. Lindner (ed), *The James Bond Phenomenon: A Critical Reader.* Manchester; New York, NY: Manchester University Press, 232–47.

'Miss Tessie Reynolds', *Bicycling News,* 30 September 1893: 210.

Modleski, T. (2005), *The Women Who Knew Too Much.* New York, NY: Routledge.

Molloy, J. T. (1980), *Women: Dress for Success.* London: W Foulsham & Co.

Molloy, J. T. (1996), *New Women's Dress for Success.* New York, NY: Grand Central Publishing.

Moniot, D. (1976), 'James Bond and America in the Sixties: An Investigation of the Formula Film in Popular Culture', *Journal of the University Film Association*, 28(3): 25–33.

Moonraker (1979), [Film] Dir. Lewis Gilbert, Eon.

Morand, P. (2010), *The Allure of Chanel*, trans. E. Cameron, London: Pushkin Press.

Morocco (1930), [Film] Dir. Joseph von Sternberg, Paramount.

Mortimer, R. (1963), 'Two Heroes of Our Time: James Bond and the Admass Daydream', *Sunday Times*, 31 March: 28.

Mower, S. (2006), 'Alexander McQueen Fall 2006 Ready-to-Wear Fashion Show', US *Vogue*, 3 March. Available at: www.vogue.com/fashion-shows/fall-2006-ready-to-wear/alexander-mcqueen (Accessed: 10 March 2018).

Mulvey, L. (1975), 'Visual Pleasure and Narrative Cinema', *Screen*, 16(3): 6–18.

Mulvey, L. (1981), 'Afterthoughts on "Visual Pleasure and Narrative Cinema" inspired by King Vidor's *Duel in the Sun* (1946)', *Framework: The Journal of Cinema and Media*, 15/17: 12–15.

Nair, P. T, (1974), 'The Peacock Cult in Asia', *Asian Folklore Studies*, 33(2): 93–170.

Naughton, J. (2015), 'The Secret History of 007', GQ, November. 224–31.

Neale, S. (1983), 'Masculinity as Spectacle: Reflections on Men and Mainstream Cinema', *Screen*, 24(6): 2–17.

Never Say Never Again (1983), [Film] Dir. Irvin Kershner, MGM.

Newman, R. (2015), 'Blond Bombshell', *Evening Standard Magazine*, 23 October: 63.

Newton, H. (1989), 'Maryam D'Abo: Bond Bombshell', US *Vogue*, 1 August: 322–3.

Niagara (1953), [Film] Dir. Henry Hathaway, Twentieth-Century Fox.

Nickel, H. (1991), 'The Dragon and the Pearl', *Metropolitan Museum Journal*, 26: 139–46.

O' Brien, L. (2007), *Madonna: Like an Icon*. London: Corgi.

O'Connell, S. (1998), *The Car and British Society: Class, Gender and Motoring, 1896–1939*. Manchester: Manchester University Press.

Octopussy (1983), [Film] Dir. John Glen, Eon.

OED, s.v. "exotic" (a. and n.), accessed 2 April 2019, http://www.oed.com/view/Entry/66403?redirectedFrom=exotic

OED, s.v. "trousers" (n.), accessed 2 April 2019, http://www.oed.com/view/Entry/206795?rskey=5RhWok&result=1

Olson, Nancy (2018), 'A James Bond Favorite: Omega Seamaster, With A Facelift'. Available at: www.forbes.com/sites/nancyolson/2018/03/23/a-james-bond-favorite-omega-seamaster-with-a-facelift/#4f43227f629d (Accessed on 23 November 2018).

One Hundred and One Dalmatians (1961), [Film] Dir. Clyde Geronimi, Disney.

On Her Majesty's Secret Service (1969), [Film] Dir. Peter Hunt, Eon.

Owen, C. N. (2005), 'The Bond Market', in E. P. Comentale, S. Watt. and S. Willman (eds), *Ian Fleming and James Bond: The Cultural Politics of 007*. Bloomington, IN: Indiana University Press, 107–25.

Özüdoğru, Ş. (2016), 'Ottoman costume in the context of modern Turkish fashion design', in M. A. Jansen and J. Craik (eds) *Modern Fashion Traditions*. London; New York, NY: Bloomsbury, 121–41.

Ozzard, J. (2003), 'Fall 2003: Ready-to-Wear: Diane von Fürstenberg', US *Vogue*, 9 February. Available at: www.vogue.com/fashion-shows/fall-2003-ready-to-wear/diane-von-furstenberg (Accessed on 10 October 2018).

Pagnoni Berns, F. G. (2015), 'Sisterhood as Resistance in *For Your Eyes Only* and *Octopussy*', in L. Funnell (ed), *For His Eyes Only: The Women of James Bond*. New York, NY: Wallflower Press, 119–27.

Pajaczkowska, C. and B. Curties (2008), 'Looking Sharp', in M. Uhlirova (ed), *If Looks Could Kill: Cinema's Images of Fashion, Crime and Violence*. London: New York, NY: Koenig, 62–27.

Parker, M. (2014), *Goldeneye: Where Bond was Born: Ian Fleming's Jamaica*. Hutchinson.

Parks, L. (2015), '"M"(O)thering: Female Representation of Age and Power in James Bond', in L. Funnell (ed), *For His Eyes Only: The Women of James Bond*. New York, NY: Wallflower Press, 255–64.

Partington, A. (1992), 'Popular Fashion and Working-Class Affluence', in J. Ash and E. Wilson (eds), *Chic Thrills: A Fashion Reader*. London: Pandora, 145–61.

Patton, B. (2015), 'M, 007, and the Challenge of Female Authority in the Bond Franchise', in L. Funnell (ed), *For His Eyes Only: The Women of James Bond*. New York, NY: Wallflower Press, 246–54.

Peacock, J. (1998), *Fashion Sourcebooks: The 1960s*. New York: Thames and Hudson.

'People are Talking about', US *Vogue*, 1 February 1965: 130–1.

Pearson, J. ([1966] 2013), *The Life of Ian Fleming*. London: Bloomsbury Academic.

Pepys, S. (2003), *The Diaries of Samuel Pepys – A Selection*. R. Latham (ed), London: Penguin Classics.

Peterson, C. L. (2000), 'Foreword: Eccentric Bodies', in M. Bennett and V. D. Dickerson (eds), *Recovering the Black Female Body: Self-Representation by African American Women*. New Brunswick, NJ: Rutgers University Press, ix–xvi.

Petrov, J. (2016), '"A Strong-Minded American Lady": Bloomerism in Texts and Images, 1851', *Fashion Theory*, 20(4): 381–413.

Phili, S. (2012), 'Style Reconnaissance: *Skyfall*'s Jany Temime on Daniel Craig's Wardrobe Requests', *GQ*, 9 November. Available at: www.gq.com/story/jany-temime-skyfall-interview-james-bond-style-daniel-craig (Accessed: 1 June 2017).

Pîrvu, A. (2012), 'Style in Film: Eva Green in *Casino Royale*'. *Classiq*. Available at: http://classiq.me/style-eva-green-in-casino-royale (Accessed: 21 March 2018).

Pîrvu, A. (2015), 'Barbara Bach as Bond Girl in *The Spy Who Loved Me*'. *Classiq*. Available at: http://classiq.me/barbara-bach-as-bond-girl-in-the-spy-who-loved-me (Accessed: 7 September 2017).

Planka, S. (2015), 'Female Bodies in the James Bond Title Sequences', in L. Funnell (ed), *For His Eyes Only: The Women of James Bond*. New York, NY: Wallflower Press, 139–47.

Polan, B. and R. Tredre (2009), *The Great Fashion Designers*. Oxford: Berg.

Poole, R. (1989), 'Bloomsbury and Bicycles', *ELH*, 56(4): 951–66.

Press, G. (2012), 'Interview with Jany Temime, *Skyfall* costume designer'. *LBD BLOG.* Available at: www.littleblackdress.co.uk/magazine/favourites/interview-with-jany-temime-skyfall-costume-designer/ (Accessed: 1 September 2017).

Quantum of Solace (2008), [Film] Dir. Marc Forster, Eon.

Raise Your Glass (2010), [Music Video] Comp. Pink. Available at: www.youtube.com/watch?v=XjVNlG5cZyQ (Accessed: 27 February 2018).

Rausch, A. J. (2009), 'Gloria Hendry', in A. J. Rausch, D. Walker and C. Watson (eds), *Reflections on Blaxploitation: Actors and Directors Speak.* Lanham, MD: Scarecrow Press.

Rebranded (2014), [VIDEO] Available at: https://www.theguardian.com/global-development/video/2014/nov/16/rebranded-survivors-ink-us-sex-industry-tattoos (Accessed 21 December 2018).

Reid, S. E. (2002), 'Cold War in the Kitchen: Gender and the De-Stalinization of Consumer Taste in the Soviet Union under Khrushchev', *Slavic Review,* 61(2): 211–52.

Richler, M. (1971), 'James Bond Unmasked', in *Mass Culture Revisited.* New York, NY: Van Nostrand Reinhold Company, 341–55.

Riviere, J. ([1929] 1966), 'Womanliness as a Masquerade', in H. M. Ruitenbeek (ed) *Psychoanalysis and Female Sexuality.* Lanham: Rowman & Littlefield, 209–20.

Roberts, H. E. (1977), 'The Exquisite Slave: The Role of Clothes in the Making of the Victorian Woman', *Signs,* 2(3): 554–69.

Rooji, M. J. de (2013), 'Elevation', in L. Edelkoort (ed), *Fetishism in Fashion.* Amsterdam: Frame Publishers, 200–5.

Rothman, L. (2012a), 'James Bond, Declassified: 50 Things You Didn't Know About 007', *Time,* 28 September. Available at: http://entertainment.time.com/2012/10/04/james-bond-declassified-50-things-you-didnt-know-about-007/slide/a-shining-night/ (Accessed: 5 May 2018).

Rothman, L. (2012b), 'Fighting, Flirting, Feminism: The Bond Girl Evolution', *Time,* 9 November. Available at: http://entertainment.time.com/2012/11/09/fighting-flirting-feminism-the-bond-girl-evolution/ (Accessed: 1 May 2018).

Royster, F. T. (2009), '"Feeling like a woman, looking like a man, sounding like a no-no": Grace Jones and the performance of Strangé in the Post-Soul Moment', *Women & Performance: A Journal of Feminist Theory,* 19(1): 77–94.

Sabin, R. (2008), 'The Face of Fear', in M. Uhlirova (ed), *If Looks Could Kill: Cinema's Images of Fashion, Crime and Violence.* London: New York, NY: Koenig, 32–9.

Sacher-Masoch, L. von ([1870] 1970), *Venus in Furs,* trans. H. J. Stenning, London: Luxor Press.

Salisbury, H. E. (1959), *To Moscow and Beyond, A Reporter's Narrative.* New York, NY: Harpers Brothers.

Salmon, C. (2017), 'Joanna Lumley is right: Idris Elba shouldn't play Bond – in fact, no one should', *The Guardian,* 10 May. Available at: www.theguardian.com/film/filmblog/2017/may/09/idris-elba-james-bond-joanna-lumley (Accessed: 18 March 2018).

Schmidt, C. (2012), *The Swimsuit: Fashion from Poolside to Catwalk*. London: Berg.

Segal, L. (1997), *Slow Motion: Changing Masculinities, Changing Men*. London: Virago.

Sergeant, A. (2015), 'Bond is Not Enough: Elektra King and the Desiring Bond Girl', in L. Funnell (ed), *For His Eyes Only: The Women of James Bond*. New York, NY: Wallflower Press, 128–36.

Serlin, D. (2006), 'Disability, Masculinity, and the Prosthetics of War, 1945–2005', in M. Smith and J. Morra (eds), *The Prosthetic Impulse: From a Posthuman Present to a Biocultural Future*. Cambridge, MA: MIT Press, 155–83.

Severson, A. J. (2015), 'Designing Character: Costume, Bond Girls, and Negotiating Representation', in L. Funnell (ed), *For His Eyes Only: The Women of James Bond*. New York, NY: Wallflower Press, 176–84.

Shaw, K. (2015), 'The Politics of Representation: Disciplining and Domesticating Miss Moneypenny in *Skyfall*', in L. Funnell (ed), *For His Eyes Only: The Women of James Bond*. London; New York, NY: Wallflower Press, 70–8

Sherman, B. (2015), 'Ghosts', in C. Wilcox (ed), *Alexander McQueen*. London: V&A, 243–46.

Shields, R. (2009), 'A Tale of Three Louis: Ambiguity, Masculinity and the Bow Tie', in P. McNeil and V. Karaminas (eds), *The Men's Fashion Reader*. Oxford; New York, NY: Berg, 108–16.

Shklovsky, V. (1997), 'Art as Technique', in K. M. Newton (ed), *Twentieth-Century Literary Theory: A Reader*. Basingstoke: Palgrave, 3–5.

Shoard, C. (2018), 'A female James Bond? Never, confirms executive producer', *The Guardian*, 5 October. Available at: www.theguardian.com/film/2018/oct/05/there-will-never-be-a-female-james-bond-confirms-executive-producer (Accessed: 11 October 2018).

Shome, R. (2014), *Diana and Beyond: White Femininity, National Identity, and Contemporary Media Culture*. Urbana, Chicago and Springfield: University of Illinois Press.

Silver, A. and J. Ursini (2013), *Film Noir*. Köln; London: Taschen.

Simmel, G. (1957), 'Fashion', *American Journal of Sociology*, 62(6): 541–58.

Simmonds, M. (2015), *Bond by Design: The Art of the James Bond Films*. London: DK.

Singer, O. (2017), 'Fashion's Most Powerful Androgynous Icons', *Vogue*, 30 August. Available at: www.vogue.co.uk/gallery/fashion-androgynous-icons-annie-lennox-prince-david-bowie (Accessed: 5 September 2017).

Single White Female (1992), [Film] Dir. Barbet Schroeder, Columbia Pictures.

Skyfall (2012a), [Film] Dir. Sam Mendes, Eon.

Skyfall (2012b), [Music Recording], Comp. Adele Adkins and Paul Epworth, XL Columbia.

Sleeping Beauty (1959), [Film] Dir. Clyde Geronimi.

Smith, N. M. (2015), 'Monica Bellucci: "I'm not a Bond girl, I'm a Bond woman"', *The Guardian*, 17 September. Available at: www.theguardian.com/film/2015/sep/17/monica-bellucci-james-bond-spectre-bond-woman (Accessed: 3 May 2018).

Spaiser, M. (2011), 'Blofeld: The Mao Suit'. Available at: www.bondsuits.com/blofeld-the-mao-suit/ (Accessed: 23 April 2018).

Spaiser, M. (2014), 'Silva: Cream Jacket and Printed Shirt'. *The Suits of James Bond*. Available at: www.bondsuits.com/silva-cream-jacket-and-printed-shirt/ (Accessed: 1 June 2017).

Spaiser, M. (2016a), 'James Bond and the Gauntlet (Turnback) Cuff'. *The Suits of James Bond* Available at: www.bondsuits.com/james-bond-gauntlet-turnback-cuff/ (Accessed: 22 April 2018).

Spaiser, M. (2016b), 'Blofeld's Navy Nehru Jacket in Spectre'. *The Suits of James Bond* Available at: www.bondsuits.com/blofelds-navy-nehru-jacket-spectre/ (Accessed: 23 April 2018).

'*Spectre*: New Day of the Dead featurette', *The Telegraph*, 15 June 2015. Available at: www.telegraph.co.uk/film/james-bond-spectre/opening-scene/ (Accessed: 8 May 2017).

'Speaking of Pictures: the perils for spike-heeled girls', *Life*, 10 October 1960: 14–15.

Spectre (2015), [Film] Dir. Sam Mendes, Eon.

Spivak, G. C. (1988), 'Can The Subaltern Speak?', in C. Nelson and L. Grossberg (eds) *Marxism and The Interpretation of Culture*. Urbana and Chicago: University of Illinois Press.

Spooner, C. (2012), 'The Lady is a Vamp: The Cultural Politics of Fur', in S. Tarrant and M. Jolles (eds), *Fashion Talks: Undressing the Power of Style*. Albany, NY: SUNY Press, 165–78.

Stacey, J. (1994), *Star Gazing: Hollywood Cinema and Female Spectatorship*. London; New York, NY: Routledge.

Stam, R. (2005), 'Introduction: The Theory and Practice of Adaptation', R. Stam and A. Raengo (eds), *Literature and Film: A Guide to the Theory and Practice of Film Adaptation*. Oxford: Blackwell, 1–52.

Steele, V. ([1996] 1997), *Fetish: Fashion, Sex and Power*. Oxford and New York, NY: Oxford University Press.

Steele, V. (2001), *The Corset: A Cultural History*. New Haven: Yale University Press.

Steele, V. (2013), 'Bondage Fetish: The Corset', in L. Edelkoort, (ed) *Fetishism in Fashion*. Amsterdam: Frame Publishers, 45–9.

Steele, V. and J. S. Major (1999), *China Chic: East Meets West*. New Haven, CT: Yale University Press.

Stempien, M. (2015), 'The Making of James Bond: How Anthony Sinclair Suits Helped Turn Sean Connery's Defining Character into a Style Icon'. *JustLuxe*. Available at: www.justluxe.com/fine-living/mens-fashion/feature-1959662.php (Accessed: 22 April 2018).

Street, S. (2001), *Costume and Cinema: Dress Codes in Popular Film*. New York, NY: Wallflower Press.

Summers, J. (2015), *Fashion on the Ration: Style in the Second World War*. London: Profile Books.

Summers, L. (2001), *Bound to Please: A History of the Victorian Corset*. Oxford: Berg.

Swift, T. (2006), 'Review: *Casino Royale*'. Available at: http://toddswift.blogspot.com/2006/12/review-casino-royale.html (Accessed: 10 April 2018).

Tanner, B. (2003), 'The Spy Who Came out of the Closet'. *Bond Lifestyle*. Available at: www.jamesbondlifestyle.com/articles/spy-who-came-out-closet-part-1 (Accessed: 22 April 2018).

Temime, J. (2015), 'The costumes of *Spectre*'. Available at: www.007.com/the-costumes-of-spectre/ (Accessed: 9 April 2018).

'The Cloche is Dead? Long live the Cloche! The New Spring Hats' (1924), *Vogue* (Early March): 31–5, 84.

The Dark Knight Rises (2012), [Film] Dir. Christopher Nolan. Warner Bros.

'The Début of the Winter Mode' (1926), *US Vogue* (October): 55–63, 68–9, 152, 164, 166, 168, 170.

'The Great Cole Scandal Suit' (1965): 'New but not nude' [advert], US *Vogue* (January): 43–47.

The Great Gatsby (1974), [Film] Dir. Jack Clayton.

The Living Daylights (1987), [Film] Dir. John Glen, Eon.

The Man with the Golden Gun (1974), [Film] Dir. Guy Hamilton, Eon.

The Postman Always Rings Twice (1946), [Film] Dir. Tay Garnett, MGM.

The Spy Who Loved Me (1977), [Film] Dir. Lewis Gilbert, Eon.

The World Is Not Enough (1999), [Film] Dir. Michael Apted, Eon.

The World of Suzie Wong (1960), [Film] Dir. Richard Quine, Paramount.

'This is the body that is fashion' (1965), *US Vogue* (January): 73–6.

Thumim, J. (1992), *Celluloid Sisters: Women and Popular Cinema*. Basingstoke: Palgrave Macmillan.

Thunderball (1965), [Film] Dir. Terence Young, Eon.

Thurston, A. J. (2007), 'Paré and prosthetics: the early history of artificial limbs', *ANZ Journal of Surgery*, 77(12): 1114–19.

Tomorrow Never Dies (1997), [Film] Dir. Roger Spottiswoode, Eon.

Uhlirova, M. (ed) (2008), *If Looks Could Kill: Cinema's Images of Fashion, Crime and Violence*. London; New York, NY: Koenig.

Vainshtein, O. (2009), 'Dandyism, Visual Games, and the Strategies of Representation', in P. McNeil and V. Karaminas (eds), *The Men's Fashion Reader*. Oxford and New York, NY: Berg, 84–107.

Venus in Furs (1967), [Music Recording] Comp. Lou Reed, Andy Warhol.

Venus in Fur (2013), [Film] Dir. Roman Polanski, Lionsgate.

Vincendeau, G. (2005), 'Hot Couture: Brigitte Bardot's Fashion Revolution', in R. Moseley (ed), *Fashioning Film Stars: Dress, Culture, Identity*. London: British Film Institute, 134–46.

Vinken, B. (1999), 'Transvesty – Travesty: Fashion and Gender', *Fashion Theory*, 3(1): 33–49.

Wagner, T. L. (2015), '"The Old Ways are the Best": The Colonization of Women of Color in Bond Films', in L. Funnell (ed), *For His Eyes Only: The Women of James Bond*. London; New York, NY: Wallflower Press, 51–9.

Walden, C. (2008), 'James Bond Girls Dressed to Kill', *The Telegraph*, 22 October. Available at: http://fashion.telegraph.co.uk/news-features/TMG3365679/James-Bond-girls-dressed-to-kill.html (Accessed: 30 March 2018).

Walford, J. (2013), *Sixties Fashion: From 'Less is More' to Youthquake*. London: Thames & Hudson.

Walsh, J. (2012), 'James Bond: The Spy who Loved to Look Cool', *The Independent*, 30 June. Available at: www.independent.co.uk/arts-entertainment/films/features/james-bond-the-spy-who-loved-to-look-cool-7896694.html (Accessed: 25 April 2018).

Warwick, A. and D. Cavallaro, (1998), *Fashioning the Frame: Boundaries, Dress and the Body*. Oxford and New York, NY: Berg.

Waters, N. (2015), 'Léa Seydoux on Being a Modern Bond Girl', *AnOther*, 29 October. Available at: www.anothermag.com/fashion-beauty/7971/lea-seydoux-on-being-a-modern-bond-girl (Accessed: 12 November 2017).

Weintraub, S. (2012), 'Costume Designer Lindy Hemming Talks Catwoman', *Collider*, 10 July. Available at: http://collider.com/lindy-hemming dark-knight rinon interview/ (Accessed: 16 April 2018).

Welters, L. M. (ed) (1999), *Folk Dress in Europe and Anatolia: Beliefs about Protection and Fertility*. Oxford: Berg.

Werle, S. (2010), *Fashionisto: A Century of Style Icons*. London: Prestel.

'What has happened to Bond Girls?' (1978), *Sunday Telegraph*, 17 September: 10–11.

Wilcox, C. (ed) (2015), *Alexander McQueen*. London: V&A.

Wilson, E. ([1983] 2007), *Adorned in Dreams*. New Brunswick, NJ: Rutgers University Press.

Wilson, E. (2008), 'Dressed to Kill: Notes on Dress and Costume in Crime Literature and Film', in M. Uhlirova (ed), *If Looks Could Kill: Cinema's Images of Fashion, Crime and Violence*. London: New York, NY: Koenig, 14–19.

Winterson, J. (2002), 'Girls, Girls, Girls', *The Guardian*, 13 September. Available at: www.theguardian.com/film/2002/sep/13/artsfeatures.jamesbond1 (Accessed: 1 May 2018).

Woollacott, A. (2006), *Gender and Empire*. Houndmills, Basingstoke, Hampshire; New York, NY: Palgrave Macmillan.

Wright L. (2007), 'Objectifying Gender: The Stiletto Heel', in M. Barnard (ed), *Fashion Theory: A Reader*. London and New York, NY: Routledge, 197–207.

Wu, J. (2009), *Chinese Fashion: From Mao to Now*. Oxford and New York, NY: Berg.

'Young Idea' (1961), *Vogue*, January: 47–48.

You Only Live Twice (1967), [Film] Dir. Lewis Gilbert.

'Youthquake' (1965), US *Vogue*, January: 112–19.

Index